The Lie That Tells a Truth

W. W. NORTON & COMPANY

New York · London

The Lie That Tells a Truth

A Guide to Writing Fiction

JOHN DUFRESNE

For information about permission to reproduce selections from this book, write to
Permissions, W. W. Norton & Company, Inc., 500 Fifth Avenue, New York, NY 10110

Manufacturing by Courier Companies, Inc.
Book design by Barbara M. Bachman
Production manager: Julia Druskin

Library of Congress Cataloging-in-Publication Data

Dufresne, John.
The lie that tells a truth : a guide to writing fiction / by John Dufresne.— 1st ed.
p. cm.
Includes bibliographical references.
ISBN 0-393-05751-8
1. Fiction—Authorship. I. Title.
PN3355.D88 2003
808.3—dc21
2003005091

W. W. Norton & Company, Inc., 500 Fifth Avenue, New York, N.Y. 10110
www.wwnorton.com

W. W. Norton & Company Ltd., Castle House, 75/76 Wells Street, London W1T 3QT

2 3 4 5 6 7 8 9 0

A good traveler has no fixed plans,

and is not intent on arriving.

—LAO TZU

For all my teachers and all my students

and for Agnes Berard,

at whose kitchen table I learned to love stories

Contents

X

The Process

The Product

Other Matters

Introduction

)(

Every child is an artist. The problem is
how to remain an artist when we grow up.

—*Pablo Picasso*

I'll assume that if you're reading this introduction, then you must want
to write. Why else would you be loitering around the Writing/Publishing sec-
tion of the bookstore when all the really interesting and dangerous people
are over in the Self-Help/Addiction aisle? (And there are lots of them.) Well,
the plain truth is that if you want to write, you can. And if you *want* to write
but you *don't* write, you're inviting madness. (Kafka said that or something
like it.) Wanting to write means, of course, that you're not writing. And
wanting to write but not writing will lead to frustration, guilt, and regret.
And regret eats the soul. Writing, on the other hand, leads to discovery,
insight, and accomplishment. The fact is, it's easier to write than it is to want
to write. Just pick up your pen, put down a word. Any word.

So what's been stopping you? Maybe you used to write poems and stories
(in fact, you've kept them; they're in a box up in the attic), but then the kids
came along and there was simply no time. Or perhaps all you ever wanted to be
was a writer, but you succumbed to the wishes of your uncompromising par-
ents, or you listened to your exasperated and very practical significant other or
to your own insecurities and you went off to law school, but now, years later,
you can feel that old creative ache in your bones. You're cross-examining a
defense witness, and you're thinking, Damn, I could have come up with a bet-

ter story than this. Where are the details? Or maybe you've never written, though you've always wanted to, because the whole idea of writing seems overwhelming. I mean, Where do I start? Well, the *idea* of writing *is* overwhelming; the act of writing, however, is simplicity itself. Maybe you've quit writing a dozen times but find yourself thinking about your old characters again. Or you got your MFA in creative writing but landed this teaching job and all you seem to do these days is grade freshman compositions. Or everyone in your writers' group is producing like crazy; everyone but you, that is. And you joined the group to give yourself a kick in the butt. You're creatively frozen for some reason. Whatever your story is, if you have the itch, it's time to scratch.

Johann Sebastian Bach was approached by an admirer outside of St. Thomas School in Leipzig. The enthusiastic young man praised the master's work. Bach smiled. The man said, "Can you tell me how I can become a composer? It's my dream."

Bach said, "I have no idea."

"But, sir, you *are* a composer."

Bach nodded. "But I didn't have to ask."

To be a composer, Bach knew, you write music. No secrets. And when the music is ready, the orchestra will appear.

Now, maybe Bach said what I allege he did to the eager young man or maybe he didn't. I made up the anecdote, but it could have happened. I chose Bach as a subject because he really did say this: "Anyone who works as hard as I do, can do as well."

Remember when you were a child, and you were stuck in the house on a rainy day, and Mom sat you at the kitchen table, gave you a pencil, a sharpener, a box of crayons, and a ream of paper, and you went at it? You drew all day long and never got blocked, never concerned yourself with perfection, never worried about repeating yourself. All of your people had triangle noses, brilliant smiles, and arms like the branches of a tree. (You could write a fascinating essay about your childhood drawings, couldn't you? Writing gives you the license to be impractical, to consider the marvelous and the arcane, and at what other moment in your day, in your entire life, do you take your own childhood seriously?) You were so good at this because you were into the fun of it. The play. It didn't matter that only two of your masterpieces made it to the refrigerator door and the others got recycled. It was the making of the art that both compelled and rewarded you. The *doing*, not the *having done*. What this book aims to do is get you back into the fun of making things up.

So start writing today. You can begin right now if you remembered to bring a pen along—there are napkins in the coffee shop. Napkins are for writing. It's not enough to want to be a writer; you need to write, and in doing so *become* a writer. (Okay, tomorrow, then. Today you'll need to buy new pens, some writing tablets, and you'll need to create a little office, a writing room or alcove or corner for yourself at home, put up the "Do Not Disturb" sign. But no later than tomorrow. Excuses—we've got a million of them. In the writing world, however, excuses are irrelevant.) There are no classes to register for, no entrance exams to take, no aptitude tests. No one else can or will give you permission to write, so don't even ask. And no one else can stop you. No one to blame, no one to thank.

You don't need to know what a plot is. We'll get to that. You don't even need to know what to write about—you'll get plenty of suggestions. What to write about, I admit, can be very intimidating when you are beginning to learn the craft, but if you do the exercises in this book, you'll have generated enough material and characters to keep you happily writing for the rest of your life.

This sounds so easy, but there is a cost. You have to pay for the privilege of writing with your time. But that's not so hard. You only have to want to write as much as you want to watch TV or go to the movies. You manage to get those done. You can probably manage all three. You pay with your time, your patience, your passion, your persistence. And one more thing. You have to be willing to fail, to see that you aren't half so clever as you thought you were. (But then, humility is the first step on the road to wisdom.) There's really nothing mysterious about all this. If you want to hold your novel in your tight little fists in a couple of years, then you have to sit down right now and get to work.

In fact, before you leave the bookstore why don't we wander over to the Self-Help/Addiction aisle and pretend to browse? The air is thicker over here, isn't it? Someone's wearing patchouli. Can you believe these titles? *Think and Grow Rich* (I did; I didn't); *Wisdom of the Ages: 60 Days to Enlightenment* (Oh, please! I'm not opposed to gullibility, but where does it stop?); *Get Anyone to Do Anything* (An honest self-help book, at least); *Lesbian Sex Secrets for Men* (Thanks, but no thanks); *Power Thought Cards* (Power thoughts?); *Why Is It Always About You?* (Am I whining?); *Understanding Your Angels and Meeting Your Guides* (My God, I think he's serious); *Extended Massive Orgasm* (Hmm). Where were we? Oh, yes, we're here for material. So let's eavesdrop.

Did that woman standing alone with *Conversations with God* in her hand just say what I thought she did? She's in love with a noodle? You think she said poodle? Or strudel? (Mishearing invites invention.) And who's she talking to anyway? And what about the guy over by the Dr. Phil display? The guy with the headphones on. (Listening to Enya?) What's on his mind? Okay, he's going to buy the book. So let's picture him at home tonight reading it. Where's he sitting? Who else is in the house? Does he read with a pen in his hand? With the TV on? Why did he come to the store tonight to buy this particular book? Now you've got the idea. He and the woman who talks alone and that young man over there in the bondage pants and the "I Was a Teenage Malcontent" T-shirt are characters in our short-story-in-progress, "Singles Night at the Book Emporium."

You're going to meet resistance in your writing life (only some of which will come from your critical self). People who love you will tell you you're not being productive. You're wasting your time on a pipe dream. They'll say they could use some help with the supper. They'll say the garage needs cleaning. They'll say, Okay, you gave it a shot, and we're so proud of you for trying, but now let's get on back to the real world. Tell these people that you know your writing will not change the world but it may change you. (Is that what they're worried about?) Tell them you are not going to be good, that you're not going to do what you're supposed to do. If they persist, tell them that you're going to write about them. You've got a story in mind. It's called "Your Money or Your Life." Tell them you'll get the house painted, mop the dust bunnies under the bed, you'll pay the gas bill, but not right now. Tell them you love them, and you'll see them again just as soon as you find the verb that will make this sentence sing.

Laurence Sterne said he wrote the first sentence and trusted in God for the rest. God here is a metaphor for the Muse. Muse here is a metaphor for Work. Writing is, among other things, an act of faith, like engaging in conversation is an act of faith. You launch into a sentence not knowing where it'll go, but trusting that it'll make some sense and that it'll come to an end. A story is a long conversation between you and the reader. So let's get started. Let's be bad. Let's go looking for trouble. Let's commit some fiction.

Thanks to Florida International University for the
Summer Research Grant that allowed me the time to finish this book
and to the Florida Arts Council for an Individual Artist Fellowship.
And thanks to Brother Joseph Gerard and Brother Capistran,
who, way back when, turned me on to literature
and encouraged my first efforts at writing.

And, of course,
I want to thank Jill Bialosky and Richard McDonough
for all their encouragement and support.
And as always, thank you, Cindy. Thank you, Tristan.

The Process

Getting in Shape

Ж

Go to your bosom: Knock there, and ask
your heart what it doth know.

—*Measure for Measure*

Jesus said, If you bring forth what is within you, what you bring
forth will save you. If you do not bring forth what is within you,
what you do not bring forth will destroy you.

—*The Gospel of Thomas*

*Y*ou wouldn't be here if you didn't want to write, so let's write. We'll chat later. Get out your pen and paper or fire up the computer. Pour yourself a coffee. Unplug the phone. Once you start, you can't stop. Give yourself a half hour. Relax. Don't think too much. You're starting a journey, and you don't know where you're going. But you do know you're going someplace you haven't been before. Take ten minutes for each exercise. Here we go.

1. HERE AND NOW! Write about where you are physically right now. In the writing room or the kitchen, in a theater, on the subway. Write about the feel of the pen in your hand or the sound of the paper as your hand glides across it. Write in first person, present tense. The smell and the sounds. Even the silence has a sound—let us hear it. Keep jotting down sense experiences. What do you see out the corner of your eye? Think of a color and look up and

write down what you see that's blue or green or whatever you chose. (Interesting how that invoked color suddenly jumps out at you, how the color itself determines what you see.) What about the textures of things? What does the seat feel like? Think about your body and how it feels configured as it is. Shift around a bit. How does that feel? What do you see now that you didn't see before? How could you have missed it? How can you look at something, you might wonder, and yet not see it? What else have you been missing all your life? ("The first act of writing is noticing." —W. H. Auden.) When you get distracted, go with the distraction. Write about it.

2. THE SHOE THAT DROPS. You are aware that something is missing in your life. And it's not money. It's something more important than that. What is it? Or who is it? Don't resist it now. It can't hurt you. No one else needs to know. Something (someone) you've never had or something (someone) you've had and you've lost. It is a hollowness that eats at your heart. It's what you think about when you're sitting alone in a quiet room, and it's three A.M., and you can't sleep. It's the shoe that drops and snaps you out of your dreams. It's what you remember just when you think everything in your life is going so well. Or perhaps, when you consider dying, you think: This is what I need before it's too late. Write about this void, give this emptiness a shape.

3. HOMETOWN. Think about the place where you grew up, and, of course, the time you grew up there. How was that place different from any other place, than the place where you live now? And even if you haven't moved geographically, the place has changed, hasn't it? What were the local rituals that made it unique? Think about language, vocabulary, dialect, accent. Think about foods, think about the work people did. The work they didn't do. Remember the annual events that everyone looked forward to. The schools, the architecture, the folkways. The town or the neighborhood legends and characters. This could be the setting for stories, remember. Walk around the town or the neighborhood and put your five senses to work. Stop and talk to the people you find there—the people from your own past. Think about the seasons, the light, the ground, the schools, the churches, the secret places you escaped to.

You just spent a half hour writing quickly, serenely, and without expectation, and in doing so you gathered enough material to write any number of

stories. And remember, you don't have to stop now. When you get a few minutes today or tomorrow, go back to the notes you just took, read them, and keep on writing. Let the words and the material, the memories and images guide you. This is when writing is the most fun. You've got nothing to prove and a world—your world, in this case—to explore. And now you'll be thinking about these recollections, these revelations, all day. Don't dismiss them.

The Lie That Tells a Truth is meant to be a plain-speaking guidebook that helps you to do what you've always wanted to do—write stories. I'm talking specifically to fiction writers, but I think most of what I have to say is applicable to memoirists as well. (The spell-check on my computer just told me there's no such word as *memoirist*, told me to use *memorist*, which, in fact, isn't a word, which is why you can never trust in spell-check or grammar-check, for that matter, which is often quite ludicrous in its pronouncements. You do it yourself. Is spelling important? [Grammatik just told me to change that sentence to *Is spelling importantly?*] You bet it is. And so is good grammar and accurate punctuation. What could be more obvious than that? Fortunately, there are dictionaries and stylebooks that will address just those issues—you don't have to memorize a thing. I confess to being a less-than-proficient speller. I know that every time I want to spell *occassion* [see there; got it wrong again] *occasion*, I will have to look it up. Words with double consonants are my downfall. And *its*/*it's*. You can use spell- and grammar-check programs, just don't rely on them.)

>
> *"Refuse to write your life and you have no life."*
> —PATRICIA HAMPL

>
> *"It's never too late to be what you could have been."*
> —GEORGE ELIOT

Where were we? Oh, yes. There's nothing mysterious about the writing process—unless you've never done it, of course. We'll talk about what a story is (and what a novel is) and how one gets written. Writing is a craft, and it can be taught and can be learned. I learned it. Writing is a skill, and none of us are born with skills. We work at them. What can't be taught, of course, is talent and passion. Talent is cheap, however. ("Talent is long patience." —Flaubert; "Genius is eternal patience." —Michelangelo; "Everyone has talent. What is rare is the courage to follow the talent to the dark place where it leads." —Erica Jong.) Passion is much more significant.

We'll do more of the kind of writing exercises you just did. An exercise is

an act of employing or putting into play; an activity that requires physical or mental exertion, performed to maintain fitness. It means practice. From the Latin *exercitium* n. *exercito*—"to keep at work." The idea of the writing exercises in the book is to get you fit, practiced, ready to write. This is the writing that comes before and between your stories and novels. This is the writing designed to get you ready to compete, as it were, to get yourself excited, to get you writing without effort and strain eventually. The idea is that writing is fun despite what they taught you in school. You may not be able to get to that story every day, but you sure can write every day. Exercises may help to keep you thinking and living like a writer. So let's do another one. This will take you a bit longer. Set aside a block of time. In fact, let's just talk about time for a minute. Time and writing.

>
> *"All the things one has forgotten*
> *scream for help in dreams."*
> —ELIAS CANETTI

In a chapter of *Becoming a Writer,* the chapter entitled "Harnessing the Unconscious," Dorothea Brande says that the first step toward being a writer is to hitch your unconscious mind to your writing arm. She contends that it is possible to write for long periods of time without fatigue and that if you push yourself past that first weariness, you will find in yourself a reservoir of unsuspected creative energy, a second wind. If you want the full benefit of the unconscious part of yourself (we might think of this as the right brain, the nonanalytical part of ourselves, or some other metaphor), you must learn to write smoothly and easily when the unconscious mind is in the ascendant. She says the best way to do that is to rise a half hour or hour earlier than normal, as early as you can. Begin to write without talking, without reading the newspaper, without making the coffee or turning on the radio. Begin to write down anything that comes to your mind, rapidly and uncritically. You are learning to write in the twilight zone (her phrase, not Rod Serling's) between waking and sleeping so similar to the true hypnopompic state you may just have left.

After a couple of days you'll find that there are a certain number of lines that you can write easily and without strain. In subsequent days, push the limit. Try to double it. Writing is now becoming a part of your life. (Julia Cameron, in *The Artist's Way,* has a variation on this system. She calls it "Morning Papers" and suggests that every morning, without fail, but not necessarily on rising, you handwrite three pages of whatever is there.

Everything that comes out is important in at least one respect—whatever it is, often worries, was likely to impede your focused writing later on in the day.) Now you're ready to teach yourself to write at any given moment. After you've dressed in the morning, look ahead at your day and find fifteen minutes that you'll have for yourself, and schedule that time for writing. Come hell or high water, keep the appointment. Keep this strategy up every day, but vary the times. Morning, afternoon, late at night. Keep the date to the second. Vary the length as well. Maybe you can sneak in a half hour on Saturday, an hour here, twenty minutes there. (Cameron has a variation on this exercise as well. She calls it the Artist Date—you make a date with your artist/the child inside/the creator and you actually take her out for an enjoyable time. You go to the park to write or to a café where you can linger, etc.)

There is a deep inner resistance to writing that is apt to surface at these moments, and your lazy self (your frightened self? your humble self?) will suddenly begin to find busywork to do. The easiest thing is to put off writing because you have a headache, or because the phone rings, or the person from Porlock is at the door, or the clothes need to be put in the dryer, or Kmart's having a sale on motor oil, or the bills have to be paid. Disregard it all. If you fail repeatedly at this exercise, Brande says, give up writing. Your resistance to writing is greater than your desire to write. I think

> "What one has lost, or never had, feeds the work. There is a chance to make things right, to explain and explore, and aided by memory and its transmutations, find a new place where I have not been and did not wish to go."
>
> —JOYCE CAROL OATES

she's being unduly harsh, but maybe not. Why force yourself to do something that you don't want to do? There's something unwholesomely puritanical in that. So try these two procedures in your notebooks for the next two weeks, let's say, and make them nonnegotiable. Early morning writing—three pages will do (and you do not have to read them at all); and writing by appointment—fifteen minutes will do. You will not only be learning how to write, you'll also be learning how to be a writer.

Now for the exercise.

AUTOBIOGRAPHY. You want to write your autobiography, but you don't know where to start. Well, you don't start by writing, *I was born on . . .* and

continue on until today. Too large and daunting. You need to focus, gather material. Following is a list of questions and suggestions that might help. But don't limit yourself to them. Write about them in as much detail as you wish and write about anything else that these questions suggest to you.

The source of much of the material that finds its way into our writing is our own lives, our own values, our own emotions. Flannery O'Connor said that anyone who has survived beyond the age of twelve has enough fictional material for the rest of her life. And remember, too, the unexamined life is not worth living.

What are your tastes in music, books, painting, sports, cars, foods, beverages, films, plants, furniture, houses, politicians, magazines, appliances, friends, television shows? (That should take the rest of the day.) Have your tastes changed as you've grown?

Describe what you remember of your childhood prior to beginning school. Do you remember your toys, your dolls, your room? Where did you play when you played outside? What is your earliest memory? Write about that. I've had people tell me they remember being in the womb. Other folks have said they can't remember anything before they were six or seven. Why do you suppose that is? I can remember a dream I had when I was two. I know my age because my sister, my competition, had just been born and carried home from the hospital. She was killed in my dream, suffocated by shadow men. (I've apologized.) I also remember being a year old and standing in my crib watching my father come home. But perhaps the memory was constructed from photographic evidence—there is a picture of me in his hat taken at that moment. Can it be a memory if you see yourself in it? Probably not. At any rate, memory is our autobiography. And the first memory is where you say your life begins.

.

"Everybody needs his memories.
They keep the wolf of insignificance
from the door."

—SAUL BELLOW

Discuss three events that have caused you to be profoundly unhappy. And it's not always the obvious events that make us the saddest. Think hard. What is the best thing that has happened to you in your life? The worst? (Just a reminder: There are no right answers. Do this again next week, and you'll likely have different answers.)

What are your major fears? We think of phobias as abnormal and

irrational, but they still count. And not all fears are irrational. I've had friends tell me they aren't afraid of death. I don't believe them. I'm with Céline, who said, "If you have no imagination, death is nothing. If you do, it is too much." Give examples of your fears and try to trace the fears back to childhood incidents if you can. Maybe you're afraid of the dark for a good reason.

When do you feel most at ease and comfortable? And where? And what are you doing when you are at this ease? Are you alone? (Why is it that we can stare at the ocean or at a fire in a fireplace for hours? What is the comfort we find there?)

Now that you're blissful, and since I brought it up: How do you think you'll die? How would you like to die? *Like,* I suppose, is the wrong word. (I think of Woody Allen's line about achieving immortality by not dying.) Imagine your own funeral, your wake, the gathering after the burial. (This is your only chance to be there.)

Describe some silly, foolish thing you've done. What does it feel like to remember this? How did it feel then?

What are your attitudes toward the opposite sex, love, money, insanity, suicide, abortion, violence, family life, animals, poverty? Remember that our attitudes are seldom simple, often ambivalent. Be honest with yourself. Maybe you're a liberal and a feminist and believe in a woman's right to choose, but you're not sure what you'd do if you were confronted with an unwanted pregnancy.

What would you like to change about yourself? Why haven't you done it already? When will you start the change? Wanting to write starts today.

What are the motivating forces in your life? What are your ambitions? Describe your life in ten years as you want it to be. How would you live if you could have anything you want? What do you want?

Describe any jobs you've had. Talk about the people you worked with.

Have you had any mystical experiences? What were they? What do you feel like when you talk about them?

What did you want to be when you were five? (Me, I wanted to be a cowboy-priest. Riding the range, delivering the sacraments.) When you were ten? Why aren't you that person you dreamed of being? Do you still long to be that person? What's stopping you?

Write about all of the places you have ever lived. Describe each house in great and loving detail. Recall if you were happy or unhappy in these places

and why. Describe the kitchens, the yards, your bedrooms, the neighbors, the views, etc. What were the family dynamics in each house? List the smells that you remember and the memories they conjured. Remember the meals.

Remember the worst part of being a child. Dramatize it. Remember the best of it and dramatize that.

As a Matter of Fact

)(

All novels are burdened with the need to
make life more interesting than it is.

—*Wright Morris*

Now that we've talked about mining your own life for fictional* material, let's see what that implies. Let me give you an example of a story I wrote based on actual events from my life. The story is called "Surveyors," and it's in a collection called *The Way That Water Enters Stone*. It may be the most autobiographical story I've ever written. Why didn't I just write memoir, just write the facts, in other words? Well, first the real events. (If we can trust memory to furnish the real events—ever ask two people to recall a dinner they had together several years ago? You might wonder were they even in the same restaurant.)

When I was between, say, five and nine, I spent most of the summer with my grandparents in their apartment on Fairmont Avenue. Not far from our own house, actually. Still on Grafton Hill. In the evenings after supper, my grandfather and I would sit outside on the thin strip of crabgrass beside the gravel driveway and gaze out over the tomato garden he'd planted in the lot next door to his three-decker. He'd drink from a bottle of Tadcaster ale. In late July, when the tomatoes were finally ripe, he'd pick one and eat it. I didn't particularly like tomatoes, or any other vegetable (you could call them fruit, but I knew what they really were) except corn on the cob, and I would not have eaten a tomato, not raw, certainly, not off the vine. My grandfather would

have carried a saltshaker along, and he'd sprinkle salt onto the tomato at each bite. (I'm trying to remember if it was the quilted glass shaker from the kitchen table or a tiny Morton disposable one.) And we'd talk.

The reason I remember the ritual at all, and the reason I wrote about it, was that it ended. Ended rather abruptly. One evening (could have been afternoon, actually), a couple of men (or maybe it was one) came and walked through the lot that was my grandfather's garden. No one walked in the tomato garden but my grandfather! He went to speak with them. I figured they were in big trouble. Later, in the kitchen, he told us that the men were going to build a house in the vacant lot. And before the next summer, they did.

"A good writer sells out everybody he knows, sooner or later."

—ALICE McDERMOTT

As you can see, I'm not very conversant with the facts, but what is indelible for me is the emotion of those evenings and of their loss. And that's where the story came from. I loved sitting beside my grandfather, being pals. I hated when I could no longer do that. I hated that someone we didn't know took my grandfather's greatest pleasure, his garden, away from him. And we were helpless to do anything about it. And I wanted to address the truth of my feelings, my hurt and my anger, wanted the reader to feel what I felt then. Here's how I turned that summer and that loss into a story.

I don't remember how the tomatoes were planted; they were bushy, staked, unpruned, and seemed to cover every inch of soil from the sidewalk to the cyclone fence, from the driveway to Clarendon Street. But in the story there are "six rows of twelve tomato plants each." I figured there had to be a system to the planting, so why not this one? My grandfather was a carpenter as well as the painter I call him in the story, and he would have enjoyed the straight lines and symmetry. Why should he be denied them because I

"When a writer is born into a family, that family is doomed."

—CZESLAW MILOSZ

couldn't remember? And you, the reader, certainly don't want to be told something like "the plants were everywhere." Nothing is everywhere.

Tomatoes were tomatoes to me at nine. Round, satiny red, and aromatic. I couldn't have told a Nebraska Wedding from a Brandywine from a Cherokee Purple, but my grandfather could have, and so in the story he harvests several varieties, and you get to see them. It didn't make dramatic sense

to spend paragraphs or pages describing the months of nights we sat outside together. Certainly some nights it rained, other nights my grandfather sent me back inside to get him another bottle of ale, and more than once Henry Potvin stopped by, and he and my grandfather talked about fishing. None of which was important to what I wanted you to feel. So the long summer became the one summer night. And in order for you to care about our little problem, you needed to know us a little better.

> *"The problem with fiction is that it has to be plausible. That's not true with non-fiction."*
> —TOM WOLFE

So my grandfather had to tell a story. And the story had better have something to do with one of our themes. *Loss* would do. So he tells the boy—me, but not me—about how he lost the house he built with his own hands. Lost it to the banks in the Depression.

Or maybe he didn't tell me that particular story during that particular summer. It was a story I had heard many times in my childhood. I even played with the girl who then lived in the house my grandfather had built and lost, the house my mother grew up in. I longed to go inside, but was never invited to. The Bowmans were more formal people than we were. Protestants. Mr. Bowman was principal of Providence Street Junior High School. The apple tree that my grandfather had planted still grew in the Bowmans' backyard. But the pigeon coop and the mink cages were gone. And I never did see the eponymous surveyors with their transits. In the story, one of them wore a New York Yankees ball cap. But dramatically and thematically their appearance worked. Weren't my grandfather and I also surveyors of the garden? And didn't the baseball cap reflect more loss, the earlier televised ball game resonating here, our beloved Sox losing to the Yankees earlier in the story? And we did not watch the men bulldoze the garden. If I did see it, I have repressed it.

> *"What is remembered is what becomes reality."*
> —PATRICIA HAMPL

More likely I came back from the wading pool at Holmes Field one afternoon or home from a Little League game at night and saw that the lot had been cleared. In the story, by the way, the saltshaker is yellow and shaped like an ear of corn just because I liked looking at it.

When you use material from your own life in your fiction you have the benefit of a familiar setting; you have incidents or events that will become

your scenes; you have characters that you know, or think you know. You have a beginning, a middle, and an end to your story. All of that should make the writing of the story easier. But it doesn't. The advantages are also the disadvantages. Take character, for instance.
You think you know your grandfather, but then you realize you don't even know yourself, do you? You do things for no discernible reason half the time, don't you? If you can't know yourself, how can you presume to know another person? The

.

"We owe respect to the living; to the dead we owe nothing but the truth."

— VOLTAIRE

point is you are not writing about a real grandfather, but a fictional one, the one you've made up, the one you've chosen to remember. The character on the page is immediately different from the character he is based on. (So what is memoir? you might ask. I don't believe that the autobiographer recalling his impoverished childhood can remember conversations he had when he was three. And I don't think you believe it, either. Invention is inevitable. It's all fiction. Memoir is a fiction about your own past. That's what I think now.)*

Let me quote Janet Malcolm. In writing about Chekhov's story "The Lady with the Pet Dog," she says, "If privacy is life's most precious possession, it is fiction's least considered one. A fictional character is a being who

.

(Of his wife on her deathbed.)
"I found myself, without being able to help it, in a study of my beloved wife's face, systematically noting the colors."

— ÉDOUARD MANET

has no privacy, who stands before the reader with his 'real, most interesting life' nakedly exposed. We never see people in life as clearly as we see the people in novels, stories, plays." And this is why we read fiction. It is honest and relentless. In coming to understand why the characters do what they do, we may come to understand ourselves. So forget the model and attend to the character. Characters who are based on folks you

* At a writers' conference, a memoirist came up to me after the first morning of writing exercises. She said, "I don't ever bother myself with fiction, there being so much drama in real life." But she said she found the exercises, like those in this book, helpful for her in her memoir. On the last day of the conference, she rushed up to tell me what had happened. She wasn't sure if this was normal with fiction writers. She told me about the little boy she had discovered in the photography exercise—he was the child of the couple in the photo. She said he had stolen her heart away. "I don't know what kind of trouble he's got coming. I'm worried about him." His name was Dukie and she just thought about him all the time. Couldn't sleep for thinking of Dukie. I told her it was normal and wonderful. Boys like Dukie keep us writing.

know have to displace the folks you know before they can come alive.

And then you think about the beginning and the end of your story, and you realize that life doesn't come with plots. You're writing about the dwindling relationship you had with a best friend, say. You're trying to understand it—a great reason to write about it, of course. The friend suddenly stopped talking to you after twenty years of companionship. When did the problem begin? you wonder. In the story, do you establish the friendship first? Why? Maybe the problem began when you realized this pal hadn't returned your last five phone calls. What did you do to him? Maybe he was hurt that you told him what you thought about the way he was treating that last girlfriend, what's-her-name? When did the problem—and when does the story—end? Is it over, in fact? Is there even any dramatic material there to work with? Have you done anything to save the friendship? Maybe you could start close to there, the first time you stopped by his house to ask what was going on.

>
>
> *"True to life becomes fiction when it perceives more than it observes."*
>
> —WRIGHT MORRIS

When a story is based on autobiographical material there is a tendency to be slavish to the facts. You write a scene because "that's the way it happened." Well, we don't care that it happened that way. Fiction is telling the truth, not telling the facts. (Truth is something like the essence of fact. Facts are subject to interpretation or we wouldn't have a phrase like "The *true* facts may never be known.") Let's say you're writing a story about a marriage in trouble and you base it on your own troubled marriage. In the scene you remember, the scene you're writing, your wife is confessing her infidelity. The husband (he looks a lot like you) is stunned. He doesn't know what on earth to say. How could she have done this to him? He looks at her. They're in the car on the Interstate. He thinks for a second he should barrel into the guardrail. He collects himself. His wife is weeping—with shame? The cell phone rings. He answers it. It's his brother saying he has tickets to the Marlins game on Saturday. And so on. Well, maybe that is the way it happened in your life, but is the phone call necessary in the scene you're writing? Doesn't it break the tension? Maybe you don't need it. Most of what happens in our day is mundane. But fiction is not about trivialities. Once you begin your story, you owe your allegiance to the story

>
>
> *"Everything one invents is true."*
>
> —GUSTAVE FLAUBERT

and not to the facts of your life. Remember, the reader doesn't care about your life, only about the lives on the page.

There's a part of every writer, every artist, that stays detached, that is always observing, watching himself the same way that he watches others. It's all material out there, after all. And of course, this must be disconcerting to those who notice the detachment. Especially if it's your spouse and you're having a heated discussion. Sincerity has nothing to do with it, either. A writer, naturally, can't ever be completely involved in the moment because part of her is taking notes. And eventually people catch on to your game. They know that you are stealing from their precious lives for your wretched little stories. People may stop talking to you. Other writers will talk, but only if you promise you won't appropriate their tales.*

> *"Transformation—taking the raw materials of your life, making small and large changes to turn what you know into fictional material. Transformation gives you power over events—life is disorganized, here you impose order; protects you—no one knows who he is; provides new insights by trying to see it from the point of view of your characters, not the people you knew; gives you power over your story."*
>
> —KIT REED

What, then, is your obligation to family and friends? I think your obligation is not to hurt anyone. And that means you may have to stuff that story about your Cousin Billy and his embarrassing trip to the emergency room into the desk drawer until Cousin Billy has died. Unless you can disguise it. I've modeled characters on people who have not recognized themselves, thank God. I was in a conversation with my mother, sisters, and other family members one afternoon and heard some wonderfully quirky and juicy material that I just knew had to be in a story, and before the chat was finished I

*At a party of writers and friends not long ago, a woman, a technical writer, told a story about her psychologist boyfriend, how he kept washing his hands all the time, even had a sink in his office. Whenever he shook a person's hand, he washed his own. Dozens of times a day. All the other little conversations in the room quieted. Heads turned toward the woman. She continued on about how she and the psychologist had slept together on vacation but had not had sex, much to her dismay and bewilderment. When someone mentioned that she should have brought the boyfriend along to the party, she said, Oh, no, he doesn't get along with people. All the writers grabbed for their pens and any paper they could find—napkins, drink coasters, whatever. I expect we'll be seeing stories about misogynistic, obsessive-compulsive psychologists with performance disorders pretty soon.

had figured out how to use it. I wasn't so crude as to take notes at the kitchen table, of course. As soon as the others left the room, my mother looked across the table at me and said, "Don't you dare." And I haven't.

Other people see themselves on every page, even when they aren't there. You tell them, No, this is fiction. I made it up. They smile and say, But I was in the room when it happened. You tell them it didn't happen, and they start describing what else went on. They name all the other "characters" in the scene. People are disappointed when you tell them the guy on page 17 isn't them. So you let them believe it. Maybe they're right, after all. Memory is a rascal.

EXERCISES

.

Genealogy

You can count on this. Your family is full of stories. With your parents' help or your grandparents' or a professional genealogist, make up a family tree. And then find out everything you can about each of the people there. And then, with that information to go on, imagine the rest. Write an anthology of family stories. Call it the "Miami River Stories" or whatever.

Write about your Cousin Billy, who—oh, that's right, we're waiting for Billy to pass on. Write about your Uncle Gino (but change his name), who left home at sixteen, became a cowboy out West for a while, and the next time you saw him he was on TV holding his baby hostage with a pistol aimed at her head. This after his wife left him. Write about your Aunt Randeane, who smuggled rum from Barbados to Key Biscayne in the twenties; your cousin Weezie, who went to LA in the fifties to make her fame and fortune in the movies, married a page at NBC who left her and went on to became a well-known TV star. Talk to your family and find out who were the relatives they admired or despised. Dig through photograph albums, family Bibles, whatever you can find.

Young Love

Recall your first love. Try to remember the person, the emotions of the affair. Try to remember your own compulsive and odd behavior. Your entire

world and all its priorities were changing. Recall your big date, the first one, the prom, whatever. The one that just came to mind is probably the right one. Write about it in loving detail, from the time you left your house for hers until you dropped her off at her door and took the bus, the car, hitched a ride, or walked home. Remember touches, smiles, caresses. Remember her smell— Ambush, Ivory, gardenias, Prell. What did you talk about? Was there a song you two heard? Do you recall the lyrics? What is it like remembering all of this? Do you perhaps have a sense of loss, sadness? Or is this a pleasant reminiscence? A sense of loss is perhaps natural and inevitable, since one of the losses is your youth, your innocence, and all they stand for.

Now imagine you married this first love. (Or if you did, that you didn't.) You did not break up because you met someone else in the cafeteria or she told you what she really thought about Bob Dylan. You worked through the difficulties instead, and you stayed together. So imagine your life with her now. Picture your house, your apartment. Look around at your things and at hers. Walk into every room and out into the yard. Use your five senses. You can smell supper cooking, hear music on the stereo. Who exactly is living in this house? Are you happy here? Is everyone else? Are you doing what you want to be doing? What do you do? How is it different from the life you have been living these many years? Not better or worse, just different? Now it's night, and everyone's in bed. You sit in the living room and relax. You imagine how life might be different for you. You think of how you might want to change your life. Write about that.

Brush with the Stars

I once opened for Rick Nelson and the Stone Canyon Band at a jazz club on the Massachusetts North Shore called Sandy's. Rick was making his comeback. I was part of a comedy act. Rick stayed in his dressing room, and I really only saw the top of his head except when he was onstage, and then ladies my mother's age tossed their undergarments at him.

What was your brush with the stars? We've all had them. By *star* we're talking celebrity, of course, someone intimidating. Remember that a star can be local. An outrageous DJ on a small AM station. An athlete whose feats are legendary in your region. Miss Winnetka. The champion bronc rider of Montana. Someone with fame whom you consider to be unapproachable. Write about the brush briefly. Recall the significant details. What you and he

or she were wearing. How close you got, what you were thinking. What were the sounds, the smells, the sights. What happened.

I've heard some great ones. John Clellon Holmes, my teacher at the University of Arkansas, once told me about following Ezra Pound around Venice for an hour. He was too intimidated to approach. A co-worker of my father's ran into Larry Bird at a bar in French Lick, Indiana, and spent the evening playing hoops with the legend in Bird's backyard.

Now imagine that what happened was not all that happened. Imagine that the pair of you were tossed together by fate. Say, that after that show at Sandy's, my car wouldn't start. It's freezing, my friends have gone. Rick comes out of the club and jump-starts the Datsun. He hangs around to make sure it doesn't stall out. So then I say, "Rick . . . may I call you Rick? Let me buy you a coffee." So we drive into Salem and find an all-night diner, and we talk. Rick takes three sugars and no cream in his coffee and I'm surprised. It turns out Rick is real sad about his life. He shows me pictures of his kids. I ask him about Tom Harmon and about his brother David. He says he wishes his life really were just like the TV show.

Write a story with two central characters—someone like you and the celebrity you meet. Tell the story of that evening. Use the real details, the real meeting to get you started, and go from there.

Writing Around the Block

※

The professional guts a book through . . . in full knowledge that what
he is doing is not very good. Not to work is to exhibit a failure of nerve,
and a failure of nerve is the best definition I know for writer's block.

—John Gregory Dunne

Writing should be a snap. We've been telling stories all our lives;
we know all of these words; we've got a pen and some paper and a million
ideas. We sit. We fiddle. We put on some music. We scribble. We stare out the
window. We remember we have that wedding to go to next August. Better
buy a gift soon. We smooth out the paper. We consider how none of our
errands are getting done while we sit. We get up. And now we know what
writers already know: that writing is difficult, that it is a disorderly and
unnerving enterprise, and because it is, we all have, it seems, developed an
unnatural resistance to the blank page. We don't appreciate having our con-
fidence subverted, our intelligence maligned. There are days we'd rather
defrost the freezer or strip the linoleum than engage in the solitary and frus-
trating toil that making a story can be. We think, If I don't start, then I can't
fail. Writing is messy, inefficient, and unreasonable. It's a humbling business.
We're used to and we expect immediate gratification for our cognitive
efforts—we're smart, after all—and then we learn that all writing is rewrit-
ing, that this is the craft so long to learn.

Understand that if you didn't write today it's because you didn't want to.
You didn't have the perseverance or the courage to sit there. You lacked the

will and the passion. Maybe you don't enjoy it enough—we always find time to do the things we love. Your choice not to write—and it *is* a choice—had nothing to do with what has been called *writer's block.* Writer's block is a fabrication, an excuse that allows you to ignore the problem you're having with your story, which means, of course, that you cannot solve the problem. But it does let you off the hook, doesn't it? You can tell your friends, I have this strange and debilitating neurological paralysis that affects only writers, and it's untreatable. I just need to let it run its course. Saying you've come down with block gives something else the control over your behavior and conveniently absolves you from responsibility.

.

"Inspiration is to work every day."
—CHARLES BAUDELAIRE

You must not accept or embrace this expedient but ludicrous notion that you can be blocked from writing. Writing is a job, like being a secretary is a job. And if you have a job, you go to work every day or you lose the job. Imagine a secretary with secretarial block. Imagine her phoning her boss to say she just doesn't feel inspired to type today. Maybe tomorrow. You go to work like a hairdresser goes to work, and some days the styling goes better than others. But you style just the same.

.

"If you hear a voice within you saying: you are no painter, then paint by all means, lad, and that voice will be silenced, but only by working."
—VINCENT VAN GOGH

So ask yourself why you aren't writing. Answer the question honestly. And if you're a writer, you'll answer in writing, because that's how you think best, how you concentrate your mind, how you make sense of the confusing world. Perhaps you discover that you're afraid to fail. After all, you've failed at this before. Your desk drawer is crammed with half-written stories, isn't it? Well, know this: Every work of art *is* a failure. No story is ever what it could or should have been. You aren't perfect, never will be. Neither is your writing. Get over it. Perfectionism is the voice of the oppressor. It's Mom or Dad or your professor or your critical self telling you you're not good enough. And the only way to silence this discouraging voice is to write.

.

"Be regular in your daily life like a bourgeois, so that you may be violent and original in your work."
—GUSTAVE FLAUBERT

The problem is, it's not that we want to write; it's that we want to write *well*, right now! And that is to misunderstand the writing process. A good first draft is a poor first draft. You haven't explored, discovered, taken risks, surprised yourself. You've simply transcribed thoughts to paper. This is taking dictation, not creation. Expecting too much from an early draft is the most common mistake beginning writers make, and it leads to frustration and disappointment.

> *"Blocks are simply forms of egotism."*
> —LAWRENCE DURRELL

Hemingway said it: All first drafts are shit. You must allow yourself to fail. You only write a first draft in order to have something to revise.

Or maybe you've lost faith in your material or confidence in yourself. Well, here's an open secret. You will experience that same uncertainty and uneasiness in the writing of every story. This is how writing happens. You bring that anxiety to the blank page. Writing honestly means thinking the whole thought, the uncomfortable thought, confronting your fears, your shame, and your demons. To do that you sit and move the pen and you respond to what emerges. You don't get up. You know that the hours at the desk are more important than the lines on the page. Relax. It's okay to sit and seem to do absolutely nothing. You're working, you just don't know it. I once spent five hours staring at a blank page, trying to solve the vexing problems of

> *"Writer's block is a luxury most people with deadlines don't have."*
> —DIANE ACKERMAN

a short story. I wouldn't let myself get up. Nothing got written in those several frustrating hours, but the next day the story seemed to write itself. Evidently, I needed to spend the hours ruminating to earn the hours composing. Talent is patience. Genius is tenacity.

There is one perilous and seductive response to feeling mired that you want to avoid. You're stuck, you think, and you suddenly get an idea for a better story, and this inspiration gives you permission to abandon the present one. You drop the old story onto the pile in the drawer, and you begin writing again with gusto. But soon you hit the wall and stumble, and then you're rescued by a scintillating idea for yet another story. Resist the temptation to move on. Remember that ideas for stories are not stories. Stories are the shaping of experience, and they have beginnings, middles, and *ends*. So take notes about your brilliant new idea, but don't go to it yet. If you do give up on your

present story, consider that you weren't writing about what's of crucial importance in your life. If you had been, you could not have stopped. Perhaps you weren't writing to understand, but to preach. Or you didn't care enough about your characters, meaning you didn't know them well enough, meaning you need to spend more, not less, time with them. Write to the end. Learn to finish, so that you can see how it's done, so you have something to rewrite, so your confidence will grow. Each story is this same struggle.

> *"The best thing is to write anything, anything at all that comes into your mind, until gradually there is a calm and creative day."*
>
> —STEPHEN SPENDER

You already know that everything in your life is calling you away from the writing desk. And always will. Get used to it. No one except you thinks that your writing is important. And remember that watching TV is not writer's block. Going to a party is not writer's block. You can kill time or use time. We're all writing against the clock.

Writing is not for everyone. If you keep resisting, maybe you *should* quit. Maybe if you aren't writing, you shouldn't be. But if you find yourself back at the desk, don't give up, give in. Write every day. What could possibly stop you? Maybe you can't complete the scene you began yesterday, but you don't have to. You can't stop yourself from thinking. Writing *is* thinking. Why stop

> *"Every writer I know has trouble writing."*
>
> —JOSEPH HELLER

writing? You can describe the room you're in, or make a list of everyone who has ever frightened you, or let your character tell you about her traumas, her dreams, her secret, the one she's been keeping from you. In so doing, you might even stumble onto the information you need to finish that troublesome scene. Carry a notebook. Keep your antennae up. Take down the details. Writing a story wasn't built in a day.

And when I say notebook, I don't mean a journal. This is not for you to write down the facts of your daily life. (After all, what will you write? "I sat at the desk and wrote. The phone rang several times. I think the UPS carrier rang the doorbell"?) It's not a diary. The writer's notebook is your anthology, so to speak. It's where you gather the flowers of your thought. And you ought to carry it with you. I buy those 8 1/2 x 11 blank, lined books you can find at your chain bookstore for $5.99. I carry a shoulder bag during the day, and so have no trouble hauling my notebook along. You might want to keep your notebook

on your desk and carry a memo pad with you. (And if you forget your memo pad, use the napkins at the restaurant. And if you forgot your pen [shame on you!], the waitress will have one. Your job at a restaurant, of course, is to eavesdrop on the neighboring tables.) I just noticed that the pad I use is manufactured by Mead and it's called

> *"You can always write something. You write limericks. You write a love letter. You do something to get you in the habit of writing again, to bring back the desire."*
> — ERSKINE CALDWELL

"Memo Book Carnet." Why haven't I ever noticed that before? Anyway, when you get home, transfer the notes to the notebook. It takes months for me to get through a book. And then I pile them near my desk.

Write down remarks that you hear or read on the craft of writing, conversations that you overhear in restaurants; tape in newspaper articles, photographs that you might use in a story sometime; write down phrases or words that might become titles or chapter headings or dialogue; list story ideas, titles, names, words, images. Keep your senses alert and gather your data in the notebook. The constant use of the notebook keeps you working, writing, and provides a mine of material to be used down the road. Keep all of the writing exercises that you do for this book or on your own in the notebook. Keep anything pertinent to your development as a writer:

> *"If there is no wind, row."*
> — LATIN PROVERB

character sketches, found poems, observations, all of the preliminary stuff that comprises the initial stages of the writing process. When you wake in the morning, write down the dreams you had last night. That could be a dream your character has in a story you'll write four years from now. Write it all down, or you *will* forget.

EXERCISES

.

The Writing Room

For years I wrote in the kitchen. Now I have an office, a converted sun-porch, which will last until the next hurricane. It overlooks a mangrove preserve. Yellow-crowned night herons, great blue herons, ibises, and Louisiana herons sometimes perch on the fence in the yard and watch me work. My cat curls in a puddle of fur on my desk. We have agreed to share the space. If you are ever momentarily stuck, look at the objects in your writing room. What do they have to say about you and your past? Your present? You're writing this down, of course. That alarm clock. The Ranger Joe ranch mug. The toy bus. The wooden shoe. The photograph of a derelict house in Arkansas. The Mardi Gras beads. Why are these objects important to you? Why have you saved them? Why do you keep them near? How do they make you feel? What objects that you have owned in your life do you wish you still had?

Memories Are Made of This

Write about a memory that each of these words provokes. Take five minutes on each. For starters. You can always return and write some more in that notebook. Here we go: *window; flowers; photograph; classroom; rain; crayon; wedding; vacation; pet; fear.* Anytime you want to get started in the morning, you can open your dictionary (it's never far from your desk; neither is the thesaurus) and choose a word at random and write abut the memory evoked.

Making a List, Checking It Twice

Maybe it's that I'm obsessive-compulsive or maybe it's that I know I'll forget whatever is so important in two minutes (or maybe that's the same thing), but I make lists. (Lists were perhaps the first written literature. Even before that list Moses brought down from the mountain, and before Hammurabi's list of laws, someone probably scratched something about cleaning the cave, planting the wheat, hunting the mammoth, gathering the firewood.) I have lists of possible story titles, interesting names, lists of things

I have to do. My characters make lists. I used to worry about this behavior, but these days I wonder how people get along without their lists. How do they know what to pick up at Winn-Dixie? Lists free you up to think about more important things, to daydream. Anyway, many of us do keep shopping lists, Christmas card lists, guest lists, birthday lists, and lists can be helpful for getting in touch with your usable past and with your obsessions.

So here are some lists for you to make in your writer's notebook:

1. List all of the friends you've ever had. Put an X beside those you've lost contact with.
2. List all of the pets you have ever had, even the short-lived goldfish from Woolworth's and the little turtle that turned into cardboard overnight.
3. List all of the moments you'd live over again for whatever reason. (To get them right this time. To enjoy them afresh.)
4. List everything you've ever done that you are ashamed of.
5. List every object that you've ever lost.
6. List the best meals that you've ever eaten.
7. List the toys and games that you owned as a child.
8. List your favorite songs.
9. List your favorite smells.
10. List your goals for the next five years. Prioritize them.

Take five to ten minutes on each list initially. They will suggest events, emotions, people, you haven't considered in a while. What else do they suggest? Use the lists in the coming days for sources of material for your fiction.

Brainstorming

This technique has been around for a while. It's based on the notion expressed by the Nobel laureate Linus Pauling, who said, "The best way to get a good idea is to get lots of ideas." The goal is to come up with as many ideas as possible as quickly as possible. Brainstorming has traditionally been a group activity in which one person's response triggers a response in another and the energy created by the group propels the creative process. But you can also do it alone.

You're stuck on your story. Let's say your character has just told his wife that he is leaving her. He leaves their house. What does he do now?

Brainstorm alternatives. Here are the rules. No criticism is allowed. Do not censor yourself. Everything goes. Defer judgment until later. You have to be freewheeling and move beyond the conventional thought. Next, go for quantity. More is more. When you've generated a substantial list, look at the items and combine them and improve on them. Which of the items intrigues you the most? Go with it.

Connecting the Dots

Pick a sentence at random from a piece of writing. Pick another sentence at random from another piece of writing. Begin a paragraph with the first line. End the paragraph with the second line. Try these: 1. *I was half asleep at the Quality Inn.* 2. *This is the town at the end of the road.* And here's a variation of the exercise. This time take two lines that strike you from different poems. One becomes the first line of your short-short story, the second, the last. (You'll cut them in the revision, no doubt.) Open your poetry anthology, read a bit (it's always beneficial to read poetry before you write fiction—to remind yourself about the importance of sound and music in stories and about the importance of the freshness of image and the precision of syntax), make your selections, and write. Here's a couple to get you started: 1. *Hope is the thing with feathers.* 2. *My desolation does begin to make a better life.* Don't fret, just write.

Word-a-Day

You're going to open your dictionary and select the fifth word in the second column (or whatever you decide today). And then you're going to write the word down on a blank page and freewrite on the word until the page is full or for one minute, or what you will. The secret here is not to think. Write fast. If you are stuck, write, "I'm stuck. I'm supposed to be writing about *smoke,* but I can't . . ." Just don't stop. Don't censor yourself. Don't worry where it's going. Follow the accident. The only way to go wrong is to think. The first time is the hardest because we are so used to thinking and being analytical, and all that. Open the dictionary, point your finger. Go! (I just tried this. Gave myself a minute. Got *invertebrate* for my word, didn't think but wrote: *the blubbery slug who slimes his way across our sidewalk each morning and scales the house behind the hibiscus. Slugs don't seem to have backbones. At least at La Cucina I've never sensed a snap when I eat the escargot. Last*

time there, Felipe and I talked about Roma and Milano, and he ordered more garlic bread. I hadn't thought about Felipe and his wife Nina in a while. Who'd have thought a slug would evoke a restaurant? One could do worse than start the writing day with a given word.

Clustering

Here's another technique or exercise to get started or to get unblocked or to collect information for your story. Northrop Frye said that any word can "become a storm center of meanings, sounds, associations, radiating out indefinitely like ripples in a pool." This technique of clustering, or mapping, as it's called in some texts, addresses the preceding sentiment. It's an idea taken from Gabrielle Rico's *Writing the Natural Way.* At least that's where I first saw it. It's based on the knowledge we have of the two hemispheres of the brain. The hemispheres seem to have distinct functions and roles. If we were to describe the two hemispheres of the brain in terms of corresponding faculties, we might come up with something like this:

LEFT BRAIN/THE CRITIC	RIGHT BRAIN/THE CREATOR
craftsman	*artist*
sign	*design*
analytical	*relational (holistic)*
parts	*whole*
intellect	*intuition*
abstract	*concrete*
conscious	*unconscious*
objective	*subjective*
tell	*show*
verbal	*nonverbal (imagistic)*
temporal	*nontemporal*
note	*melody*

and so on. Because of the dominance of the left hemisphere (thanks to schools and beginning with our acquisition of language), we have to learn to turn it off and to give the creator equal time. We have to trust this intuitive, nonlogical part of ourselves. Easier said than done.

This technique is based on word association. You know, the shrink says

dog, and you say *cat.* She says *mother,* and you say *father.* She says *love,* and you say *wreckage* or whatever. In this case you begin with a word that you write on a blank page and circle. And then you write the first word suggested by the circled word and connect it to the first with a line. Then associate that word with the next and so on. When you come to a natural conclusion to that string of associations, go back to the original word and begin again. Don't think. Let your right brain associate. Don't stop moving the pen. Don't censor. First thing that comes into your head. So here's a word to start with. Write it, circle it, and go! *Loneliness.*

As you fill up the page with associative words, some will surprise you, and that's as it should be. Don't try to make sense of where this word train is taking you. Soon enough, you will suddenly sense that you have something to write about. That is the intuitive leap that the exercise prompts. The right brain has been making patterns, making sense of all this. It can't do anything else. Stop, look back at the cluster for a starter word or sentence. Now write your sketch or your scene or whatever was suggested by the words. You're tapping into your unconscious, into your nonverbal mind. We have responses and opinions about everything, but we may not be aware (be conscious) of them. Now do another cluster in your notebook. Remember: Associate. Don't think. Write the word in the middle of the page. Cluster on *fear.*

Becoming a Writer

How we spend our days is, of course, how we spend our lives.

—*Annie Dillard*

Sometimes you need to unlearn what you know because what you know is keeping you from discovery and creativity. I had to unlearn most everything I was taught in grammar school, in high school, and in college about writing. I was taught that *first* you thought and *then* you wrote. If you were smart and deliberate and organized, you'd only have to write the thing the one time. Revision was punishment for sloppy thinking. I learned how to outline in grammar school. If we were writing a theme, as we called them, a composition, we were to outline the entire work ahead of time, starting with the title and then the Roman numeral *I* for the general topic sentence, followed by capital letter *A* for subtopic one, and so on. So the outline of the composition might look like this:

I. My Summer Vacation
 A. Packing
 B. Day One
 1. What We Forgot
 a. To Stop the Newspaper Delivery
 b. The Road Atlas
 c. The Cooler with Lunch
 2. The Car Breaks Down

 a. Mom and Dad Argue

 b. The Tow Truck

 (1.) Expired AAA Card

 (2.) Ride to the Garage in Lowell

 C. Day Two

 1. The Downtowner Motel

 a. Pool Closed

 b. No Television

 2. Car Finally Ready

 a. Mom and Dad Argue

 b. Lost in Haverhill

 c. Mark Puts His Leg on My Side of the Seat

II. Hampton Beach, New Hampshire

 A. The Casino

 1. Video Games

 2. Amanda Jones

 a. Her Braces

 b. Kissing Her

and so on. Outlines were meant to be logical, schematic, organized, balanced, ordered, and correct, everything that writing is not. So I learned to write the composition first and then do the outline, and the sisters were none (no pun intended) the wiser.

And then there was the matter of the five-paragraph essay, which was the mold into which all thoughts could be poured. This is how composition was taught in college in those days. The first paragraph introduced the main thesis and directed the reader to the three (and only three) main supporting subtopics. Each subtopic got its own paragraph, which began with a topic sentence and developed through supporting information. The last paragraph restated the main thesis (which for some reason was not articulated clearly enough in the opening) and reminded the reader (who must have a minuscule attention span) of the recently stated three supporting ideas. Nonsense, of course.

> *"An idea occurs when there is chaos, and suddenly you see relationships, when you find meaning where you looked before and there seemed to be only disorder."*
>
> —LUKAS FOSS

Forget all of that (unless you, in fact, find outlines helpful and can remain flexible in your use of them) and forget, too, the notion that writing is all about inspiration or the Muse or any other romantic nonsense promulgated by people who have no idea what writing is, and who think, I suppose, that when they finally are inspired with a full-blown idea for the Great American Novel, the writing part will proceed without difficulty. They've got the pen and the paper and, after all, the dictionary with all the words they'll need.

Don't think that there's a right answer to any question. There *are*, of course, people who think they have the right answer. And they are ever eager to share it. (And there's nothing as dangerous as an idea when it's the only one you've got.) These are the wags hosting radio talk shows, the true believers preaching at the Sunday service, the politicians running for public office, and, too often, the experts in front of a classroom. Answers aren't even the point.

>
> *"Habit is the denial of creativity and the negation of freedom; a self-imposed straightjacket of which the wearer is unaware."*
> —ARTHUR KOESTLER

Fiction is not a quadratic equation. You are not trying to *solve for x*. So relax, you're not unlocking problems, you're creating them. And remember that the answer you get depends on the question you ask. Asking the right questions is what fiction writing is about.

And don't think you need to be logical to write fiction. Stories aren't imagined with logic. You need to learn to trust your feelings, your intuition, your unconscious mind.[*] Logic is helpful when you need to assemble the toys you bought your kids for Christmas, when you need to figure out if you should remortgage the house now that the interest rates have dropped, but logic eliminates the element of surprise and discovery. Logic doesn't leap, it plods. Logic is necessary to the writer later on, after you've created the story,

[*] About the unconscious: Coleridge tells us he conceived "Kubla Khan" in a dream. Friedrich Kekule understood the structure of the benzene ring after dreaming of snakes linked together head to tail. Jean Cocteau wrote this about his composing *Knights of the Round Table*: "I was sick and tired of writing, when one morning, after having slept poorly, I woke with a start and witnessed, as from a seat in the theater, three acts which brought to life an epoch and characters about which I had no documentary information and which I regarded, moreover, as forbidding." Whenever Thomas Edison was stymied in the lab, he'd take a nap, and a solution, he claimed, would arrive in his sleep. Frederick Eugene Ives studied the problem of the half-tone printing process, went to bed in a state of "brainfag," awoke, and saw before him "apparently projected on the ceiling, the completely worked out process and equipment in operation." (Anecdote on Ives from James Webb Young's *A Technique for Producing Ideas*, NTC Business Books, 1998.)

to see if it's all making sense and is clear, direct, and spellbinding. Remember that if it's logical your character does x—hires a detective to trail his wife, say—then probably everyone else, including your reader, will have thought the same. Logic understands that which is consistent and noncontradictory, but life, we know, is ambiguous, chaotic, inconsistent, and contradictory. (And so is writing a story.) Maybe thinking is all about making connections, seeing the random heap of sweepings that Heraclitus saw and imposing a beautiful order on them—the way the first stargazers looked up and saw the bear, the lion, and the hunter in that impossibly hectic sky. And our brain does that so well, showing us the path from one arbitrary idea to the next.

.

"What is originality? To see something that has no name . . . hence cannot be mentioned although it stares us in the face."
—FRIEDRICH NIETZSCHE

Which gives me a chance to talk about what I think of as the Synaptic Theory of Composition. How do you prevent the reader from being a passive observer? I think you do it by what you don't show. I think you do it by surprising her. I think you do it by writing powerful emotional moments. By making her care about the lives of the characters. It's the first I want to talk about here, this matter of leaving out. (Hemingway said that the best stories have the most left out.) What's not on the page may be as important as what is.

Synapse is from the Greek *synapsis,* point of contact. Specifically, a synapse in the brain is the small gap separating two neurons. You've got pre- and postsynaptic endings (your two scenes, let's say). In order for a message to travel from one neuron to another (one scene to another) there needs to be a gap between them. Like the gap in a spark plug. No gap, no fire, no ignition, no motion.

.

"One must avoid ambition in order to write Otherwise something else is the goal: some kind of power beyond the power of language. And the power of language, it seems to me, is the only kind of power a writer is entitled to."
—CYNTHIA OZICK

This is how I think when I'm writing fiction. I don't want any chapter, paragraph, sentence, word, to follow logically from the previous. I want that leap, that surprise, that divergent thought. Perhaps I learned this from watching movies because it's not unlike Eisenstein's theory of montage, meaning the

unity of shots of seemingly unrelated objects in the same film sequence so that they take on a new relationship to each other in the viewer's mind. Eisenstein came up with the idea and wrote about it in his essay "The Montage of Attractions." He was influenced by his study of the Japanese written language where the juxtaposition of two symbols (my examples are Chinese) say *man* 亻 and *mounain* 山 equal 仙 meaning *immortal*. (Because those in search of enlightenment often retreated to mountains? Or because mountains are as enduring as we might wish to be?) That's a way of metaphorical thinking that we as writers want to cultivate and develop. The whole is greater than the sum of its parts. It is the juxtaposition that makes the meaning. Or this 好 meaning *good* from the character 女 *woman* and 子 *child* or *children*.

So it's the contrast between the images that moves the story forward, that allows for the reader to fill in, to connect, what at first might seem arbitrary images. Here's a simple example from a story of mine. In the story, "The Freezer Jesus," the first-person narrator Arlis Elrod says:

> And then comes that Friday and I'm walking Elvie up the path from the bean field at dusk and I notice the porch light on and I tell Elvie we must have had a visitor stop by. As we get closer I notice a blemish on the freezer door that wasn't there before. Then suddenly the blemish erupts like a volcano and commences to changing shape, and what were clouds at first become a beard and hair, and I recognize immediately and for certain that image is the very face of Jesus right down to the mole near his left eye.
>
> What is it, Arlis, Elvie says to me. Why you shaking? Of course, Elvie can't see what I see because she's blind as a snout beetle. So I tell her about this Jesus and somehow she knows it's true and falls to her knees and sobs.

Then I write about Arlis's thoughts and how this is the oddest thing that's ever happened in Holly Ridge, Louisiana. And Elvie tells him to call the newspaper. And in the next scene a reporter comes and checks it all out and writes his piece. Now the reader knows that Arlis did what he was asked to do, even though she didn't see it, and she didn't need his thoughts to understand. She immediately imagined a phone call to the city desk at the *News-Star-World.* Don't tell the reader what she doesn't need to know. Don't tell her what she can assume.

A slight digression on this matter of thinking illogically and of letting the arbitrary guide you. I called it divergent thinking a moment ago. The concept was, as far as I know, first expressed by the French writer Paul Souriau, who said, *"Pour inventer, il faut penser à côté."* To invent, you should think sideways. Divergent, oblique, sideways, or lateral thinking goes away from choosing the next logical step; it invites completely irrelevant ideas to intrude on the continuity of patterned thinking. From these intrusions come disconnected, off-the-wall ideas that may seem unrelated to the problem until suddenly they generate creative and exceptional solutions. We normally think in patterns that are predictable and repetitive, and the idea of divergent thinking and arbitrary structures is to break down those patterns.

> *"Writing isn't hard work; writing is hard play."*
> —RICK DEMARINIS

Arthur Koestler defined lateral thinking as a "shift of attention to some feature of the situation, or an aspect of the problem, which was previously ignored, or only present on the fringes of awareness." So if you're stuck, and every idea you come up with seems like a cliché, or it's too predictable, open a dictionary to any page. The first noun defined on the page or in the second column or wherever you decide is your unblocking word. Play with all its meanings for a few minutes and see what wild, uncalculated connections they might have for your original problem.

So, you don't seek answers. And you don't rely on logic. What's next to unlearn? Don't feel like you have to follow rules. There are no rules to writing fiction,[*] except, perhaps, the one: *Be interesting.* There are, however, conventions. This is how stories have traditionally been told: with characters in trouble, with a plot providing the shape for the tale, and in sentences. You don't have to use traditional syntax if you don't want to; you can eschew punctuation, eliminate characters. (But why would you?) Fiction is the freest, most subtle art form available to us. A story can include menus, answering machine messages, billboards, dreams, memories, e-mails, diaries, songs, mathematical equations, and so on. But just remember, if you do decide to be unconventional, then you are calling attention to yourself and to your cleverness, and you have to then be better than everyone else. You're saying, I don't need to limp along on the crutch of plot the way that Faulkner did or Tolstoy did. Watch me dance, you're saying—and indeed we will. We'll be watching for the slip.

[*] W. Somerset Maugham said: "There are three rules for writing the novel. Unfortunately, no one knows what they are."

You already know that writing stories is not a very practical enterprise. Everyone you know has told you so. Why the hell are you doing this anyway? You're going to have no social life if you start in on this—except the one you enjoy with the people you made up, who are, fortunately, much more fascinating than you or your buddies. Fiction writing will not provide a pension for your old age, won't make your golden years pleasant. We all liked to make things up when we were kids, but so many of us (thanks to schools and commerce and parents) got over it and got on with the business of life. Fiction writing is arrested development—thank God! It's play. Serious play, but play nonetheless. Just know that you should quit right now if you can.

Plato, of all people, said, "Life must be lived as play." *Homo ludens.* That's who writers are. A different species. Man the player, not man the wise. So what do you do when you play? You make up the rules as you go along, like old Calvin and Hobbes. ("I've got the Calvinball, everybody else has to go in slow motion!") You indulge your imagination. You lose yourself in the activity—because you're doing it for you. Your mind is not on loan

"Chance furnishes me with what I need. I am like a man who stumbles along; my foot strikes something. I bend over and it is exactly what I need."

—JAMES JOYCE

to an employer or customer or teacher. Play is not a frivolous business. Play is how we learned everything of importance. It's how we learned to be grown-ups—by pretending to be them. Writing a story is pretending to be someone else. Play is how we learned the joys of language, for one thing, spouting our nursery rhymes for hours at a time. *What's your name? Puddin Tane. Where do you live? Down the lane. Ask me again and I'll tell you the same.* Why is rhyme such a delight to us? And who is this Puddin Tane? And what does his house look like? And what kind of trouble is he in? Where did he pick up that attitude? When you're fooling around, you generate lots of new ideas because your defenses are lowered and you're not worried about being efficient, practical, or correct.

To err is right. Only a fool does not make mistakes. James Joyce said that there are no mistakes, that an error is a doorway to discovery. People who invent things—and that's what you're doing when you write a story (invent: "to produce by the use of imagination or ingenuity")—are always failing. Think of it this way. If you do what you always do, you will not make mistakes. But if you try something new, you will make your share. You need to

take chances when you write stories, and if you're afraid to fail, if you're afraid to take the wrong road in the story, then you won't ever write anything worthwhile. You'll write what we all can write. The formula story.

There are no deadlines. You have all the time in the world to write this story. Who cares if you write a hundred pages that don't pan out? Throw them away—they will never leave you. Elie Wiesel said that there is a big difference between a two-hundred-page story and a two-hundred-page story that started out as an eight-hundred-page story. The other six hundred pages are there. Only you don't see them. On the other hand, you are writing against the clock, and the story you don't write today will never get written. We get no groundhog days. Nothing happens twice.

You must be passionate about this business. You must want to write so badly that it hurts not to. If you don't write today, you ought to feel guilty. If you don't feel guilty, you aren't meant to write. If you don't write today, you will be diminished. Don't deceive yourself. Be honest—the fiction writer's job—and admit you'd rather make a comfortable living than spend an uncomfortable afternoon with a blank and needy page. Serious fiction writers don't have time to waste on making money. (Now, that last sentence is one I took out—too haughty, pompous, self-righteous—and then put back in because it points out that you need to write for the story and for nothing else. No personal ambition allowed.)

> *"Only when he no longer knows what he's doing does the painter do good things."*
> —EDGAR DEGAS

You need to take chances, make mistakes, write serenely, be passionate, and you must be comfortable with ambiguity. You must believe in serendipity (the unexpected discovery by accident), and in synchronicity (you're looking for an idea and unexpectedly experience an event that solves your problem), and in the creative power of chaos. Chaos now, order later!

You *are* creative. Don't say you're not. That's a cop-out in the way that writer's block is a cop-out. We're all creative. And we were all told not to be. Some of us—for whatever reason—did not listen. We write because we want to live a thousand lives or because we want to have our say or because it's how we understand the world or because it's not there or because we need the love and attention or because: *fill in the blank.*

But you aren't writing your story to express yourself or to fulfill yourself. You are writing to discover, to understand, to tell the story of your characters

in trouble, to be scrupulous in the exploration of their lives. In so doing, you *will* express yourself and you *may* be fulfilled, temporarily at least. But don't count on it. I think there's a difference—and I'm generalizing, of course—between the fiction writer's impulse and the poet's, memoirist's, and essayist's impulses (which I find similar). The latter trio are always seeing the world through their own reflected images. It's a more self-confident impulse; it's an assertion, a claim. The storyteller is more humble, chastened, uncertain, anxious. We're not sure we have a claim to any knowledge. What we think is unimportant. What the character thinks is all.

And please don't hunger to be original. Original does not mean creative. Original does not mean *different,* as too many young writers think. It means *to arise, to be born. Different* is easy. *Original* is from the Latin meaning *source,* as in *origin,* the point at which something comes into existence or from which it derives. The heart, the mind. Origin, not destination. Genuine. Original doesn't mean you neglect to punctuate or capitalize. It has nothing to do with the superficial, with the way you dress, with the alleged hipness of your characters and their multiple body piercings and insatiable drug-taking. Original is honesty, and it's a way of seeing the world in

>
>
> *"Have something to say and say it as clearly as you can. That is the only secret of style."*
>
> —MATTHEW ARNOLD

a fresh and exhilarating way. It's taking the reader's breath away with the adjective that describes the noun, not with a pose, with outrageous and often antisocial behaviors. No poseurs allowed at the fiction writing desk!

(Yes, I've had some nasty encounters with writers like this, so bear with me while I vent a little.) The writer who wants to be an original often becomes mannered in his writing process because what matters to him is how he is perceived by the reader (*audience,* in his mind), not how his characters are understood. And the perception desired is one of admiration, naturally enough. Listen, you need to care more about your characters than about yourself. You have to care more about people than ideas, even ideas (as I've said elsewhere) of the divine, ideas of another world. This is the world you must deal with—the one we live in, the only one we can know about. What we have are aspirations of another world. Explore that. Ask why do we have those aspirations. Self-expression is a pose, and can often be an excuse not to write, not to revise. And often what the self-absorbed writer has to express is common knowledge.

What this ersatz writer most often resists is the plot, of course, because everyone else is doing it. But why would one resist the architecture of action? Because it's too difficult to execute? Well, writing isn't easy. (Saying you are a writer, that *is* easy.) Writing a story is taking the path of most resistance. Writing isn't about freedom. Writing creatively is learning to impose limits on your work. Nothing paralyzes the imagination like too much freedom—the tyranny of the blank page. Art is about selection. Art is not life. Life is life. Art is not spontaneous, but premeditated. Life comes without plots except the ones they bury us in. But fiction is shaped by plot. The desire to do what no one else has done is a vulgar wish, and one that has no place in fiction writing. Why does one want to feel that one is unlike others? Yes, some writers who shun plot *have* captivated readers by their delicious prose, profound meditations, intense visions, and political insights (Lydia Davis comes to mind), but the longer the work, the harder it is to keep the reader's attention all the way to the end. Writers who want to be original can be heard to say that they didn't want the reader to understand what the story was about or they want each person to decide for herself what it's about. They mistake experiment with failure. They call their compositions works in progress. They don't need to finish, of course, because they are not concerned with the characters' lives.

>
>
> *"The novel manufactured to entertain great multitudes of people must be considered exactly like a cheap soap or a cheap perfume or cheap furniture. Fine quality is a distinct disadvantage in articles made for great numbers of people who do not want quality but quantity, who do not want a thing that 'wears,' but who want change,—a succession of new things that are quickly threadbare and can be thrown away. . . . Amusement is one thing; enjoyment of art is another."*
>
> —WILLA CATHER

The writer driven by the desire to make it new often does not understand that the newness comes in revision, comes with diligence and persistence, and is not a spontaneous or natural condition. To quote John Gardner, "The first quality of good storytelling is storytelling. A profound theme is of trifling importance if the characters knocked around by it are uninteresting, and brilliant technique is a nuisance if it pointlessly prevents us from seeing the characters and what they do. You are trying to create a vivid and continuous

dream in the reader's mind and that dream is broken by bad technique." This writer who wants to be original does not understand that if you write the story about this particular character's intense and heroic struggle to attain his goal, the story will, indeed, be new.

The writer who wants to be original is attracted to the strange, the bohemian, the seedy, the weird, let's say. This writer admires his own work, and so do his friends who think he's incredibly bohemian and ahead of his time. Male writers of this stripe—and they mostly are guys—tend to write nihilistic, experimental stories, often based on comic book heroes or sci-fi premises. There are often buckets of gratuitous blood in their stories; sex is always loveless. They tend to admire Charles Bukowski. The female writers tend toward experimental structures as well—episodes, not plots, (originality as an excuse to be lazy?)—often based on mythic heroines or New Age premises. There are truckloads of worthless, abusive men in their stories (and

>
>
> *"Some writers confuse authenticity, which they ought always to aim at, with originality, which they should never bother about."*
>
> —W. H. AUDEN

one who is not); sex is always orgasmic. Male and female, these writers are more interested in style than in content. Their lust is an egotistical and crass one—the lust for nonconformity.

Look, there's nothing wrong with writing about the strange, the weird, and the bizarre if you are going to explore the lives and not simply exploit them. Jerome Stern in *Making Shapely Fiction* warns us not to write the "Weird Harold" story, one focused on a character who is strange and different. We get many examples of the character's behavior, but no insight into the character, who seems otherwise worthy of fictional representation. However, the writer hasn't figured out a shape that gives readers what they need in order to know the character from the inside, to understand what might be driving him, what he might be searching for, what might be missing that makes him do what he does.

Don't write the "Weirdsville" story, either, where we focus on a community of peculiar and strange figures (often in California). Drug addicts. Flophouse residents, mental patients, psychics. Psychics, for one, are not weird or strange. They are quite wonderfully ordinary. In Hollywood, Florida, for example, certainly not the epicenter of the arcane, there are forty-one psychics listed in the local phone book, from Ann Marie to Mystic

Zoria. They read palms, tea leaves, tarot cards, horoscopes, crystals. You can visit them or they'll come to your house. You can even call an 800 number. They advertise in the Yellow Pages with the same tacky clip art as roofing companies and beauty parlors. These are spiritualists, perhaps, but they are also small-business enterprises, the backbone of our capitalist economy. And drug addicts are not weird. They are ill. And homelessness is not weird. It is a choice on occasion, perhaps, and it can be sad and hopeless. Insanity is not weird, but it is often tragic. And remember this, that bizarre and eccentric behavior might be interesting in a character if explored, but in an author it is irrelevant. (End of rant. Thank you.)

Writing is learned by imitation. We are all trying to be Shakespeare (and we will all fail), not because he was different or original, but because he created Hamlet, Falstaff, Lear. So we imitate the masters and one day the door opens and we say something original almost in spite of ourselves. How does that happen? If you don't make your first gurgle, you'll never learn to sing. It's important, when you don't know anything, that you know you don't know. Figure out what you have to say, but if all you have to say is this is a weird place (I guess the rant's not finished), then we don't need to hear it. We don't want opinion, we want drama and understanding.

A fiction writer should not worry about linguistic brilliance of the showy and obvious kind, but instead worry about telling her story. Style is not imposed. Style is how you live your life. If you are concerned with your way of telling, then you are not concerned with creating consistent, well-rounded, profound characters. A fiction writer ought not to worry about pleasing everyone. Write for yourself first of all. Know that you will discover when you explore, and you might not like what you discover. Still, fear should not stop you from discovery. Deal with the unpleasantness in the next story. The fiction writer ought to have a sense of humor, ought to be determined to live an imaginative life, the only one worth living.

EXERCISES

.

In Dreams

Recall a dream from childhood, a recurring dream, or a dream from last night. This dream has stayed with you for some reason. Do you know why? Can you guess? Certainly the images that you created in your sleep were vivid, and the emotions they evoked were powerful. You can't forget about them. Write about this dream. Be as precise and as concrete as you can be. Try to see the dream—to dream it again if you can. Don't try to make sense of the images and transitions, just write them down. Think about these images that you created. Can you trace the dream images to events and images in your waking life?

One purpose of this exercise is to examine images that are yours, that you created unconsciously—with the right brain, as it were—and to try to explore the territory that they came from. Perhaps you can learn to travel there when you're awake, at the desk, pen in hand.

Hypnopompia

The half-hour between waking and rising has all my life proved propitious
to any task which was exercising my invention. . . . It was always when
I first opened my eyes that the desired ideas thronged upon me.

—Sir Walter Scott

Descartes made discoveries while lying in bed; Einstein made connections between space and time while in bed; I get many good ideas in that half-awake, half-asleep time in the morning when dreams intrude on thoughts and vice versa. This is the first thing I do every morning. I work out problems to stories without much conscious effort, come up with new ideas and, more often, odd images or intriguing associations. If you haven't tried to tap into the creative potential of this period just before getting out of bed, then you might be missing out on an easy way to access the unconscious mind.

The Russian psychologist A. R. Luria discussed the hypnopompic state in

his book *The Man with a Shattered World*. Pavlov, he wrote, argued that the cortex is subject to the "law of strength." Powerful stimuli produce strong reactions and leave solid traces that more readily come to mind. Only during states of exhaustion or sleep is this balance disrupted: strong and weak stimuli register with the same intensity, arouse equally strong responses, and leave just as permanent traces. . . . Strange associations that unexpectedly occur when you are falling asleep or waking . . . your thoughts are confused and you can readily become disturbed by things that appear trifling during the day.

Keep a writing tablet or, if you won't be disturbing anyone, a tape recorder near the bed. Wake yourself deliberately early, then allow yourself to drift back to sleep. A snooze alarm is good for this activity since it will keep prompting you awake. Try to pay attention to the unusual thoughts and images that occur to you as the logical, analytical, workaday self tries to rouse the body to action. Don't try to record any of this while you're in bed. Just let it happen. When you finally get up, immediately write down or commit to tape what you saw, heard, smelled, thought. Don't worry about whether it makes sense or not. Just write fast. Perhaps this also means you should try napping while you write—to feel refreshed and to let the trivial impress itself.

By the way, on the other side of sleep lies the hypnagogic state. These are the minutes in bed as you begin to fall asleep. And the process will work as well there. You'll have, perhaps, a more difficult time recalling what you saw and heard in the morning. On the other hand, your hypnagogic images may continue in your dreams.

In the Beginning Were the Words

Here are ten words: **shilly-shally, melody, jaw, scream, ring, door, bolt, nest, capricious, charm.** Connect these words in a story that begins: *Every woman thinks she can change the man she marries.* Remember that every noun can be verbed.

Word Association

Here is a list of eight objects. Your job is to put them into two lists of four: oar, relic, cockroach, container, wagon, geyser, chart, pallet.

Your list may look like this:

oar/cockroach/wagon/geyser and *chart/relic/pallet/container*
> Based on movement.
Or: *oar/wagon/cockroach/container* and *chart/pallet/geyser/relic*
> Based on letters *a* and *o*.
Or: *oar/container/wagon/pallet* and *relic/chart/cockroach/geyser*
> Based on wood.

You've got your list, now explain the categories. The point is this: The words were selected at random. You made the association, the categories. (In a few minutes I came up with three.) You abstracted the pattern. You and your right brain. Now, how many other ways can you divide that group into fours? Try it. Are the patterns in the material or in the way you look at it? The patterns seem to be triggered by the material, certainly, but the pattern has to exist.

Pick Yourself Up

X

One's real life is often the life that one does not lead.

—*Oscar Wilde*

Here's the story of how I became a writer, sort of. How I made up my mind to do something about what I had always wanted to do. Like you, I had always wanted to write, had always written, in fact. If there was an essay exam in school I was getting an A. But I wasn't very good at telling stories, and stories were what I wanted to write. I would find out later that there are at least a couple of talents at work here in the fiction business. You need to know how to write, of course, but you also need to know how to tell a story. You may be good at the one, but not the other. My friend Charlie Willig was the most fascinating storyteller I've ever met. And he was full of stories. He could keep you engrossed all day long. He could tell you about laying a pipeline in Oklahoma and keep you riveted to your chair, and laughing to beat the band. He knew stories about everyone we worked with, everyone in Augusta. I'd say, Charlie, you need to write these down. But he never did. I was wrong, he didn't need to. He just needed to tell them. He liked the intimacy and the immediacy of the response, something writers have to do without. He liked an audience. The audience, often an audience of one, brought out the scamp in Charlie. I wanted him to come on by every morning and tell me a story or two—give me something to write about. And he knew how to tell a story. He did not rush. He painted pictures. I couldn't figure out how so many interesting and funny things were happening to Charlie. Years later I

read something that Allan Gurganus wrote about stories: "Know something, sugar? Stories only happen to the people who can tell them." That was Charlie's secret. I figured I'd better start writing fast. By the way, not everything that happened to Charlie was funny. When he died he was younger than I am now. And I think about him often. I hear his voice, saying, "Karen's uncle is ninety-five and his kids are nearly eighty, and he's still worried about them. And he ought to be. . . ."

DUST YOURSELF OFF

Midway on our life's journey, I found myself

In dark woods, the right road lost.

—Dante

Every End Is a Beginning

My father called, woke me out of sleep, asked me to meet him at Walt's Luncheonette in twenty minutes. This was in Massachusetts in October. We sat at the counter, smoked my father's Marlboros, drank Walt's stale and tepid coffee. We probably talked about the Patriots. I can't remember. I would have asked how Mom was doing. He would have said, "She wants you to come by for supper. Bring your laundry." And Walt would have sat on his stool by the cash register, his wooden leg propped up on a plastic milk crate. This is what I do remember:

My father said to me, "Your marriage is over. The divorce is final. I read the notice in the paper." When he said this, he stared at his hands. My father, I knew, had been hoping, praying, for a reconciliation until the end. He loved Marilyn. Besides, Catholics don't do this. He said, "Maybe it's for the best." He clapped me on the shoulder, left me his smokes, paid the check, told me to call, and went back to work.

I'd known the divorce was imminent. I'd set it in motion, after all. Still, I felt ambushed and assaulted by shame. Whatever else divorce means, it means this: You've failed at the most important enterprise in your life. So there I was, approaching thirty, suddenly single and unemployed. Lost.

I'll tell you about the fiasco at work in a minute, but first a caveat. Here's something else Catholics don't do—confess in public. It's an unseemly process. It's indecorous, impolite, arrogant. To my mind confessional poets

ought to do penance, but should not receive absolution. I'll believe anything I read except autobiography. A fiction writer has no reason to lie. A memoirist has an illusion to protect.* When I write stories, I know that I know nothing. When I write about my life, I think I know what I'm talking about. That's the dangerous part. So, all right, I'm uncomfortable in these woods. I'll get over it. Just know you're hearing a version of a truth. Know that I've got secrets I'm not even aware of.

Things Fall Apart

During the early months of our separation, I lived from house to house, imposing my suddenly squalid self on friends and family. I went to marriage counseling, went to movies, went to Moynihan's Tavern. I went to my job at the Crisis Center. I worked with troubled kids: runaways, junkies, truants, thieves, the occasional kidnapper, but mostly with ordinary, rambunctious kids, temporarily out of control. I tried to keep them alive until their hormones settled down. I loved my job. How could I be a loser if I was saving children's lives?

My friend Matt and I found a cheap apartment. Matt was quiet and kind. He dated an urban planner with twin daughters (who would both go on to scholarships at MIT, while Mom went on to marry a poet—but we didn't know about that then). Matt was an organizer for the Clamshell Alliance, an activist group trying to close down the Seabrook nuclear plant. They held their meetings in my living room, which would not have been a problem, except that my ex-wife-to-be was dating (and would marry) another Clamshell organizer. I didn't want to be at meetings where the sexual politics were quite so intriguing, especially since I was the object of speculation. So I handed in my hard-earned left-wing credentials and started hanging around with rock musicians and writing songs for a local band, songs with decidedly unradical lyrics like "Workman's Compensation": *I like the way she takes dictation;/ She's the workman's compensation./ She's the deep water in the steno pool,/ Want to dive right in*, blah, blah, blah. You get the picture.

* In a *New York Times* essay, the memoirist Andre Aciman wrote: "Perhaps this is why all memoirists lie. We alter the truth on paper so as to alter it in fact; we lie about our past and invent surrogate memories the better to make sense of our lives and live the life we know was truly ours. We write about our life, not to see it as it was, but to see it as we wish others might see it, so we may borrow their gaze and begin to see our life." (Maybe I ought to trust memoirists after all.)

Matt was disappointed in me. Matt was sweet, but a stranger to irony. I said, Matt, it's not me talking; it's the persona. He shook his head, asked me to stop killing mice in our apartment. The snap of the traps wakes the twins. Besides, I should be more humane. I said, Matt, the mice are in the utensil drawer. They've gotten at your tahini, into your box of granola.

My girlfriend was an astrologer and a psychic healer. How could this work? She believed in coincidence; I believed in science. We broke up long enough for me to go out with a woman whose husband was a heroin addict (she'd forgotten to mention him) and another whose boyfriend cooked us breakfast. I was acting reprehensibly. I went back to my astrologer. (She knew I would.) My life was a mess, but I still had my job.

> *"When you put down the good things you ought to have done, and leave out the bad things you did do, that's memoirs."*
> —WILL ROGERS

We hired a new director, a glib and chummy fellow—let's call him Gerry—who thought our way of running the center by consensus was unprofessional and inefficient. (He was right, of course.) We needed to appeal to the captains of the mental health industry. It wasn't enough to be successful; you had to look successful. Otherwise, the socialites who run the United Way would give our funding to the Boy Scouts.

At his first staff meeting, Gerry presented as a *fait accompli* a reorganized chain of command. At the same meeting, he announced that his was an open marriage and offered to call his wife to verify that they had mutual permission to sleep around. We said, That's okay, we'll take your word for it.

Every Friday morning we had Group—a three-hour encounter session, the last vestige of our old democracy. Group was always intense, often volatile, was intimate, and could be incestuous. Like, say, the woman sitting beside you, your old friend, might announce that she's no longer living with the guy to your right, the

> *"An autobiography must be such that one can sue oneself for libel."*
> —THOMAS HOVING

one tapping his foot a mile a minute, but is in love with the woman across the room. We wielded honesty like truncheons. We hired a psychologist to facilitate the sessions.

This particular morning I told Gerry I didn't like the bureaucratic direction we were taking. He told me I had trouble with authority. I told

him I didn't think he ought to be snorting nitrous oxide from Reddi-wip cans at parties. We run a drug prevention program, after all. He said I must have problems with my daddy. I told him to blank himself. He asked me if I wanted to take it outside.

Somewhere during this exchange one would have expected a therapeutic intervention by the psychologist, something like, "Johnny, you sound angry. Do you want to go with that?" or some other nugget of psychobabble that would have diffused the hostility. But she remained silent. I should have noticed what she was saying. She sat cross-legged on the floor beside Gerry, staring at her knees. We speak two languages, one with words, one with gesture. With words we can lie. She was, I learned, sleeping with Gerry.

> *"There is an undercurrent, the real life, beneath all appearances everywhere."*
> —ROBERT HENRI

My seven-year career as a catcher in the rye was finished. I started painting houses with my friend Mike. Mike was legally blind. I had no car. We carried our buckets, brushes, and ladders on the bus. Things weren't getting better. I was broke. I shopped with food stamps. I bought loose tobacco and rolled my own. I had no prospects, no self-esteem. But I did have time to write.

Every Beginning Is an End

And the more I wrote, the more I wanted to write. I wasn't good at it, but I was determined. All my heroes were writers. I wanted to admire myself. I decided to believe in what I could become rather than in what I had become. I assessed my life. Clearly it was troubled and without direction. Trouble is also opportunity. If you have no direction, any road is a good one, even the one less traveled. A fortunate fact of life is that disorder breeds discovery; order breeds habit.

It occurs to me now that I might have subverted my quiet life in order to force myself to change. My desire to write had been a source of contention in the marriage. Art is not a way to make a living, she said. (She was right, of course.) To my wife, security meant you've grown up; you've decided to be responsible. To me, security meant you've given up; you've decided to be ordinary. (One of my characters would later say: "I'd rather be on fire than be ordinary.")

I had learned at work that our thoughts, feelings, and behaviors are connected. Change one, you change them all. So I invented my future, created my confidence, imagined myself in some other place where the most important relationship in my life was the one between me and my stories. To do that I knew I had to leave town, family, friends, expectations, commitments, and the pressure to remain the same. I knew I might fail, but sometimes it's better to be reckless than right, better to be foolish than prudent, better to be hungry than satisfied. Better to lament the leaving than the life. The hardest part of beginning is ending. The toughest part of going is saying good-bye.

> *"All writers, I think, are to one extent or another, damaged people. Writing is our way of repairing ourselves."*
> —J. ANTHONY LUKAS

I applied to writing programs. The acceptance from the University of Arkansas was the match I used to burn my bridges. I bought a rusted GMC Vandura from Kachedorian's West Side Market for $400. It smelled like lamb. I packed it with everything I couldn't sell at the yard sale. Somewhere in Tennessee the hood-latch busted. I secured the hood with clothesline. When the retreads blew, I bought new retreads. When the transmission seized, I drove into Fayetteville in first gear. Vandura died on North Gregg. I got $25 for her shell. By the

> *"Every time I agree with myself, I write an essay. When I disagree with myself, I know I'm pregnant with a short story."*
> —AMOS OZ

next week I was sitting in the beer garden at George's Majestic Lounge listening to Lucinda Williams sing on a tiny stage, and I was surrounded by other writers who thought nothing in the world was more important than poems and stories. I started writing like crazy and haven't stopped. Some of what I've learned about writing stories in particular has taught me about life in general.

You get to revise your life again and again until you're living the life you set out to live. You get to examine yourself, and if you're not doing what you want to be doing, you get to start over. You create the world you want to live in, and you go there. No one else gets to write your story. Every day is an opening sentence, a new beginning. Every morning is a new youth, every afternoon an aging, every sleep a little death. And in every sleep, the dreams you have deferred will haunt you.

EXERCISES

.

The Loved One

Recall someone that you have loved, may still love, but someone who is, however, no longer in your life. (William Butler Yeats advised writers to write about themselves when they are most like themselves—when they are in love with things that vanish.) Write down this person's name. Freewrite on that person for two minutes or so. When you finish, you'll have already collected some important and perhaps surprising material. Do that now. Write whatever comes to you. Don't think, follow the words. Don't stop.

You are going to write a story with two main characters, the fictional you and this missing person, and *you* will be the central character. At this stage you don't need to know what the story's about. If you did already know the outcome and the events and the meaning of the story you would not need to write it. We write and tell stories in order to make meaning of our lives. Fiction is exploration—all writing is, for that matter. James Baldwin said: "When you are writing you're trying to find out something which you did not know, what you don't want to know, what you don't want to find out."

Now remember something that the two of you did together. Write it down quickly. Just the facts, a sketch, an outline. Do it. Okay, now we have two characters and an event.

Fiction must exist in images, not in abstractions. So now recall that event that you just jotted down and place the two of you in the particular location where the event unfolded. In that restaurant, in the living room, on the beach, wherever. Look around, touch, listen. Describe the characters and the setting in as much detail as you can. Much more detail than you could ever use in a story. You are trying to engage your own imagination, and you need the vivid and evocative details to do so. And as yet you do not know which of these details will trigger the deep emotions. Be as precise as you can be. Use all of your senses. If, for example, your two characters are in a restaurant, describe that aroma of ginger and garlic you can smell. And look at the table. There's the tablecloth. It's bone-white, isn't it? Are there any stains on it, wrinkles in it? Yes, there's a wine stain? Well, what shape is the stain? Does

the shape remind you of anything? Anyone? What about the salt and pepper shakers? Glass cylinders with steel lids? That's the kind of detail you want. Look at the place and at the characters. Listen to them. And listen to the ambient noises.

Let us add now that you are going to write this story as a reminiscent narrator. You will tell the reader a story about the time that you and this person did something together. Now what is the dominant mood of this recollection when you remember it? How do you feel now when you recall that time, this person? Write about that. What was the mood then? Write about that.

Imagine you know where this person is and how to contact this person. Now write him a letter and tell him what you remember about that time and how you feel about it now. Tell that person everything you can.

Did you then, at the time of the event, want something and did you try to get it? Was there something stopping you? Did you try hard? If you answered yes, you have all you need to use the above material for a story. What about now? Is there anything regarding this person or this event that you want? What's stopping you from getting it? Can you try (if only imaginatively) to get it? If you can't write about that time directly, imagine other characters in your places. In this way you will not be constrained by facts. Let the one of them most like you do the wanting. Write their story. Now imagine that this other person read your letter. Let this person answer you by writing his recollection of the same evening.

Writer at Work

We've all had jobs, and so will our characters. Work is always interest-ing to read about, if not to perform—the details of what we think of as exotic behavior. We read to learn about the world, after all. There are the mysteries of the workplace, the jargon, the hierarchy, the rituals, the craft, and so on. Who hasn't wondered what goes on in the kitchen of your favorite restaurant? Take a story you've written and give those characters jobs. Ozzie Nelson didn't work, so far as we could tell, but most of us do. And we spend most of our waking life at work. We spend more time with our co-workers than we do with our families. Our jobs define us to ourselves and to the world. Our self-esteem depends on our work status, if not our performance. Unemployment is devastating. In urban America we tend to ask people we've just met what

they do. And we don't mean when they get up in the morning or when they're alone at night. We mean job. And that's what we expect to hear. So let's see your character at work, talking about work. And see how that changes the story. Remember that our figures of speech, our metaphors, our way of looking at the world all come to some degree from our jobs. What a farmer thinks of the landscape may be different from what a miner thinks, a developer, a factory worker.

For starters, remember jobs that you've had. Remember the details of the job, those things you've forgotten till now. The rituals of the factory, how the break bell was always two minutes late, how the break was fourteen, not fifteen minutes long, how you had to sneak into the head to cop a smoke. Remember how you folded the papers when you were a paperboy, how you scratched in "paid" by the customer's name when you collected. Remember getting hassled by the inspector when you drove a cab; remember getting ripped off by riders. Remember the workplace and the people around you. Write about the tasks you performed at all your jobs and about the people you worked with. Your characters might have one of your jobs. Or you might try one of these:

> Hypodermic needle assembler—she inserts needles into needle hubs and inspects for defects. She needs hand/eye coordination and needs to work steadily and routinely.
>
> Broth mixer—he controls the flow sifter and vats to measure and mix liquid solutions for fermenting, oxidizing, and shortening; works with yeast, sugar, shortening, water, milk, enrichers; must carefully control the temperature of the broth; runs the solution through a heat regulator and into dough-mixing machinery.
>
> Crab butcher at a seafood processing plant.
>
> Stripping shovel operator at a coal mine—she scoops up and moves the broken overburden, which is pushed within her reach by dozers.
>
> Thread tool grinder setup operator in a tool and die shop—he's on his feet all day.
>
> Route driver for UPS.
>
> Dipper at a rubber factory—she dips forms into liquid-compounded latex rubber to coat them, makes balloons and rubber gloves.

Doll wigs hackler—he combs and softens synthetic hair by pulling it through a hackle, a combing tool with projecting bristles or teeth.

The Occupational Outlook Handbook has listings for hundreds of jobs. Get it on-line. Something called TBRnet does as well. The *Dictionary of Occupational Titles* is the best and may be accessible on-line, and is certainly in the library.

Sitting Alone in a Quiet Room

Most of the evils of life come from
man's being unable to sit still in a room.

—*Blaise Pascal*

Once upon a time—*four words that Eudora Welty says you can't* use in fiction. (We might add seven more: *And they all lived happily ever after.* No one does. [All right maybe you can use them ironically.]) Time is place. Place is character. Character is destiny. Destiny is making a choice to seize the opportunity of chance. At least that's what one of my characters thinks. A few months ago I imagined a scene in which a young man named Delaney sits alone in a quiet kitchen, waiting for another character to enter, and I sat in my kitchen, clutching my pen, watching him, waiting to see what he would do. He looked at the clock. And so did I. I saw it closely. It had a white, plastic, art deco-ish case, and a square white dial with rounded corners. The numerals on the face were black and chunky. The 1s wore little visors. The black hands looked like kitchen knives. A cook's knife and a boning knife. The red second hand began with a spade, looked like a drink stirrer. At the bottom of the face, the words *Telechron Movement.** Well, there it is, isn't it? Space and time. Simultaneous yet discrete. Like the idea of the three-personed God.

* I said I saw the clock that Delaney saw and then described it. The way I did that was to put down my pen and reach over to the reference books, pick out a photo book on fifties home style, and leaf through the pages until I found a clock not unlike the one in my grandmother's kitchen when I was a boy. And then Delaney looked at it.

It occurred to me and to Delaney that Time didn't used to be like this, that it is measured in the mind. Was it discovered or invented? Once, Time consisted of light and dark, warm and cold. Then we felt the need for hours. Why did we need them, and how did they change us? We have the Industrial Revolution to thank for minutes. And now we have seconds, milliseconds. What will Time be like in the future?

Questions provoke more questions. The world opens like a flower. Some things I learned while writing that scene: The brain consists of two hundred billion neurons and is the densest object in the universe. Some of those neurons recognize gender, others facial expression, mood, sound, etc. I learned that something can come from nothing, and that this *nothing* has a name—*virtual proton*. When light traverses an electron, it produces a particle of Time—a chronon. So then Time is matter! All because a young man stared at a clock. All because I sat and listened.*

* And I should add that I worked on this scene for weeks—first reading everything I could about Time and then writing a scene in which Delaney decides that he will live in this very minute and so determines to watch the second hand make its sixty-second sweep. And I wrote down everything he thought about in that minute. Some seconds take sentences, while other seconds pass in a phrase. In fact, here it is:

> Delaney looked at the clock on the wall above the stove, waited for the sweep hand to reach twelve, and determined to be aware of every second for the next minute. The clock had a white, plastic, art deco-ish case, and a square white dial with rounded corners. The numerals on the face were black and chunky. The 1s wore little visors. The black hands looked like kitchen knives. A cook's knife and a boning knife. The red second hand began with a spade, looked like a drink stirrer. Three seconds had gone by. Four. No time, no verbs. Five. Who came up with this idea of seconds? How obsessive do we need to be, anyway? Wasn't it enough to measure duration by seasons, by moons, by suns? Does the unit of measurement change the nature of time? Doray Defroster. The name on the clock: Doray, like notes on a musical scale; the model name, Defroster, what a modern freezer's built to be. Alliterative and puzzling. Why is there a circle punched out of the face below the word Doray? Not a winding hole, of course, but meant to seem like one? At the bottom of the face: Telechron Movement. Well, there it is, isn't it? Space and time. Do we want the coordinating conjunction? Space-time. There. Simultaneous yet discrete. Like the idea of the three personed God. Twenty-three seconds had passed, in the kitchen at any rate. Passed into what? Three-personed God, batter my heart, wasn't it? Who said that?
>
> You can't live like this, in the minute as it were, alert to the passage of seconds. That would be like keeping a diary of every minute of your life, which life would amount to keeping a diary of every minute of your life. Maybe. Maybe all that time is is that which—that what which?—what idea which, that function which, that quantity which enables a date to be uniquely associated with any given event. Could time be like light, both a particle and a wave? Yes, what was it Clay Mercer said? A chronon— time becomes a particle when a photon crosses the diameter of an electron. Time possesses mass.
>
> There couldn't be a beginning of time by definition; there could be nothing before time existed. No time before time. No time after time. Like a story, we live it forward, but understand it backward. Except that time has no direction. And eternity then? The awareness that time is fixed, that it's all an eternal present, and that everything and everyone always exists? Maybe this awareness is the heaven, the nirvana they talk about. But if we don't become aware of this while we're alive, what then? We're always alive? But are we always conscious when we're awake? Forty-five seconds. Almost finished. So much can transpire in f . . . ifty seconds. Fifty-one.
>
> "Delaney, what are you doing?"
>
> "Aunt Sudie, you scared a year off my span of life. I'm watching the clock."

The First Commandment of writing fiction is, *Sit Your Ass in the Chair.** And sit it there daily. Strap on a seat belt if you must, but sit. (Velcro slacks?)

> *Sudie looked at the clock, at her watch. "It's a minute fast."*
>
> *Delaney turned. "Don't say that."*
>
> *Delaney looked up and saw the second hand sweep past the black dots at seven seconds, eight seconds, then round the corner of the square and on to the numeral 2. He hadn't been able to keep his vigil after all. Not for the mistaken minute, and not now for the present minute.*

I was so proud of my little scene and what I considered my clever insights. I tightened it up eventually and published the story, "This Is the Age of the Beautiful Death."

* And the other Nine Commandments are:

 2. Thou Shalt Not Bore the Reader.
 3. Remember to Keep Holy Your Writing Time.
 4. Honor the Lives of Your Characters.
 5. Thou Shalt Not Be Obscure.**
 6. Thou Shalt Show and Not Tell.
 7. Thou Shalt Steal.***
 8. Thou Shalt Rewrite and Rewrite again. And again.
 9. Thou Shalt Confront the Human Condition.
 10. Be Sure That Every Death in a Story Means Something.

** If you have something to say, why would you make it difficult for someone to understand you? Could it be that you're not so smart? That you think if you muddy the water a bit, it'll seem deeper than it really is?

*** Artists who have weighed in on the Seventh Commandment:

Lionel Trilling: "Immature artists imitate—mature artists steal."

T. S. Eliot: "The immature poet imitates; the mature poet plagiarizes."

Igor Stravinsky: "A good composer does not imitate; he steals."

Stravinsky again: "One must always steal, but never from oneself."

Ralph Waldo Emerson: "Genius borrows nobly."

Wilson Mizner: "If you steal from one other, it's plagiarism; if you steal from many, it's research."

Pablo Picasso: "Bad artists copy; good artists steal."

Picasso again: "Copy anyone, but never copy yourself."

George Moore: "Taking something from one man and making it worse is plagiarism."

Thornton Wilder: "I do borrow from other writers shamelessly! I can only say in my defense, like the woman brought before the judge on a charge of kleptomania, 'I do steal, Your Honor, but only from the very best stores.'"

George Balanchine: "God creates, I do not create. I assemble and I steal from everywhere to do it from what I see, from what the dancers can do, from what others can do."

Josh Billings: "About the most originality that any writer can hope to achieve honestly is to steal with good judgment."

Archibald MacLeish: "A real writer learns from earlier writers the way a boy learns from an apple orchard by stealing what he has a taste for and can carry off."

Alexander Pope: "Most authors steal their works, or buy."

Philip Johnson: "Creativity is selective copying."

John Updike: "My purpose in reading has ever secretly been not to come and judge, but to come and steal."

Michael Caine: "I only steal from the best people."

Lawrence Durrell: "I pinch."

Writing is, after all, a physical activity. A story does not exist before the act of writing. An idea for a story is not a story. Thinking about writing is not writing. Telling your friends that you're working on a novel is not writing. Only writing is writing. And it's also a way of thinking (not the result of thought).

.

"Only the hand that erases can write the true thing."
— MEISTER ECKHART

It is not the way we think when we are unencumbered by pen and paper (or keyboard and screen), when we are otherwise distracted or in motion. Writing is a way of thinking that both focuses and rattles the mind, that enables, even compels us to think the complete thought. It allows for reflection, appraisal, and revision. It draws and concentrates our absolute attention. And if you are a writer, writing is how you think best. It is the only way that you can make sense of the world. And writing is harder for you than it is for anyone else. (And also more joyous for you than for anyone else.) If the process of writing is thought, the product of writing is language distilled and refined. It is speech that is concentrated, layered, coherent, textured, clear, stimulating, and resonant. No small feat.

Many people want to have written. Writers want to write. Writing is what you do, not what you've done. It's the doing, the intense activity of the mind that fascinates the writer, that allows him to shape order from chaos. Writers write. And writing is work. And you go to work every day. It's not a choice. If you don't punch in, you lose your job. What

.

"Wisdom begins in wonder."
— SOCRATES

could be more evident? My father stoked a coal furnace and later operated a backhoe and did so for fifty years, and showed up every day, whether he was sad, sick, or hungover. Me, I get the privilege of making up stories, the opportunity to think about what's most important in my life every day. I can be better than myself, meet people I'd like to hang out with, live in a world more vivid and compelling than the one outside my door. Why wouldn't I go to work every day?

Writing stories is sitting alone in a quiet room, without distraction, face-to-face with yourself. We need seclusion to see the world, need to close our eyes to watch our characters. As Pascal knew, diversion is both our consolation and our misery. It passes the time and helps us forget that we are dying. As writers of stories, however, we don't have time to kill, and our only job is

to confront the human condition, to say that this is what life is like and this is how it feels. Every story should be a plunge into reality, not an escape from it. In America we are obsessed with diversion and amusement. We clutter our lives with distractions, with televisions and stereos and TVs and DVDs and radios and telephones. We go to movies, sporting events, we shop, we drive. We do everything we can to stay out of that quiet room, to avoid the recognition of our mortality.

But death is the central truth of our existence—the sadness at our core. Everything we love will vanish. We can't hold on to anything. It is this tragedy that accounts as well for the beauty and nobility of our lives because in the face of this knowledge, we go right on loving, trying to hold on to what we cherish, defying death with hubris and with faith.

Introspection without distraction. You sit and face the blank and innocent page with anxiety and confusion, with doubt and uncertainty. You write because you insist on meaning, and you can't, for whatever reason, rely only on Faith or Science to provide it. Faith, Nietzsche told us, is not wanting to know the truth. Science is God's story (or it's Nature's). You

> *"The purpose of art is the lifelong construction of a state of wonder."*
> —GLENN GOULD

crave a person's story. You want meaning, but not answers. Fiction writers understand that there are no answers, simple or otherwise. The point is not to answer, but to question, not to solve, but to seek, not to preach, but to explore, not to assure, but to agitate.

You sit in the room and create a reader, and you try to engage her imagination. (And remember you do not have an audience—you're not the Pope. *Audience* is a marketing term that means something like *lowest common denominator.* It means this much blood and that much sex and X number of pages and embossed jackets. It means *formula,* and formula, we know, is for babies.) Like you, the reader sits in a quiet room with your book in her lap, and she finishes the act of creation

> *"Ever tried? Ever failed? No matter. Try again. Fail again. Fail better."*
> —SAMUEL BECKETT

that you started. You furnish the vivid and significant image, and she furnishes the room. Writer and reader construct the story together, both are active, imaginative, generative. This is why no other art can move us like literature—as readers, we are in on the creation, and we are transported to

another world. It's why we begin to read our favorite books one page a day, so they will not end, so we can stay in their world a little longer. If you did your job as a writer, you know that your central character will be changed, your reader will be changed, and so will you. From that day forward, none of these lives will ever be the same again.

In fact, writing a story is very much a plot. You want something—to understand the lives of your characters, which means resolving the trouble in your central character's life, which means completing the story—and you want it intensely. If you don't finish, your life will be significantly diminished. And so you pursue your goal and battle every obstacle, not the least of which is yourself and your lack of confidence, your obstructionist tendencies, the world calling for your attention, the chaos of the characters' lives, those elusive words, and so on. You sit day after day. All important struggles are internal, you sense. You struggle and at last you finish your story. Or you don't. Plot's resolved, story's over.

>
> *"When I'm not working I sometimes think I know something, but when I'm working, it is quite clear I know nothing."*
> —JOHN CAGE

The difficult behavior of solitude and rumination—that cherished drudgery—sets a tone for your life and your work. You refuse to allow your work to become a commodity, an escape. Truth is not merchandise. You don't waste your time or the reader's by writing about what is not of crucial importance in your life. Writing time is sacramental. This is when you remind yourself that there is more to life than consumption and amusement and jobs. There's grace and there's knowledge. Grace that is achieved, knowledge that is imagined.

>
> *"It's nervous work. The state you need to write in is the state that others are paying large sums of money to get rid of."*
> —SHIRLEY HAZZARD

And all of this will make you anxious, confused, bothered, erratic, and that's as it should be. Don't go to therapy. Bring your anxiety to the page where it will do you and the reader some good. If you deny anxiety, it's useless to you. Use it as an opportunity to explore and open up. Every problem, remember, is also an opportunity. Like our characters, we need trouble. Security is a kind of prison. We write from where we got the wound. Go there. Write about what you're afraid of, what you're ashamed of, what you can't

forget about, what keeps you up at night, what you don't want to know about yourself. Write about what you don't understand. (This might seem contrary to the old chestnut: *Write what you know!* But remember that what you know is everything that you can imagine or research. The advice might be better expressed as: *Don't write what you don't know!*) Writing's too hard to bother with less. Tolstoy said, "One ought only to write when one leaves a piece of one's flesh in the ink pot each time one dips one's pen." We have enough bad art around already—the literature of body counts and body parts. It's depressing, disheartening, dishonest.

You sit in a room and you try to write stories. Your job is to be honest, clear, and fascinating. And so you rewrite again and again. You come to understand that disorder is the source of the mind's fertility. Doubt isn't the opposite of knowing. It is a part of knowing. It's not what we know that matters, but what we don't know because therein lie the seeds of wonder—a writer's most important tool. You drive through your uncertainty and arrive at what Rūmī called a state of "astounded lucid confusion." You learn that talent is perseverance, that patience is genius, that the only story that does not get finished is the one you gave up on. To quote Einstein: "It's not that I'm

.

> *"Any artist must expect to work amid the total, rational indifference of everybody else to their work."*
>
> —URSULA K. LE GUIN

so smart, it's just that I stay with problems longer." (He also said that the secret of creativity is to hide your sources.) You write serenely and without ambition. You learn to tolerate, and even to cultivate ambiguity. You foster what Keats called "negative capability": "being in uncertainties, mysteries, doubts, without any irritable reaching after fact and reason." You write to do justice to the lives of the people in your story. Fiction, you realize, is an egoless pursuit. The reader doesn't care about you, but about these characters and their trouble.

You learn that honest fiction is subversive, asking us to question everything we believe in. Maybe the world is not what we were told it is. Maybe the character's apparent motivation is a lie. Maybe opposites are true. Maybe mystery is not in the world but in our eyes. Maybe our lives, like the universe, are all motion without direction. Fiction is also disturbing—it confronts our received values and aims at an emotional response—it won't let us alone. It is morally based, emanating from deeply held and vigorously challenged beliefs, and can only be written by one who is deeply engaged with his material and committed to finding a truth in the tempest.

You learn that fiction, like dreams, exists in images, that it's sensual. It is life-affirming. Fiction is humble and it is a celebration of mystery—mystery, which constitutes the beauty of life. You don't have to be smart to write stories, but you must be curious. Fiction is inquisitive. The story's job is to ask *why?* and *how?* The process of writing is intuitive and illogical, otherwise there would be no dis-covery or surprise. Who said that logic was thinking? Fiction is nonjudgmental. There are no victims or villains, not as central char-acters at any rate. You witness what the characters do, and you write that down. It is not yours to judge, to blame. Fiction is particular, precise, exact, concrete. It's subjective, the objective world being an illusion or just one other subjective point of view. It's about people. As a fiction writer you believe that people are more important than ideas—even, as I've said, ideas of the divine. And fiction is bold, daring. Nothing, you realize, is obtained without risk. Fiction is discovery, and you can't discover if you don't explore, and you won't explore if you won't take chances. And you learn that every story is a failure, that it's never what it should or could have been. At best, we try, as Samuel Beckett suggested, to fail better. And like second marriages, fiction is a victory of hope over experience.

> *"You can't want to be a writer, you have to be one."*
> —PAUL THEROUX

Sit in the quiet room and deal with all of that moment by moment. Writing is a cumulative activity—it doesn't happen at once—it builds upon itself. You sit, and out of the silence rises the word. And one word leads to another. I said fiction writ-ing was a job, but it's more than that, of course. It's a way of life. When you write every day, you realize that everything else in your life is incompatible with writ-ing. Your spouse and chil-dren, your friends and job,

> *"You do not need to leave your room. Remain sitting at your table and listen. Do not even listen, simply wait, be quiet, still and solitary. The world will freely offer itself to you to be unmasked, it has no choice, it will roll in ecstacy at your feet."*
> —FRANZ KAFKA

TV, social life. All are calling you away from the desk, all want your attention, your time, your energy. And it will ever be so. Still, the only reason to leave the writing room is to go in search of material. When you're writing every day (and five minutes will do because for the other twenty-four hours and fifty-five minutes, your antennae are up), your story becomes a magnet for everything that happens in your daily life.

Auden said the first act of writing is noticing. Noticing begins with a sense of wonder, an assertive curiosity about the world, a wanting to know how and why. Your job is to see what no one else sees, to see what's there, not what's supposed to be there, or to see what others see but think about it differently. You savor what others dismiss. You know that an image or idea on its own might be static, but combined with another can become dynamic, can resonate and illuminate.* Emerson said, "In every work of genius, we recognize our own rejected thoughts." And because you can't know which images will respond to stimulation, you collect them all. Someday, you trust, you will use them.

It's a provocative world out there, and you try to make yourself susceptible to it. You understand that every object is worthy of your attention because a story can begin anywhere, because everything is implicit in anything, because any irritating grain of sand can become a pearl. You look at the world and you try to see as many levels of meaning there as you can. You ask, What else can it be? You develop what Flannery O'Connor called anagogical vision, a religious term meaning you're able to see different levels of reality in a single image or situation. *These ain't hogs I'm scootin' down, they are my salvation.* You give your imagination opportunities. You present it with as many images, concepts, ideas, words, people, paradoxes as you can—some will fire the brain. You know that the best way to have a good idea is to have lots of ideas. You trust both your imagination (*that which connects*) and your story to lead you.

I have a half dozen quotations written on index cards taped to the wall beside my writing desk. I read them when I want to know why I'm doing what I think I'm doing. From Jean Cocteau: *The spirit of creation is simply the spirit of contradiction.* Eugene Ionesco: *Only the ephemeral is of lasting value.* Anton Chekhov, paraphrased, by Nabokov, I believe—wish I had saved the

* Friedrich Schiller, German poet and dramatist, as quoted by Freud in *The Interpretation of Dreams* had this to say on the subject: "In isolation an idea might be quite insignificant, and venturesome in the extreme, but it may acquire importance from an idea which follows it. . . . In the case of a creative mind, it seems to me, the intellect has withdrawn its watches from the gates, and the ideas rush in pell-mell, and only then does it review and inspect the multitude. You are ashamed or afraid of the momentary and passing madness which is found in all real creators, the longer or shorter duration of which distinguishes the thinking artist from the dreamer . . . you reject too soon and discriminate too severely." And even if you can't use your idea or image in a story right now, isn't it great to know these odd bits of information? Like you know about Throckmorton Sign: when a man breaks his hip, his penis will point to the fractured side. And I'm not making this up. Of course, I don't know that it's true. (Maybe it is, half the time.) Or you know that a jubilee is a congregation of oxygen-deprived fish.

citation: *We are not condemned by our mortal sins which are aberrations and which may, in fact, take great courage to commit. We are condemned by our venial sins which we may commit a hundred times a day, until they become a way of life.* Ludwig Wittgenstein: *Everything that can be thought of at all can be thought of clearly. Everything that can be said can be said clearly.* Leo Tolstoy: *Man survives earthquakes, epidemics, the horrors of disease, and all the agonies of the soul, but for all time his most tormenting tragedy has been, is, will be—the tragedy of the bedroom.*

The words remind me what a serious and important business telling stories is. What a privilege it is to be able to sit here in this room and imagine my darlings in trouble again. Like my housewife, call her Donna, sitting there in her quiet study, dreading the moment her husband comes home. She's drinking coffee, wondering what she will say to him, how, yes, she loves him, but she just doesn't think she can go on living with him. I sit at my table and watch her. She fidgets. I tap my pen, I look up and to the left. There's a knock at the door. Not my door. Hers.

EXERCISES

· · · · ·

Of course, you can't always be in a quiet room. But you can always write—and you'll want to learn to write wherever you are. Take a notebook with you to a bar, sit and write, and watch what happens. People won't be able to figure you out. They'll want to know what you're up to.

Milieu

Try this. Try writing in different places. Carry this book, or carry a list of writing exercises with you at all times and, of course, some kind of notebook. Whenever you get a chance to sit, take the opportunity to write. Write in a bar. Not one of these franchise fern bars, but the neighborhood pub. A place where people go to talk. Listen to the patrons. Jot down what they are saying. That smell of cigarette smoke—how would you describe it? What does it remind you of? What are people wearing? What does that tell you about them? How is the place decorated?

Write in a laundromat. Who else is there? Take a look at the magazine titles, the orphan socks in the bin on the counter. What mood does the place

put you in? Write about that. Describe the rhythm of the machines, the smell of the dryers. What is unique about this laundromat? How is it different from every other laundromat in the world? These folks in here have stories. What do you imagine they are? You've brought your laundry. Do you know what you're doing? Have you washed clothes before, operated one of these machines? Ask someone for help. Write about what happens. At some point in your stay a toddler will come within six feet of you, stop, and stare at you. Might even say something unintelligible. Ask her name. Introduce yourself. How does her mother react?

Try writing in other places where people gather—cafés, malls, bus stops. If your characters drive expensive cars and have their shirts dry-cleaned, then you might bring your notebook out to the country club and settle in at the nineteenth hole. Write in a church, an old church if you can, a Catholic church if possible. Can you smell the incense? What is the effect of the light flooding through the stained glass? Write in a cemetery (a good source of names, by the way) or in a rowboat drifting on a pond. Write in an art museum. Put yourself in that house in Truro in the Hopper painting. Imagine your life there.

There and Then

Write about where you want to be right now. On a beach in the south of France. At the theater in London. In a cozy cottage on the Aran Islands. Now imagine yourself there and situate yourself in that place. Look around. Listen, inhale the air. Begin to write down the details of this place. Pretend that you're remembering the place from your last visit. Memory is imagination. Write in first person, present tense. The smell and the sounds and the textures. Yes, just like the first exercise in the book, "Here and Now." See yourself clearly. Are you sitting, standing, walking? Stop what you're doing and reach down and pick up the object at your feet. What is it? Describe it. Put it in your pocket or your pack. Whenever you see this object again, you'll remember this idyll, this wonderful trip to your favorite place. Write about the people who are there and the people who are not. Time to return. What does it feel like to leave?

Getting Black on White

X

It's one of the things writing students don't understand.
They write a first draft and are quite disappointed, or often *should* be
disappointed. They don't understand that they have merely begun, and
that they may be merely beginning even in the second or third draft.

—*Elizabeth Hardwick*

Stories and novels don't get written. They get rewritten. All matters of consequence in fiction are addressed in revisions. And the most essential fact about revision is that you have to have something to revise. The first draft. The Irish short story writer Frank O'Connor* explained a first draft this

* If you haven't read Frank O'Connor, do it tonight. No, I'm not kidding. Any collection of his will do. Go to the library; go to the local bookshop. Pick up *Collected Stories* or any other of his books. Read "My Oedipus Complex" or "Guests of the Nation" or "My First Confession." You'll be hooked. Here's a truth. There are two ways to learn how to write—by writing and by reading. You'll learn more about writing a short story by reading O'Connor or Chekhov than you'll learn in a semester's fiction writing class. But you have to read as a writer does. That means reading it twice. Read it once to let it happen. Read it again to see *how* it happened. The first time you're letting yourself enjoy the tale, letting the language and the action work on you. The second time, you're casting your critical eye on the material. Once you know the beginning, middle, and end, once you know the journey, you can go back and see how the author took you from start to finish. Pay attention. How were the transitions made? Why did the author make this particular choice—of word or scene or behavior? All writing is making choices. If you admire a move that the writer has made—make that same move in your next story. And now that you're in Ireland, you might as well stay awhile. Read William Trevor, who along with Canadian Alice Munro is perhaps our finest contemporary writer. Read Edna O'Brien and James Joyce and Anne Enright and Roddy Doyle, and the list goes on. Why have the Irish produced such brilliant storytellers?

And remember this, you don't have time to read crap. Don't bother yourself with miserable literature. Toss the book across the room and pick up Cormac McCarthy or Andrea Barrett. They'll take you to other worlds. They'll scare you to death and break your heart.

way. He said that he followed Maupassant's advice to get black on white: "I write any sort of rubbish which will cover the main outlines of the story, then I can begin to see it."

Writing a first draft ought to be easy because, in a sense, you can't get it wrong. You are bringing something completely new into the world, some events and some people that did not exist before. You have nothing to prove in that first draft and nothing to defend. You have every-thing to imagine. And the first draft belongs to you alone. No one else sees it unless you want them to. You aren't writing for a reader just yet—you wouldn't insult her with your meandering and unassured words, your unrealized characters, your clumsy rhythms, your uninspiring world. You write the first draft for yourself, so that you can read what you have written, so that you can determine what you still have to say.

>
> *"All first drafts are shit."*
> —ERNEST HEMINGWAY

You begin the draft of the story at the same place everyone else begins. That is, you begin the journey not knowing where you'll end up. You may have a destination in mind, and you may well set off in that direction, but what you'll encounter along the way will likely alter your course. As a writer you are a traveler in a newfound land. You're what the French call a *flâneur*, a wanderer, an idler, a stroller who aimlessly loses herself in a crowd, taking in all the rich detail of your story, going wherever curiosity leads you, collecting impressions along the way. The narrator of my novel

>
> *"A writer is a man who, embarking upon a task, does not know what to do."*
> —DONALD BARTHELME

Deep in the Shade of Paradise compares the writer's journey to a tourist's: "You can drive from New York to Miami on I-95. Or you can go by way of Bemidji and Tolstoy and Tonapah and Monroe." You wind up in the same place—but, ah! the journey. This uncertainty, though daunting, is crucial to the writing process. It allows for, even encourages, revelation and surprise, while it pre-vents the manipulation of character or plot to suit your preconceived, and usually ill-conceived, notion of what the story must be. In writing the first draft, you begin to work through all the uncertainty and advance toward meaning.

You ought to be reassured by all this, but, of course, you're not. Writing a first draft isn't easy. It takes perseverance to write a story, it takes that and more to write a first draft. It takes faith and grit, boldness and resilience. It

takes poise and good fortune. "The first draft," according to Bernard Malamud, ". . . is the most uncertain—where you need guts, the ability to accept the imperfect until it is better." You must have the courage to allow yourself to fail. The first draft is where the beginning writer most often finds himself stuck, discouraged, doomed.

This novice I'm thinking of is the person—you've met him at parties[*]— who claims to have dozens of scintillating, compelling ideas for stories. He can describe his story to you—and he *will* as soon as he discovers you're a writer—in elaborate detail. It's most often about his own experiences. He may be able to articulate theme, explain how he'll go about revealing character, lay in symbols, build tension, unfurl the plot. But he never gets the

> "*Writing is a process of dealing with not knowing, a forcing of what and how.*"
> —DONALD BARTHELME

story written, though he feels an urgency to do so. Often it is this very urgency that aborts the narrative. This novice writer wants to dodge the drafting process and write the story immediately. He doesn't know what every experienced fiction writer knows: that the story does not exist before

[*] If you are at a party or a bar or another social gathering, you might want to tell folks you write stories. At first they won't know what that means exactly. They'll say, No, I mean what do you do for work, how do you make a living. Then they'll tell you their stories. And when they do, take notes. My story "I Will Eat a Piece of the Roof and You Can Eat the Window" began at the King's Head Pub down the street from my house. My friend David and I were having a beer and talking about books. Beside me at the corner of the small bar sat a woman nursing a beer. She was eavesdropping on our conversation and eventually asked us to recommend books for her to read. I told her to read mine and wrote the titles down on the back of her business card. That led to more literary talk and introductions and so on.

David suggested we move on from beers to the harder stuff. The woman said she'd like Macallan. We raised our glasses. She said, "Here's to the man who drank Macallan." Of course, I said, Who was he? She told us the long and complex story about the boyfriend whom she met ten weeks ago and how he was supposed to move in with her this weekend, but he died. I thought, She's pulling our legs. Probably knows how gullible writers are. The boyfriend had told his wife and his two young children that he had fallen in love—not something he'd planned, just happened—and was leaving them. That night he took the family boat out on the local river—needed to get out of the house or was thrown out of the house—and died—suffocated by a faulty heater. The boat was docked at his father-in-law's marina. That would have been enough for me, I suppose, but I went home and got on-line and checked the local newspaper in the boyfriend's hometown. Indeed, he had died along with a friend. I picked up my pen and started taking notes.

Not all stories are quite so tragic or so ripe with fictive potential. Many have to do with loss and infidelity. One night after I read at a bookstore in Lakeland, Florida, an eighty-year-old woman told me how she had one love of her life and, unfortunately, he was married to someone else. She moved here forty years ago when he did. She followed him from California. Two years ago she and her lover were on a Caribbean cruise. She woke one morning in their cabin and found him dead in their bed. She had to call his family. She was not allowed to attend the funeral. And so on. She told me I could have the story because she wasn't going to write it. But I haven't written it. So you can.

the act of writing, that it emerges through the flow of images and the rhythm of words. He fails to understand that while life might be (or is it *seem?*) spontaneous, art is not.

And so he makes mistakes. He sets unrealistic goals for what he may not acknowledge to be, but is in fact, the first draft. He undermines his effort by holding unrealistic expectations of his imaginative and organizing powers. And so he becomes discouraged when the people in his head are unrecognizable on the page, when the intense emotion he felt in real life is unrealized in what he writes. The beginning writer

.

"A careful first draft is a failed first draft."

— PATRICIA HAMPL

who has read a great deal is even more susceptible to this kind of dejection. She knows that the García Márquez story she just read did not flounder the way hers seems to. She loses confidence and hope, becomes intimidated by the magnitude of the problem that is the nascent story, is humbled by her vaulting ambition. What had seemed like an exciting and noble undertaking now seems foolish and impossible. What she doesn't understand is that García Márquez wrote five hundred pages to get those seventeen.

What's the lesson here? Do not write beyond what the first draft is meant to accomplish. Do not demand or expect a finished manuscript in one draft. (Any writer who tells you he wrote his story in a draft is a liar or a loafer.) The worst thing you can do in writing a first draft is to let your critical self (the boss) sit down at the writing table with your creative self. The critic will always stifle the writer within. And you ought not to be worried about your style or the music of the prose or your word choice—you

.

"You have to have an idea of what you are going to do, but it should be a vague idea."

— PABLO PICASSO

make the best word choice you can for now, knowing it'll get better later. Don't even worry about the flow of the plot. You're trying to settle into this new community you've moved to, trying to get to know the people who live there.

Use the first draft to explore the world of your story. If you want to care about your characters (and if you don't, your readers won't), you have to know them, and to get to know them, you have to hang out with them, talk to them, listen to them. Engage that part of yourself you may ignore in the analytical, task-oriented world of your daily life. One way to do so is by freewriting—writing quickly without concentrating, without evaluating or

considering, on any subject for a designated time. Do not lift the pen from the paper or fingers from the keyboard. If you're stuck, write, "I'm stuck. I'm supposed to be writing about grief, but I can't." Whatever you do, don't stop.

If you're having trouble, that means you're thinking. You're being logical, critical. You can freewrite on any emotion, on any character, on any place. If you're stuck, write your character's name on the top of a blank page and freewrite for five, ten, or however many minutes you need to prime the pump. Or free-associate. Write down a word, an emotion, a city, and then write the first word that comes into your head, then the next, and the next. Again, don't think, don't consider, just associate, only connect.

> *"I am always doing what I cannot do yet, in order to learn how to do it."*
>
> —VINCENT VAN GOGH

I brainstorm lists whenever I feel stuck. As fast as I can, I'll scribble all the possible choices that my character has or that I think he has at that moment in the story. And I never go with the first item; it's always too obvious. (First thought, worst thought.) I'll try another, and if I don't feel excited by where it leads me, I'll try again. I'll ask why would he do this and not that. Sometimes he'll tell me, and then I know I'm on track. I'll look at the room my characters are sitting in, and I'll describe everything in it, from the cabbage rose wallpaper to the clanging cast-iron radiator to the chipped cornice above the dining room door. Even the smell of the bananas darkening in a wooden fruit bowl on the windowsill. Now I'm there with my characters, and though the wallpaper may not appear in the story, something else that I may have otherwise overlooked will.

> *"Writing is exploration. You start from nothing and learn as you go."*
>
> —E. L. DOCTOROW

Just before he tells his wife he's leaving her, my husband notices their child's pacifier under the coffee table. What does he do now? Time for another list.

Out of the blue, have your narrator (first or third person, it doesn't matter) make a declarative statement about your central character. It's better if the statement contains a quirky or even desperate action, and it should come as a surprise to you. Perhaps the character's action is one that you had considered her incapable of performing. And then ask the natural questions suggested by that statement. The answers to those questions will provide the raw material for the rest of the narrative. Like this:

The narrator of my story "The Fontana Gene" said:

When Billy Wayne Fontana's second wife, Tami Lynne, left him for the first time, he walked into Booker T. Washington Elementary School, interrupted the fourth grade in the middle of a hygiene lesson, it being a Thursday morning and all, apologized to Miss Azzie Lee Oglesbee, the substitute teacher, fetched his older boy Duane, and vanished for a year and a half from Monroe.

The line was a gift that appeared because I pushed the narrator to tell me something about Billy Wayne that I didn't already know. Suddenly I had a father, a ten-year-old boy, at least one other male child, two wives, a town, submerged trouble, an eventual reconciliation, a second split, a kidnapping, a disappearance. I began to ask questions. What was it made Billy Wayne do something so desperate? Why would he take just the one boy? Why would Tami Lynne take him back? What would he do to make her leave again? What did he do and where did he go for a year and a half? Why did he come back? And what about that voice? Who is it telling this story? Not the narrator I thought I knew. I answered the questions for days, writing away in my notebook. I fiddled with structure and shape. Three months later I had an unwieldy first draft, but one that interested me immensely. Six months later I finished the story. Four years later I finished the novel that grew from the story. A decade later, I'm still writing about that place and those people.

.

"Nothing you write, if you hope to be any good, will ever come out as you first hoped."

—LILLIAN HELLMAN

Or let's say your central character—Mary, let's call her (not memorable enough? okay, she's Ursula)—let's say Ursula has just discovered that the man she has called Daddy all her life is not, in fact, her father. What does she do? You're not sure. Perhaps you're not sure because you don't know her well enough yet. So the narrator makes a statement—and Ursula's telling the story, so she's our narrator. She says something like, "I ran away from home at sixteen." Already you see you may have tapped into a childhood trauma. Now you take advantage of your natural curiosity. Ask the questions that are suggested by her statement. "Why?" "Where to?" In fact, the reporter's questions are a good place to start. Who? What? When? Where? Why? and How? But gradually get more and more specific. The more specific the question, the

more information is revealed in the answer. "What did you do when you got off the bus in Youngstown?" (She went to Youngstown! Where had she been living?) Did she go alone? Was she running *from* something or *to* something? How long did she stay? Did she go back home? Why and when? Why did she run away on that day and not the day before or a year earlier? Ask the questions and then answer them as specifically as you can. This is how all fiction gets made. A writer learns which questions to ask. (So do this right now in your notebook. Someone says, "Today, I decided to change my life." Ask the questions. Answer them. Begin a narrative if you get carried away. Give yourself twenty minutes tops. You have to, of course, invent the character who spoke those words. This is another exercise that you can use anytime in the writing process, just like freewriting.)

>
> *"If you know what you are going to write when you're writing a poem, it's going to be average."*
> —DEREK WALCOTT

Your first draft is an exploration. You invent characters and you wonder what they'll do. You watch them, and they surprise you, delight you, maybe they shock you. You gather information, do research, generate scenes. You write it all down with a temporary disregard for logic, transitions, and grammatical conventions. In the process, you learn that the story you set out to write is not so interesting as the one that has emerged on the page. The purpose of exploration is discovery, and what you discover in writing that first draft are character, structure, plot, theme, tone, setting. In short, you begin to discover what it is you have to say about what it is you're writing about.

Trust in the writing process. It may take you on tangents, lead you astray more than once—that's its purpose. It might cost you reams of paper and days of your time, but none of it is wasted. All the work you put in on one story is put in on all the stories you will ever write. In the first draft, rely on spontaneity, rely on inspiration, follow your tangents, pursue your blunders. Don't want to say something so badly that you can't hear what the story is trying to tell you. All first drafts are experimental, chaotic, messy, and all take time, energy, patience, persistence, and devotion. You won't get it right the first time, and that's as it should be. The purpose of the first draft is not to get it right, but to get it written.

EXERCISES

.

Nothing imprisons the mind more thoroughly, nothing stifles
inventiveness and artistry more brutally, than too much freedom.

—Natalie Angier

Nothing is quite so intimidating as the blank screen or the blank page. Art is
all about imposing limits on yourself. We need to put a mark on the page, so
that our narrative can begin to take shape. Any mark will do to get a draft
under way. A name, a place, a title, an image, an event. Get out your pen and
your notebook.

5 Minutes, 5 Fingers, 5 Times

Following are five writing exercises that will take you twenty-five minutes
total and might leave you with five significant sketches for stories. Give your-
self a minute to start and a minute between exercises and this whole writing
will take a half hour. (Well, actually, I've given you three of each, so you can
do this for an hour and a half today or work on it for three days.) So order a
double espresso, and settle into your booth at the diner. Don't stop.

1. Paul Valéry called the presented first line *une ligne donnée.* So here's a gift
for you—the first line of your story: "We saw it on Friday on the road to
Thompsonville, the wicker love seat, right out there, straddling the center
line." Write that down and keep going. Don't stop to think much about it. You
might wonder who's talking and who's "we" and who's being addressed and
where's Thompsonville, and so on.

 First lines are everywhere. Open a poetry anthology and choose a line
you love or one at random that has a ring to it. When you've finished the
story, you probably will not have the line in the final draft, but it will have
done its job. They are not just in anthologies; they're in newspapers and mag-
azines and are being spoken all around you every day. Here's one from a
recent e-mail. A friend, Robert Stinson, professor and writer, said he over-

heard this wonderful line in a bagel shop: "Well, they're not exactly the sort of people you'd want chewing on your toenails." Keep the antennae up.

Here's another: "Out of the mud two strangers came and caught me splitting wood in the yard." You might wonder who's talking and what he or she may have thought might be going on inside and what he or she walks into and what he or she does there and why the narrator came in and why it was important for him or her to have nothing going on. This particular sentence is the opening two lines from Robert Frost's poem "Two Tramps in Mud Time."

And here's one more: "You wake up, and you do not know where you are or who you are or what you are . . ." from Sharon Olds's "Making Love."

2. Titles of short stories are always symbolic. So here's a title: "The Box." Now write a short story that relies on a box as a symbol. Before you begin, let's look the word up in an unabridged dictionary. Singular "box": 1. A container typically 4-sided with lid; 2. A square or rectangle: to draw a box around your answer; 3. A special compartment in a public place—as in box seats; a designated area in a public place—jury box, batter's box; 4. Featured printed matter with borders in a column; 5. A post office box; a large portable radio; vagina. And those are only its meanings as a noun. But enough for now. Start writing.

You might try one of the above lines of poetry as the first line in "The Box" and see what happens. Whenever you need a title, open that dictionary and choose the first noun you see. Consider its denotative and connotative meanings, its symbolic possibilities, and go to work. I just tried this and came up with "floaters." It's almost so easy that someone must have used it already. Corpses, of course, in the East River. A person who can float, stay in the water, out of trouble, as it were. One who wanders, a drifter. An insurance policy that protects movable property. And, of course, the specks that fly in front of your eyes and move off when you try to look at them. Already my mind is making connections. In literature we often want a word to mean as many things as possible.

Another title: "The Vision." Singular "vision": 1. The faculty of sight; 2. Something that is or has been seen; 3. The manner in which one sees or conceives a thing; 4. A mental image produced by the imagination; a person or thing of extraordinary beauty; 5. The mystical experience of seeing as if with the eyes, the supernatural or a supernatural being; 6. Unusual competence in discernment or perception; intelligent foresight.

And a third: "Headgear." (I told you it was random.) Singular "headgear": 1. A covering, such as a hat or helmet, for the head; 2. The part of a harness that fits about a horse's head; 3. The rigging for hauling or lifting located at the head of a mine shaft; 4. *Nautical.* The rigging on the forward sails of a craft. Not listed, but it comes to mind: What you might find for sale in a head shop. Good luck.

3. Many stories start with a character. So let's find an intriguing one, then put him in a compelling situation, and then muddle along to see what happens. When I was a high school student, I worked as a bag boy at a local supermarket, the Big D. We were all boys (girls worked on the registers as cashiers or back in the meat room) and we made $.95 an hour. I bring this up because of a trend that I note. Here in South Florida all the bag boys (they are called sackers here) are older men. Retirees. They do a better job than we ever did. They are more pleasant, polite, and effective, and probably don't steal candy like we did. I notice as well that the gender discrimination continues. I want to know what it feels like to be doing this, listening to shoppers bitch and huff around the market, and so on. But I'm afraid to ask. So I'll find out by writing a story, by letting this sacker tell me his story. So here's my character (and yours), a sixty-seven-year-old retired steelworker from Gary, Indiana, who lives across from the Publix. Didn't like all his leisure time, so he works mornings. He's stopped into Bud's Bar for a drink after punching out on Saturday. He's talking to Bud about some personal trouble. (And maybe he's not from Gary; he's from your hometown. And maybe you're sitting nearby listening in on the conversation, and maybe you buy him a drink and start. You find out he lives alone, has a cat, a son out in Colorado. Or you find out he's married, the wife's on oxygen, and she still smokes.)

Here's another: She's an exterminator for a pest control firm and a single mother trying to raise two kids. She's been dating this guy who teaches at the local community college. Something happened last night that is bothering her. Give her a name and let her tell her story. Think about what she wants. What's stopping her from getting it? What's the name of that company? *Bug-off? The Bug House? Bugaboo? Roachbusters?* And how old are the kids? What does her boyfriend teach?

And another: He's sixty-three, unemployed, and living with his mother. He watches TV, practices yoga devoutly, and volunteers at the yoga center. Once he had a promising career as a corporate lawyer. And then something happened. Let him tell his story.

4. Start a story from a given situation. It should be odd, unusual, even troubling. Like this: Your car is back-ended in traffic. You and the driver who hit you pull off to the side of the road. You get out of the car, but he doesn't. He watches you, puts his hands in the air, but you don't know what that means. Your bumper is detached and the rear lights are busted. The trunk lid is sprung. You walk to the man's car. He has no legs. What happens now? Write the story and find out.

Try this: You're at work. You're thinking how dull your life has become. But how can you change it? You love your spouse, can't imagine life without the kids. But you're dying inside. You had such potential. If you don't do something now, you'll never get another chance.

Or this (how does it feel being a character?): You've just taken your elderly and ailing mother to visit her sister in a neighboring town. You're back in the car and about to drive home when Mom looks at you and says, "I know I'm supposed to know you. But tell me who you are."

5. Just write, don't think about a story at this point. Five minutes, of course. You'll need an image. Pick three (one at a time). Overalls, silk, the high school prom, a wedding, your mother's house slippers, the smell of clothes drying on a line, a crib, third grade, honey, a scream from the next apartment. You want to proceed scenically if you can. Show and don't tell. People doing something.

The Epigraph

Writers sometimes preface their stories (and frequently their novels) with epigraphs. The epigraphs express theme in most cases. Washington Irving begins "The Legend of Sleepy Hollow" with four lines of James Thomson's poem *The Castle of Indolence*. Edgar Allan Poe uses a line from Seneca. The stories may not have been suggested by the quotes, but they may have been, and certainly could have been. Write a story suggested by one of the following quotes:

> *"God made everything out of nothing,*
> *but the nothingness shows through."*
> —*Paul Valéry*

"If you look really close at things,
you'll forget you're going to die."
—Montgomery Clift

"The danger lies in the emptiness of
so many of the words we use."
—Sherwood Anderson

"One must choose between God and man."
—George Orwell

"There exists an obvious fact that seems utterly moral:
namely, that a man is always a prey to his truths."
—Albert Camus

You may have favorite quotes that you'd like to try this with as well. Let's take the Anderson quote as an example. As writers, we know the importance of words and we take the statement to be true of prose. But let us think of verbal communication and the peril of empty words. We often say things we don't mean. And this might be fine exchanging pleasantries with the clerk at the post office. But what about in the evening doing dishes with the spouse? What is it that allows us to use empty words then? Fear of silence? Well, let's write a story. The first scene—the kitchen. The couple. She's washing, hands plunged into the gray, sudsy water in the steel sink. He's drying. He's talking. She's heard it all before. It's about commitment. This time, he's telling her, he means it. But she stopped listening a long time ago. We've got something already. An intriguing situation. Two characters, trouble, a setting. Think more about that kitchen. Look around, take down the details. Look at the two of them. Write a brief character sketch of each. Let's say it's her story we want to tell. We ask, what does she want? Let's see. She wants out of the marriage. (So they *are* married!) What's stopping her? Take the story from there.

Doing It Again (And Again [And Again])

✕

I am in a sorry state, for I do not even know what I do not know.

—*St. Augustine*

By now you understand that revision is not a matter of choice. So don't resist it or resent it, and don't misunderstand its importance. All writing is rewriting. (There, I've said it again.) You've gotten black on white, and now you have something to work with. As a writer, you have both the opportunity and the duty to rework your story to find the best word that you can, the precise phrase, the essential scene, and to do it over again until you've got it all right. If you are hesitant to proceed, consider why that is. Perhaps you've written about characters you don't care about. Well, you can, if you want, settle that matter in revision. Get to know them better, find the secrets that make them vulnerable and endearing and worth your time. Why else wouldn't you revise? You set out to write a beautiful story, a heartbreaking one, but you failed. Now you get to do it again and begin to approach the vision in your head.

Writing is not supposed to be easy or quick or extemporaneous. Writers always rewrite their stories and their memos and their e-mail. The two best pieces of writing advice you can get are all about revision: 1. Finish the story; and 2. Don't expect to finish it today, or in this draft, or anytime in the near future.

No doubt you've done some revision already. You've revised words in a problematic sentence, changed a character's name a couple of times, made

chapter five chapter seven (or turned paragraph five into paragraph seven—
here, as elsewhere, *story* means short story or novella [novelette?] or novel).
If you're like Dorothy Parker, your revision begins with the first sentence of
the first draft. Miss Parker claimed that in writing seven words, she revised
five. William Stafford thought that revision began even before he wrote any-
thing down. And I think he's correct. Before the pen moves on the page, you
think, "No, not *Call me Walter. Call me . . . Ishmael.* That's it!"

In a sense, we're always revising as we write. Planning, drafting, and
revising seldom proceed in a linear fashion and, perhaps, should not be
thought of as distinct tasks. All three go on in the first draft as well as in the
second and the tenth. You've got
endless problems to deal with:
inconsistent characters, sputter-
ing plot, rambling dialogue, dis-
cordant prose. You've got the
obligatory scene you dread hav-
ing to write; you need to make more effective use of the setting; your tone is
wavering; your themes are prosaic. Your job as a writer amid all this chaos is
to remain calm and confident—later, by degrees, you'll sort all this out, make
sense of disorder. But not right now.

>
> *"But an author is one who can judge
> his own stuff's worth, without pity,
> and destroy most of it."*
> —COLETTE

This is the state that Keats called *negative capability,* and if you don't have
it, you'd better cultivate it or you're doomed. Doomed to writing facile, for-
mulaic, superficial, inoffensive entertainments, at best. Here's how Keats
defined the term (I've done so else-
where, but it bears repeating here):
"When a man is capable of being in
uncertainties, mysteries, and doubts,
without any irritable reaching after

>
> *"It doesn't matter how slow you
> go, so long as you don't stop."*
> —CONFUCIUS

fact and reason." Keats also spoke of poets as being "the most unpoetical of
anything in existence . . ." We may substitute *writer* for *poet* and continue
with Keats's remark: ". . . because he [the writer] has no Identity—he is con-
tinually in for—and filling some other Body."

I write many drafts longhand. (I suppose I write longhand because that's
how I learned to write, and also because I can't type very well and so I have
to look at the screen and the fingers and concentrate on mechanics. I com-
pose with a pen [a fountain pen, no less] because I like going slow.) I change
sentences, words, phrases as I write, often recopying the entire annotated

draft from the first line to the point at which the corrections get so messy and confusing that I have to stop and begin recopying yet again. In this way I get to feel the rhythm of the prose, hear the tone of the narrative voice. As a result, the first lines of my stories and chapters are rewritten more than the last lines. Each draft, each rewritten page, is neater and more competent than the previous. I find that I even sabotage myself by deliberately misspelling a word, so I'll have to rewrite the page again. I know that each time I undermine my tendency to be lazy in this way, the story improves. (Yes, this is the most inefficient writing method on earth, and I need to get less anal about it all because I have a lot of stories I want to write, and have decidedly less time to write them in. I should have taken typing in high school. I took Latin instead.)

When I'm finally satisfied that the elements of plot are in place, and I think that at last I know what my characters want, I type this draft into the computer. I print it out, then put the copy away for a few days. When I read it again, I immediately begin to tear it apart. What I couldn't see in the heat of writing usually becomes clear now. I see that a story I thought was good so recently can be made even stronger. I make the changes, wait, reread, and start over.

Revision means, as you know, "seeing again." Now you can read your story, see what you've said, and sense what still needs to be said. Revising means casting a critical eye on your work, and doing so makes this different from your first draft, where you kept the critic,* the editor, away from the writing desk—or you tried to, at least. (*Critical* meaning "characterized by careful, exact evaluation and judgment." Also meaning: "Having the nature

* Kenneth Tynan defined a critic as a man who knows the way but can't drive the car. Which brings up a point. What are we to make of critical responses to our work, whether in the *New York Times* or in the workshop, the writing group? Well, you probably ought not to get too excited about the praise and not too exercised about the damnation. You're not that good and not that bad. You also need to understand that not everyone will be a generous and sympathetic reader of your material. Listen to what people have to say—if they can be specific about it—and when a response makes sense, then pay attention to it. Disregard all the rest. Don't write for critics. Remember, if you did everything the critics want you to do, you'd be writing their stories, not yours. Let them write their own.

If you give your story to a friend or a colleague to read, try to be specific about what you're looking for. Have them read with a question or two in mind—this way they can be specific and helpful and won't feel they are jeopardizing a friendship: Tell me, does the central character earn your sympathy? Do you think the boy tried hard enough to win the heart of the girl? Does the setting add meaning and significance to the plot? Asking someone to simply read and respond is asking for vague generalities. Set your agenda for the response. When you find someone who is a careful and honest reader of your material, give her more of your work. But that means you owe her a dinner or two.

of a turning point; crucial or decisive." And: "Indispensable; essential." And: "Fraught with danger or risk." All of those definitions apply to the revising process.) You will reorganize material; examine words, phrases, and paragraphs; consider character and plot; look at beginnings and middles and endings and transitions. You add, delete, reshape. You examine your new choices. There are a thousand steps in the process.

It is here in revision that your imagination becomes deeply engaged with your material, when you come to know your characters and begin to perceive their motivations and values. In other words, revision is not the end of the creative process, but a new beginning. It's a chance not just to clean up and edit, but to open up and discover. Remember that you didn't get it right the first time. So it's premature to begin the polish.

When you've completed a draft of your story, as I said, it's a good idea to set the manuscript aside and return to it later. Take a week or more if you can. You do have those other ideas to get to work on—you're writing every day now, and the ideas won't stop coming. Each time you read the story over, you'll see something new. You'll see a missed opportunity, a botched line, a deflated metaphor (and it seemed so buoyant just last week), typos everywhere you look. Read the manuscript out loud (or have someone read it to you) and note the places where the rhythms are smooth or hard, the prose graceful or awkward, a character's diction consistent and revealing or jarring and unconvincing. Note the thematic connections, the narrative tangents. Listen to your story. Listen with a pen in your hand and jot notes. What is the story trying to tell you? (I just wrote two lines here, and then I took them out. Here they are [or were]: *Visualize your characters, and before you go on to the next draft, imagine what they're doing or what they think they're doing, and imagine how they feel about it.* That made sense when I wrote it, but not when I read it back.) There might be something, an

> *"My own experience is that once a story has been written, one has to cross out the beginning and the end. It is there that we authors do most of our lying . . . one must ruthlessly suppress everything that is not concerned with the subject."*
> —ANTON CHEKHOV

> *"I'm happy when the revisions are big. I'm not speaking of stylistic revisions, but of revisions in my own understanding."*
> —SAUL BELLOW

image, a notion, a theme that you started in the opening that fades away, fails to resonate. You need to see where you might reintroduce that something. Or places where you forget you're reading and enter the world of your book—these are the parts that are working. Examining the good passages will help you strengthen the weak.

You're a writer, so you see what no one else sees in that story. You see what's really there. That's your job. Just as you notice every significant detail about your character's appearance—the thin scar on her left index finger, say—so, too, you notice the confusing shift in tense in your narrative, the awkward transition, the intrusive or extraneous adverb. You see what you wrote, not what you thought you wrote.

> *"It's a matter of rewriting and rewriting. If I'm writing a story, I may rewrite a page ten, twelve times."*
> —JOHN BERGER

You look at your current draft, and you ask the right questions: Have I shown and not told? Is every scene essential? Have I written the obligatory scenes? Have I chosen the point of view that is most likely to add interest and to afford the reader clear access to the central conflict? Is the plot a causal sequence of events and not merely chronology? Has my central character changed? If so, how? If not—more work to do. Does each character speak in a distinctive voice? Have I made it difficult enough for my central character to get what she wants? Is the setting evocative? the theme fresh? the tone consistent? Are the details vivid, accurate, revealing? Are the characters credible? Have I started too early? Ended too late? Is the material important? Did I dig below the surface? Have I let my characters off the emotional hook? Have I made the reader care about the lives of these people? Well, the questions go on and on.

> *"The main rule of a writer is never to pity your manuscript."*
> —ISAAC BASHEVIS SINGER

Answer these questions honestly, make all the necessary changes, and see if the changes necessitate additional changes. (They will.) A character's precisely described gesture is worth a page of exposition. Then you read it all again and ask yourself more questions: What is my story about? Was that my intention? What emotional experience do I want the reader to have? Have I caused that to happen? Is the story as clear as it can be? If a scene drags, cut it; if dialogue rambles, tighten it. Make every word count.

Of course, you can't answer all your questions or address all of your con-

cerns at once. And you don't have to. Take your time, concentrate on one thing at a time. Relax. The first draft was an act of discovery in which you indulged yourself and your characters. These next drafts will be less indulgent, will be at times merciless. The story will improve with each revision. Revise for character today, for plot tomorrow. Try to get all the words right on Thursday. (That's the

"Writing is . . . like sculpture, where you eliminate to make the work visible. Even those pages you remove somehow remain."

—ELIE WIESEL

best day, the day you get the words right. You walk around on air.) The more you write, the more you'll want to write.

One of your jobs in telling your story is to audition characters. You're a casting director. Some of the actors make the grade, others do not. Years ago I was visiting a writer friend in Ohio. As we walked down the street of the cozy college town, he pointed out a small man selling newspapers. When I asked who he was, my friend said, "Uncle Me," and he explained Uncle's incestuous parentage; his grandfather was also his father, I think it went. I looked at my friend with that glazed look a writer gets when he's on to material. My writer friend smiled and said, "Everyone in this town is trying to write that story." I said, "First one published gets it."

Uncle Me was in the first 150 pages of the first draft of *Louisiana Power & Light*. But he wasn't coming to life. He didn't breathe. He was Billy Wayne's quirky best friend, but he was a caricature. So I gave him the starring role in the community theater production of *King Lear*, but still Uncle was flat. I eventually realized I couldn't get past the fact of his diminutive size and his unfortunate

"Look for all the fancy wordings and get rid of them. . . . Avoid all terms and expressions, old or new, that embody affectation."

—JACQUES BARZUN

parentage. I was exploiting him. For his own good, and the good of the book, I had to let him go.

On the other hand, Hotson Taylor had one job to do in that book—to drive Billy Wayne and Earlene from Marianna's Café back to the Palms Motel. By the time the taxi ride was over and I knew that Hotson was trying to quit smoking and was a socialist cabdriver, I knew he'd earned his way into at least one more scene. He was around, it turns out, for the whole book. It's characters like Hotson who surprise you, who say or do something you did

not expect them to say or do, who earn their keep. The characters refuse to be manipulated.

You write and you rewrite. Your story improves with each pass. You look for solutions to the problems in the story itself. (If your car breaks down, you look under the hood for the trouble, not out at the highway.) You realize you are writing better than you ever thought you could. You fix a problem and a new one appears. You persevere and write on. If you never revise, you never learn to write. You see that these made-up characters of yours have become vivid and intriguing people who live interesting and often terrifying lives. You begin to resent the time spent away from them.

Now let's talk a bit about editing and polishing. There are some common stylistic problems that you will want to address in each stage of revision or at some point before the manuscript is finished. The following list may help you do that. By "challenge" here I mean to take out the possibly offending word or phrase, read the piece again, and only if the word or words in question are essential should you put them back in.

> *"When you read proof, take out the adjectives and adverbs wherever you can. You use so many of them that the reader finds it hard to concentrate and he gets tired. You can understand what I mean when I say, 'The man sat on the grass.' You understand because the sentence is clear and there is nothing to distract your attention. Conversely, the brain has trouble understanding me if I say, 'A tall, narrow-chested man of medium height with a red beard sat on green grass trampled by passers-by, sat mutely, looking about timidly and fearfully.' This doesn't get its meaning through to the brain immediately, which is what good writing must do, and fast."*
>
> —ANTON CHEKHOV
> (IN A LETTER TO GORKY)

1. *Challenge every adverb.* "The adverb is the enemy of the verb." Mark Twain said that. Or Unknown did—I've seen it attributed to both. Often what we need are not two words, one modifying, thus weakening, the other, but one stronger word. Not "He walked unsteadily," but "He staggered." Adverbs modifying verbs of attribution are particularly intrusive and offensive. "'I see the problem,' she said confidently." *Show* us her confidence; don't tell us.

2. *Challenge every adjective.* "The adjective is the enemy of the noun,"Voltaire said. (Hmm.) Mark Twain said, "As to the adjective: when in doubt, strike it out." Like adverbs, many adjectives are unnecessary. Often the adjectival concept is in the noun modified. A night *is* dark, an ache painful, a needle sharp, a skyscraper tall. Color is often redundant, as in *blue* sky, *green* grass, and so on. Other adjectives are too conventional, like a *tender* heart or a *sly* fox.

3. *Challenge every verb with an auxiliary.* Replace passive voice verbs with active ones that are immediate, clear, and vigorous. "I kissed her" is better than "She was kissed by me." And it's shorter. On the other hand, you might want to use the passive when the performer of the action is irrelevant: *My house was broken into last night.* Also, replace progressive forms of verbs with simple forms. "I brewed coffee" indicates a more definite time than "I was brewing coffee." And it's shorter. There are, of course, times when you want the progressive—to show actions taking place simultaneously: "I was brewing coffee when the power went out." (On the other hand, be sure to use the past perfect tense when denoting an action completed before a time in the past: "My mother *had* already called the plumber by the time I arrived." The calling took place before the arriving.)

4. *Challenge the first paragraph.* Sometimes the first paragraph helps get the story going, but often it merely introduces the reader to the story you are about to tell. Action might actually begin in the second paragraph. So pick up the story and start reading with the second paragraph.

5 *Challenge the last paragraph.* If the last paragraph unnecessarily summarizes or explains the meaning of the story, cut it out.

6. *Challenge every line that you love.* Arthur Quiller-Couch advised writers to "Murder your darlings."* Dr. Johnson put it this way: "Read over your compositions, and whenever you meet with a passage which you think is particularly fine, strike it out." Distressing counsel, you might think. But the point

* I've often heard this quote attributed to Mark Twain ("Sometimes you have to murder your darlings") and to William Faulkner ("Kill your darlings"). I've heard it attributed to scores of teachers, photographers, and other artists as well. But the only quote I can find documented is Sir Arthur's. In *On the Art of Writing*, published in 1916, he wrote, "Whenever you feel an impulse to perpetrate a piece of exceptionally fine writing, obey it—whole-heartedly—and delete it before sending your manuscript to press. *Murder your darlings.*"

is that you need to take out every word that is there for effect, every phrase you think is clever, every sentence for which there is no purpose or point. Hemingway said prose is architecture, not interior decoration. Your concern must be with the characters and not with your own wit, style, or cleverness. If it's not advancing the plot, expressing the theme, or revealing the character, then it goes.

7. *Challenge every exclamation point.* Like adverbs, they are intrusive. You get, let's say, three exclamation points in your life. Use them wisely. Using an exclamation point is rather like laughing at your own joke.

8. *Challenge every use of the verb "to be."* We tend to overuse it. "To be" will be used (like here) as an auxiliary often enough. We're comfortable with it; it's flexible. But it's weak. Whenever you can, find a stronger, more assertive verb. Not "Yonder is your orphan with his gun," but "Yonder stands your orphan with his gun." Not "It was Sarah who spoke," but "Sarah spoke."

9. *Be alert for your pet words.* They may be more pests than pets. They are the words you overuse without even knowing it. My own problem words are "very," "just," and "that." Delete them if they are not essential.

10. *Be alert to your narrative weaknesses.* Perhaps you tend to shift tenses for no reason or your first person narrators tell too much and ignore the scenic. Know your tendencies and strengthen your writing by addressing them.

11. *Be alert for every cliché.* Or hackneyed word or phrase, every overused or unnecessary modifier. If you've heard it often, don't use it.

12. *Cut every nonessential dialogue tag.* In a conversation between two people, you may need only a single tag:
 "Doris, I'm home," Lefty said.
 "In the kitchen, dear. Did you remember the milk?"
 "Got it right here."
 And so on. The new paragraphs clearly indicate who is speaking.

13. *Eliminate everything you're not sure of.* If you doubt whether a sentence, word, or behavior belongs, it doesn't.

14. *Read the draft aloud.* Listen for awkward and repetitious words, inadvertent rhyme, faulty rhythm. Your prose should be music. Fiction needs to be at least as well written as poetry.

15. *Proofread.* For clarity, consistency, grammar, punctuation, spelling, economy. And then proofread again.

Well, that's a start. Revision is not just a time to edit. It's a time to invent and surprise, to add texture and nuance. In writing fiction, you must be honest and rigorous. You cannot judge your characters or want to say something so much that you manipulate them, twist the plot, or ignore what their reactions and responses would be. Revision continues (in fact, we should probably say *revisions*—plural) until you feel you have done all you can to make the story as compelling and honest as possible. And how do you know when you're finished with the story? You never are, really. It's been said that Tolstoy never read his novels after they were published because to do so was agonizing. He knew he could have made them better. When I read to an audience from my work, I'm often editing as I go, even though the book's been published. I'm amazed at how I could have let a clunker like that get through. And I went over the story, what, a hundred times? Ask yourself if you care enough about these characters to put in the time, energy, and thought it takes to work a story into its best possible shape. If you quit, if you don't revise, then you don't care enough. But if you continue, then one day you'll think you've done all you can do. On that day, you send the story off into the world.

EXERCISES

· · · · ·

Rx for Your Ailing Story

You've got a story you've been working on, but you're not satisfied with it yet. You aren't sure what's wrong with it, so you can't make it better. Here are some simple, quick remedies that might get you started. Answer the questions in your notebook.

1. Have you made things hard enough for your central character? We want struggle. It can't be easy for the central character to get what she wants. The writer's job is to obstruct. The harder a character has to try to get what she wants, the deeper she digs into herself, and the deeper she digs, the more we'll know about her, and the more we know, the better we'll like and understand her, and the better we like her, obviously, the more we'll care about her. And now there is more at stake. So throw some more obstacles in the character's way. Make it impossible for her to get what she wants. (And then watch her get it—maybe.)

2. Have you chosen the correct point of view? Have you arranged for the reader to get the most efficient access to the mind of the central character? Try changing the opening paragraph by altering the point of view. Write it in first person as the story is happening. Now write it in first person told by a reminiscent narrator. (I remember when . . .) Write it in third-person limited, third-person omniscient, third-person objective. If any of these new vantage points seems intriguing, press on and see what happens to your story.

3. If your story is based on autobiographical material, there may be a tendency to be slavish to the facts and not to the emotional truth of the story. Your allegiance should belong to the story and not to your life. You may need distance to effect this allegiance. So do this: Change the gender of all the characters. The character you thought was Emily is now Emile. The character you thought was you is not. You might also arbitrarily make the young people old and the older people young. Or change the locale of the story. It's not winter in St. Paul, it's summer in Houston.

4. Have you shown and not told? Have you written the obligatory scenes and only the obligatory scenes? Have you made the quick expository cut from scene to scene? Go through your story and look at the exposition. Did anything important happen there (offstage, as it were)? If so, make a note to put it in the scene. Is there anything you can cut from exposition? Cut every sentence that is not essential. Now look at your scenes. Any small talk? Cut it. Any attempts at getting expository material in the scene? Any furnishing of rooms in dialogue? ("My, that's a lovely velvet painting of a panther over your plaid couch, Marge.") Cut it. If the room needs to be furnished, let the narrator decorate.

Time to Go Deep

Describe one of your central character's obsessions, or something which haunts her, something you know about, or you have an inkling of, but which does not appear in the story, at least not in black and white. Write about the obsession in as much detail as you can. (Maybe it's an obsession of your own—one you don't understand.) Now trace that obsession back to its source. Something happened in that character's childhood. You get an image, a person, an event. Write about that. (Your character is obsessed with security, with saving money, with playing it safe, because every payday Dad and Mom would have a fight about the family finances, frightening arguments for a five-year-old.)

The World Intrudes

For no reason at all, insert the following items (or one of them) into your story: a recorded telephone message (one your character leaves or one he gets; from whom? a credit card company? Mom?); a menu (is she ordering out?); a portion of a radio talk show (NPR? Rush Limbaugh?); an original song (and here you get to write your own!). Now insert the following lines and continue with them. *This time last year I (or he/she) was . . . ; Five years from now I (he/she) will be . . .; I (he/she) hear a knock at the door . . .* Some of these whacks on the narrative head might jar the story in a new and interesting direction.

Dream Time

Write about the most frightening and disturbing dream you've ever had. Remember all of the details and write about the emotions you felt in the dream and feel now writing about it. Give that dream to your central character.

The Story's History

The last act of writing must be to become one's own reader. . . . To begin passionately and to end critically, to begin hot and to end cold; and, more important, to try to be passion-hot and critic-cold at the same time.

—*John Ciardi*

Write a history of your last story. When the idea for the story first occurred to you. The inspiration. Write about how it incubated, how you knew you were ready to write. What were your original intentions and how did they change? Why did they change? What worked for you in the writing process and what did not? Remember those times that you felt stuck. How did you come unstuck? How did the second draft differ from the first, the second from the tenth, and so on? Was there a breakthrough moment on this story? What was it? The Eureka Moment. When did you know you were finished and how did you know? What do you think you did well?

The idea here is, of course, to learn from your own work and to reassure yourself, if you need it, that you've done this before—you've imposed order on the chaos that was the nascent story—and you can do it again. You've got the proof and a blueprint for your successful process. Writing a story's history allows you to make more efficient use of your talents and will alert you to technical and procedural pitfalls. Writing the history will help demystify the writing process. It's not luck and it's not miraculous. Writing, you'll see, is work and persistence, and it is solving problems. You solved a technical problem this way last time, and you can do so again.

Instant Revision

This is not meant to be a thorough revision of a draft. More complete revisions have preceded this "instant" phase and others will follow. But let's say you have a draft in decent shape. Get yourself a cup of tea, sit down at your desk, and read the story. Now take the following steps:

1. Delete the first paragraph. The beginning of our story is often an introduction. Introductions are intrusive and unnecessary. They may have been essential parts of the creative process, leading us to our material, generating that material, perhaps. But unnecessary in the final version. So start reading the story in the second paragraph. Often that is where the story begins. (Or in the third or fourth paragraphs.)

2. Delete the final paragraph. The end is often a summary, a pulling of the punch. Sometimes we lose faith that we have made our point and here we attempt to restate it. If we haven't shown it, it's too late now. Don't tell us

what the story we've just read was about. Don't telegraph a message. Read your story and stop at the penultimate paragraph. Is it better?

3. Make sure that each sentence justifies its existence. If the paragraph makes sense without it, if it's not revealing character, expressing theme, advancing plot, what is it doing there? Conrad said: "A work that aspires, however humbly, to the condition of art should carry its justification in every line."

4. Strengthen each verb. Circle them all. Ask yourself if you have used the exact verb that you wanted. Is this guy really walking or do I see him strolling, swaggering, limping? Is he trimming the hedge or lopping at it? Especially take a look at verbs that are modified by adverbs. Adverbs weaken the verbs they qualify. Normally, one good verb will take the place of a verb and its adverb. How often have you used the verb *to be?* If you are like most of us, too often. Change all of those that you can strengthen.

The Meaning of Life Is to See

X

In a way, nobody sees a flower, really, it is so small, we haven't the
time—and to see takes time, like to have a friend takes time.

—*Georgia O'Keeffe*

I had seen them all my life. The white flowers that blanketed the
scrubby field beside the housing project where I grew up. I picked a bouquet
of them for my mother one afternoon and carried them home. She took them
from me. She thanked me, kissed my forehead, winced. She held the flowers
at arm's length. She told me they were weeds and would make her sneeze.
She put them in a glass milk bottle and left them in the front hall. These
unprepossessing flowers grew beside the road and beside the barbershop wall
at Cozy Corner. They grew in the pasture at the Poor Farm. They were vigor-
ous and prolific. But it wasn't until I was in college that my girlfriend told me
what they were called: Queen Anne's lace. Now that these flowers had a
name (in fact, three names—they're also called wild carrot [and are the pro-
genitor of our garden carrot] and bird's-nests) I saw them differently, more
intimately, I thought. But still not closely. It wasn't until I read William Carlos
Williams's poem "Queen Anne's Lace" that I discovered there was in the cen-
ter of the floral cluster what Williams called a "tiny purple blemish."* Sure

* Williams published four flower studies in his collection *Sour Grapes* (1921): "Daisy," "Primrose," Queen
Anne's Lace," and "Great Mullen." Read them to see, among other things, how precisely a flower can be seen.
The photographer Garry Winogrand said, "Nothing is quite so mysterious as a thing well-described." And
the mystery is what we celebrate, isn't it?

enough, at the next opportunity, I checked the plant and saw the distinctive wine-colored mark, not on every cluster, but on many. How could I have looked at the flowers all my life and not have seen what was there?

Now I felt like I knew a secret. Now I could tell Queen Anne's lace from fool's parsley from hemlock parsley from caraway from cow parsnip. But I *still* hadn't seen it. Not until I read a field guide to wildflowers was I able to see the remarkably complicated structure of this ubiquitous and unpretentious plant. First you see the umbrellalike flower cluster. Look closer and you see that the cluster is made up of many smaller clusters. At this point, a magnifying glass will help. Closer still and you see that each tiny white floret has five petals and five stamens with creamy anthers and a pistil. The pistil is composed of two parts and sits in a cuplike calyx. If you look at the center of the large flower medallion, you'll see the violet floret mentioned by Williams.

You would think I'd learned my lesson. But a couple of years ago I was in Fort Bragg, California, with my friend Doris Bartlett. We went to Glass Beach, a former municipal dump site where years of pounding surf have deposited tons of polished glass, the old milk and beer bottles come back as treasure. Here's what I wrote in my notebook when I got back to the inn:

Walking along a path from Glass Beach in Fort Bragg. Lush with wild-flowers, shrubs, especially those deep yellow ones—but not until Doris told me the name—sweet pea—did I look and and actually see the flowers, the furry pods—green—some purple on bushes w/yellow & plum flowers & the sage-like green. My life was enriched by the knowledge of the word.

Some weeks later, I read my note and wrote a poem about our walk back to town:

With Wings of Delicate Flesh

All I know is what I have words for.
—L. WITTGENSTEIN

Walking with Doris on
the path from Glass

Beach to town in Fort
Bragg, the brush lush
with wildflowers, and I'm
thinking of Miss Chinchilla's
fabulous pink Cadillac and
her Tattoo Museum,
and not until Doris tells
me the name of these yellow
and plummy flowers
—sweet pea—
do I see the winged petiole,
the clasping stipules,
the banner, wings, and keel
of the blossom, the downy
purple and green pods, brushed
with fine white hairs.

Knowing the names of things can help you to see them. Knowing that this tree is not a generic palm but a princess palm helps you to see how it is different from that nearby Canary Island date palm. And your description will help the reader see the precise palm as well. (The only reason to ever describe a tree is to show how it is different from any other tree.) In addition, knowing the names of things earns your narrator authority and credibility. You don't want your third-person narrator, for instance, to say that the dentist picked up that long, slim, silvery thing, you know—the what-do-you-call-it. And "He picked up the metal dental instrument" won't do, either. It could be a bone file or a spatula or a scaler.

Wittgenstein said, "The limits of my language are the limits of my mind." (He also said, "Don't think, look!") Can we see a color if we have no word for it? The ancient Greeks had no word for blue. Their sea was "wine dark."* We English speakers have a bundle of *blue* words: aquamarine, azure, cerulean, cobalt, cornflower, cyan, delft, gentian, indigo, lapis lazuli, lupine, midnight, navy, peacock, Prussian, to name a few. The Jale tribe of New Guinea have no word for green—leaves to them are either light or dark. English has: avocado, celadon, chartreuse, cypress, emerald, forest, jade,

* "What year did the world get color?" my son asked me. He was seven. He was convinced that sometime before the mid-1950s, the world as well as its movies and its TV shows were all black and white.

kelly, lime, loden, mint, moss, olive, pea, teal, and tourmaline, to name some. You've already thought of others, no doubt. And they are not even the same color, are they? (Right now I can look out my window and see the stand of trees in the mangrove swamp. And I can see that the leaves that I would have said—had I not been thinking about all this—were green, are, in fact, not all the same color. The leaves of the red mangrove are a rich and brilliant green, those of the black mangrove beyond are a lighter, buttery green on top and silvery beneath.) Around the world in places where intense sunlight has caused dark eye pigmentation, people often have the same word for blue and green. Does that mean brown-eyed people don't see what blue-eyed people see? The Koyukon Indians of Alaska have sixteen terms for snow, indicating, deep, falling, drifting, blowing, granular, powder, crusted, and so on. They certainly are looking more closely at snow than we're accustomed to doing.

> *"If you gaze for a long time into the abyss, the abyss gazes also into you."*
> —FRIEDRICH NIETZSCHE

The writer's job is to see the world clearly and to—well, let's let Joseph Conrad explain: "My task is by the power of the word to make you hear, to make you feel—it's before all, to make you see." We want the reader to see exactly what we have seen. But, too often, we look when we should see, we glance when we should gaze.* The documentary photographer Walker Evans said, "Stare, it's the only way to educate your eye." And William Blake said, "I can look at a knot of wood till I am frightened by it." We look at the forest, say, but the quality of our attention is minimal. We miss the details, the curves of the branches on the tree, the tint of color on the leaves. When we look at the world we often see what's useful for us to see and disregard the rest of the irrelevant visual clutter. We see the yellow line in the middle of the highway. We look ahead to where we're going. The car follows our eye. We don't see the beetle crawling on the dashboard, the wild violets by the side of the road, the roseate spoonbill preening on a cypress limb. What we need to remember is that every image is useful to the writer. We need to teach ourselves to see accurately and profoundly, to use sight effectively in our lives and in our fic-

> *"We are instinctively blind to what is not relative. We are not cameras. We select."*
> —ROBERT HENRI

*Why are there so many verbs denoting vision that begin with the letter *g*? *Gaze, glance, gape, (take a) gander, glimpse, goggle, gawk, glare, glower.* And so many suggest looking with an attitude.

tion. We need to remember that what we see depends on where we look.*

We believe in the primacy of sight. Our own eyes are the center of the visible universe. Sight dominates the way that we apprehend the world. We say that seeing is believing; I saw it with my own eyes! When we want to let someone know that we understand them, we say, I see what you mean. And it's love at first *sight*; what does she *see* in him?; the mind's *eye*.

But can we trust our lying eyes? We're all familiar with the pencil that bends in the glass of water. Take it out, it's straight again. Magic? What about the familiar illusion called the Rubin face vase? You see a goblet or you see two men facing each other. How many times have you held a dime in your hand? Looked at the date? Flipped it for heads or tails? Well, which way is Roosevelt facing? (And why should you even have to think about it? Why did you have to re-create the visual image in front of your face just then? And even if you guessed correctly, you weren't absolutely sure, were you?) We have two blind spots in our fields of vision, and we're not even aware of them. About twenty degrees to the right of center in your right eye, left of center in your left eye, are spots where the world vanishes, and yet we don't see a gray fuzziness there. Something, or some process, in our brain fills in the blank area with an appropriate color and pattern. What we see is not what's there, but a reprocessed image, what might be there. What we are seeing is in some ways a fiction. We see a world that we invent. Look in a mirror. The face you see is an exact reversed replica of your own, right? Wrong—it's half the size—measure it.

.

"To gaze is to think."

—SALVADOR DALÍ

.

"The most important instrument of thought is the eye."

—BENOIT MANDELBROT

If someone asked me the color of the street outside my house, I'd say gray, and I'd be wrong. The street now in the bright morning sunlight is not the color of the street in the late afternoon, or after a rain, or at night. And I probably would have said that the color of a shadow is black, but now that I've done a little research, I know that a shadow's color shares the color properties of the object on which it is cast. A shadow cast on a green lawn is not the color of the shadow cast on the beige wall of my house.

*When I stand at the beach and look out to the horizon, I can see for approximately three and a half miles. I see the casino boats adrift and aglow out past the international limit. But when I look up at the night sky, I can see for billions of miles. I can see back to the beginnings of time.

In fact, we don't see everything we look at. Perception is selective. We can't see from every angle at once. We can't see every color. Honeybees see in the ultraviolet range and we do not. On the other hand, honeybees (who actually have five eyes, two compound and three simple eyes or ocelli) can't see the color red, see it as black or the absence of color. Human beings are capable of seeing about ten thousand colors, but most of us not trained in the visual arts can only distinguish four thousand. And what you think of as red

.....

"There is a difference if we see something with a pencil in our hand or without one."

—PAUL VALÉRY

(crimson shades) may not be what I think of as red (scarlet shades). A French priest and an Australian aborigine looking at Chartres Cathedral will see it differently. A farmer and a coal miner do not see the same landscape, though they look at the same vista. We see what we expect to see, what we want to see, what interests us. We focus on conspicuous features in our environment and filter out the details that don't apply to our purposes. We are attracted to

.....

"The surest—also the quickest— way to awake the sense of wonder in ourselves is to look intently, undeterred, at a single object. Suddenly, miraculously, it will reveal itself as something we have never seen before."

—CESARE PAVESE

what moves, to what is large, bright, incongruous, to what is new, to what seems beautiful. But as the artist Robert Henri reminds us: "No *thing* is beautiful. But all things await the sensitive and imaginative mind that may be aroused to pleasurable emotion at the sight of them. This is beauty." And this is seeing. When you have seen something beautiful, you have looked

at it beautifully. When you look closely at things, you see what is unique about them, what is surprising and deserving of your attention.

How do you teach yourself to see? Perhaps you need to begin to look at the world in an unhabitual way. Say, look at it an inch at a time. Carry a camera with you wherever you go. Take pictures of buildings and of locations and (surreptitiously) of people that you might later use in your stories. I take pictures of abandoned homes and buildings. Each of them represents a broken dream to me, an emblem of what could have been. And I love signs, like the "No Trustpassing" sign painted on a house in my neighborhood. Take photos or just look at the world through the viewfinder. Compose what it is you want to see. Now you begin to see differently and understand that you

have control of what you see. I have a small 2¹/₂" x 4" camera with three formats and a zoom. It's perfect. Mostly I look through it, sometimes I snap. Dorothea Lange said, "The camera is an instrument that teaches people how to see without a camera." And that's the idea, to cultivate a curious eye.

This makes me think about traveling. When we travel, visit new places, we tend to be alert, to notice things that we might not ordinarily pay attention to. We notice the unusual flora and fauna, the peculiar architectural details, the illuminating local customs, the strange food, the exotic aromas. Travel trains us to notice. We are open to new experiences; we welcome new interaction with people. We are assertively curious. Everything we see attracts our attention. We are, in fact, a lot like fiction writers when we are travelers. And that's a state we want to try to foster in our daily lives. To be travelers when we're at home.

"If you really see things around you, you're not lonely anymore."
— FREDERICK FRANCK

When she visited the University of Arkansas for a reading, Elizabeth Bishop stayed at a motel out by the new mall. Beside the mall was a pasture. When the student driver arrived to carry her to the event, he found Miss Bishop sitting in her room by the window, watching cows through binoculars. She told him she didn't go anywhere without binoculars. (So now you've got your notebook, your pens, some paper, a camera, a pair of binoculars, and a book—you always need to carry a book with you [what if you're stuck in line at the registry of motor vehicles or in traffic or at the dentist's office?]—in your bag at all times. Might as well take a magnifying glass as well—you might just wander into a field of Queen Anne's lace, in which case you'll also need the Allegra.) Can't afford a camera? Make yourself a viewfinder with two L-shaped pieces of cardboard and two paper clips. No paper clips? Use your hands as a frame the way the Hollywood directors did in the old movies. The idea is that you are actively aware of everything you're looking at, and you are choosing. You are looking with an intelligent eye, a vigilant eye.

"Where the telescope ends, the microscope begins. Which of the two has the grander view?"
— VICTOR HUGO

That's looking closely. There's also something I think of as looking softly. In *Louisiana Power & Light*, Billy Wayne Fontana "noticed himself notice everything. When he walked through the canebrakes, he would do this thing

with his eyes where he would look at some distant spot on the horizon, just rest his vision there, not focus on anything, try not to look, and that way he could scatter his sight and could see anything that moved anywhere, from the ground at his feet to the sky over his head and for 180 degrees left to right. If anything at all stirred, that fleshy-headed vulture wheeling in an updraft, the aspen leaf twitching on its branch, this shamrock spider jerking at the side of her web, then Billy Wayne saw it, watched it, studied it." This is letting the world reveal itself to you. Suddenly the periphery is as important as the center of sight. This is looking without an agenda, without a purpose. And it works. Try it. Look at a distant spot and let your eyes relax and unfocus. Any movement anywhere will leap out at you. Go to the movement, and then when you're satisfied, go back to the distance.

.

"The greatest thing a human soul ever does in this world is to see something and tell what he saw in a plain way. Hundreds of people can talk for one who can think, and thousands can think for one who can see. To see clearly is poetry, prophecy, and religion all in one."

—JOHN RUSKIN

Whatever you look at, don't just use your eyes. Remember that every object has a story to tell if you ask it the right questions. Why is this cat (the one lounging on my desk as I write, swatting her tail across the tablet) striped the way she is? The little plastic table-shaped deal that comes in center of the pizza box—who designed that? (What's it called?) Who made it? Who sells it to pizza parlors? Who built the machine to make it? Someone constructed a building to make these things. Someone else's family's well-being depends on the manufacture and sale of these devices. (As docs the integrity of the cheese-and-tomato topping.) Every object looks back. Every object is a mirror. Meister Eckhart said, "The eye with which I see God is the same eye with which God sees me." (Speaking of Whom, weren't God's first words, "Let there be light"? And why else would He need light except to see? Then He separated light from dark—so they were mixed up at first. Think about that.)

When all is said and done, maybe we don't really see until we write. Look at the room you are in for a minute. Go ahead, put down the book and look around. Now look again, this time with the pen in your hand. Write down what you see—more than you saw before, right? And in greater detail. What you haven't written about you haven't seen. That's what a writer believes. What you see is who you are.

EXERCISES

.

A Field Guide to Fiction

A story is kindled by its particulars. You ought to read and have at hand guidebooks to birds, insects, wildflowers, architecture, whatever, to learn how language can be used to identify—to be precise, clear, unambiguous—and to learn the names of things. Images, if thought about carefully, will lead to metaphor, and metaphor may be at the heart of your story. Learn to be specific. Don't say fruit, say papaya. Give things the dignity of their names. Better to say the Swedish ivy in the window than the plant in the window. The name presents us with a more vivid image—we see what you want us to see. More specific? How about the leggy, variegated Swedish ivy?

When we know the names of things, we are no longer general, abstract. We are more thoughtful and aware. The person who looks out his window and sees trees is poorer intellectually than she who sees a stand of live oaks.

Read William Carlos Williams's poems mentioned in the chapter, and read Elizabeth Bishop's poem "The Fish" to see how language can be used with precision in this way. Now read some guidebooks. Take a walk in the neighborhood with one. That tree at the corner that you've been watching for ten years. It's a ginkgo. A male. And those birds in the yard aren't sparrows at all. They are warblers, songbirds. Look in Peterson's guide and see if you can tell which. Go out into the woods or a park and choose a flower you don't know. Sit down with your notebook and begin to describe it. Look closely. Feel it. Smell it. Listen to it. Write about it from stem to blossom. Now go home. You ought to be able to find it in a field guide based on your description. Now write a poem about it. Or write a scene in which your character—she's a botanist, why not?—shows the flower to her beloved. Or better yet, she describes it to her blind father.

Every Picture Tells a Story

*I am a fan of photographic art. As much as I love and admire the land-*scapes of Ansel Adams and Eliot Porter, their photographs don't move me the way narrative photography does. This makes perfect sense for a fiction

writer—to look for story in everything around him. I especially admire the work of Walker Evans, Dorothea Lange, Paul Strand, and the "Killing Time" portraits of Joe Steinmetz. Photographs of people being themselves offer the viewer character, setting, mood, tone, mystery, event, and may even suggest plot. What more could a writer ask for?

A picture in a collection of Farm Administration photographs that I saw while browsing through the library stuck with me. I made some notes. Here was a man hunkered down by his child, both of them, as I remember it, smiling into the camera. The man's name was Gonzala Hazard and the place was a migrant labor camp in Belle Glade, Florida. I imagined what life might have been like for Gonzala Hazard in the camp in Florida in 1954. Eventually, the thoughts became a story, "What Follows in the Wake of Love." Gonzala, it turns out, is dead before the story begins, and it is his death that leads to the drama in the story.

In *Deep in the Shade of Paradise*, Boudou and Benning play a game with photographs that they call "A Picture Is Worth a Thousand Words." Boudou looks at the picture of an abandoned house (one that I had photographed, in fact, and which you can see in the book) and makes up the following story that he calls "Mr. Wilde":

*Mr. Archibald Wilde died because his heart stopped just like that. His heart stopped and his wife—his second wife, Barbara Jean—ignored him when he gripped the sides of the kitchen table—*and here Boudou acted the role—*looked across at her and managed to say he thought he was having a heart attack, just before his arms relaxed and his face smashed into the bowl of tapioca pudding.* Boudou slapped the table. *Barbara Jean didn't call the ambulance, didn't carry Archibald to the hospital. After he died, the whole family pretended that Barbara Jean was so sweet and everything. They tapped her on the back, hugged her, said, "There, there, Barbara Jean, you mustn't blame yourself." They dabbed her eyes with Kleenex. Gave her some Beeman's gum to chew. Aunt Rita signed over her share of the inheritance to Barbara Jean, and the family persuaded Archibald's other sisters, Rose, Lily, and Violet, to do the same. Barbara Jean was amazed at her good fortune as was her boyfriend Timmy. Barbara Jean tried to sell the little white house, but everyone thought it smelled of rancid pork and mold, and so she just abandoned it and moved into town. Timmy was thinking, No more drive-ins, no more*

Fat Willie's Fish Camp. Timmy was thinking multiplex, Red Lobster.
The end.

Go to the library or the bookstore and head for the photography section. Choose a photographer whom you admire and look through her work until an image seizes you. Or go to your own attic and leaf through the family photos until a photo of someone you don't even know intrigues you. Now study your chosen photograph for a few minutes. Look at it closely. Note the composition, the light and shadow, the expression, the subjects' hands, and so on. Now give the photograph a title. Even if it has one, give it your own. Okay, now what does the title suggest? Do you detect thematic material already? Write about the title for a few minutes.

Look at the photo again. It will suggest a mood or perhaps an emotion. This might be, in fact, what originally attracted you to the photograph. Write down the mood on a blank sheet of paper and freewrite on that mood. Forget the photo while you're doing this. The emotion or mood is important. Don't let yourself think about it, write as quickly as you can.

Back to the picture. Where are we? And when, what year? What season? What time of day? Write about this place and this time. Give the place a name and a population. Take a walk down the main street. Look at the buildings and the businesses there, the folks out on the sidewalks. Write about this place.

Look at the photograph again and decide whose story you want to tell. Give this person a name. This exercise is easier to do if you have people in the photograph, but it works as well in photos in which the presence of people or their absence is palpable. For example, the cover of my novel *Louisiana Power & Light* is a brilliant photograph by Patricia McDonough, and when I first saw it, even though I thought the book was finished already, I was moved to write a scene in the book in which my central character looks on the scene rendered in the picture.

So now we have a central character with a name and a place with a name. We have a title, a mood, a setting. Let's consider plot. This central character must want something. What is that? Why does she want it? The motivation should be fairly intense. There must be something at stake. Who or what is in conflict with the central character? In other words, what are the obstacles in the central character's way? What will prevent her from getting what she wants? How will she struggle? Will she get what she wants? What are the moments of complication? Climax? Think and write.

Now select a point of view from which to tell the story. Have the point-of-view character or the narrator make a statement about the central character. Ask the questions suggested by the statement. Answer them. Write some more. We're just collecting information and getting ready to write.

All of these questions of plot, character, point of view, do not have to be answered immediately. (And since we haven't even discussed them yet, don't worry too much right now.) In fact, you probably want to avoid thinking overmuch about what happens in the story just yet. You don't want to tie your characters into behavior that is something you want and not what they want. The point is that now you have a lot of raw material in which to begin the construction of your story. And all in a very short time.

Now try this. Think about the photographer. Who took this picture? What was in his mind as he looked through the viewfinder? What happened just before he took the picture? What or who is just outside the frame? What happened just after the photo was taken? Did the photographer and the subject speak? About what?

Stopping Time

In the previous exercise we worked from a visual image to a narrative. Now let's try the opposite, narrative to visual image. Let's try to write a story of a photograph and do so in a thousand words. Jayne Anne Phillips has done something like this in her short-short story "Wedding Picture" in the chapbook *Sweethearts*.

What we are trying to do is to fix an event in time and space, to make the resulting image work symbolically. (Ritual events, like weddings, funerals, baptisms, graduations, and so on, work well in this context. They represent moments that we'd like to save and treasure.) This is, in fact, how many short-short stories seem to work. The narrative is an emblem of the larger story. The formal wedding photo, for example, represents our culture's faith in family and in romantic love. It suggests much more than it states. Like the haiku, it starts us thinking. The suit, the tie, the white wedding gown, the crucifix, the flowers, the rings, the candles, all are symbolic. And as a photographer you know that what is left out is as important as what is left in—it casts its shadow onto the story.

Imagine you are a photographer who wants to snap the picture that will suggest what is going on in that room, in that church, in that backyard. The

mood, the tension, the atmosphere. You want your picture to reveal the character of these people, not just their personalities. Will your picture be black and white? Color? Interior? Exterior? Candid? Posed? Who is it that has caught your attention?

Watch your characters, see what they are doing. You need to assess what it is you think is at the heart of this business. And what's behind it. Take your photograph just when they are doing something that expresses the essence of the ritual or the conflict (all stories are about trouble).

Now that you've taken the photo, describe it in elaborate and precise detail. You'll notice things now that you perhaps did not see through the viewfinder. And now you can crop the photo, darken or lighten. Look at all of the details. The position of the hands, the keys on the table, the light from the lamp, that ring, the scar. And now your task is to describe the photograph in such a way as to reveal the narrative that lies beyond the borders of the picture.

Snapshots

In an interview, Alice Munro said: "I like looking at people's lives over a number of years, without continuity. Like catching them in snapshots. And I like the way people relate, or don't relate, to the people they were earlier." Your character is entertaining someone at home. Who? Your character pulls out a family photo album that documents his life and looks through the photos with his guest. He annotates the photographs. "Here I am with my grandfather at Lake Quinsigamond. This was just before he died." "This is my sister Margaret. She died of polio when she was eight." And so on. You might read the short story "Family Album" by Siv Cedering Fox in *Sudden Fiction International* for an idea of how this might work. Look closely at the pictures, at the automobiles, the furniture, the people and their fashions. The source of light, the expressions. What mood do the individual photographs suggest? What have you learned about the family and the character? What mysteries have surfaced? Is the character aware of them? What does the guest think about all of this? You might get out your own albums and look through the pictures for a while in preparation. What does it feel like to see your old self, your old friends, to see people who are no longer in your life?

Clishmaclaver*

The universe is made of stories, not atoms.

—*Muriel Rukeyser*

very Sunday afternoon throughout my childhood, our considerably extended family—my grandfather was one of nineteen children—met at my grandparents' apartment for a dinner of pot roast, brown potatoes, and string beans. Doris's family and Eva's and Joan's and Lucille's and Bea's daughter, and the uncles, and occasionally the great-aunts and uncles from Lowell or Holyoke or Canada. And every Sunday I licked the beater that had whipped the cream for the chocolate pie and ate the blueberries that didn't fit into the shell. And when the meal was over and the dishes cleared, and Memere's sons-in-law had drifted to the parlor to watch the Red Sox blow a five-run lead to the Yankees, and the children went outside to play in the driveway, then someone perked a pot of coffee, set the sugar bowl and the can of condensed milk on the table, dealt the ashtrays to the aunts, and then we all sat around the kitchen and talked about the family and the neighbors. If Uncle Fred was there—*Mon Oncle* Fred weighed well over three hundred pounds, wore a straw hat and suspenders, used a cane, more for fashion than from necessity, and sported a droopy mustache—he'd bluster on about his childhood on the farm or his hunting trip to Maine. And if Uncle Fred wasn't

* *Claver* is a Scottish word for gossip. *Clish-clash* means the alternate clash of weapons and idle gossip, as well. Combine the two and get the musical word of our title. I've never used the word before and thought I should. I like it. Other words for gossip include the colorful *scuttlebutt, tittle-tattle, palaver,* and *chitchat.*

there, we'd speculate about the number and whereabouts of his "illegiti-mate," as we called them then, children.

Gossip, I loved it. And that turns out to be the writer's job: to attend to the gossip and spread it as far as you can. At the heart of all good fiction and at the heart of all good gossip is the same thing: trouble. If you think about it, fiction is nothing more than gossip about the people you've made up.

My job on those Sundays was to sit away from the table and to listen, to fetch another pack of Pall Malls from my mother's purse, bring Pepere another bottle of Tadcaster ale from the shed, and "Go see why your brother's crying, tell him if I have to get off this chair he's going to be a sorry young man." (And I just remembered that my mother pronounced Pall Mall as Pell Mell.) The adults talked about what on earth the Barry boy might be up to in that enormous tent he's pitched in his yard next door and about what a fine job the landlord was doing with the property—but isn't he a little strict with his kids?—about what Bunny Bourassa was up to down at Moore's Pharmacy on Thursday night, about Uncle Richard and how he came back from the Air Force with a Southern accent, and about why George Lucier spends every night on the same stool at the Queen Elena Bar.

>
> *"I think [the need for narrative] is absolutely primal. Children understand stories long before they understand trigonometry."*
> —OLIVER SACKS

I listened to stories of my grandfather smuggling alcohol from Montreal to Worcester during Prohibition, and about the time he got drunk and shot up the radio with his deer rifle, emptied the ice box, and hid the food under his bed. My teenage aunts talked about the boys at the Jay-Dee Grille, the motorcy-cle boys who looked like the Everly Brothers. I heard sto-ries about people we'd just seen that morning at Mass and the no-good they were up to. About "Whozee" and "What's-His-Name's Wife" and don't they have any shame? And about who was sick, and who had lost a job, and who owed money to whom.

>
> *"A man is always a teller of tales, he lives surrounded by his stories and the stories of others, he sees everything that happens to him through them; and he tries to live his life as if he were recounting it."*
> —JEAN-PAUL SARTRE

Hearts were mended at the kitchen table, grief was shared. I learned that

people who we thought would always be around sometimes pass from our lives. I learned about the aunt I never knew, who had Down's syndrome and died as an infant, and what that was like to have death come to the door and enter the wrong room, to come for the child and not the mother.

All of the stories I heard around that table were about people I knew, set in a world I lived in, told in a language I understood, in a voice I recognized and enjoyed. The people in their stories tended to be the independent ones, eccentric, perhaps quirky, like Uncle George, whose life is more a spontaneous fiction than anyone I've ever met. He claimed to be pals with every player on the Celtics, and when, as a private, he drove home from Fort Devens with a jeep, he told us the colonel let him use it because they were pals. And we believed him. Until the MPs showed up at the door.

> *"Any story told twice is fiction."*
> —GRACE PALEY

I'm not even sure why, at nine or ten, I was so entranced by all this idle, easy, unrestrained table talk. I do know that I enjoyed sitting with the family, all of us crammed into this sunny little room. Storytelling—gossiping—is a communal activity (in a way that story writing is not). It connects the teller to the told, the talk to the tale. And I felt important and included. I suppose the adults thought that I was old enough to understand what was going on.

> *"No community can exist without a community story."*
> —THOMAS BERRY

I wasn't. I knew that P.G. meant pregnant and that that meant a baby was on the way. But as to the whispered implications of all that, I had no idea. But I could tell, the way my aunt lowered her voice when she leaned forward to share the information, that it meant something powerful and disturbing. And I did understand that at the heart of each bit of gossip was a mystery. "Why would Bert White, with the devoted wife, the two polite little boys, the prosperous appliance repair business, just up and run off to New Hampshire with the undertaker's daughter?" Not a story, exactly. More like an anecdote (the what) that contained the germ of a story (the why), containing what Henry James called the virus of suggestion. And I was infected.

The gossip I listened to was morally judgmental at times, but was never malicious. The scandal, the trouble, may have titillated, but the speculation informed. A situation would be mentioned: Doris: You heard about the Zalauskas boy? Joan: Saw it in the papers. Memere: I feel bad for the parents. Eva:

Say what you will about the Lithuanians, they take care of their own. (And I just remembered that my grandmother, Memere, couldn't pronounce *Lithuanian*. She called them *Lutrainians* and considered them pretty close to Catholics.) And then they'd all try to make some sense of it: How does a nineteen-year-old kid from the neighborhood wind up in Oklahoma, of all places, shooting at police officers? Maybe he was sick in the head. Hanging out with a loose crowd. He went to public schools—what could you expect? And so it went, the family trying to wrest meaning from the inexplicable, trying to uncover motivation. And the more we talked, the more we discovered, and the more we discovered, the more we talked. And soon it was Sunday night and the younger kids were cranky and whiny, the sons-in-law asleep in their various parlor chairs, dreams of a pennant dashed for another year. Time to go home. We knew that telling stories didn't change the world, but we suspected it changed the tellers and the listeners. We in our decaying mill town were connected to the larger world. We had our troubles, too.

>
>
> *"Gossip isn't scandal and it's not merely malicious. It's chatter about the human race by lovers of the same. Gossip is the tool of the poet, the shop-talk of the scientist, and the consolation of the housewife, wit, tycoon and intellectual. It begins in the nursery and ends when speech is past."*
>
> —PHYLLIS McGINLEY

The people we admired and talked about did not always do what they were supposed to do. And that is why we admired them. Like us, they were individuals, had their own minds. They may have behaved strangely at times, expressed inappropriate thoughts, felt muddled and powerful emotions. So did we. They were not heroes. Neither were we. They were the people in the neighborhood, living quiet but important, funny, and often heartbreaking lives. I found none of these qualities in books. I read the stories they told us to read in school, but I couldn't hear that familiar voice on the page. And I couldn't find my neighbors, myself, or anyone like us, like the Berards and the Favereaus and the McDermotts and the Sochalskis in the books, and so books meant nothing to me then. But stories meant everything. Gossip brought me to literature. And I want to make a case for its importance in your life.

>
>
> *"There is only one thing in the world worse than being talked about, and that is not being talked about."*
>
> —OSCAR WILDE

Gossip is oral history. It connects you to your town or neighborhood, and your town or neighborhood now to the town or neighborhood of the past. "Little Ralph Moberly is running the family business into the ground. It's a shame. He's a no-account just like his father, Big Ralph, was. His granddad must be turning over in his grave. Mr. Moberly started the dry-cleaning business on a shoestring. Lost his house in the '38 hurricane, his daughter in the '53 tornado. Never lost his faith. Finest man you could ever meet. Built that company up so his grandchild could throw it away on horses and women." Gossip is told in the honest vernacular of your home. Grace Paley advised us all to pay attention to those voices. She said, "If you say what's on your mind in the language that comes from your parents and your street and your friends, you'll probably say something beautiful." Where do stories come from? From the people who live beside you.

> *"Love and scandal are the best sweeteners of tea."*
>
> —HENRY FIELDING

Alice Munro transforms gossip into high art in her stories. Munro is an enchanter who lifts us out of our world and carries us to the higher ground of her fictional Ontario, a world at once more compelling and consequential than our own. She writes breathtaking stories of desolation and writes them, my friend Dick McDonough says, like a grandmother with a dagger under her cape.

Munro's stories are complex and luminous meditations on the failure of intimacy and the longing to connect. The stories operate on a kind of chaos theory wherein, say, an Australian's whimsical decision to visit an old friend in Canada will change the life of a woman he has never met because that woman will be invited to a lunch, because her brother died and she's alone, and because they needed a sixth, and at lunch she will hold her fork in such a captivating way that the visitor from Australia, the friend of the guest, will be charmed, will commence a long-distance courtship. And as her life is changed forever, so are the lives of everyone else in her rural town. We do not live our lives in isolation. In Munro's world—and in ours, she convinces us—chance is more consequential than choice. And there are no answers. Life is not a question, after all; it's an exclamation.

Leo Tolstoy's neighbor Bibikov, the snipe hunter, lived with his mistress, Anna Pirogova—a juicy bit of business already. But then he shifted his affections to his children's German governess, decided, in fact, to marry the Fräulein. Anna's jealousy turned to rage. She ran away, wandering the coun-

tryside, crazed with grief. Then she threw herself under a freight train at the Yasenki station. The following day, Tolstoy went to the station, attracted by the scandal of the woman who had given all for love, who had died this trite, if tragic, death. He learned of a letter she had written to Bibikov: "You are my murderer. Be happy, if an assassin can be happy. If you like, you can see my corpse on the rails at Yasenki." Tolstoy turned the shocking incident into one of the world's great novels, *Anna Karenina*.

A bit of gossip about a new lady on the esplanade begins Anton Chekhov's extraordinary story "The Lady with the Pet Dog." With Chekhov, perception is genius. He looked at the world an inch at a time and found the sublime in the mundane. He wrote with precision, elegance, humor, and brutal honesty. He knew that any fool can face a crisis; it's the day-to-day that wears us out. Our most heroic act is to confront the relentless oppression of the routine.

EXERCISES

.

I Heard It Through the Grapevine

I want you now to think about your life and the scandals and rumors attendant to it. What rumors have been spread about you? Have you helped to circulate? Think of what you're ashamed of. Feel guilty about. Want to forget about. Think of the scandals you have witnessed. In your life, in the lives of people close to you, in the lives of celebrities. Jot some quick notes. Think of the gossip you have heard recently, the gossip so juicy, the scandal so delicious you couldn't wait to tell someone. Who did you tell? How did you tell it? Now spend a couple of minutes outlining the most interesting bit of gossip you can recall. We're only interested in what the trouble is, not in analyzing it.

The Secret Life of Aunts

Take an aunt from your family or make one up. An aunt that you are not all that close to but whom you like and admire. You've always pictured her life as calm, orderly, neat. Fulfilling, but rather unadventurous, let's say. But gradually you have come to realize that your aunt is more than bright

smiles and smart suits. She has an imagination that you know nothing about. Imagine her secret life. The one your family is unaware of. Just for starters, what is it she thinks about on the bus ride home from work? Thinks about at night before she falls asleep? The answers come as a surprise to you. Who are the people she knows—these people more important than you are in her life? What is it that she wants in her life? And why? Think about this aunt. Use the answers as the basis for a story. For example, let's say this aunt never married. Has never dated so far as you know. She is always by herself at family affairs. But then one afternoon, as the aunts play whist at the dining room table while the uncles watch football in the den, this aunt, glancing through *Town & Country*, looks up and says to no one in particular, "When I get married, this is the sort of bedroom I'd like."

Chance Encounters

You meet a person you knew ten years ago—before you lived where you do now, before you married, before you had a career. You knew this person casually from work and had occasion to socialize a bit at work-related parties. You think you may even have had a heartfelt conversation with him or her one time, though you can't recall it exactly. You were upset, maybe drinking a bit, she was a good listener. That's your impression. So you chance into each other in Macy's housewares and you chat, catch up on the one or two mutual friends you remember. You learn that one of these old friends has died and you're surprised. You think of that presence and a desk and you can't believe she's gone. You show the ex-coworker a picture of your kids. She takes out her wallet to show you her house, and you notice a photo of yourself. Write about what happens then.

The Product

⋈

Getting Her Up the Tree,
Getting Her Down

If you're writing a story and are confused
about the end, go back to the beginning.

—*Cynthia Ozick*

Someone, but I can't remember who, once said that the definition of a plot is: Get your hero up a tree, throw rocks at her, throw bigger rocks at her, then get her down. We'll deal with the up and the down here, the beginning and the end, and leave the rock-throwing for another chapter. First things first. You have an idea, a story to tell, you begin to write, the character is described, encounters trouble, makes decisions, begins his quest, and here the story starts to peter out. Stories want to begin, but the beginning of the writing process, the first scratches in the first draft, may not ultimately be the best first lines for the story. You must catch the reader's attention immediately or there is no reason to go on. And this goes double for your first reader—the editor. If the first line doesn't knock her over, then her consideration of your story is finished. After all, if you can't get the first line—which should be your strongest, most poetic line—right, then what are the chances that the rest of the story is any better? (A rather harsh sentiment, we might think, but one I've heard editors articulate.) Remember, there are tens of thousands, hundreds of thousands, of writers out there (more people writing than reading, it seems), and there are far fewer editors. If the editor doesn't like the opening

line, the work is easy to reject—there are plenty more where that came from. Every editor is looking for a reason to say no. The pile on her desk is too high; there are the weekend plans; she's got her own novel to write. Don't give her a reason to say no—be careful with your manuscript, your characters, and your words. Especially those first words.

A good beginning is full of intimation and assurance, the intimation being that here are characters who have something remarkable to tell us— you've never met people quite like these—the assurance being that something compelling, something surprising and unusual, something you just won't believe, is about to happen. But don't ever promise what you can't deliver, and don't initiate conflict that you cannot resolve, don't load a gun that you will not fire or light a fire that you will not put out.

> "If you can't catch the reader's attention at the start and hold it, there's no use going on."
> —MARIANNE MOORE

And while we're on *don'ts*, don't begin your story with long descriptions, or indeed any description, without first establishing a point of view. Don't write, as Snoopy would have, "It was a dark and stormy night on the heath. The wind screamed through the heather. Thunder resounded off the nearby cliffs." Better: "The man pulled the jacket over his head, but the wind-driven rain beat against his face. He wondered how far he had yet to go to reach the doctor's house. He waited for a stroke of lightning, saw the house over the second hill, stepped carefully." Now we have point of view, voice, tone, character, theme, setting, trouble, goal, and not simply a vague and innocuous statement of time and place.

Don't begin with an idea, begin with people, preferably people in action. (Ursula Le Guin writes, "Beginners' failures are often the result of trying to work with strong feelings and ideas without having found the images to embody them.")[*] Begin with scene if you can, but don't begin with some motiveless activity in a scene and then launch into a flashback. Like this: "Jeff drove his PT Cruiser into the Pollo Tropical parking lot and listened to the end of the Stones' 'Sympathy for the Devil.' He noticed the attractive young couple in the VW Beetle. He remembered when he and Ellen went to the junior prom in his Bug: 'Do you think we'll make it?' Ellen had said. 'I've got a case

[*] I think this is close to T. S. Eliot's notion of the objective correlative: a situation or a sequence of events or objects that evokes a particular emotion in a reader or audience. Or William Carlos Williams's "No ideas but in things."

of oil in the trunk.'" If you have a flashback on the first page of your story, reconsider. Here's why.

One or two things may have happened. First, you wrote your few sentences and realized that you didn't know enough about your character to continue. And so you wrote some backstory—the night of the prom, in this case. You wrote until you were comfortable that you knew your character a little better, and then you returned to the parking lot. Well, you needed to write

>
> *"In our openings, we are most likely to lie."*
> —ANTON CHEKHOV

that backstory, but we don't need to read it. Your plot, the character's struggle, must happen in the present of the story, not in the past. Cut the flashback. The second possibility is that you found your real material. You began the story in the parking lot just to get your character doing something, just to get the narrative under way. You didn't really know why he was at Pollo Tropical. Hunger, perhaps. He's acting without purpose, we might say. And then you found that the real trouble is in the past, back there with Ellen, back in high school. The love of his life, the woman he lost. Well, now what you need to do is jettison the opening and get us back into the past. (Which becomes the present of the story.) In his wonderful book on writing, *The Triggering Town*, Richard Hugo says there are always two subjects, the triggering subject (in this case, the parking lot, the song, the VW Beetle) and the generated subject (Ellen and the prom). The generated subject is the one with the emotional intensity needed to carry you, your characters, and your reader through the story.

Don't introduce a story—just jump in. And don't succumb to the imitative fallacy (as in "art imitating life")—starting the story too early, when the trouble is nowhere in sight. "The alarm clock rang. Joe turned in his bed, reached for the clock, and punched it off. Six A.M. He rolled over and caught forty more winks. When the snooze alarm sounded six minutes later, he felt rested and not so resentful of his day." The story starts much later than this,

>
> *"Whenever possible tell the whole story of the novel in the first sentence."*
> —JOHN IRVING

we hope—when he gets to work and discovers that he has been fired. So: "Joe knocked on Mr. Brind'amour's door and wondered why the boss wanted to see him before he had a chance to finish the Collins report." To this point, Frank O'Connor says that a short story begins when everything but the

action is over. In other words, don't start at the beginning, when everything is about to happen, when trouble only faintly casts its shadow. Begin in the middle of things. Start as close to the end as you can. If you have an alarm clock going off at the opening of your story, reconsider. Better to have your character wake up with two men standing by the bed. They tell him he's under arrest. Waking up can be a dangerous time, as Kafka knew. Waking to an alarm, not to an alarm clock.

The first line of the story breaks the silence. All of us will read any first line of anything. But will we read the second? Think of yourself in the doctor's office (nothing terrible, I hope) leafing through the magazines, reading the first lines of article after article until finally one first line for some reason compels you to read the second. The first sentence has to make the reader want to go on to the next. A good first line of a story, whether it charms, amazes, intrigues, shocks, or seduces you, has to do so quickly and must, in the words of Susanne Langer, tear you out of your world and drop you into the world of the story. And now it is impossible not to go on, not to want to know what's up with these people.

>
> *"Start clean and simple. Don't try to write pretty or noble or big. Try to say just what you mean. And that's hard because you have to find out what you mean, and that's work."*
> —WILLIAM SLOANE

A good first line is intriguing, energetic, immediate, unqualified. The leisurely beginning is difficult to pull off in a novel, nearly impossible in a short story. The first line should be striking and surprising. It should appeal to the senses. You're trying to create a dream in the reader's mind (as John Gardner famously put it) and you do so with vivid and significant details. Weak openings signal confusion. The writer, we think, hasn't figured out what he's writing about yet. When he does, we'll read it. The first line has implicit in it the entire story. It ought to present specific character, specific incident, specific conversation, specific mood. Beginnings are not a time to generalize. Flannery O'Connor said: "If you start with a real personality, a real character, then something is bound to happen; and you don't have to know before you begin. In fact, it may be better if you don't know what before you begin. You ought to be able to discover something from your stories."

Sometimes a first line is a given, a gift from the Muse, as it were, but it arrives only if you are there at the desk and are ready to receive it. (This has

never happened to me. I hear a line, and it suggests character more than it suggests narrative. Like this one I heard recently: "I'm so short and the line is so long.") More often, however, the opening line appears in revision. When we finish the draft, we read the story and see what it is we've said. And now we know where to begin. Then we can determine if we started too early, too late, in the right voice, with the appropriate tone, and so on. You might, in the process of drafting, write many lines looking for the one that works. Lewis Carroll thought there was nothing imposing in all this. He said, "Begin at the beginning, go on till the end, then stop." Donald Barthelme, however, speaks for many of us when he says, "Endings are elusive, middles are nowhere to be found, but worst of all is to begin, to begin, to begin." Here are some people who began well:

"All happy families are alike, but an unhappy family is unhappy in its own way." —*Anna Karenina*/Leo Tolstoy. Tolstoy gets right to it—we're only interested in trouble. We don't want to read about happy people in Blissful Valley. (Have I said this before?) This is a statement of theme. He'll build his novel on contrast, we expect. And maybe he's also saying that we're all unhappy, dysfunctional families.

"My wife Norma had run off with Guy Dupree and I was waiting around for the credit card billings to come in so I could see where they had gone." —*The Dog of the South*/Charles Portis. The voice here is irresistible, as is the promise of an inevitable search and a wild and funny confrontation. Character and conflict. Guy Dupree—can't you just see him already?

"All children, except one, grow up." —*Peter Pan*/J. M. Barrie. A provocative character description. Intimations of immortality. Of course we'll read it.

"The Jackmans' marriage had been adulterous and violent, but in its last days they became a couple again, as they might have if one of them were slowly dying." —"The Winter Father"/Andre Dubus. A brilliantly ironic and tragic statement. We're most alive when we know we're dying. A theme worth exploring. Here's a writer who's taking a chance.

"There was a summer of my life when the only creature that seemed lovelier to me than a largemouth bass was Sheila Mant." —"The Bass, the River, and Sheila Mant"/W. D. Wetherell. I want to meet Miss Mant and the boy who admired her. This is a world I already feel comfortable in. I'm expecting to be a little sad. The kind of sadness that makes you miss your own youth, that makes you understand how precious our time is.

"What to know about pain is how little we do to deserve it, how simple it

is to give, how hard to lose." —"Widow Water"/Frederick Busch. An eloquent statement of an important theme. We know we're in good hands when the narrator can be so clear about what is so complex.

"Francis Marion Tarwater's uncle had been dead for only half a day when the boy got too drunk to finish digging the grave and a Negro named Buford Munson who had come to get a jug filled, had to finish it and drag the body from the breakfast table where it was still sitting and bury it in a decent Christian way, with the sign of its Savior at the head of the grave and enough dirt on top keep the dogs from digging it up." —"You Can't Be Any Poorer than Dead"/Flannery O'Connor. Humor, death, wantonness, religion, and a couple of beguiling characters—who could stop here?

(When you get some time or when you make the time, pick up Flannery O'Connor's collected stories and just read the opening lines. All of them are quite wonderful. Study them, notice what she does each time. Pick up the stories of any writer you like and do the same.) One more:

"As Gregor Samsa awoke one morning from uneasy dreams he found himself transformed in his bed into a gigantic insect." —"Metamorphosis"/Franz Kafka. How's he going to pull this off? More important, what's it feel like to be a bug?

Okay, so you've got your story under way. Now your problem is, when does the story end? Well, we don't need the resolution of the characters' lives, you know that, just the resolution of their present difficulties. Take a look at Chekhov's "The Lady with the Pet Dog," which ends with Gurov and Anna still meeting in secret, still married to other people, with the hardest part still ahead of them, but knowing they will be together—maybe not happily ever after, but together. And *how* does it end? Try to avoid what used to be called the O. Henry ending, the twist, the gimmick, the surprise. Surprise endings trivialize what came before, suggest that the characters and

"At the end of a story or novel I must artfully concentrate for the reader an impression of the entire work, and therefore must casually mention something about those whom I have already presented."

—ANTON CHEKHOV

what should be the important thematic business of the story are only in the service of what amounts to a punch line. These surprise endings often depend on the withholding of important information that should have been revealed in the opening act of the story. Here's an example. An undergradu-

ate student I once had handed in the first story she'd ever written. (And it was well written.) It opened with a young hooker in her flat with her boyfriend/pimp. We get to meet her and learn a bit about her history. Her parents were divorced when she was a girl. She was raised by an abusive mom. (It was as if the author were excusing or apologizing for her character's behavior, which is, of course, unnecessary, unimportant, and for now, beside the point.) Cut to a scene with her and a john. An older man. Not much conversation. When the sex is finished, we see the pair of them in her bed. We get an unwarranted shift in point of view to the john, who looks over at a photograph on the nightstand of the hooker as little girl. She's on a swing in a playground. Her father is pushing her. You've probably guessed already—the man in the bed is her father.

> *"The desire at the start is not to say anything, not to make meanings, but to create for the unwary reader a sudden experience of reality."*
> —VALERIE MARTIN

Well, this is a letdown. That's it? We end here with no repercussions? Better to start the story where it ends, don't you think? A man realizes he has just had sex with his daughter. What does he do now? What does he think? How does he live with himself? Or write her story with the knowledge that she has slept with her dad. Not a story I would like to write, maybe, but one filled with trouble and consequence. Write this story and we might learn something (maybe something unpleasant) about the human condition. A twist ending is like sentimentality in that it is a form of cheating, of borrowing emotion from outside the story. Even as powerful a story as "The Lottery" suffers, I think, in this respect. You can only read it once. It's stunning the first time, but because it depends on the skillful withholding of information, it is spoiled by familiarity. Significant stories, important and resonant stories, on the other hand, are enhanced by repeated readings.

I like to start a story or a novel quickly and to end it lyrically. Endings shouldn't be loose, shouldn't drift or dissolve. They have to make a statement. They can be dramatic, but more often are muted, subtle. The story has already made its point or it has failed. The ending cannot bail the story out, cannot impose a meaning that wasn't already evident. A good ending must, of course, resolve what has gone before it, and must somehow rise above the story, must stand as an emblem of the story. You start your ending when you write the first line of the story. The ending should be inherent in the opening.

It should not do more than resolve. We don't need to be reminded about what happened. We don't need to know what else has happened in the characters' lives—the end is not a time to introduce new information. We don't need a moral or a message. We only need the problem resolved. Don't end the story, if you can help it, with a thought, an idea, a spoken word. Leave us with a compelling visual image of the central character, one that is so resonant and compelling that it stays with us when we close the book. Think about what DaVinci said: "An emotion, a state of mind, always finds expression in a person's face and body. [And it's the body in motion that we are more concerned with here in our ending.] When a man is angry, he shows his teeth and frowns; his eyes seem to shoot darts; he tightens his facial muscles and his whole posture, stiffening his neck and balling his fists. Such emotion may be a person's face like an inscription in bronze; it becomes character." What is it our character does here in the last frame* that suggests her character and the change she has undergone?

And one more thing. The last line is as important as the first, if for different reasons. End the story on your best, or second best, line. Don't write past it. This is the line that echoes in our mind when the story's over.

EXERCISES

.

In the Beginning

Stories begin with people. Who are these people in your head and what do they want? Don't introduce the people, just get them acting. Writing a scene is like watching a play You're at the theater and the curtain goes up. You get a glimpse of the set, and then a character walks onstage, and then another. They go at it.

Think drama while you write the opening to your story. Don't try to write a story, just an opening. Let's try it. Two characters. One wants some-

* The word *frame* reminded me where I got this notion of the visually compelling final image in a story. I got it from the movies, from the freeze-frame. Specifically, from the last frame of Truffaut's *The 400 Blows*. I still have the image of the young Antoine on the beach burned into my mind twenty years after last seeing it. *The 400 Blows* is proof, if you needed any, that movies can be as powerful, as life-changing as literature. Truffaut said, "I still ask myself the question that has tormented me since I was thirty years old: Is cinema more important than life?" Truffaut knew what we know, that a great story conceals as much as it reveals.

thing from the other; the other doesn't want to give it. Do not use exposition to explain anything about these people. (You can set the scene if you want to, or just wait till later.) Let them act out their relationship. Remember that when people talk, they also act. And they act in revealing ways. So what you want to do is use a couple of telling gestures which will let us know what's really going on behind those words.

For example:

"What time should I meet you?" Bart said.

Sue drew a deep breath. "I told you I'm not going."

"I'll meet you in front of the theater at five."

"I hate musical comedies."

Bart took a steel comb from his back pocket, looked into the rearview mirror, cocked his head, combed his hair into a pompadour, and patted it down lightly. "I could just pick you up at home, if you want."

"Stop this," Sue said. She chewed at her thumbnail. "You know I'm going out with Russell now."

"Wear that sexy red dress, will you, doll?"

Contrast Sue's deeply drawn breath and her thumbnail-chewing with her assertive words. Contrast them with Bart's grooming. I don't know much about these two yet, but I'm willing to write some more and find out. I'll ask some questions, answer them, go on.

Your turn. Get your characters onstage. Watch them. Which one wants what from the other? Why? Let him or her go after it. A good place to start. Now write down what they say.

Curtain Up

You know what your character wants and you know why she wants it. You know she wants it intensely enough to do something about it. You know what stands in her way, and you know there'll be more obstacles later. Now you're ready to write the opening *scene* of the story (which is not the same thing as the opening of the story, necessarily). You know when you write it that it may not be the opening scene of the final product. But you know now that you're going to surprise your character with trouble. You also know that nothing gets written easily and mechanically and that you have work to do before you can bring those characters to life. So today do the following: Read some opening scenes from books that you admire and try to figure out what is working there.

The heart of every scene is conflict, so consider what the conflict will be here at the start. Think about the place, the setting. Where and when. Write the details of the room, the field, the office, the car, wherever. What's the date? Weather? Time? What are the sounds, the smells, the textures, the tastes, if any? What is your character thinking about? How does she feel? Mood? Who are the people in the scene? Describe them and their attire (this so you can see them clearly, not so a lot of extraneous details will appear in the scene). What is your character doing? Describe in detail. Do the same for any other character. What might the point of view in the scene be? The narrator? What is the climax the scene will build to? What might the last line of the scene be? The first line? Will characters talk? How does each person speak in terms of tone, diction, figures of speech, dialect, whatever? (No two people speak alike and no character speaks like the third-person narrator.) You're not looking for answers here, you're looking to open up the scene, to offer yourself possibilities, to gather potential material.

And in the End

This time don't think about writing a story, just about writing the last paragraph. Imagine your central character (perhaps the one from the exercise above) doing something. See her closely. She has gotten what she wants or has not. You are surprised she is doing what she's doing, but you realize that the behavior perfectly depicts her emotional state. Leave us with a picture of the character. A freeze-frame.

Here are some behaviors that maybe you could use. The behaviors are a bit odd, and that makes them provocative, which is what a writer wants. They're quirky but not bizarre. Consider this behavior as the last thing the reader sees in your story.

Your character is having a perfectly good tooth pulled. What drove him to this? Why would he do such a thing? Why doesn't the dentist protest? Who said he was at the dentist's? (Which brings to mind the fleet of unlicensed mobile dentists we have here in South Florida, who keep their equipment in the trunk of their cars! But that's another story.)

Having brought up jobs, the exercise works even better if your character is described by vocation. So it's a priest at the dentist getting the tooth pulled. Making more sense already! Penance. (Are we talking Santeria priest, by the way?) So let's do a few more.

A stand-up comic sleeps with a crucifix.

A gift-shop manager digs a shallow grave.

A bank teller (are there any left?) pretends to be blind.

A lifeguard sends money to a televangelist.

You get the idea. Open the phone book, find an occupation, give it to a character who's got a lot of trouble in her life. Imagine what she does at the end of the story. Write it down. After you've done that, of course, you can imagine what made her behave in such a peculiar way. And that will lead you to the genesis of your story.

Emergency Fiction: How to Begin

(**This exercise was borrowed from Steve Barthelme, friend and writer,** author of *And He Tells the Little Horse the Whole Story* and, with his brother Frederick, of *Double Down*. Steve teaches creative writing at the University of Southern Mississippi in Hattiesburg.)

1. A story follows an *active character* through *emotionally charged* experiences which *change* him or her.

2. Put things you like in your story.

(If you like snakes, put a python in your story. [What do you like?] If you like water, let it rain. If you like the color red, color the room red, with paint, not blood—any half-wit can slosh buckets of gratuitous blood around and call it significance or horror. The horror is in the prose.)

3. Put things which make you nervous in the story.

(Afraid of the cops? There's one living next door. Afraid of envy? Write about your pal the best-selling novelist with half the skill you have. Claustrophobic? The door is locked.)

4. Here is how you create a character:

Bobby Ray . . .

5. Here is how you create a setting:

looked across the kitchen over the beige Formica table, past yesterday's dirty dishes, and out the window past his Buick Deuce and a Quarter at Barbara Ann's Harley-Davidson.

6. Here is how you create a situation:

 at her brand-new Harley-Davidson Night Train. "I believe you, darlin'. I don't know what made me think something was going on."

7. Here's how you create a second character:

 New Paragraph: *Barbara Ann smiled, dropped her cigarette into the sink, hopped down off the counter. She let her hand fall softly on his blue jeans.*

8. Here's how to emotionally charge the situation:

 "Bobby Ray," she said, "I'm done with being a middle school teacher."

9. Here is how to emotionally charge the situation again:

 New paragraph: *He looked at the red snake tattoo on her forearm and shook his head. A lot can happen in a week. She'll probably want me to get a job now. Hell, there's always Randeane.*

10. Here is how you add a small surprise to make the world of the story as rich as the world the reader lives in, while at the same time developing character and suggesting his mental state:

 He reached into his pocket for his smokes, forgetting that he quit three years ago.

11. Here is how you add emphasize what has just happened:

 He looked up and met her eyes.
 "Want a smoke? she said. That smile again.

12. Here is how you intensify the situation:

 "Look," Bobby Ray said, "you can't keep the bike. Bring it back, get your money."

13. Here is how you further intensify the situation:

 Barbara Ann locked the door, turned, and smiled. "I don't think so. Did you know that Randeane left for New Orleans this morning with that crooked deputy sheriff?" She laughed, put her arms around his waist, said, "You best be nice to me, Bobby Ray."

 Here it is, not a bad beginning:

*Bobby Ray looked across the kitchen over the beige Formica table, past yester-
day's dirty dishes, and out the window past his Buick Deuce and a Quarter at
Barbara Ann's brand-new Harley-Davidson Night Train. "I believe you, dar-
lin'. I don't know what made me think something was going on."*

*Barbara Ann smiled, dropped her cigarette into the sink, hopped down
off the counter. She let her hand fall softly on his blue jeans. "Bobby Ray,"
she said, "I'm done with being a middle school teacher."*

*He looked at the red snake tattoo on her forearm and shook his head. A
lot can happen in a week. She'll probably want me to get a job now. Well,
hell, there's always Randeane. He reached into his pocket for his smokes
forgetting that he quit three years ago. He looked up and met her eyes.*

"Want a smoke?" she said. That smile again.

*"Look," Bobby Ray said, "you can't keep the bike. Bring it on back, get
your money."*

*Barbara Ann locked the door, turned, and smiled. "I don't think so. Did
you know that Randeane left for New Orleans this morning with that
crooked deputy sheriff?" She laughed, put her arms around his waist, said,
"You best be nice to me, Bobby Ray."*

The Queen Died of Grief

X

I guarantee you that no modern story scheme, even plotlessness,
will give a reader genuine satisfaction, unless one of those old fashioned
plots is smuggled in somewhere. I don't praise plots as accurate
representations of life, but as ways to keep the reader reading.

—Kurt Vonnegut

Plot is the structuring of the events in a story. It's what happens, but it's more than what happens. It's the *what* that leads us to the *why* and the *how*. Plot, then, operates over time, but is not simple chronology. E. M. Forster explained it this way: "'The King died and the Queen died' is a story. 'The King died and the Queen died of grief' is a plot." The difference, of course, is cause and effect. Episodes do not necessarily make a plot. Plot is about the word *so*, not the word *and*. It's about *because of the reason given; consequently; with the result that; in order that.* Think of Forster's *story* as the narrative in chronological order. (Ask your six-year-old what happened at school today, and you'll get story.) Think of *plot* as the writer's arrangement of events to achieve a desired effect. Plot is the writer's organizing and unifying principle, her magnet to which all the other narrative elements attach. It is the architecture of action. The characters need something to do, and the reader needs to know that this journey is purposeful, that he is headed somewhere.

Aristotle told us that plots have beginnings, middles, and ends and that complex plots, the best plots, proceed through a series of reversals and

recognitions. A reversal is a change in a situation to its opposite. (The messenger from Corinth tries to allay Oedipus' fear of marrying his mother by telling him who he really is. The message produces the opposite effect.) A recognition is a change from ignorance to knowledge. (Oedipus now understands the terrible truth that he had struggled to learn.)

John Gardner put it this way. The basic plot of all stories is, and I'm paraphrasing: You have a central character who wants something and goes after it despite opposition, and, as a result of a struggle, comes to a win or a lose. (Gardner also said tie, but I like to think you get what you want or you don't.) Let's take this definition as a starting point. I don't want to talk about plot itself here,* but about how you might let the necessary plot do your thinking for you, how consideration of plot will lead you to matters of characterization, tone, theme, setting, drama, and so on. So this is about how you as a writer might go ahead and think about your story and begin composing it.

And let's let Chekhov answer the question, What do I write about? He said, Make a man and a woman the balance of the story. Sit them at a table, put an ashtray at the table, call the story "The Ashtray," and write the story. (Raymond Carver, for one, took this advice and wrote a narrative poem called "The Ashtray.") With Chekhov's suggestion in mind, we'll try constructing a story, thinking how it might evolve. Our characters, this being the twenty-first century and all, don't smoke. So maybe we'll call our story "Coffee" or "In the Kitchen." Surely we'll discover a better title before we're finished.

We'll start, then, with a man and a woman, husband and wife. Call them the Wymans, Ruth and Kenneth. We know that every story is about trouble. No one wants to read about happy people living in Blissville. (They're all alike, after all.) So let's say that on the eve of their tenth wedding anniversary, Kenneth tells Ruth that he is leaving her. Let's stop here before we get ahead of ourselves.

We know that everything of importance in a story, and Kenneth's declaration is certainly that, ought to happen in scene. (A scene is a unit of dramatic action with a beginning, middle, and end. It's the opposite of telling. It *shows* what happened. Scene brings action and dialogue to the reader, who witnesses what goes on.) And nothing unimportant can happen in a scene— no small talk, for example. (No one sitting at dinner ever asks someone else to pass the ketchup, please, unless the bottle will be used as a weapon.) The

* For a brief discussion of what plot is, see the next chapter, "Plottery."

struggle, whoever it is, needs to be dramatized, not explained or summarized. And we ought to begin as close to the end of our story as we can. If this is the story of the Wymans' marriage in crisis, we don't need the whirlwind courtship, the wedding at the country club, the years of happiness. We need to start as close to Kenneth's stunning announcement as we can. And in order to write the opening scene, we'll need to know where it'll take place, and when. We need to set the stage.

So Ruth is in her kitchen, sitting at the table, drinking coffee, reading the morning paper. Maybe we take a look at the page she's reading and see that it's the movie page—perhaps she's planning what she'd like to see this weekend. She's a movie lover. We note that we now have a theme to exploit—illusion versus reality—if we want to. And we wonder what kinds of movies she enjoys, who her favorite directors are, her favorite actors. Kenneth enters the room. He's in a gray suit, white shirt, yellow tie. We look back at Ruth, see that she's in her chenille

> *"The first thing that you have to consider when writing a novel is your story, and then your story—and then your story! . . . You may have the most wonderful scene from real life. . . . But if it does not make your subject progress it will divert the attention of the reader."*
> —FORD MADOX FORD

robe, the one with the cowgirl riding a pinto pony, twirling a lasso, on the back. Kenneth lays his briefcase on the counter. He pours himself a cup of coffee from the Mr. Coffee machine. He hesitates, does not take his seat across from Ruth as he normally does. Without turning, he says, "Ruth, I'm leaving you." What does Ruth do or say? We've got the trouble we were looking for, certainly. We watch Ruth, watch her closely, intently. Maybe we have to close our eyes to do so. It strikes us—perhaps because Ruth was on the movie page—that imagining a scene and writing it are like watching a movie. You stare at the characters and wait for them to act, and they do. And something else about movies and fiction: They do their work differently.

If our story were a movie, we would have presented the viewer with the images mentioned. He would have seen Ruth (she's that actress who played the spy in a recent political thriller); he would have seen the table (one just like it in the Sundance catalogue) and the counter and Kenneth and the coffee cups. He would have sat there passively sucking it all in. But this is fiction, which means that the reader is in on the creation of the story. We furnish a

detail, the reader furnishes the room, as it were. We said *table,* and he had to see it. Was it round? Enamel-topped? Pine? We mentioned the counter, and the reader saw it and saw the briefcase. We didn't tell him the color of the countertop or its construction. Marble, tile, or Formica? And we didn't describe the briefcase—the reader created it.

That's how scene works. The story is a collaborative endeavor. The writer provides the clues—a river, say—and puts a character neck-deep in the river, and the reader sees the arrow of ripples around the character's body, sees the gunmetal-gray of the water. (John Gardner famously compared the fiction writer's process to creating a dream in the reader's mind. And dreams, we know, exist in images.) Umberto Eco put it this way: "Every text is a lazy machine asking the reader to do some of its work." The point is this: The making of a story is partly the achievement of the reader. If fiction is good, no two readers can be said to have read the same story. A visual image presented on-screen is virtually the same for all who see it, but an image sketched on a page will be imagined slightly differently by each reader. An action rendered will be seen a little differently. Anyone who has seen the movie of a book they love will inevitably be disappointed in the casting. Your Emma Bovary was so much more alluring and sensual than theirs. (By the way, I think it's our creative collaboration as readers that accounts for the fact that no other narrative art can move us like fiction, can take us out of our world and drop us into a world more brilliant and intense than our own. We lose our sense of time and we resent the return to our mundane lives.)

Kenneth is still standing there. Ruth has looked up from her paper, but before she does anything else, we decide we need more information. Before we can draft the scene, we need to see the kitchen more clearly, and we need to learn more about this couple. We're going to know everything about that kitchen before we write the scene. And we'll come to know it by writing about it. Writing is how we see best. And we do so for at least two reasons. First, when people talk, they also do things, move, behave. (In conversation, for example, we are always talking with at least two languages, verbal and bodily, and they may not always be saying the same thing.) So we need to know the potential of the room. We need to know what our characters can do. So we see that the table is in the middle of the room, that Ruth's back is to the stove and fridge. The sink is a double basin and is stainless steel. Above the sink is a window, and on the sill is a leggy grape ivy in a clay pot.

Now that we're at the window, we can look out to see what Ruth can see.

We can know the weather, the season, and perhaps something more about the place. Thinking about the season, we realize that season could affect the tone of the story. So let's say it's winter. There's an empty clothesline in the backyard, icicles on the slack lines. It's brilliantly sunny. The kind of sun that blinds the eyes, makes them tear. We can see the wooden fence and above it the white clapboard side of the house next door, and its eaves crusted with snow.

We're going to look in the refrigerator to find out what the Wymans are eating. We'll open the freezer and the vegetable drawers. We'll know who's on a diet and who has a sweet tooth. And we just found this out, much to our surprise: The refrigerator door is covered with children's drawings and with elementary school commendations. Now we know the couple have children. Two of them, let's say. A boy nine and a girl seven. Lucas and Maddie. They're still upstairs sleeping.

> *"Plots are what the writer sees with."*
>
> —EUDORA WELTY

What this means is that the story just deepened and intensified. Kenneth is no longer just leaving his wife, he's leaving his children as well, and he needs to take the responsibility for doing so. We won't let him forget it, and neither will Ruth. He needs to know that the children are going to think this divorce, should it come to that, is their fault. They will be traumatized. We like the story better already. One of Maddie's drawings is of the family: The four of them are holding hands beneath a blue tree; their mouths are circles; they seem to be singing.

Then we'll go through the junk drawer, the mail piled on the counter next to the Mixmaster, see what bills they owe, what magazines they subscribe to (aspirations and curiosities), who's corresponding with them. We'll see what's on the walls. A crucifix. A calendar, certainly. Is it from a church? A pharmacy? Does it feature landscapes of western deserts? Recipes? Objets d'art? Are there dates circled, doctor's appointments noted, hockey practices? Sooner or later we'll get to the medicine cabinet in the bathroom and find out who's taking what and why. Writing a story is archaeology. Not all of these details will make it to the page in black and white, but they all afford us insight into the characters; they all cast a shadow on the story, and so they are all important. We can never know too much about our characters. The details that do make it to the page are those we find particularly striking and consequential. Revelations lurk in details, we know. Now we feel more confident. We proceed with our scene.

Our definition of plot implies several things. That there is *one central char-*
acter, not two or three. Not humanity. One individual. In the story of the diffi-
cult Wyman break-up we must decide which of the characters is our central
character. Whose story is it? His or hers? (We can write his story or her story,
but not at the same time.) The effect that we want the story to have on the
reader will help us make that decision. As will other considerations, like
which character are we more interested in? Which do we think the reader will
find more interesting? Which is more compelling? What themes do we want
to explore in the story? So, one central character per plot. One central char-
acter, and that central character must be *active.* Beginning fiction writers
sometimes employ passive central characters, but we know better. No stories
of people smoking French cigarettes, staring out the window of their garret,
philosophizing about life. No stories of the starving young literary genius sit-
ting at his computer writing stories about a starving young literary genius,
whom the editors seem to have it in for, who is obviously ahead of his time,
who will one day set the publishing world on fire. No stories in which things
just happen. Because things don't ever just happen. Divorce, for example
doesn't just happen. It has a history. The character must want something; in
other words, must be *motivated* to act and then must act. Motivations in colli-
sion create conflict—another definition of plot.

We have decided that the story will be the wife's, will be told from her
point of view. Her situation compels us is why, as do the themes of loss, aban-
donment, grief. These are things we don't understand. We decide that what
she wants is to save the marriage. (Otherwise we don't have a story. She can't
say, I was wondering when the hell you were going. Now I can call that cute
waiter over at the Brasserie.) Her motivation should be considerable and
fairly intense. She doesn't see how she can live without Kenneth. She believes
children need to have a father in the home. (She is, we suddenly realize, the
child of divorced parents. She was ten when her dad moved out. So she is
acutely aware of the pain and the trauma involved in the breakup of a mar-
riage.) She loves Kenneth to death. (And love alone would be enough moti-
vation.) She gave up her career ten years ago—let's say she was a social
worker—to raise the children and doesn't know how she could possibly sup-
port them on her own. She will not let herself fail at the most important rela-
tionship in her life. Her whole life, her sense of who she is, her emotional and
mental well-being are at stake, as is her future and the futures of her chil-
dren. This is a marriage of long standing. Ruth knows that love abides, and

goddammit, she's not going to let anyone destroy her dream. She is going to do something, we can be sure.

We have our central character, and we know what she wants, and we know why she wants it. And now she has to go after what she wants—despite opposition. The opposition is clear enough. Let's get back to that kitchen. Ruth knows that she didn't hear right. Kenneth turns. He repeats himself, this time looking into Ruth's eyes. But he doesn't let her respond. He starts right in on what sounds to us like a rehearsed speech, an apology, an argument. He says she knows very well that they haven't been getting along for quite some time, that they hardly talk, make love sporadically and routinely. She's complained about all that to him, hasn't she? He's about to say that when a marriage is in trouble, it takes courage for one person to come forward and say so, do something about it, salvage what he can of his life, but Ruth interrupts him. (Or maybe she waits till his rant is over—we'll figure that out in revision.) She's incredulous. She wants to believe this is a cruel joke. She says, What the hell is going on? He says, I need some space.

> *"There are thirty-two ways to write a story, and I've used every one, but there is only one plot—things are not as they seem."*
> —JIM THOMPSON

(And that's a cliché that we might want to reconsider, to rewrite, to get past the euphuism to the truth. Which brings up an important point. Our job in the story is not to blame Kenneth. What would be the point of that? No one person is to blame when a relationship runs aground. And as fiction writers we know that every person has his reasons. And our job is to understand those reasons. Right now we don't like what Kenneth is doing to his wife, our hero. But at some point in the story he is going to get the opportunity to explain himself. Every character gets a chance at redemption—but not all of them take it.

If Kenneth were a bastard, we would not want Ruth to win him back, and the story would no longer compel us. There needs to be a moral balance in the story. She loves him, after all. So he must be lovable. He needs to be worthy of her pursuit. In the struggle that will constitute the plot, the opposing forces should be similarly strong—there must be some doubt as to the outcome, and that includes the moral outcome. As George Bernard Shaw put it, "Evil conquering good is not so interesting as good conquering good." Our job is not to judge our characters, but, as Chekhov reminded us, to witness

their behavior. We know that in real life, while people may be victimized, and while people may act villainously, there are, in fact, no villains and no victims, not as central characters, at any rate. We are, each of us, saint and sinner. Aristotle said that a central character must not be so virtuous that instead of feeling pity or fear at his downfall, we are simply outraged. Similarly, the character cannot be so evil that for the sake of justice we desire his or her misfortune. Remember, we aren't pointing accusing fingers. Fiction is not a treatise; it is an examination. Perhaps we could go so far as to say that a fiction writer cannot write about a central character that he does not like. To do so is to have judged the character as unworthy of affection. The writer does not have to approve of or excuse a character's behavior, but he must try to understand it. If he dislikes the character, he is unlikely to try.)

Ruth says, There's space all around you. Kenneth tells her he's taken an apartment for the time being. He won't be coming home tonight. He'll call at seven to talk with the kids. She says, What do I tell them in the meantime? He says, Tell them I'm on a business trip. Ruth cries. She takes a tissue out of her robe pocket and blows her nose. She tells him she loves him. How could he do this to her? She says he owes her something after ten years of marriage. You wouldn't treat a dog this way. Kenneth touches his briefcase. She says, You can't just walk out.

We have now illustrated what Frank O'Connor called the three necessary elements in a story. Exposition: *Ruth Wyman was a housewife in Rochester, New York.* Development: *One day her husband told her he was leaving her.* Drama: *"No, you're not," she said.*

Back to our definition a second: *One central character (Ruth) who wants something (to save her marriage) and goes after it despite opposition (as she is doing).* Conflict is at the heart of every story. *And as a result of a struggle . . .* It cannot be too easy for our central character to get what she wants. Ruth may tell Kenneth that he's being rash, that she knows they can work out any difficulty they may have if only he'll stay. She can beg him to stay: Just stay this morning so we can talk. You can't walk out that door and leave me alone. But the only thing that Kenneth cannot say is, Yes, you're right. What was I thinking? I knew I should have had my coffee before I said anything. Kenneth cannot stay. That would be too easy. No struggle, no story. Ruth goes to Kenneth and throws her arms around him. He's not a monster. He feels terrible but resolute. He's thought a lot about this. He says, We'll talk tonight. They hear the bare feet of their children hit the floor upstairs. Kenneth takes

Ruth's arms from his shoulders. He apologizes. She can't speak. At the end of our opening scene, Kenneth walks out the door.

It occurs to us that we've got another decision to make. Who is going to tell Ruth's story? Ruth can tell it, of course. A third-person narrator can tell it and grant us access to Ruth's thoughts and feelings. Those are essentially our choices. (Ruth can pretend to be talking about a character named Ruth, whom she calls *You*—she needs to distance herself from the pain, perhaps. *You're sitting at the kitchen table, drinking your first coffee of the day, checking the paper for movies the kids might like to see this weekend, when your husband turns to you and casually announces that he's leaving you.* But this is first person in disguise. We could also have a third-person narrator who refused to grant us access to any character's thoughts or feelings, but why would we? Isn't the real drama below the surface?) We might think about people we know who are undergoing divorce. We hear his side of the story, and then we hear hers, and they don't jibe. We don't

> *"There are only two or three human stories, and they go on repeating themselves as fiercely as if they had never happened."*
> —WILLA CATHER

know who's telling the truth. And that's the issue we'll have to face if we let Ruth tell us her story. Is she reliable? Can a woman be honest about the man who is emotionally battering her? What is her temporal and emotional distance from the material? Is she telling the story as it unfolds? Is this thirty years later? Why is she telling us this story? If we want her reliability to be a part of the exploration of the story, then let her tell it. If we want to focus more deliberately on the separation itself, on Ruth's determined, heroic effort to save the marriage, perhaps a third-person narrator would better serve us and the reader. Third-person narrators conventionally don't lie. Let's go with the third-person narrator. And remember that we write the story, but our narrator tells it. We have to create him and his voice. He might sound a lot like us, but he doesn't need to.

Ruth cannot give up, of course. This is a struggle, and that means that the action will be protracted. We remember what she wants—to save the marriage. Every time she struggles to do so, we'll need a scene. We can't *tell* anything important—we need to *show* it. So what are the scenes we'll need at the very least? (In early drafts I like to write the obligatory scenes and then connect them with any necessary exposition, try to make the quick transition from scene to scene.) So for now—it's our first draft—let's leap ahead to some-

time that afternoon when Ruth arranges for her friend Tischalynne to pick the kids up after school, screws up her courage, and drives herself to Kenneth's office. We saw him in that suit. What does he do? It's Rochester, so maybe he works for Kodak. He could be a lawyer, but there are too many unpleasant associations with that profession. We don't want people stereotyping our characters. (Perhaps it occurs to us that lawyers in courtrooms tell stories, too, best story wins, and we pause to consider how that fact might be exploited in our tale. The difference between the courtroom narratives and a fictional narrative is that the trial lawyers are not interested in the truth, only in winning a case. We decide not to obscure the plot.) So let's have Kenneth be the director of the Monroe County adult literacy program. He's an admired man. He's overworked and underpaid. Ruth walks right past Kenneth's secretary and into his office. As in our first scene, we'll need to know what Kenneth's office looks like. We need to know if that family photo is still on his desk. We need to know the source of light.

>
>
> *"As regards plots I find real life no help at all. Real life seems to have no plot."*
>
> —IVY COMPTON-BURNETT

Ruth tries to reason with Kenneth. She wants to know where he's staying. She wants to know what he's planning. Is he coming back or what? She says they ought to go to marriage counseling. Jesus Christ, he owes her at least that much. Kenneth says this is neither the time nor the place. She says, What's more important to you than your marriage and your family? Ruth had come to the office with hopes of convincing Kenneth to come back home where he belongs, but her rage and her pain are uncontrollable, and she can see this is going nowhere. It's only making matters worse. Once again, the only thing that Kenneth can't say is, All right I'll be home tonight. He does say he has an appointment with the United Way. He puts his jacket on, tells Ruth to stay in the office as long as she needs to. She can't breathe. She tells Kenneth that she's not going to tell the kids anything. He's the one that's going to tell the children, who adore him, that he's leaving them.

And now we see that we have discovered another scene to write. And we realize as well that this will be the scene where Kenneth explains himself to his kids, speaks honestly, earns our esteem. We don't know why he left, do we? He hasn't told Ruth why—not convincingly, at any rate. Of course, by the end of the story, he will. If we have to, we'll lock him and Ruth in a room and we won't let them out until they've been honest, until they've pushed

past the clichés ("midlife crisis," "love but not *in* love," "you've changed") and gotten down to the fears and the dreams and the anger, and whatever else is down there. Sometimes characters don't want to deal with their emotional issues. And sometimes we find ourselves as writers happily abetting their avoidance. We do that because we don't want to have to deal with our own emotional issues, either. Let me give you an example from my own work.

A subplot of *Love Warps the Mind a Little* has to do with the central character's relationship with his dad. Throughout the book, Laf considers his rather unhappy, unsatisfying relationship with his father. He never felt close to him, resented Dad's jokes and sarcasm, felt abandoned when Dad and Mom moved to Florida when he was eighteen. Well, now Dad's dying and Laf's brother says he ought to come down and visit. Laf has his own problems, but he does eventually make some phone calls to Dad, and the bond, tenuous though it is, is reestablished. At long last, Laf flies to Fort Lauderdale. In my manuscript, Laf's brother picks him up at the airport and as they drive down Federal Highway to Dad's place, the cell phone rings. Laf's father is dead. Cut to the funeral. I thought, That's clever how I handled that. So tragic that Laf waited a day too long to visit, and so on. My editor Jill read the manuscript and said something's missing, isn't it? The father, she said, and I knew. You lead up to the scene for the whole book and then you don't write it? Well, I knew why I didn't write it. It was going to be difficult. Jill, of course, was right. I wrote the scene. And in so doing I finally got to know the father. And so did Laf.

Maybe this is a good opportunity to spend some time getting to know Kenneth. So we write about him. We find out that he is in a lot of pain himself. This is the most difficult and most vicious thing he has ever done. He had thought he was incapable of such cruelty. We found this out because we asked a question, and then we shut up and let him talk. We wrote down what he said. He's confused. He can't imagine not being with his kids. He can't believe that he would hurt someone whom he thinks he still loves, but may no longer feel passionate about. He feels frightened more than anything else. He's unhappy, and so is Ruth. He can see it. They've become dull, habitual, uninteresting. He has to do something. He doesn't want to wake up at sixty and find out he's wasted his life. Maybe that's too strong. Doesn't want to go through the motions. That's better. It's not Ruth he feels shackled to, but the marriage.

And now that he's taken the first step, he knows he can't go back. How

much crueler would it be to go home now, only to leave again in a month or a year, to put Ruth through this hell again. Or worse, to stay with her but live his real life elsewhere. He doesn't want to drown in resentment. When he looks ahead to the best possible ending, he sees himself and Ruth, best pals, sharing a drink, talking about their marvelous and successful and entirely well-adjusted kids. He's starting to drift into a fantasy world. We take what he tells us at face value. Not everything rings completely true, maybe, but we'll have plenty of time to chat with Kenneth again. All of this note-taking has let us into Kenneth's thoughts and feelings. But we've decided to tell the story from Ruth's point of view, so we're not going to get access to Kenneth's thoughts and feelings in the story. He'll have to articulate them in speech or in actions.

We're thinking ahead to the scene with Kenneth and the kids, and so is Ruth. He's coming over Friday night after work. Meanwhile, the world intrudes on Ruth. The kids need rides to school and to practices and appointments, and her mother's been calling about Christmas plans—are they coming to visit or not?—and the kids want to know when Daddy's coming home. They miss him. Tischalynne keeps asking if everything's okay. Ruth pretends it is. She's hoping that she can convince Kenneth to come home and that no one will ever know that there was a problem. They're the Wymans, for God's sake—people are depending on them to prove that marriages can still work. And she begins to consider how many people would be affected by this divorce: her family—it'll kill her father; Kenneth's family; their friends— they'll have to divvy them up like books and CDs; the kids, the folks at the literacy program, at the PTA, the dance school, the Little League. What will Father O'Brien think? She's trying to pretend that everything's okay, but she breaks down crying at the supermarket, at the custard shop, at red lights. She can't listen to music, can't drive. She almost hit a child on a bike. She can't eat. The kids keep saying what's wrong, and she tells them she has a bad headache. She despairs, but then remembers Friday night when she'll have another chance to talk to Kenneth. He must be missing the kids. He must be tired of living in some cramped apartment. Ruth does not allow herself to think that the apartment might belong to another woman, that Kenneth might be finding all the solace and love that he needs. She is so hopeful she can't sleep.

We're making things difficult for Ruth because that's our job. We love her, care about her, but we're being as ruthless as we can be. And this is why.

The harder she tries to get what she wants, the deeper she digs into herself, into her emotional resources, the better we'll know her; and the better we know her, the better we'll like her, understand her, and care about her. Sometimes we may write a story and the plot seems to be structured just fine and the characters are interesting and active and all, but the story doesn't lift off the page. It might be that we didn't make it hard enough for our central character. So we put in more obstacles, see what happens.

We want to make it difficult for Ruth, but we don't want to beat her up. We want the obstacles to have to do with her struggle to save the marriage. We could have given Lucas cystic fibrosis, for example. Could have had the car die in the middle of a snowstorm. Ruth herself might have learned she has breast cancer. The mortgage payments could be months overdue. And we may decide that one of those things could happen. But we need to ask if it will serve the plot and not diffuse the thematic issues in the story. We realize that we've focused on Kenneth as the single obstacle so far. We understand there may be others. What about her own pain and humiliation? Is Ruth having to struggle past her own resistance to a reunion with Kenneth? What if she confesses to Tischalynne over drinks, and Tischalynne says, We all wondered when you'd leave the son of a bitch? Ruth doesn't understand. She's not leaving, he is. What did her friends see that she has been blinded to? And so on. We jot some notes. We'll begin to fill in the narrative in the next draft. But for now, we leap to Friday night.

Maybe Ruth has had her hair done. She's dressed the kids in their best clothes and warned them to stay clean or Daddy will be angry. She's prepared Kenneth's favorite meal. Is it porterhouse steak, baked potato, and salad? Or does that make Kenneth too ordinary? Or as ordinary as we want him to be? Let's grant Kenneth a culinary imagination. (Already we're thinking of the reversal at the imminent dinner table; can't wait to write it. But first—the favorite meal.) Ruth makes scallopini à la Bolognese, alternating layers of veal, prosciutto, boiled potatoes, Parmesan, all of it cooked with butter, eggs, ham, and cheese. (This is why we have cookbooks in our homes.) She checks the clock. We know that we'll set this scene, these scenes, in some other room or rooms than the kitchen. We do so because we want to find out more about Ruth and Kenneth.

Kenneth rings the doorbell, which Ruth doesn't understand. The kids go crazy. Kenneth gives them the new toys he's bought. A Malibu Barbie for Maddie and a video game for Lucas. Ruth makes him a martini. He sits with

the kids on his lap in his favorite chair. He looks around the room like he's never been here. So we can look with him. We're in the den. The photo of Kenneth and Ruth on their honeymoon in Barbados is still on the TV. The magazines on the coffee table seem to be neater than usual. The kids want to know what they're doing this weekend. Slow down, Kenneth says, one at a time.

They all sit down to dinner in the dining room. Years ago Ruth got on an Early American kick and bought this Ethan Allen set with captain's chairs and a leaf that allows ten people to sit down together to eat. She bought a hutch to match, a dry sink, and two primitive paintings of children playing with barrel hoops. Kenneth scrapes the prosciutto and potatoes to the side of his plate. Lucas says, Daddy, eat everything on your plate. Kenneth tells him, Daddy's on a diet. Ruth feels like she's been hit in the face with a shovel. Then it's true. The son of a bitch has a girlfriend. She stands and hurries out of the room. She has a good cry in the bathroom.

> *"I believe in not quite knowing. A writer needs to be doubtful, questioning. I write out of curiosity and bewilderment. . . . I've learned a lot I could not have if I were not a writer."*
> —WILLIAM TREVOR

She doesn't even recognize herself in the mirror. She can hear Maddie telling Kenneth that Mommy cries all the time. She doesn't want her tears to frighten him, doesn't want him running from her obvious pain. She pulls herself together. When the kids go to bed, they'll talk. And who knows, he may stare into the faces of his kids and realize what a fool he is being.

Later, back in the den, we see how hurt Kenneth really is, how wonderful and loving and honest he is with the kids. He tells them how he and Mommy need to spend some time apart. Ruth can't help it—she interrupts: Daddy needs to spend time apart. Kenneth does what he can. He hugs the kids, kisses them, tells them he'll call them every night and see them whenever they need him, whenever they want him. He's doing what he can. Ruth is beside herself. How can he go through with this? The kids are screaming. They want to go to Daddy's house. That wouldn't be a good idea, he says. Daddy has a roommate, Ruth says, and regrets it immediately. Kenneth tucks the kids into bed, reads them stories, comes downstairs when they're asleep, says good night. Ruth wants to know about the other woman. Kenneth doesn't try to deny it. Ruth says, What's going to happen to me? Kenneth says he wishes he could see the future.

Later, after several glasses of wine, Ruth calls the number Kenneth gave

her and leaves a rambling message on the machine. She tells him he's killing her. Tells him he's destroying the children's lives. Tells him no one will ever love him the way she does. Don't expect your bimbo to hang around for very long. Jezebels never do.

If we were allowing ourselves a chance to shift points of view, we might write a scene here where Kenneth and his girlfriend, call her Suzy, listen to the message. Suzy is so understanding, so appropriately guilty. She knows the pain Ruth must feel. She knows how this is tearing up Kenneth. They didn't want this, didn't want to fall in love. It just happened. She never dated married men, but it was different with Kenneth. They were soulmates. (Whoops! There's a word we never want to see in a story. Along with *unicorn* and *lifestyle*. It's meaningless New Age jargon, and if we wouldn't use it, we can't let our characters use it. We're no better, no smarter, no cooler than they are.) And then we might stick around and listen to Kenneth talk to Suzy, be more honest with her than he has been with Ruth or with himself—and isn't that why he loves her . . . if he does love her?—why he feels so much more *centered* (another buzzword we'll probably change later) around her? He can be himself. And maybe we learn that he doesn't want to live without passion in his life, and he has for too long. It's his fault, he knows, at least as much as it's Ruth's. The chemistry isn't there. They don't excite each other. (We're not sure he can speak for Ruth, but he is at least speaking honestly for himself.) He had begun to think of himself as sexless, joyless. That is, until Suzy. And so on. Now, if we think all this information is so intriguing and important that we need it in the story, then we'll rethink our point-of-view decision.

It's been a month since Kenneth left, and he shows no signs of coming back. The first night the kids went to their dad's for a sleepover, Ruth was miserable. She couldn't stand the silence in the house. She turned on televisions in several rooms for company. She thought maybe the kids would have a better life without her around. She didn't deserve this. No one should be abandoned by the people they love. No one should ever end up alone, never mind when they're thirty-five years old. But she's not alone, and she finds that out when she tells her friends and family, at last, what's going on. She gets nothing but love and understanding and attention. Tischalynne tells Ruth, Whatever you decide, I'll be there for you. Ruth says, I have decided—I want Kenneth and my family back, but I have no control over that. Ruth's Dad says she and the kids never have to worry about anything, not money, not a place to live, not anything, as long as he and Mother are around. What we're

exploring is Ruth's world, and we're learning things about her we didn't know earlier, and we see that folks are making it easier for her to move on. And she'll have to struggle against that as well, won't she? Are folks trashing Kenneth? Are they just as flummoxed (don't get to use that word enough) by his behavior as Ruth is? We'll find out.

Maybe a couple of events embolden her. Let's say on the next weekend that the kids are due to go to Kenneth's, Lucas and Maddie tell her they don't want to go. They don't have fun over there. Dad talks more to Suzy than to them. They never get to be alone and just play with him. She calls Kenneth and tells him. And then she realizes—maybe in a conversation with Tischalynne—that Kenneth has a strategy. He's not confused at all, not frozen with indecision. His not deciding what he wants *is* a decision. He's not going to go to counseling; he's not going to ask for a divorce; he's not ever going to bring the subject of their relationship up. And so he's forcing her to do it—forcing her to make the decision to say, I can't take it anymore. And that lets the son of a bitch off the moral hook, somehow, eases the guilt in his Catholic soul. Ruth calls him, tells him to meet her at the Brasserie on Friday for a talk.

Let's go back to our alternate definition for a moment. Motivations in collision. We need to think about what Kenneth and Ruth want from this dinner date. (The Brasserie, we decide, is their favorite restaurant. It's where Kenneth proposed to her.) Ruth is still trying to save the marriage, but she needs Kenneth to decide, and decide right now. Decide to come home, to try counseling—and to do so he needs to leave his little missy—decide something. Have the goddam courage to do something. Think about other people for once in your life. It's a risk she's willing to take. No going back.

Kenneth, on the other hand, is more convinced than ever the marriage is over. He believes in new beginnings. He realizes he can still be what he always wanted to be. He can change everything. He can be in a dizzyingly romantic relationship and still be a fabulous dad. He can take control, begin to live an adventurous life. And as a happier man, he'll be a better father, a more creative and productive administrator, an ardent lover. He'll be fulfilled. He doesn't know how he'll say this. He's glad that Ruth suggested the restaurant. There wouldn't be a scene in a public place. (Of course, we already know he's wrong about that.)

We just mentioned Kenneth's job and it occurs to us that we haven't exploited it yet. How do we work the fact he's an administrator, a literacy

expert, into the story. Should we? Work must account for much of Kenneth's idea of who he is. Like the rest of us, his way of looking at the world is affected by his job. A photographer, for example, looks at a landscape in a different way than a furniture salesman, let's say, or than a developer (the one-word oxymoron). Our figures of speech come from our work, as does our way of speaking, to some degree. Maybe we could exploit the irony in the fact that Kenneth teaches people how to communicate, but seems unable to do so himself. Is that too obvious? Too easy? Maybe he should have a different job. He's in social services—that's how he met Ruth in the first place. Let's say he's a counselor for troubled youth. His awareness of his own children's anxieties is heightened. He's a listener by trade, then, a clarifier of problems. Let's go with the job change and see if we can work it into our scene at the Brasserie.

Ruth is there first. Ruth made the reservations. She's on the cell to the kids when Kenneth joins her. He kisses her on the cheek. She hands him the phone. He talks to them, tells them to have fun at Tischalynne's, says he loves them. Ruth and Kenneth order dinner and drinks. The conversation is cordial. Ruth is trying to assess Kenneth's mood and intentions, and she is, she realizes, giving him the opportunity to broach the unavoidable subject. She is disappointed, but not surprised, that he doesn't. He could go on with this small talk all night. Ruth tells him she needs him. She says no matter what he decides, she'll always be there for him. She had one great love in her life and he is it. There won't be another. But you have to decide what you want. I can't wait around while you equivocate in your honey's arms. She knows that the longer he's with Suzy, the harder it'll be to get him back. He falls back on his *I'm confused* excuse. He tells her he's started therapy to help him work out his issues. Ruth says she's happy for him, and even she's not sure of the tone of her voice, but she's not waiting for his eventual therapeutic epiphany. He needs to decide tonight. No, she's not kidding.

The handsome waiter brings the dinners (blackened swordfish for him [are we trying to poison him with mercury?]; grilled Atlantic salmon for her) and this gives us a moment to consider what's going through Ruth's head. She's waiting for an answer, but she has more to say. She wants to say she feels humiliated by him. He's made her feel unlovable and unattractive. But if she says all that, he'll only get defensive and withdrawn. She wonders if she should tell him that she has parked outside his love nest on many nights, staring at the apartment windows. Should she admit that she was the vandal

who hammered in the driver's-side window of Suzy's Tercel? (I sense a possible title in that word: "Vandal"? "The Vandal"? "Vandals"?; the Vandals were fifth-century barbarians so wanton in their destruction that their name entered our vocabulary; they were unable or unwilling to put down roots, satisfying themselves with plunder.)

We hear utensils scrape the china plates. We hear Kenneth's jaw cracking as he chews. We note he's chewing more methodically than he usually does. We can hear, and Ruth can hear, bits of conversation from other tables, the piped-in classical music, a diner's hearty laughter. We've just discovered how to write silence—describe unobtrusive noises. Ruth says, I'm waiting for your answer. Surely you've had time to think about this. Surely you've thought of nothing else. He says, It's not as simple as you're making it out to be. This is an important decision, he says. She says, You bet it is. Tell me, Kenneth, are you coming home or not? Try being honest for once in your life.

Kenneth says, You sound angry. I understand why you're angry. Maybe if we explored your anger— Ruth interrupts. Don't use your psychobabble bullshit on me, Kenneth. I'm not one of your fucking juvenile delinquents. Heads turn at nearby tables. Kenneth says he won't stay here if she's going to act irrationally. Ruth says, Then tell me what you want from me.

We look at Kenneth. He puts down his knife and fork. He takes a deep breath. He says, All right, you want honest, I'll give you honest. He speaks calmly. He tells her he's not coming back. She cries. He says, You know, you always want to talk, but if you don't hear what you want to hear, you cry, and that effectively ends the conversation. Are your tears more honest than my words? Do you want to hear this or not? She calls him a bastard. (Another reversal, we note: This is not what she had planned.) She accuses him of not ever loving her. He says he always thought he loved her, but now that he has experienced real love, he sees he did not. And maybe the scene escalates further. Ruth's tears enrage Kenneth. Once he gets going he can't stop himself. He doesn't even care who overhears him. He tells her to get a lawyer. She tells him she'll take him for every penny he's worth. Says she'll get the house, get everything. He says she can have everything. She says he'll never see his kids. He says, No court would agree to that. Let's talk sense, he says. It's over, where do we go from here?

Maybe that happens or maybe they both are too afraid to push the issue any further. They mollify each other for the time being. Ruth because she needs the hope to go on living, Kenneth because he needs to think he's being

as considerate and caring as he can be, given the hideous circumstances. We'll find out when we write the scene. At any rate this brings us back to the definition.

Let's see, a central character who wants something, goes after it despite opposition, and as a result of a struggle, comes to a win or a lose. There must be a *resolution*. The central character gets or does not get what she wants. Kenneth runs off with Suzy. (We make a note to get to know Suzy better than we do. She's not central, but she's integral. We don't even know how old she is. We need to know her history as well. [Every story is many stories.]) Or he agrees to go to marriage counseling to try work things out. He's not promising anything. He's had to break up with Suzy when he missed his kids so terribly and saw their pain. He'd try to make it work for their sake. Maybe he thinks it won't work, but he'll be the dutiful husband with the mistress across town. And then he remembers how he dreaded turning into that person.

> *"Listen to your broccoli, and your broccoli will tell you how to eat it."*
>
> —MEL BROOKS

The opening lines of a story are a contract with the reader to finish telling the story that is begun. Don't change stories in midstream. We can't have Ruth suddenly fall in love with that waiter, for example—that's another story. If we keep our side of the bargain, the reader is likely to keep hers. We'll tell the reader about Ruth's struggle to save her marriage, and the reader will keep on reading generously. Remember that we don't need the resolution of Ruth's life, just the resolution of the problem. As a result of this action, the plot, the central character is changed. (And as the central character changes, so will the reader if we've done our job. She will have the emotional response that we've engineered, that we've enabled her to experience, and she will understand something about her life that she didn't understand previously.)

The change in the central character can be dramatic. Ruth is alone, but realizes that she has the strength to go on. Or she gets Kenneth to agree to come back. We're all hopeful the marriage will be saved. Or the change can be more subtle, like the revelations Joyce called epiphanies. Ruth sees Kenneth with Suzy, and what she sees convinces her that she has never given him the love that this woman displays. Or how about this bit of irony? Ruth and Kenneth are back together. We need to think scene again to close the story. She's gotten what she has struggled so courageously for. We admire her so. We like symmetry, and so we decide to close the story where we started it.

In the kitchen. Ruth is at the table, drinking her coffee. She's reading, but maybe it's not the paper. (We're thinking we need to illustrate the change in Ruth, not just note it.) Kenneth comes downstairs, pours his coffee, gets the cream out of the fridge, the sugar out of the cabinet, and stirs them into his cup. (Is this a change in the norm—has Ruth been in the habit of setting the cream and sugar on the table?) He kisses Ruth on the forehead and sits across from her. He opens the paper. He slurps his coffee as he drinks. Ruth watches him move his lips as he reads the sports page. She's beginning to realize that getting Kenneth back is not the victory she had expected. In fact, it's a prison sentence, isn't it? She is married, yes, but she has been so humiliated and hurt by him that she knows the relationship can never be the same again and that she will never stop resenting him for the pain. She knows that she's the loving one, that she's the strong one (she's had the strength to be weak), and yet she's the one who suffered and who has been made to feel guilty and inadequate. And now we see what she's reading. The book that Kenneth likes so much. The one he asked her to read. The one he talked so much about in counseling. It's something by Wayne Dyer called *Manifest Your Destiny*, and it's full of all that Joseph Campbell kind of crap like "Follow your bliss," something only a man could say, and only a man could get away with.

We have a simultaneous reversal and recognition. How do we end? Not with her thoughts. Too static, too literal. What we'd like to have happen to the reader is that when she closes the book or magazine, the final image stays with her, and she can't get that haunting picture, that freeze-frame, out of her head. What is different about that kitchen from when we first saw it? A difference that might indicate an emotional change? Is the answer out the window? Is the grape ivy dead? We can be more subtle than that. Is it something about the cowgirl on the back of her robe? We're not sure yet, but we're confident now that after another draft or two or three, after looking more closely, after spending more time with these two, after getting to know them better, we'll find just the image we need. And probably we'll be watching Ruth do something in that final sentence of the story that so moves us, that is so surprising, and is so right, that we are stunned. We didn't know we could write this well. And we put the story aside and enjoy the moment, walk around town like we own it, knowing that in the morning we'll have the great pleasure of getting back at the story once again.

EXERCISES

.....

Steal This Plot

Let's do what Shakespeare did. Let's borrow our plots. What you'll do is take a Shakespearean play or a work of classical literature or folklore and write an outline of it. You get ten minutes for a novel outline and five minutes for a short story. Only you will change the time and the place and the characters. What you'll end up with is your own plot, but with allusions to a classical work. The way, say, *West Side Story* is not *Romeo and Juliet*, but certainly owes a debt to the play. James Joyce used *The Odyssey* for *Ulysses*; Jane Smiley used *King Lear* as a model for *A Thousand Acres*, and so on.

Here's one I did in ten minutes: The patriarch of New York's Mastrovito crime family, Aldo "The Cat" Mastrovito, is murdered in the Casa Mia Trattoria during the San Giovanni festival. Rumor on the streets has it that the hit was ordered by Aldo's own brother and capo, Nicky Mastrovito. Nicky had already seduced his brother's wife on a recent Vegas holiday. He may have been worried that word would get back to Aldo soon enough, and he decided to act. Nicky was a natural, of course, to take his brother's place at the head of the family, which he did. Not long after solidifying his position, Nicky married his ex-sister-in-law, which raised a few eyebrows in Little Italy. But, understandably, no one was in a position to object. No one, that is, except Aldo's son Carlo, the natural heir to the family business before the recent tragedy. Carlo receives his father's eye in the mail and with it an anonymous letter that fingers Nicky as having, indeed, ordered the assassination. Carlo knows that he has to avenge his father's death. But Carlo is no ordinary mafioso. He's a student at NYU, a theater major. This will be the performance of his life, he knows. He has to convince his mother and uncle that he suspects nothing, in order to get close enough to Nicky to kill him. He counterfeits madness to escape the suspicion that he is a threat. He quits school, hangs out with some bohemians in the Village, pretends to take drugs and drink. He turns on his girlfriend Annette, the daughter of Nicky's right-hand man. Their relationship deteriorates and he allows it to. He cannot let Annette into his confidence. She grows distraught. In an effort to seem on

the road to recovery, Carlo accedes to his mother's wishes and gets involved with an off-Broadway theater company. A year has passed and he has had several opportunities to kill his uncle but he has hesitated. Was he lied to? Did he have proof? He has lost the rage he once felt and needs it restored. And he needs to get that proof that Nicky is really responsible. He writes a script for the small acting company and invites his mother and uncle to the premiere. The play is about the murder of a mafia don. And so on. Annette, depressed, kills herself. Carlo mistakes Annette's father for Nicky and kills him. Nicky realizes now what's going on, and he wants his nephew killed, but needs it done discreetly so as not to upset his wife overmuch. He hires a couple of Carlo's actor friends to take him for a ride and kill him. But Carlo turns the trick and has them killed by a rival mob. Annette's brother Paulie hears of her death and goes after Carlo. They all die. You recognize the plot of *Hamlet*.

Try making Odysseus an American Marine officer who tries to make it home after the bombing of the Beirut barracks. He falls in with a CIA plot and gets arrested, ambushed by the Intifada, escapes to Germany. He is in the underground and is saved by a young woman named Clavdia with whom he falls in love. And so on. Epics, of course, lend themselves to novels, while smaller pieces, like those in Ovid's *Metamorphosis*, lend themselves to short stories. Try a few of these. Take out the play, the poem, the novel, and write it fast. In ten minutes you have the outline of an entire novel. Tomorrow get to work on it.

Here's another plot that we want to be a novel. We open with trouble and with the central character. The wife and mother. Call her Maria. She wants her husband back because she loves him and can't imagine living without him. She's in her kitchen. It's raining outside. The dishes aren't done. She weeps and carries on. A friend tries to comfort her. As they talk we learn that the husband—let's say he's a public figure, a hero, an athlete, for example—has left her for another woman from a prominent family. All she's ever wanted to do is please him. The friend, we see, is worried that Maria is suicidal and may do something horrible. The children happen onto the scene and are disturbed by their mother's weeping. Maria's response to the children is anger. They bring the father to mind, perhaps. The friend tries to tell Maria that this is not the end of the world. It will seem better soon. Her children, her friends all need her, care for her. Life will go on.

Everyone considers the husband, call him Jay, an admirable figure, but we learn that he is not. He's been abusive and domineering. Another friend calls, wishing Maria well, offering support. Maria and the friend drink wine, listen to Billie Holiday on the CD player. She seems a bit more restrained. Talks about her love. They complain about men and husbands. How they are tyrannical, mercurial. She wishes her family were here in South Florida, not still in New York. She feels so alone.

She sees her husband's photo in the paper with his new girlfriend and the announcement of their nuptial plans. With the couple are Maria's own children, smiling for the camera. He has started the divorce proceedings and a custody fight. Now all Maria can think about is revenge. She vows to her self to kill the husband and his girlfriend. She considers ways of pulling it off. Hiring someone for the job. A fire at their house, and so on. Clearly these are fantasies. But then she makes threatening phone calls to the other woman. Confronts her and gets physically abusive. Charges are filed. Her own lawyer tells her this is not going to look good in the fight for the kids, for alimony and all that.

Jay comes to persuade Maria to let him take the kids for a weekend snorkeling in the Bahamas. She refuses and confronts him with his despicable behavior. He confronts her with her outrageous behavior but then offers to work out a comfortable and amicable financial settlement for her. He tells her her life without him will be a better one—he reminds her how they fought, how she always complained about his traveling, his social obligations, how no one ever treated her as an individual, just as his wife. He says he loves her, but this is for the best. He is calm, collected, restrained in the face of Maria's furious rebuttal.

She makes arrangements to go on holiday. We're not sure why. Perhaps distance will help her forget Jay, get over her loss. She asks Jay if he and the girlfriend will watch the kids while she's away. He agrees and is happy she is becoming more reasonable. He arranges a dinner for all of them. They talk it over. The scene at the restaurant is tense, but Maria manages to act civilly toward Jay and speak courteously about the other woman, Grace, who has not come. The kids are excited at the prospect of a long holiday with Dad. Maria is contrite, apologetic for the way she's been acting. She needs to relax. The friend was right—time heals all wounds. She cries when saying good-bye to the kids, gives them instructions, hugs them. She decides that she can't let them go after all. They put up a fuss.

When she picks up the kids in the morning, she sends the little girl back to Auntie Grace with a gift, a token, a truce offering, she calls it—Godiva chocolates.

And so it goes. The other woman dies from the poisoned chocolate. Maria realizes what she has done. Her life is ruined. Her children will be taken from her. She's overwhelmed with anger and confusion. It's Jay who should be ruined, and all he is is a martyr, a figure of sympathy. She cannot control herself. She decides to take from him the one thing that will affect him. She murders her children quite brutally. Then she calls and tells him. His love, she tells him, was too feeble. And this is his punishment. This is what he'll have to live with. Well, of course, this is *Medea* by Euripides (and may remind you of the Susan Smith story, the South Carolina mother who drowned her children in her car). Ten minutes, and now I can write for the next four years.

A Stranger Rides into Town

Here's a familiar plot device, a staple of stories for centuries and more recently of action movies and TV shows: A stranger rides into town. Who are the significant strangers in your life? Remember when they came riding into your life, how they came, why they stayed or why they eventually left. What about those who remained as strangers, yet had a significant impact on your life?

What about that party you were at when you heard a particularly intriguing and strange voice, or you heard the door shut, or you heard someone whisper, and you glanced up from your conversation and saw this person you had never seen before, but you couldn't take your eyes off him? Write about getting to know this stranger.

Or remember those times you have been a stranger in a strange room. Perhaps you changed schools and got dropped into this sixth-grade class of longtime friends and you were scared to death. Remember that first lunch in the cafeteria, how you didn't eat, how all you wanted to do was talk your father into moving back to Illinois.

The Quest

Here is another familiar plot line: A person sets off on a quest. What in your life have you started out to find? Did you find it? Why? Why not? Have you given up? What are you seeking now? Where are you looking? Would you recognize your grail if you found it?

Specifically, what journeys have you made? Write a narrative about a literal or figurative journey that you've taken. Did you move when you were young? Do you remember the first day you walked to school or took the bus? The first day you crossed the street? What has been your most important journey? Crossing a room can be as perilous as crossing the Atlantic. Think of yourself as Columbus on a serendipitous exploration, or as Beowulf in search of Grendel, or as Odysseus just trying to get home despite danger and distraction. Think of the time you went to your girlfriend's mother's wake to comfort your girlfriend, you thought, and you caught a ride home with her friend, and you didn't know it then but you had discovered your future wife. Call the story "1492" or "Columbus's Wake" or something.

On my first day of school, preprimary, at Sacred Heart Academy, I was four and I missed the bus home. We lived across the city in a housing project. My mother, of course, was frantic. The nuns took me to the convent and fed me milk and Oreo cookies. They called a neighborhood doctor who drove me home. I have learned to trust in fate.

Love and Marriage

Here's an excerpt from Chekhov's notebook in which he sketches out a plot to a story that he did not write. You get to write it. In a sense, it is not a plot yet. It is more like an anecdote. The motivation is not supplied, the causal relationships between events need to be explored. However, it is a terrific anecdote from the master of the small moment and the telling gesture. Now you can concentrate on character. Character, of course, is the heart of fiction. Plot is there to give the characters something to do. Here it is: "N., a teacher, on her way home in the evening was told by her friend that X. had fallen in love with her, N., and wanted to propose. N., ungainly, who had never before thought of marriage, when she got home, sat for a long time trembling with fear, and not sleeping, cried, and towards morning fell in love with X.; next day she heard that the whole thing was a supposition on the part of her friend, and that X. was going to marry not her but Y."

How will you tell the story? Let's think about this. What do you have to consider? First off, I should say that you should set the story in your world and not in Chekhov's Tsarist Russia. You have a central character N., whom you will baptize with a name. Who is the narrator? What is the voice that tells the story? What point of view will you utilize to get the story told? You

probably can't answer these questions yet, but you must start to think about them. What tense? You need setting. Where is this taking place? In what season? What year? Fiction exists in images, and images come to life in scenes. You know: Show, don't tell. What are the obligatory scenes that you must write? And where do they take place? In her living room, perhaps? So what does the living room look like? Smell like? Sound like? On the subway? What are the ads in the car? the graffiti? What do you know about this woman? What do you need to know? How does she talk? What's her voice like? Her friend's voice? Mr. X.'s voice?

Remember that a story is always trying to get at the business of human nature, to tell us that this is what it's like to be a human being and this is how it feels. To do that we have to get below the surface. Below the action and down to the values and motivation. The important question that the story must ask is: Why? Not: What? *Why* does N. do what she does? One thing she does is fall in love with X. Why? How did that happen? What else she does you'll learn as you write.

Plottery

X

Life is very nice, but it lacks form. It's the aim of art to give it some.

—*Jean Anouilh*

An idea is not a story. A first draft is not a story. A moral is not a story. A character is not a story. A theme is not a story. A plot—now, that's a story! So where do I get me one? you might ask. At your writing desk. Because plots don't exist. They can't be shopped for or ordered on-line. They are coaxed into being. They develop. They grow in the course of the writing. A plot begins to form as soon as you begin to ask yourself the appropriate narrative questions: What does my central character want? What is preventing her from getting it? What does she do about the various obstacles in her way? What are the results of what she does? What climax does this all lead to? Does she get what she wants in the end? Plot, then, is the element of fiction that shapes the many other elements—character, theme, point of view, language, and so on—into a story. It's the organizing principle of narration, let's say. It's the *what happens*, the action. The critic R. S. Crane explained plot as "a completed process of change." Joyce Carol Oates called plot "the aesthetic approximation of gravity." Plot is the force that holds the universe of your story together.

When constructing your plots, don't be satisfied with a situation in which you can already see or sense a resolution of the struggle. In other words, don't conceive a plot with ease of execution in mind. The plot is not about you, but about the characters. And it's not about ease; it's about

obstruction. You ought to think of situations which seem unresolvable. A young couple at a Delaware motel toss their newborn baby into a Dumpster.

Aristotle, our first drama critic, defined plot, in 355 BCE or so, as the structuring of the events of the story. He considered plot more important than character. Indeed, he wrote that "a tragedy cannot exist without a plot, but it can without characters." But, honestly, can you think of a character-less drama that you'd watch or read? I can't. And as the questions proposed in the first paragraph suggest, you cannot separate plot from character. Think of plot as the solution to the central character's problem. Plot is what the character does to get what she wants. Perhaps, then, Aristotle was over-stating his case. And he would certainly disapprove of what some modern writers have had to say about the primacy of plot:

"I don't work with plots. I work with intuition, apprehension, dreams, concepts. . . . Plot implies narrative and a lot of crap. It is a calculated attempt to hold a reader's interest at the sacrifice of moral conviction." So spoke John Cheever. Not that he didn't develop plots, mind you, just that he didn't "work" with them. Nelson Algren said he just kept writing until his story found its own plot. (I'd have to confess I work in this same inefficient way.) Elizabeth Hardwick said if she wanted a plot she'd watch *Dallas*. George Eliot thought that conventional plots were a "vulgar coercion." Trollope considered plot the most insignificant part of a tale, and Flaubert longed to write a book about nothing, a book without a plot. (But he didn't, of course.)

On the other hand, E. M. Forster, in *Aspects of the Novel*, wrote, "Yes—oh dear yes—the novel tells a story." And went on wonderfully to explain the need for plot: "Neanderthal man listened to stories. . . . The primitive audience was an audience of shock-heads, gaping around the campfire, fatigued with contending against the mammoth or the wooly rhinoceros, and only kept awake by suspense. What would happen next? The novelist droned on, and as soon as the audience guessed what happened next, they either fell asleep or killed him. We can estimate the dangers incurred when we think of the career of Scheherazade in somewhat later time. Scheherazade avoided her fate because she knew how to wield the weapon of suspense—the only literary tool that has any effect upon tyrants and savages."

Perhaps Forster's key word here is *suspense,* the pleasurable excitement and anticipation regarding an outcome. That's what plot affords the reader. We don't know where we're going, and we're desperate to find out. Plot suggests that this tale we're reading is a journey we're on, that each narrative

step we take leads to the next step, and that all of our trudging will carry us to the story's ultimate destination, which, for now, remains a mystery. If we understand that we're going somewhere, and we sense that that somewhere promises to be intriguing, then we'll keep on walking. We don't need or want to know the specific destination; we just need the assurance that there is one. If we guess the destination, in fact, as Forster points out, we'll be angry or bored. A plot makes the reader want to know what happens next. And that's a good thing.

Let's get back to Aristotle. We may not completely agree with him, but he's Aristotle, after all, and we're not. He's smarter than we are, and we need to listen to what he said. He explained the importance of plot by arguing that tragedy is an imitation of a life, of action, not an imitation of men. He felt that the purpose of tragedy (he based his theories on the great Greek dramas of Sophocles and Euripides) was to touch our hearts, to move us

>
>
> "A film should have a beginning, a middle and an end, but not necessarily in that order."
>
> JEAN LUC GODARD

emotionally, and he felt that the most powerful means a dramatist had for swaying our feelings were the reversals and recognitions of plot. A reversal (*peripety*), you'll remember from our earlier discussion, is a shift of what is being undertaken to the opposite in the way previously stated. A recognition is a shift from ignorance to awareness. The third element of plot mentioned by Aristotle is pathos, which he defined as "a destructive or painful act, such as deaths on stage, paroxysms of pain, woundings, and all that sort of thing."

So characters alone don't make fiction. Neither does disembodied action make fiction. Something has to happen, and characters must make that which happens happen. (Of course, less has to happen in a short story than in a novel, and so plot might be less important in a short piece than in a long one. We'll read ten pages of anything, perhaps. [That doesn't mean we'll like it.] In short fiction, revelation alone might serve as plot.) Henry James wrote, "When a character *does* something, he becomes that character; and it's the character's act of doing that becomes your plot." Can we, then, define plot as characters in action? Well, it's a start. The action must be motivated, of course, must be causally sequential, must be credible, must be compelling.

Rather than tell what Aristotle had to say, let's let him speak for himself. From "General Principles of the Tragic Plot" (in *Poetics*): "We have established, then, that tragedy is an imitation of an action which is complete and

whole and has some magnitude. . . . 'Whole' is that which has a beginning, middle, and end. 'Beginning' is that which does not necessarily follow on something else, but after it something else naturally is or happens; 'end' the other way round, is that which naturally follows on something else, either necessarily or for the most part, but nothing else after it; and 'middle' that which naturally follows on something else and something else on it. So then, well-constructed plots should neither begin nor end at any chance point but follow the guidelines just laid down." Beginning, middle, and end.

> "Irrelevance is a cloud and a drag on, weakener of the novel. It dilutes meaning. Relevance crystallizes meaning. No non-contributory image must be the rule."
>
> —ELIZABETH BOWEN

The middle of the story is the sequence of events that gives the beginning and the ending their significance, and it's the plot that encompasses them all, gives them a context. The basic formula for a plot, then, is the formula for a joke: setup, buildup, payoff.* Like this:

Setup: A man walks into a bar, sits on a stool, asks for a beer. The bartender draws a beer, sets it on the bar, tells the man he'll be right back, and leaves.

Buildup: Shortly after the bartender has gone, the man hears someone say, "You're looking good, my friend. Have you been working out?" The man says, "No, I haven't." He looks around the bar, but can't see anyone. The voice says, "Nice shirt. Goes well with the pants." Again, the man can see no one around. The bartender returns. The man says, "The oddest thing just happened. Someone's talking, but I can't see them."

Payoff: The bartender points to a bowl on the bar, says, "It's the peanuts. They're complimentary."

But a story is not a joke. Jokes and anecdotes don't make good stories, though good stories can be inspired by them. Anecdotes do not explore or reveal character. Stories do. Anecdotes are necessarily brief because they are so thin. The only thing that keeps us reading beyond the anecdote is the suspense, the wanting to know what lies ahead, the tension inherent in that mystery. No tension, no plot. No action is interesting for its own sake. Don't confuse motion with movement. Movement is motivated motion.

* Alice Adams's formula for constructing a short story goes ABDCE: Action, Background, Development, Climax, Ending.

Beginning, middle, and end. Setup, buildup, payoff. Exposition, development, resolution. Let's look at what we might as well call these "three acts." The beginning defines your major character and his goals. Aristotle says the character wants either happiness or misery. (Misery, however, seems all to easy to come by, doesn't it?) In the beginning, then, we have the initial action, the initial situation, the problem that needs to be solved. Let's say there's this woodsman, his wife, and their children who are near to starvation. And the wife persuades her husband to abandon the kids in the forest. (Yes, she's a *step*mother.) At least the two of us will survive, she argues. (Every action in a story needs to be motivated, even if the motivation seems horrific or inexplicable. Reasonless action undermines plot. Plot is all about motive.) At first the woodsman resists, but eventually he relents, though he seems heartsick at the prospect of living without his son and daughter. The children, who are still awake with hunger, overhear the scheme (the plot!). The quick-witted boy has a plan to save them. He'll leave a trail of glittering stones in the woods, and he and his sister will simply follow the stones back home. He sneaks out into the yard and collects the smooth white stones. The children are our central characters, the boy is our hero, it would seem. His goal is to keep himself and his sister in the relative safety of their home. Theirs will be an involuntary journey.

And then we get the rising action, the thickened plot, the middle of our story, as the character, call him Hansel, pursues his goals. The conflict— which is the center of every story—is explored. Here in the middle the character runs into problems that keep him, for the time being at least, from attaining his goal. And whenever his intentions are foiled, we get tension. Our boy's plan works that first time,

.

"Writing a plot summary makes the writing of the actual book a needless extravagance."

—JORGE LUIS BORGES

and the children walk back home in the moonlight and arrive by morning, much to the delight of their father and to the consternation of their stepmother. Well, that's wonderful, but not much of a story. It's too easy. The reader is not emotionally stirred.

So we ratchet up the intensity a bit. Get that wicked stepmother involved is how. (Why aren't there any wicked stepfathers in fairy tales?) Her plan is to drop the children even farther into the woods. See if they can make it back this time. Once again, the children overhear their father agree to his wife's

plan. (And you'll agree, I'm sure, that Dad's character needs work.) Hansel tries to gather his glittering stones again, but the door has been locked by the stepmother. He tells his sister Gretel that they should trust in God—always a bad idea in the best of fiction. In the morning, the resourceful boy crumbles the small piece of bread in his pocket and leaves a trail of crumbs as they walk. They'll simply follow the trail of crumbs back to their house. But the indifferent birds of the forest devour all of the crumbs, and the trail is lost. The abandoned children are worse off now than they have ever been. Their fortune has been reversed. Here they are, lost and wandering deeper into the dangerous forest with nothing to eat but the occasional berry.

Their decision to wander and not to sit and await their fate is a crucial one, of course. It leads to a marvelous discovery, a house built of bread and cakes. The ravenous boy eats the roof, the girl eats the sugary windowpanes, until they are caught by the old woman who lives in the house. At first she seems kind, but in fiction, of course, nothing is ever

> *"Plausibility lies not in the plot, whether it be myth, fable or fantasy, but in the treatment of it."*
> —GERALD BRACE

what it seems to be. The children enjoy delicious foods and sleep in heavenly beds. They might be tempted to stay here forever. One is perhaps reminded of Odysseus and the seemingly hospitable Circe. We remember the children's goal—to get back home to safety and love and father. A goal that cannot be attained by staying here. In a Homeric turn, the crone is revealed to be a witch intent on enslavement and cannibalism. Another reversal. Another violation of trust. What had seemed a providential discovery has become a catastrophe. The refuge has become a prison. The stakes are even higher than we thought. Gretel is to wait on the witch while her caged brother is force-fed and fattened for the witch's gruesome table. The resourceful Hansel manages to trick the half-blind witch by presenting a bone instead of his arm for her inspection.

A month passes (in a phrase). The witch has lost all patience and instructs the weeping girl to prepare the pot in which she'll cook Hansel. Gretel proves herself as wily as her brother and pushes the witch (a reincarnation of the stepmother?) into the flaming oven and burns the harridan to death. She releases her brother. It would seem that here Gretel has usurped Hansel as the central character. Gretel has undergone a great change, has learned that she can think and she can act. In recognizing the witch's evil

intentions, Gretel has discovered her own power, rejected her docility. She has found her strength, both physical and imaginative. As a result of the recent reversal, Gretel and Hansel's relationship has shifted, reversed.

The children discover a cache of precious gems in the edible house, are aided by a white duck who carries them across a river—hostile nature has become accommodating and beneficent. (It is Gretel again who has the wisdom to persuade the duck to help them.) They see their father's house. They begin to run. We're delighted for the children, but, unlike them, we are wary. We think this might be all for naught. Won't the stepmother simply exile them again? Won't the spineless woodsman once again acquiesce to her nasty wishes?

The payoff (the end, the logical conclusion of the beginning and the middle): The children throw themselves around their father's neck. The remorseful father is overwhelmed with love. His happiness is restored. The children's happiness is restored. The stepmother, we learn, is dead. Hallelujah! And now, thanks to the purloined jewels, they are rich. No more woodcutting for them, no more rations of bread. Plot's resolved, and only two women had to die. "Then all anxiety was at an end, and they all lived together in perfect happiness." (In our revision we might see to it that the children's actions have somehow caused the unexplained but convenient death of the stepmother and thereby returned the family to its idyllic conditions before she arrived on the scene.) We've had reversals: The birds eat the bread, the woman is a witch, rescue becomes incarceration. We've had recognitions, the moves from ignorance to awareness: overhearing the stepmother's plan, learning the witch's intentions (and doing something about it), Gretel's realization that her and her brother's lives depended on her action, trusting in the anti-Stygian duck to carry them across the river and back to their lives. And Lord knows we've had the woundings, the death onstage, and

> "Mystery is essential to plot, and it can't be appreciated without intelligence. . . . To appreciate a mystery, a part of the mind must be left behind, brooding, while the other part goes marching on."
> —E. M. FORSTER

all the appropriate pathos. We have our Aristotelian plot. Everything happens for a reason. The narrator has suggested a meaning from the events of the story. We understand who these children are by what they do. And note that there was nothing extraneous involved. Appear to digress, but don't. If an action can be taken out of a story without hurting the story, then take it out.

EXERCISES

.

Enquiring Minds

Ron Carlson has a series of stories about Bigfoot, the Yeti-like creature who supposedly inhabits the forests of the Pacific Northwest, among other places. That Bigfoot. You may want to read the stories in his early collections to get an idea of what this exercise can produce. (Or read Robert Olen Butler's *Tabloid Dreams* for similar stories.) Buy a few supermarket tabloids or borrow them from your neighbors before they toss them out. Peruse the headlines and the stories until you find an idea that is intriguing. The headlines are probably more important than the articles. The best writing in the tabloids are the headlines. For example, here's a headline: "Fishermen Abducted by Alien Craft." Now, I am not interested in the tabloid's version of what might have gone on in the craft. It's likely to be similar to the hundreds of other abduction stories it has run. But I find the notion intriguing. I am going to make the headline the title of my story. The headlines are designed to attract attention and they do. So why not?

So find your headline, use the headline as a working title, and begin to think about the potential story.* Your job is to write a story that treats this material seriously, honestly, that transforms it from exploitation and sensation to exploration and emotion. Look for the humanity in the event. Make the story your own. Do not sensationalize, do not sentimentalize, do not, in other words, do what the writers of the tabloid stories do.

So in my fishermen story above, I have many choices, of course. I can

* And here's a list of actual tabloid headlines. You can use these to get yourself started or find your own while you're waiting in line at the supermarket checkout lane. *Statue of Elvis Found on Mars!*; *Veggie-Eating Mother Has a Green Baby!*; *Gust of Wind Blows Midget Balloon Peddler 20 Miles!*; *Missing Baby Found Inside Watermelon! He's Alive!*; *Feminist Says Sex Attacks by Aliens Must Stop*; *Commies Will Try for the 4th Time to Destroy the World!*; *2000-Year-Old Man Found in Tree*; *4000-Year-Old TV Found in Pyramid!*; *Computer Talks with Dead!*; *Egyptian Mummy Is Father of My Child!*; *Wife Handcuffs Self to Husband for 10 Years . . . But She Can't Stop His Cheating*; *Bigfoot Cured My Arthritis*; *Adam and Eve Found in Asia*; *Lightning Turns Man into Woman*; *TV Preachers Are UFO Aliens*; *Aliens Stole Her Face*; *Are Your Friends, Neighbors, and Co-Workers Space Aliens?*; *Holy Cow Heals the Sick*; *Man Found Frozen in Block of Ice*; *Rush Limbaugh Urged to Run for President—By E.T.s from Space*; *Dog Boy Found in Cave*.

either accept that my central character—I'll call him Don—and his pal, Big Jim, were indeed abducted by aliens, or I can decide that they have made it all up. That seems like an important choice. Suppose I choose the latter. The obvious question, then, is why would they make up that story and let the public in on it, set themselves up for possible ridicule, and so on. I'll speculate on the reasons. I'll imagine what Don's home life is like, what he does for a living. What's going on in his life that might have triggered what some of us would characterize as desperate behavior. I can't forget that he might be just goofing around, but even then the questions persist. As I write about Don in my notebook, I'll find the clue or clues that will reveal the insights I need. I'll learn what it is that Don wants and why.

Badlands

John Steinbeck wrote The Grapes of Wrath *during the hard times of the* Depression. The people he wrote about, and the people he wrote the book for, could not afford to buy the book and may not have been able to read it. Then John Ford made the film, and it cost the moviegoer a nickel. Most of those migrant farmworkers, the subject of the movie, still could not afford to go. Woody Guthrie, who had the nickel, also had the solution. He wrote "The Ballad of Tom Joad," and in six minutes told the entire story of the film. The music carried the emotion that the lack of scene and character development in the lyrics left out. Bruce Springsteen's "Nebraska" is a careful retelling of the movie *Badlands*, which was itself based on the notorious crime spree of Charles Starkweather and Caril Fugate. (By the way, the films *Natural Born Killers*, *Wild at Heart*, *Kalifornia*, and *True Romance* were also inspired by the same murderous couple. So if you're looking for material, read the dailies as well as the tabs.)

Well, it's your turn to switch the tables. Take a song that you admire, one you find compelling, intriguing. Turn it into a story. Change the names of the characters if you want to. Change the setting, the gender of the characters. Make the story your own.

The Heart of Fiction

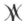

> The moment when a character does or says something you hadn't
> thought about. At that moment he's alive and you leave it to him.
>
> —*Graham Greene*

As *Graham Greene suggests, there comes a moment in the writing of* every story when your character surprises you. She says something you did not expect her to say, does something you didn't know she was capable of doing. This moment only comes when your imagination is deeply engaged with your material, with your story, with the lives of your characters. It comes in the third revision or the fourth, if you're lucky. And when it does, it means you have created a character worth knowing, a character with her own mind, a character who will not be manipulated by the author, a character who has become a person. And now you can step back and let the character get on with it. (Faulkner, when asked how he wrote *The Sound and the Fury*, said that he followed Caddy around and wrote down what she did.)* And until that desired but disconcerting moment happens, you can be sure you don't have a story yet. You're just pushing characters around like so many chess pieces. (The surprise needs to be credible, of course. When a character acts in an unbelievable manner, you're manipulating her to fit

* *The Sound and the Fury* was going to be a short story. And it all started with the image of, in Faulkner's words, "the muddy seat of a little girl's drawers in a pear tree, where she could see through a window where her grandmother's funeral was taking place and report what was happening to her brothers down below." A girl worth paying attention to.

your preconceived plot.) How do you get to the point where the characters rebel, as it were, where the characters speak for themselves? You get there by spending lots of time getting to know them (in your notebook) so they get a chance to tell you who they really are. And they aren't the two-dimensional figures you thought they were. Not by a long shot.

Character is the heart of fiction, every story's emotional center. We read stories for the people who inhabit them because we read to find out about ourselves, to learn something about the human condition. When we remember the stories we love, we remember the characters in them. We remember Anna Karenina, Holden Caulfield, Emma Bovary, Ignatius J. Reilly. We don't read for themes, though we expect to find them. We don't read for ideas or for style. We don't read to learn about the writer, certainly. We don't even care about the writer. To paraphrase Ezra Pound, great fiction has to be written, but it makes absolutely no difference who writes it. *The Sound and the Fury* is worth any number of Faulkners. Eudora Welty tells us about learning as a child that books were written by people and being disappointed that they were not natural wonders like trees or dogs. We may occasionally quote wonderful sentences to our friends, and we may admire the scintillating prose, but we are touched and moved and changed only by the characters. They become as real to us, as palpable, as alive as anyone we've ever met. (In fact, we know them better than anyone we've ever met, know them better than we know ourselves.) And they have an advantage over those we've met in that they will never die, even if they died in the story.

>
> "The character does something which is new and then the story begins to percolate."
> —WILLIAM KENNEDY

The first thing a writer needs in creating a story is tenderness for all of his characters. Characters are like children. Love them, be generous, indulgent, and forgiving. On the other hand, don't let them get away with lying, with exaggerating, with shirking responsibility, and so on. Characters need constant attention, reassurance, and love. You have to know your characters well in order to love them, and to do so you need to live with them intimately. They must be with you when you go to sleep at night, when you wake in the morning. Eventually, they'll find their way into your dreams.

You can never know too much about your characters. You know their fears, their dreams. You know their tics. Every character, you realize, has an imagination and memories, has suffered childhood traumas, has or has had

a mom and a dad. Every character has regrets. Every character has secrets. Every character has a public self and a private self and a self that he doesn't even know about. Every character has a history, a formative past. No character exists in a vacuum. A character is fully realized only when he or she interacts in a social context. At work. At the market. In traffic. To this point Arthur Miller said about plays that they have no characters, only relationships. If you leave a character alone for too long, you'd better think about some interaction soon. Fiction is people acting and reacting. Think movie, not photograph.

When you're writing your story, think of creating living people, not characters. Thinking "character" can sometimes result in caricature. Characters become real to the degree they are convincing. To be convincing they need to walk like us and talk like us. (When God was creating His people, didn't He make them in His own image and likeness?) They need to aspire and to fail. (People who are interested in success don't read fiction. They read self-help books.) We understand failure. Failure is endearing. We don't understand whining. The characters need to be ambivalent most of the time. Motivation also makes characters convincing—when we know why they do what they do. What makes mathematics interesting is not the right answer, but where the answer came from and where it leads. What makes fiction interesting is not what the characters do but why they do it. What happens in a story is the tip of the iceberg. In order to understand our characters, we ask why and we demand an answer. You want to love these characters, as I said, you want to feel for them, but you don't want to be nice to them. Slap them with one problem after another. This is

· · · · ·

"Character is destiny."

—HERACLITUS

how you and the reader will get to know them. It is the characters who teach us what love is, what nobility is, what kindness is. Who are these characters in fiction and why do we love them? What are they like? How do their lives and struggles reflect on our own?

First of all, central characters are never passive. You cannot write a successful story about a passive central character. And you wouldn't want to read one. The only people who are interesting are the people who do things. People who act. People who strive. You, for example, are reading this book not because of who you are, but because of what you've done: You have written, you are writing, you have a goal, and nothing is going to stop you from reaching it. The most common mistake of beginning writers is to create pas-

sive central characters. Boy meets girl. Boy wants girl—good so far. Boy sits by phone waiting for girl to call—not so good anymore. So, write no still lifes.

.

"Not just action, but action that depicts a state of mind."
—LEONARDO DA VINCI

Jerome Stern, in *Making Shapely Fiction,* warns us not to write a story called "The Bathtub." As soon as the water's drawn, we know the character's not going anywhere. Ernest J. Gaines says that every story should begin with a character in the middle of an LA freeway. He moves, or the story is over.

Compelling characters are those who set goals for themselves and who struggle to attain those goals despite obstacles. And it is through struggle, we know, that characters come to knowledge, and in no other way. About characters and action, Elizabeth Bowen had this to say: "The action of a character should be unpredictable before it has been shown, inevitable when it has been shown. In the first half of the novel, the unpredictability should be more striking. In the second half the inevitability should be the more striking."

Central characters are not victims and are not villains. (People always want to argue about this.) Yes, as we've said, some people may act villainously and others may be victimized, but this behavior does not define them. Life is not black and white. We are each of us saint and sinner. (And, of course, we're not talking about children, who may be perfectly good and terribly victimized.) The Christ we admire is the man, not the God, He who drove the moneylenders from the temple, who bled on the cross, who died. The purpose of a novel is not to fix blame. (Unless it's a murder mystery, I suppose, but even then the purpose is solving the mystery, not blaming.) What would be the point?

If you find yourself mocking a character, it's a good idea to think harder about him and find something for which you can respect him. Maybe the guy who seems so emotionally abusive to his girlfriend, so impatient and sarcastic and all, spends every Saturday afternoon at a nursing home singing for the patients. They love him dearly. He does it for free. On the other hand, if you find yourself admiring everything about your character, it's time to think harder about her to see what unflattering attribute will humanize her. She is irrationally jealous of her sister, though she would never admit it, not even to herself. She thinks no one notices how she never misses an opportunity to put Sister down. (Where did that jealousy come from? When in her childhood did it begin?) We have all learned from Chekhov that we cannot stand in

judgment of our characters. We are here to witness their behavior. And we should remember that it is a character's faults that make him likable. We care about people who are scared, who act foolishly, who are driven and derided by their vanity, as Joyce put it.

As a fiction writer you need to be the most honest person in town, at least while you write the story. And being honest, you know that you're not morally superior to your characters (or to your reader). To think you are is to have judged the characters. You may not like what a character does, but you have to understand—not excuse, but understand—why he does it. Tolstoy set out, we're told, to write a story in which a young mother who has an adulterous affair, who leaves her husband, her child, and her home to follow a rogue with whom she is in love, comes to her just punishment. But Tolstoy the writer, not the

> *"We want to know more about people who fail. We care about people who are scared, who act foolishly, who are tricked by their vanity and trapped by their desires. . . . Flawed characters are the unforgettable ones."*
>
> —SUSAN SHAUGHNESSY

moralist, ended up falling in love with Anna Karenina because as a writer he was honest enough to explore her values, her motivation, to ask why, and to listen to what she told him. That is the writer's job, the reader's job: to have an open mind and a receptive heart. Making up stories and reading stories increases your love for the world. The writer doesn't damn or beatify her characters, but she wants us to care about them, and so she sees that the characters deal with their behavior emotionally and morally, deal in some way with the consequences of their decisions and their actions.

Characters in fiction, then, make decisions and take responsibility for their decisions. We will not care about, nor will we read about, characters who point their fingers. Characters in fiction do not join support groups with other characters to whine about their misfortune and to blame their moms or dads or schools or politicians. Characters in stories can't get away with that nonsense. They are willful and responsible. They may, as a last resort, do whatever seems right to them, but they must (as we all must) accept responsibility for their actions. Even if what they do is done in the name of abstractions like God or country, characters must, unlike the good German soldier of the Reich or the good Marine lieutenant in Vietnam, take responsibility. No one will ever write the Ollie North story, although some arrogant and mur-

derous liar not unlike Colonel North might show up somewhere as someone's despicable minor character.

In the story "Guests of the Nation," Frank O'Connor's narrator Bonaparte is an IRA soldier guarding British soldiers during the Troubles. In the course of the hostage-holding, Bonaparte and the Brits become friends. When some Irish lads are killed elsewhere by British soldiers, Bonaparte and his friend Noble are commanded to execute their prisoners. The men are marched off to a bog, are shot, and buried. The story ends with Bonaparte's narration: "Noble says he saw everything ten times the size, as though there was nothing in the whole world but that little patch of bog with the two Englishmen stiffening into it, but with me it was as if the patch of bog where the Englishmen were was a million miles away, and even Noble and the old woman mumbling behind me, and the birds and the bloody stars were all far away, and I was somehow very small and very lost and lonely like a child astray in the snow. And anything that happened to me afterwards, I never felt the same about again." Yes, there is patriotism, and yes there is duty. But there is also common human decency.

Characters in fiction constantly surprise and startle us. Their behavior is at once consistent and unpredictable. If a character does not surprise, she is probably what E. M. Forster called a flat character, one without depth or dimension. Successful characters tend to be independent, eccentric, perhaps quirky. They don't always do what they are supposed to do. That's why we like them. They are, perhaps, free-spirited. They are people who hear the different drummer. They may sometimes behave bizarrely; they may express inappropriate thoughts; they will feel muddled and powerful emotions. They are not heroes. They are people on the margins of society. We hear a lonely voice (Frank O'Connor's term) and we recognize it as our own.

> *"If they aren't in interesting situations, characters cannot be major characters, not even if everyone else is talking about them."*
>
> —P. G. WODEHOUSE

Perhaps the most cynical thing a fiction writer can do is make a character a mouthpiece for his own political or philosophical ideas. If we, as readers, suspect that the character is just regurgitating the notions of the author (as we might with, say, Ayn Rand, whose sole concern is apparently for her own ridiculous ideas), that a character is being manipulated to suit the plot or the dialectic, then we put down the book. We must care about the charac-

ter. If we don't care for the character, we don't care for the story. (But then again, how could you take a writer [Rand] seriously who thinks the purpose of art is the objectification of values, and who could write something as silly as "Civilization is the process of setting man free from men," or as inept as "He liked to observe emotions; they were like red lanterns strung along the dark unknown of another's personality, marking vulnerable points"? Hello?)

Write about men and women, individuals, flesh and blood. Make them want something, hope for something, wait for something. Write about the problems of adults, even if the characters are children.* No dumb characters. Naïveté runs counter to what adult writers are trying to do—understand what it's like to be a human being and how that feels. No inarticulate heroes, whether they are inarticulate from innocence or alcoholism or any other reason. Drunks are not interesting. Drug

.

"A writer begins by breathing life into his characters. But if you are very lucky, they breathe life into you."
—CARYL PHILLIPS

addicts are not interesting. Not when they're high they're not. Nothing is more boring than war stories from the streets. And don't be an advocate for your characters. The more you try to say that your heroine is wonderful, the more the reader will look at her dubiously. If you say she's wonderful, but she acts like a worm, then your description was dishonest, and the narrator has lost his credibility. If she acts wonderfully, then you didn't need to tell us, did you? Don't make a claim for a character that you can't substantiate.

Where do these characters come from? Well, you can build characters the way journalists might do—look closely at the subject of your inquiry and observe carefully, notice everything you can. Look at his work, love, hobbies, past, future, desires, weaknesses, strengths, facades, and so on. That prevents stereotypes. Knowledge creates affection. A second way to build character is to put a cast together made up of parts of your various selves. Look at yourself and at the roles you play, the many characters you are—the artist, the mother, the cousin, the friend, the liar, the lover, the confessor, the supervisor, the son, and so on—and examine how each feels, thinks, dreams, and acts. Perhaps every character in your story contains a little bit of you.

* No children are interesting except your own. In order to be interesting, children need to be precocious, not necessarily intellectually precocious, but precocious nonetheless. To read how this is done, read almost anything by J. D. Salinger. His children are emotionally and intellectually precocious. We know they are paying attention to the world and to the people around them.

Think of people you know. The first thing about them you learn is their names, usually. Names are important. So give your characters the dignity of their names. As David Lodge said, names are never neutral. They always signify, if it is only ordinariness. *Huckleberry Finn, Holden Caulfield, Snopes, Ishmael, Humbert Humbert,* et al. Great characters have great names. And remember that the names you use will suggest certain traits, perhaps, social and ethnic backgrounds, geography, and so on. If you have a child, remember how much energy and time went into naming that baby. Take some of that care with your characters. If you are good, their names will be around longer than yours will. Don't use run-of-the-mill names. They are not memorable. Use a phone book to hunt up good names. If you're writing about Minnesota, get a phone book from there—the library will have them, or try on-line. Baby name books are good for first names. Names tell about parental aspirations (*Franklin Delano Smith, Chip*), tell how much a family is governed by its past (*Junior, Trip*), how much it wants to reject tradition (*Sunshine, Snow*). I know a woman from an old Yankee family, generations of Roberts and Jameses, who named her boys *Wolf* and *Sky*, short for Wolfgang and Schuyler. The central character in my novel *Love Warps the Mind a Little* is Lafayette Kosciusko Proulx. I can't even begin to write about a character until I get the right name.

> *"I have never taken 'Ideas but always characters for my starting point."*
> —IVAN TURGENEV

Lewis Nordan's novel *Wolf Whistle* deals with the very real murder of Emmett Till in Mississippi. Nordan knew he could only write the story using the real name of the character even though he knew he'd have to change it later. And change it he did, to Bobo, which was the real Emmett's nickname. Thanks to the computer, to "find and replace," changes like that are easy to make. Don't use names that look or sound alike. Roy and Ray, Don and Ron, Joe and Jim, MacDougall and McDonald. If you give a girl a traditionally male name like Claude or Bobby or if you use androgynous names like Pat or Chris, be sure the gender is established early. Take your time with names and you send a message to the reader about who the character is, where he came from, and where he is headed. Names influence the way a reader responds to your character. The narrator of the story should refer to the characters in the same way every time he mentions them. If he calls her Patricia now, it shouldn't change to Pat or Patty or Tricia later.

So you have a central character, and you know his name. Now ask yourself what he wants, why he wants it, what's stopping him from getting it, what will he do to overcome these obstacles. Once you know what he wants, you'll have a pretty good idea about what he needs to do to get it. So how do you bring this character to life? First, here's how not to do it: Don't give us an introductory capsule description of your character. *Robert "Rob" Bishop was six-foot-one in his stockinged feet. His once-sandy hair was fading to gray and now matched his alluring eyes. He put on his size-42 Armani suit jacket,* He could stand to lose a pound or two* . . . and so on. (And don't have a first-person narrator look in a mirror to describe himself—maybe into the bowl of a spoon if he notices he's upside down and his prodigious nose is alarmingly larger than it normally is.) We don't need the kind of information better suited to a police blotter. Height, weight, eye color, complexion, and so on are not usually important in a story, and they do not, on their own, reveal much about a character. We don't need to know that Cherise wears size $9^1/_2$ AAA shoes unless those shoes or those long, narrow feet will be important in solving a mystery. And if it's not a baseball novel, do we need to know that Mitch bats left, throws right? And keep this in mind: A character rendered too meticulously may not engage or convince the reader because the reader is left with nothing to contribute to the creation of the physical character.

>
>
> *"I'm sick to death of the inarticulate hero. To hell with the inarticulate."*
>
> —JOHN FOWLES

The best way to bring the characters to life is to animate them—get them moving and behaving—and invite the reader to watch them. Mark Twain said not to tell us that the old lady screamed, but to bring her onstage and let her scream. When you write fiction you are thinking with characters and not about them. Show, don't tell. The way we make characters live is to put them

* Brand names do not describe. An Armani suit might be black or striped, might have four buttons or three, narrow or wide lapels, and so on. Brand names do tell us something. They tell us that the character—and maybe the writer—are superficial to a degree. It's not enough to drive a car, the car needs to be a Lexus. They're not sneakers on his feet, they're Nikes. That might be important to your character and your plot. Nothing wrong with brand names—they lend a sense of the period. (Though they fade fast, don't they, and can date an otherwise fine story—does anyone remember Chic jeans? Earth shoes?) And they can help us see a product more clearly. Just know what else they connote. And don't describe by reference. She looked like a *Playboy* model. (They all look alike?) He was a dead ringer for Mick Jagger. (We doubt it.) This is lazy writing. One character might think another is as handsome as the young Chet Baker, but the narrator ought not to rely on what we suspect is wishful thinking.

in scene. We let them act, think, feel. We see them, we're not told about them. No descriptions of hands unless the hands are engaged in significant action—tightening around a slim neck, say, or caressing a rugged face. Same for eyes and for clothing. And dress is only important in a story when it is important to the character.

Keep us seeing the character throughout the story. Characters, like your friends, have only to be themselves to be interesting. And when your character does something, watch closely. See it all in slow motion, as it were. If he's doing something routine, let him do it in an odd way. If he's changing a light bulb, have him unplug the lamp, put on latex gloves, hold the bulb, and turn the lamp. We've learned something about him when he does it this way. Showing habitual behavior can be an effective way to characterize—small habits are revealing. But remember that patterned behavior like this is distinct from plot.

.

"Writing a story without presenting a meaningful opposing force is propaganda."

—RONALD TOBIAS

And in those scenes and in the summary, what else will make your character compelling? Give us information about the character. Where does he live and how does he live there? Is he there by choice? Would he like to be somewhere else? Where does he work? Where does he take his vacations? What does he do on a Saturday night? On Sunday morning? (Even if all of these questions are not important to the plot, they are important for you to know.) Give your character a rich internal life. She thinks in a way that no one else does. She has a unique take on life. Drop us into the thoughts and feelings of your character at opportune moments. Interior monologue can afford wonderful insights into a character, for instance. I think of every scene as an excuse to get into the mind of my character. When her father says, "My God, there's a car coming toward us," little Audrey thinks he said, "a car coming tortoise" and she gets the image of a shell on wheels and the shell looks like an army helmet, and she laughs and figures it'll never get to them, and she is oblivious when Dad pulls her out of danger.

What a character notices, what he listens to on the radio, what foods he enjoys, which smells he finds pleasant and which annoying, all tell us about the character. What a character says and how she says it tell us about her. What she says about other people tells us about her. What a person owns,

what he saves, what he enjoys tell us about him. What does her bedroom look like? What does she carry in her pocketbook?

You know that your central character must act and must be changed by the end of the story. And as the central character changes, so the reader will be changed if he is allowed to share in the humanity of the character. This sharing only begins when we know the character, because only then can we care about her. And before the reader can know a character, the writer has to know him intimately. A character not clear in a writer's mind will not be clear in the reader's.

EXERCISES

· · · · ·

Occupations

When I was a teenage bohemian hanging out at the Worcester Common or in front of Denholm's Department Store or at the Jersey Bar, my friends and I played a game that I always thought of as "Occupations," though we never called it anything. We would watch people walk by and we'd suggest to each other what this or that person did for work. The clothes, the walk, the gear, the hair, the eyes gave us our clues. It was never enough to say "lawyer." We needed to be specific: "Handles real estate transactions for the Catholic diocese, processes evictions." From the occupation we'd build a narrative by adding details of the subject's life, quickly before he rounded a corner or entered a building and before the next, more interesting figure walked by. Like this for our real estate lawyer: "His wife, Mary Kathleen, doesn't know about the new secretary, and if Phil can help it, she never will. Not until he's had his chance with this Kelly O'Brien at the regional conference in Hyannis next month. He's got two boys at St. John's Prep, both on the crew team, both going to be lawyers like the old man. His brother, John-Joe, Father John-Joe, S.J., is an alcoholic, but he's tucked away in a small parish in Athol, thank God." And so on.

And some years later, I saw *Annie Hall* and saw that Woody and Diane played the same game that we thought we had invented. The benefit of the game for writers is obvious. You get to practice character development, you learn how to build stories. So, try this. Go to a restaurant and get a table

where you can linger and observe. Do it at lunch, if you can. Lunch is when people expose their private lives. Look at the diners. Imagine what they do, what the home lives are like, what they are talking about, and so on. Just write about these interesting characters who have the benefit of appearing before you with physical descriptions and clothes, but with new, richly textured lives.

Everyday People

William Butler Yeats has said that we should write about ourselves when we are most like ourselves. We're going to try that now but with the knowledge that fiction can only be about trouble. Most of us are not spies and detectives and dashing young attorneys with the mob or the CIA after us. We don't go looking for trouble, in other words. But still, as we know all too well, trouble may seek us out and find us when we least expect it, when we are least prepared to deal with it. This exercise is designed to surprise ordinary people going about their daily routine, surprise them with potentially difficult but interesting problems.

Write a sentence in which a person is involved in an ordinary situation. For example: A stock boy at the supermarket is stacking canned goods on shelves. Or: A hansom-cab driver is sitting quietly in the twilight snow on a city street.

Now add a complication. The complication can come in the form of a person, a thought, a behavior, can come from the present or from the past. It can seem fairly innocuous or it can be boldly foreboding. For example, in the case of our stock boy: In walk these two girls in nothing but bathing suits. For our cab driver: His son has recently died. You may recognize these two situations as the beginnings of two brilliant short stories: Updike's "A&P" and Chekhov's "Heartache."

Try the exercise this way. List as many random and ordinary activities as you can in five minutes. Eating in a restaurant, riding the bus, writing a letter, voting, washing the supper dishes, etc. When the list is finished, go back and include a specific character performing each of the activities. A teenage boy washing the supper dishes, a nun writing a letter, and so on. This will be your opening sentence. Now add a sentence of complication. The nun's letter is a resignation after twenty years in the convent. The teenage boy sees the lights of his father's car enter in the driveway.

You might ask yourself "What if?" and let the answers guide you. What if a man out for a stroll on the beach finds a human hand in the sand?

Here are some examples of openings that could provoke stories, given some imaginative attention:

1. A bank teller gets off the bus at Third Street as she's been doing for the past six years. The bank building is being demolished.
2. A teacher reads the morning announcements over the intercom at his junior high. He begins talking gibberish.
3. A priest is giving a sermon. A young girl in the back of the church begins to scream.

Ask the questions suggested by the situation. Answer the questions and begin. Start with the reporter's questions and get more and more specific. Try these and write as many of your own as you can. Don't think of writing a story just yet—only an opening.

Eavesdropping

Sit in a public place. Sit near the most interesting people you see there. Get yourself a coffee, open your notebook. Be unobtrusive, but listen. Yes, you're a spy. Write down snatches of what you hear. You don't need to see the people talking, by the way. Try to capture their patterns of speech. No character speaks the same as another character. What does the person's speech tell us about him? About his education, about where he grew up, about his job, his self-esteem? Does the volume and pitch of spoken words vary during the conversation? Why? To what effect? (I just looked up *eavesdrop* in the dictionary. Of course, it means to listen secretly to the private conversations of others. I knew that much. But here's where it comes from, apparently. An eave is the projecting overhang at the bottom of a roof. In Middle English, *evesdrop* was the place where water fell from the eaves. Are you picturing what I'm picturing? A man supine on the roof, his head by the eavesdrop over the bedroom window, his hand to his ear? But then the *OED* straightened me out—you only had to be standing within the eavesdrop and listening to be an eavesdropper. Safe from a fall, but more likely to be seen. Anyway, it's a lot easier these days.)

Attributions

Take your central character and write his name at the top of a blank sheet of paper. (You can do this with all of your characters if you want.) Now list as many of his attributes as you can think of, including physical charac-teristics (look closely—an indentation on the earlobe suggests an earring in the past; the eyes?—what color brown are they?), hobbies, fears, worries, emotional hang-ups, dreams, things that he enjoys, sleeping habits, favorite foods, and so on. In short, everything that makes him him. Now you already know a lot more about him than you did five minutes ago. Pick one of the attributes and brainstorm ways in which that attribute might be exploited in terms of your story. Then revise your story with this new facet of character made visible.

The Method

X

*Our creative emotions are not subject to command and
do not tolerate force. They can only be coaxed. Once coaxed, they
begin to wish, and wishing they begin to yearn for action.*

—*Konstantin Stanislavski*

This is another chapter about your characters, specifically about getting to know them. I did some acting in college. I found that in order to know how my character would say a certain line, make a certain move, I needed to understand who he was, what his fears, hopes, secrets, and dreams were, what childhood traumas shaped him, what emotional forces drove him. And the evidence was not always on the page. I had to imagine the unseen and the unarticulated from the indications in the script. Once I began trying to write stories, I realized that I was using the same techniques from those acting days to get to know the people I was writing about, their values and their motivations. So I read books on acting to help me write stories. Interestingly, one of the best was by Michael Chekhov, Anton's nephew. It's a book called *On the Technique of Acting.* Michael Chekhov, it turned out, had studied acting with Konstantin Stanislavski, who later called Chekhov his greatest student. (Chekhov would go on to open drama schools in London and New York, where he worked with Jack Palance and Marilyn Monroe among others, and to act in Hollywood films, including *Song of Russia, Abie's Irish Rose,* and *Spellbound.*) Stanislavski, of course, was the director who staged the great plays of Michael's uncle Anton at the Moscow Art Theater.

(Anton Chekhov's admiration for and exasperation with Stanislavski has been well documented. You could read Henri Troyat's biography of Chekhov for more.)* At any rate, I read Stanislavski, and it's on his ideas, and on Michael Chekhov's, that this chapter is based.

To know, Stanislavski said, is to feel. What we as writers (like his actors) need in order to know our characters first of all is enthusiasm. We need to be eager to know and to feel. We have to be excited by our characters, by our themes, by the nut of the nascent narrative. Enthusiasm and understanding both evoke and reinforce each other. And our ardor, Stanislavski says, will allow us to penetrate what is not readily accessible. The writer should enjoy and relish what it was in his characters that first aroused his enthusiasms, the qualities that struck him about the character and to which he felt his enthusiasms respond from the get-go. Let me give you an example from my own work-in-progress.

As I write this piece, I'm also beginning to take notes for what I hope will be a novel someday. I don't have a title or a plot, but I have some characters. I almost always start with characters. A boy named Bix (the name might change), age ten at the moment, his little sister Audrey. Bix and Audrey live with an elaborately psychotic mother. The authorities can't know that Mom is crazy or they'll take the children from her and separate them from each other. What attracted me to Bix initially was his imagination, one, and his loyalty to Audrey. He's resourceful, fearless, spirited, and kind. He's Audrey's shelter. He creates a world that he and she can safely live in—it's an imagined world in part; in fact, it's several worlds. He convinces his teachers and social workers that his mom's as sane as a certified public accountant. No small feat. Then he convinces Mom that he and Audrey are being cared for by an imaginary family down the block.

* Troyat's rendering of Chekhov's death is based largely on the writings of Chekhov's wife Olga Knipper, an actress with the Moscow Art Theater. She was with her husband when he died of tuberculosis at a spa in Badenweiler, Germany. When Raymond Carver was writing his last published story "Errand," about the death of Chekhov, he borrowed heavily from Troyat. Actually he lifted passages whole cloth from Troyat. Large chunks of nine paragraphs, comma for comma, word for word. (Is this taking the Seventh Commandment of Writing Fiction too far?) Carver's genius was to introduce a fictional character into the death scene, a porter who arrives with the champagne ordered by the doctor. The blond young man is a masterful creation. He is single-minded, confused. In the morning he comes to the room with flowers for the "distinguished foreign guests." Olga instructs him on his errand. He's to fetch a proper mortician, but all he can think to do is bend and pick up the champagne cork from the floor.

And now back to biography. (And I learned this ironic business from Janet Malcolm's *Reading Chekhov.*) In his 1998 biography *Chekhov: The Hidden Ground*, Philip Callow describes the death scene, and in it he borrows Carver's fictional porter, Carver's silver ice bucket, and three cut-crystal glasses, Carver's very words. Biography, short story. It's all really fiction, isn't it?

What attracted me to Audrey were these old cowgirl boots—maybe they were her mom's!—that she wears everywhere. I even have a picture of them. Even in her pajamas, Audrey's wearing those boots. Even at the beach. When Audrey is forced to wear a dress, she wears corduroy pants under them, the pants tucked into the boots. When I want to know more about Bix, I think about what story he's making up today. I go to his imagination. When I want to know about Audrey, I look at her boots and wonder what she's up to. There's whimsy in those boots, I know, and in that flamboyant fashion sense of hers. The boots are Audrey's sense of herself, so that's where I need to go if I'm going to understand her. She's a mystery that I'm still unraveling. Right now I see those worn leather boots, the pointy blue toes, the white shooting stars on the red field, see the boots propped up on the coffee table where they are not supposed to be, see Audrey sitting there, crossed-legged, eating an orange, watching the TV, but there's nothing on. She's talking to her cat Deluxe. I listen in. She tells Deluxe all about a new singing group. They're these hip-hop vegetables called the Rapscallions. (Excuse me while I write that down.)

> *"Be sensitive to just a common stick leaning against the wall."*
>
> ROBERT HENRI

In the course of writing the story, if you get bogged down and feel your creative spirits flagging, if you are losing confidence in the plot, stop and remember why you started this journey in the first place—you wanted to get to know these people you were intrigued with. What was so beguiling about them? Why were you fascinated? Go there. Rejuvenate yourself. Get back in touch with your captivation.

To paraphrase Stanislavski again, a writer should be observant not only when writing the story, but also in her so-called real life. She should concentrate on whatever in the world attracts her attention. She should look at the object, not in a casual way as a passerby might, but with penetration and discernment. Some people are innately observant and attentive. Others of us have to work at it. Stanislavski said that in order to cultivate our critical powers of observation, we first have to observe the beautiful, and nothing is more beautiful than nature.

In *An Actor Prepares,* he wrote, "To begin with, take a little flower, or a petal from it, or a spider web, or a design made by frost on the window pane. Try to explain what is in these things that gives pleasure. Such an effort causes you to observe the object more closely, more effectively, in order to

appreciate it and define its qualities." What is it that makes a flower beautiful? Color? (Is one color really more beautiful than any other? Why is that?) Symmetry? Delicacy? Fragrance? All of the above? Does your knowledge that the bloom will fade, the flower wilt and die, make it more beautiful? (Do we bring beauty to the object?) And we are not to shun the dark side of nature.

.

"What is character but the determination of incident? What is incident but the illustration of character?"

— HENRY JAMES

Stanislavski urges us to look at the slime, at the plagues of insects, and find the beauty there as well. Pay attention, look beneath the surface. Understand why you have responded to the object as you have. You are looking for material that stirs your emotions. Specifically, you are not looking for the obvious in your character, what everyone can see, but for the truth of that character. A character built on truth will grow; one built on stereotype will shrivel. A story built on truth will grow; one built mechanically, formulaically, may well entertain and amuse for the moment, but it, too, will shrivel. A story built on truth you can read a dozen times and find something fresh and wonderful at each reading. A story built on formula you only read once. It doesn't get better. It spoils.

Let's stay with this idea a moment. I've said it before: Good writing confronts the human condition; formulaic writing evades it. Sure, you can study the bestsellers of the day and model your novel on one of them. That's easy because there is no depth there. What you see—blood, gore, robberies, drug deals, murders, arrests, courtroom histrionics, and all the rest—is all that there is. Everything is as it seems. It's far more difficult, however, to study a piece of—dare I say it?—honest literature and model your novel on that because the honest novel is not concerned with the machinations of plot, with what happens, but with the revelation of character and with why she does what she does. Nothing is as it seems. People who read escapist literature are reading to forget. People who read honest literature are reading to remember. Your job is to remember everything. So you can write to formula and produce a bestseller (not that that's easy, of course), but why not write something worthwhile, something that's more than merchandise? Write for the ages, not for today.

Take a look at the bestseller list for 1954: 1. *Not as a Stranger,* Morton Thompson; 2. *Mary Anne,* Daphne du Maurier; 3. *Love Is Eternal,* Irving Stone; 4. *The Royal Box,* Frances Parkinson Keyes; 5. *The Egyptian,* Mika

Waltari; 6. *No Time for Sergeants*, Mac Hyman; 7. *Sweet Thursday*, John Steinbeck; 8. *The View from Pompey's Head*, Hamilton Basso; 9. *Never Victorious, Never Defeated*, Taylor Caldwell; 10. *Benton's Row*, Frank Yerby. Six of these titles, including the first four, are out of print. Less than fifty years later. (Look up Morton Thompson on the Internet and you'll get "Morton Thompson's Turkey Stuffing," an elaborate recipe that actually sounds delicious and that was included in another Thompson book [also out of print] called *Joe, the Wounded Tennis Player*. I'm not making this up. The recipe turns up several times on the Net; *Not as a Stranger*, not at all.) *No Time for Sergeants* is better known as a play and a movie than a novel. Steinbeck's entry is a sequel to *Cannery Row*. Frank Yerby was my mother's favorite writer and is still the bestselling African-American author of all time. He rewrote the same book over and over. *The Foxes of Harrow, The Vixens, Captain Rebel, Floodtide*, etc. Privileged white folks down South, lots of violence, intrigue, and torn bodices. Costume novels, he called them. I once invited Mr. Yerby back to Augusta, Georgia, his hometown, for a writers' conference. He sent me a certified letter from Madrid telling me what a waste of time he thought conferences were—writers should be writing, not talking—and how he wouldn't return to Augusta under any circumstances, not even for the Key to the City. Here are some other, less popular books published that year which we do still read: *Lucky Jim, Lord of the Flies, Felix Krull, The Fellowship of the Ring, A Fable, Bonjour Tristesse*. We're not here to say what has been said, nor to write what has been written. To say something new, you must see something new. Concentrate your attention!

> *"An actor rides in a bus or a railroad train; he sees a movement and applies it to a new role. The whole garment in which the actor hides himself is made of small externals of observation fitted to his conception of a role."*
>
> —ELEANOR ROBSON BELMONT

Stanislavski said that without truth, clichés will fill up every spot in a character (and in ourselves) that is not already solid with living feeling. Truth is more important than technique. You may know how to write a splendid sentence, but if the sentence utters only the obvious, it is worthless. We already know that war is bad, abiding love redeems, power corrupts, nature is indifferent, and all of that. We know, so you don't have to tell us. Everything must be real, must be true in the imagination of the writer. She

cannot be satisfied with the appearance of a thing. She has to believe that taking the time and the effort and the concentration to look below the surface will result in understanding. She also knows enough to discard the first images she finds there. And this takes courage. First images may not be the richest or most profound.

Stanislavski teaches us to use our own life experiences and memories— our remembered feelings—to help us understand our characters. We work from an aroused emotion back to the source of it. As we come to know ourselves honestly, we come to understand our character who is undergoing a similar emotional state. People often ask me if the stories I write are autobiographical. In the sense that they are based on the facts of my life, they are not. But they *are* autobiographical in the sense that they are based on my emotional experience. In *Building a Character* Stanislavski writes, "Each person evolves an external characterization out of himself, from others, takes it from real or imaginary life, according to his intuition, his observation of himself and others. He draws it from his own experience of life or that of his friends, from pictures, engravings, drawings, books, stories, novels, or from simple incident—it makes no difference. The only proviso is that while he is making this external research he must not lose his inner self."

Feelings cannot be commanded, they can only be coaxed. Your character has been cuckolded by his wife and his best friend. This hasn't happened to you (we hope), but certainly other kinds of betrayal have. So you want to know what your character is feeling when he learns of the deception. He must be angry, you think. He must be hurt. What does anger feel like? And hurt? How does he behave when he is angry? When he's hurt? You cannot summon the anger in yourself. It won't obey. But you can go back to the time you waited on a corner of a cold street for two hours for the friend who was supposed to meet you. No apologies, no explanations. Just left you there. Or recall the "Dear John" letters you've received, or the "Dear John" voice mails you've listened to. Go back to those moments which you may be trying not to remember right now, which you've been merrily sublimating for years. And now you can feel the pain again, the anger, the humiliation, the shame, the whatever-it-is. You're beginning to understand now how your fictional husband feels. Work from there, from what Stanislavski called the emotion memory.

Michael Chekhov discusses another way to coax feelings. (Remember that you cannot force them to appear. The feelings will remain dormant despite your efforts. Our feelings are honest in that way. They do not lie. A

friend asks us how we are. We are depressed and anxious, say, because we've been laid off, and the bills are piling up, and we have no prospects. We don't want to feel that way. We tell the friend we're fine. Because we say it, because we want it to be so, does not make it so. We're still depressed. On the other hand, say our character is depressed for the same reasons. He really is, but in order for us to understand his feelings, we have to feel them ourselves.) Chekhov says that the means for inducing Feelings are Qualities and Sensations (his caps). Qualities are immediately accessible to you—especially to your movements. (Action is *what*; quality is *how*.) "You can immediately move your arms with the *Quality* of tenderness, joy, anger, suspicion, sadness, impatience, etc., even though you do not experience the Feeling of tenderness, joy or anger. After moving with one of those qualities, sooner or later you will observe that you are experiencing the *Sensation* of tenderness, and very soon this Sensation will call up a true emotion or *Feeling* of tenderness within you."

Here's the same advice in a therapeutic guise. In my first career, I was a social worker of sorts, a paraprofessional crisis intervention counselor. We ran a twenty-four-hour hotline and a drop-in center for teens. In our telephone and face-to-face counseling we used a technique we called "The Model," based, if I remember correctly, on the work of Fritz Perls and gestalt therapy. Basically, the idea was that our thoughts, feelings, and behaviors are connected. We slam our hand into the wall because we're angry because we feel ignored by our parents. We feel sad because we think our friend is avoiding us, so we pretend not to care, we act like nothing is wrong. We think the teacher loved our report and feel exhilarated and smile at everyone we meet. The fact is that feeling sad may be based on an erroneous thought, which leads us to acting morosely. The three aspects can be arranged in a triangle:

If you change one of the three, the other two will change. In our short-term counseling sessions we aimed at the easiest of the three to change:

behavior. Start doing something you like, and you'll feel better, and your thoughts will become more positive. This is a way you can think about your character as well. He's behaving nastily toward his wife. Why? Because he thinks she doesn't love him? Because he thinks she's holding him back? These thoughts make him resentful, etc. We're not in therapy, and we don't necessarily need him to change, but connecting the action to a thought to a feeling helps you to understand a character's motivation. If you want to, you can use the other characters to explore the husband's behavior. Why are you treating your wife like that? She doesn't love me. Why do you think she doesn't love you? And so on. Or you can be the counselor with your character off the page.

> *"Thought itself is engendered by motivation, e.g. by our desires and needs, our interests and emotions. . . . A true and full understanding of another's thought is possible only when we understand its affective-volitional basis."*
>
> —L. S. VYGOTSKY

"You say your wife doesn't love you. Do you want to go with that?"

"I'd rather not talk about it."

"Well, you don't have a choice. This isn't therapy. This is a story. We don't have time for lies."

"I'm not lying."

"Our biggest lie is the one we tell ourselves. You believe what you've been telling yourself. You're not interested in the truth."

"Well, she doesn't talk to me. She's not romantic like she was."

"Do you talk to her?"

"I try."

"Do you tell her you wish she was more romantic? Do you tell her you just want to talk? Do you turn off the TV when you tell her?"

"She knows."

"If she doesn't love you, why are you with her?"

"We're married."

"And . . ."

"That's it."

"What do you want to happen?"

"I don't know."

"Now we're getting somewhere."

"What?"

"You didn't say you wanted the marriage to work out."

"No, I didn't."

"Why?"

"Maybe I don't love her anymore. I guess I just got—"

"No need to blame. Just deal with the fact. You're not in love."

"I suppose I thought it would be easier to live with myself if I thought she didn't love me."

"Okay, we're past the cliché. Now let's see what's really going on. Tell me your story."

The writer is like the therapist. He listens. And he helps the patient make a coherent story of his life. Every patient, like every character, has a story, and it's a story we can learn from if we pay attention to it. And the writer is an actor as well, one who has to understand all of the characters in the story. He has to play each of them in turn as they take the stage. Writers do what actors do. We imagine a life for our characters based on the evidence in the script, based on our intuition, and based on our own emotional history.

E X E R C I S E S

.

The Ashtray

In a letter of literary advice, Chekhov once offered the following suggestion: *You could write a story about this ashtray, for example, and a man and a woman. But the man and the woman are always the two poles of your story. The North Pole and the South. Every story has these two poles—he and she.* To see what can be done when you take this seed from Chekhov and plant it in your imagination, read Raymond Carver's poem (mentioned earlier) "The Ashtray" in his collection *Where Water Comes Together with Other Water.*

We're going to use another suggestion from Chekhov to write our story. From his notebook:

At twenty she loved Z., at twenty-four she married N. not because she loved him, but because she thought him a good, wise, ideal man. The couple lived

happily; everyone envies them, and indeed their life passes smoothly and placidly; she is satisfied, and, when people discuss love, she says that for family life not love nor passion is wanted but affection. But once the music played suddenly, and, inside her heart, everything broke up like ice in spring; she remembered Z. and her love for him, and she thought with despair that her life was ruined, spoilt for ever, and that she was unhappy. Then it happened to her with the New Year greetings; when people wished her "New Happiness," she indeed longed for new happiness.

Who is this woman? What is her name? What does she look like? Where are we? And when are we there? What scenes do we need to tell our story? What is N. like? What music stirred her soul? How does she understand love? Affection? Passion? What is she doing right now? Start writing. You've got a chance to complete a story the premise of which was given you by the master of the short story.

Strange Interlude

Imagine a made-up person whom you see every day but don't know very well. Imagine that person in a particular place. Write about the place. Use all of your senses. Look at all of the objects around you. Penetrate the surface. Now write about the person. Describe her, note anything peculiar or striking about her. Now that you can see the person well, take a closer look. Search for the telling details. Whatever it was you didn't see the first time. She is unaware of your presence. Look at her hands. One hand is doing one thing, the other something else. Now she's humming a song. Do you recognize it? Now you remember why you're here. You've come to tell this person something important. What is that? Instead, you say something about her hands. She is startled and asks why you've come. You deliver the message. It's a metaphor, you figure—can't be literal. It's too odd, you think. You ask her what it means. She answers you with another cryptic sentence.

Idea to Image; Emotion to Gesture

The mind can work quite well with idea and abstraction. From what little I know about physics, ideas can be beautiful, elegant, and moving. But my mind works better with images than with ideas. And fortunately, that turns

out to be crucial in writing fiction. Fiction must exist in images the way dreams do. We may analyze and abstract a story as we would a dream. But the story and the dream are concrete. We would probably not read a mathematical text—a recipe of equations, formulas, and proofs—for edification on the human condition.

So practice thinking in images. Let's consider visual images. Close your eyes—interesting, yes, closing your eyes to see?—and write down what you see when you imagine a word that I'll boldface. Close your eyes after your read the words, of course. Like if the word is **JUSTICE**, you might see a judge on a bench, scales. You certainly cannot see the concept *justice*. You get the idea. The fiction writer wants to portray a concept, an emotion, an idea, but he has to do so dramatically, by showing, by somehow embodying the idea. Now, don't worry if your mind sees a coffee cup when you see **JUSTICE**. Write it down quickly—you can examine it later. Your mind is making associations—telling you something that is not as yet apparent. The mind has a logic of its own. Here are the words: **LOVE, DEATH, SELF, SOUL.**

Now take one of the focus images you just wrote about, the one that particularly intrigues you or mystifies you. Let's say it's a wedding ring you saw when you imagined love. Look closely and describe it. Now you're going to explore the context of the image. Pull back from the ring—whose hand is it on? And what is this person doing, and where is she? Look around. She talks to you. Asks a question. What is it? What do you say? You realize you are in the place where you first saw this person. In fact, you are younger. The radio is on. What's playing? How does it make you feel? And so on. You can try this with any of the senses.

Now make several of the following abstractions come to life by rendering them in concrete and specific details or images: *racism, growing old, wealth, poverty, salvation, evil, injustice, sin, ambition, deceit*. And now we'll move on to gesture. What are the most basic emotions? Make a list of them. Happiness, sadness, anger, and so on. When your list is complete, do what you did with ideas. Give us a person's gesture which indicates the emotion. Maybe a clenched fist indicates anger. (What, then, indicates rage?) Show us the person, show us the telling gesture. (If you do this right, you'll begin feeling the emotion yourself. Maybe not in the first draft, but when you've nailed the gesture, explored it fully, you'll feel what the character feels.) And then continue writing. What happens next?

Image and Likeness

Here's another version based on the idea above. Like dreams, fiction communicates in images. Why? To involve you in the story, to engage your narrative imagination. To affect your emotions. Images are more vivid and more emotionally powerful than abstractions. In writing, both are formed with words. In dreams, images and words are significantly separate.

Try this. Close your eyes and relax. Breathe easily and slowly. Think about the mood you are in and identify it, describe it in a few sentences. You might come up with something like, "I'm happy. I'm confused, too. And anxious."

Now close your eyes again and relax. Now you want to picture how you feel in terms of image, letting one pop into your mind. (Meaning does not need to be intentionally arrived at.) Got the picture: You standing with your future husband in front of a minister. Look closely now and describe everything there.

Which is more compelling—the ideas or the images?

The following exercises have to do specifically with characters you're already working with:

Exteriors

Look at the folks around you—in person, in books and magazines, in movies, and then look at your character(s). Give us the external details, the physical description. Height, weight, hair color, eye color, etc. Does she have any scars? How did she get them? Blemishes? How does she feel about them? What part of her body does she like? Dislike? Does she look like a parent? A sibling? A relative? Describe her face, mouth, build, arms, legs. How does she stand? Sit? How old is she? How old does she look? How old does she feel? How old does she want to be? What's her full name? Who was she named after? Does she want to change her name, or has she already? Why? Nickname? Look in her closet and drawers. Describe her clothes. What does she like to wear? A particular color? Does she have any physical tics? Describe them. Does she have a car? What kind? Anything else you can think of? Does she

have any illnesses, injuries, handicaps, or has she had any in the past that affect her now, physically or emotionally?

Interiors

What is he afraid of? What does he want? And why does he want it? What would he like to be doing in five years? Ten years? What are his tastes in music, literature, lovers, food? What is his secret life—that part of himself that he keeps hidden, lets no one know about? What is he guilty about? Ashamed of? What are his obsessions? Write about the character's moral values—those qualities or behaviors he thinks of as good, those he thinks of as evil. What keeps him up at night? Use your notes from previous exercises to help you think this through.

Days of Future Past

Examine the character's past. Make a list of important dates. A time line. Dates are doorways into a person's life. Birth, move to new city, graduation, first date, college, trip to Europe, death of father, arrest. Be as specific as you can. (Making a character who is about your age, who comes from the same region, who has a similar educational and cultural background can be very helpful later on—research is easier. The downside is maybe you don't get to imagine the world as clearly or energetically.) Who were her early friends, best friends? What were her hobbies? Where did she go on vacations? Did she have a secret place? What did she dream of becoming when she grew up? Write about her school days and play days and the difficulty of adolescence. If your character has had any marriages or significant relationships that are no longer viable, write about them. Has she had children? Write about the births and the early days of parenthood. What does she remember as the significant relationships in her life? The crucial decisions that she made? When does she consider herself to have become an adult? And so on.

The Interview

Just you and your character in a room. You know a little something about him now, and you have a reason to interview him. About what? There are things that you and the public want to know. So interview him. Ask the important questions that you didn't get at in the other exercises. Use the

reporter's questions. Get specific. Get his thoughts on politics, maybe, on social issues. Ask him what makes him angry, sad, happy. Don't let him get away with glib or dismissive answers. Think of yourself as Mike Wallace or a shrink, perhaps.

A Day in the Life

We want to know what your character does every day. The little things, the rituals, the habits, and so on. Describe her waking up. What does she do on a typical morning? What does she have for breakfast? Describe her work-day. In detail. Her friends there. What she does for lunch. Does she call any-one during the day? Who? Why? When work's over, what does she do? With whom? Back home she does what? Give us a typical day, in other words. What's on her mind while she's doing everything else? Probably she does a few things that are unusual or odd.

"Let's Talk," He Said

Ж

Dialogue's a very powerful weapon, isn't it?

—*Kingsley Amis*

Scene is at the heart of story, and dialogue is often at the heart of scene. Characters speak and they become. Dialogue is not a break in the action, it's an intensification of action. Here's something else dialogue is not: It's not the way we speak. Dialogue must appear realistic without being realistic. It's not natural, but must suggest naturalness. It is speech that is distilled, refined, and controlled. Elizabeth Bowen had this to say about dialogue: It should be brief; it should add to the reader's present knowledge; it should eliminate the routine exchanges of ordinary conversation; it should convey a sense of spontaneity but eliminate the repetitiveness of real talk; it should reveal the speaker's character, directly and indirectly; it should depict the relationships among the speakers. To that we might add that dialogue is useful for getting across what is not said as well as what is said. (Like a plot, what is on the surface of dialogue is only the tip of the iceberg. Seven-eighths of dialogue, to continue the iceberg analogy, is subtext, is below the surface.) Fictional conversation is not about information. It is often an attempt at deliberate evasion, at confusion, rather than communication. Often the purpose of an exchange is to conceal as well as reveal, to impress, to seduce, to

harm, to protect or to reject.* Every person in a conversation has an agenda, and you need to know what each agenda is.

Here are some technical considerations you might want to keep in mind when you're writing dialogue:

1. The verb *said* is more or less neutral. It does not intrude or interfere in the transaction between the characters. It disappears into the reader's perception of the scene. And that's what we want it to do. What is important in dialogue is what is between the quotation marks. *Said*, then, is the attributive verb that you should use with dialogue. The purpose of a dialogue tag (he said/she said) is to make clear who is speaking and nothing else. So use *said* almost always. *Asked* is a bit more weighted and it's also redundant. Why? Because the question mark inside the quotation mark shows us that a question was asked. Occasionally, you might want to use *replied* if a question has been asked. You might use *told* as a substitute just to break the monotony, as in *he told me*, rather than *he said*. But do so sparingly. Those, though, are the three attributive verbs that you need. Let the character's speech emote, express the tone, not the narrator's tag. If it's clear who's speaking without the tag, don't use it.

2. Don't qualify the attributive verb with an adverb, as in *he said breathlessly*, or *I think I can handle this trifling matter, he said arrogantly*.** Cut virtually every one that you write. Again these tonal tags are an intrusion on the part of the author and a sign of a lazy, careless, or unimaginative writer. Dialogue should convey its own tone. If you have to tell us how the words were spoken, then you haven't done your job with the words. Telling the characters' emotions to the reader is patronizing and off-putting. Let the character's speech emote, not the narrator's tag. Every time you insert an explanation in dialogue,

* The narrator of a story I wrote addresses this issue:

Now, we all know there is no comfort in small talk, no solace in chitchat, no substance to idle jabber about the weather or mutual acquaintants. So why do we do it? We talk with each other for various reasons: to inform, to compare, to seduce, to clarify, to cloud, to charm, to deceive, to alarm, to evade, to demur, to bedevil, to reassure, to offend, to warn, to befuddle, to flatter, to belittle, to thank, to bluster, to rattle, to arouse, to soothe, to illuminate, to apologize, to inquire, to amuse, to brag, to inspire, to order, to explain, to encourage, to dissuade, to convert, to argue, to process, to instruct, to vent, to accost, to excuse, to call attention to ourselves, to hear the sound of our own voices, to be polite, to pass the time. But when we talk to understand, to understand ourselves and what we're doing or what we think we're doing and why we're doing it, then we tell each other stories. Stories are how we remind ourselves who we are and how we're connected. Stories are sacred and communal like a burial and the gathering after it.

** This reliance on adverbs to do the work of dialogue was made infamous by Edward Stratemeyer in a cartoon strip about a character called Tom Swift. They've come down to us as Tom Swifties and can be very funny—but don't belong in fictional dialogue. *The Random House Dictionary of the English Language,*

you cheat the reader out of a chance to collaborate in the creation of the scene.

3. If you have two characters in a scene, you should only have to use a single tag. The conventions of punctuation will tell us who is speaking from there. Every time you switch speakers, you start a new paragraph. In a conversation among more than two people, on the other hand, you may need to tag every line. This can be clumsy and difficult to manage gracefully. Ask yourself, Do I need this other person in the room? If not, send him out for coffee.

4. Here are some other ways to attribute speech:

 a. Use the addressee's name: *Hello, Mary.* Now we know it's John speaking.

 b. Give a direction: *"Here you go, sweetheart." Margaret handed Josh the divorce papers.*

 c. Put in a beat, a bit of physical behavior: *He played with the cuff of his shirt. "What's this all about, Margaret?"*

 d. State an emotion directly, but show it as well: *His response made her sick, angry. "You never loved me, did you?"*

 e. Use the setting: *The rain drenched her. Her new dress was soaked. "I'll never get the job now."*

5. Use ellipses for gaps in conversation, to show a character trailing off. Use dashes for interruptions:

 "But you promised—" Jill said.
 "I told you I'd let you know," Bob said.
 "Now, look, you two, maybe you should, ah . . ." Larry said.
 "You stay out of this," Jill said.

 Make a dash by using two strokes of the hyphen key with no spaces before, between, or after. An ellipsis is three spaced periods.

6. Place the character's name or pronoun first in a speaker attribution. That's the normal syntax of an English sentence. Subject, verb, object. *Dave said*, not *said Dave*. Besides, this kind of inversion sounds old-fashioned, "literary," and juvenile—Dick-and-Janeish.

first edition (1966), defines the term: Tom Swiftie, a play on words that follows an unvarying pattern and relies for its humor on a punning relationship between the way an adverb describes a speaker and at the same time refers significantly to the import of the speaker's statement, as in "I know who turned off the lights," Tom hinted darkly. Here are a few others:

"I don't believe we've met," Adam said evenly.

"I've just received Communion," Maria announced gracefully.

"Bob and I are trying to have a baby," Charlene said rhythmically.

"I've had eighteen straight whiskies, I think that's a record," Dylan said staggeringly.

7. You can break up long dialogues by presenting some of the speech in indirect discourse, by telling what a character said. *"Where do you think you're going?" my mother said. I told her I was going to church. "Wait, I'll go with you," she said.* The middle sentence is indirect, is not directly quoted.

8. Avoid the use of eye dialect, that is, using deliberate misspellings and punctuation to indicate a character's speech patterns. (People love to argue about this one.) Here's how *The Columbia Guide to Standard American English* defines eye dialect: ". . . created by deliberately misspelling words to suggest in writing a Nonstandard or dialectical pronunciation: *wimmin* for women and *gonna* for going to. . . . Both these spellings reflect the actual sounds of Standard speech, *gonna* of course rather literally transcribing speech at a lower level, whereas *wimmin* suggests by its spelling that the speaker is too uncultivated to be able to spell it correctly anyway. . . . In fiction, drama, and dramatic poetry, *eye dialect* is frequently used to suggest the actual sounds of a particular person's speech, flaws and all. Use it sparingly: such renderings can be very hard to read, and they can, therefore, cause some readers to give up." Dialect should be achieved by the rhythm of the prose, by the syntax, the diction, idioms and figures of speech, by the vocabulary indigenous to the locale.* Eye dialect is almost always pejorative, and it's patronizing, and it takes the character out of the mainstream of the moral world of the story, makes him seem stupid, not regional. Eye dialect distracts the reader. Anyway, trick spellings and lexical gimmicks are the easy way out. Not the best way. When you use unusual spelling, you are bound to draw the reader's attention away from the dialogue and onto the means of getting it across. What could be the point of spelling a word as it's pronounced—*was* as *wuz*, or *women* as *wimmin*—except to look down at the character? Characters don't spell as they speak. The author spells for them. I faced a similar problem in *Louisiana Power & Light* in which a character has a lisp and the lisp is important because he makes an anonymous phone call and, of course, he's immediately identified. But to write the entire novel spelling this character's speech the way he pronounced it would have been distracting, annoying, and indecipherable at times. I chose to simply tell the reader that all his *l*'s and *r*'s were *w*'s. So when he said, "Drag the lake," the sheriff heard, "Dwag the wake." (When I wrote the screenplay, I was asked to use the misspellings.)

* In New England, for example, we might eat a hermit on the way to the packy. And we'd be sure to have a church key in our pocket to open the GIQ. But only in Louisiana would we set out on the gallery with a root beer coke and watch folks pass by on the banquette.

9. Avoid too many direct references to the people addressed in dialogue:

> *"John, would you clean the sink?"*
>
> *"Yes, Mary. I will in a minute."*
>
> *"A minute, John?"*

This can easily become a tic. It's not something we do often in our everyday conversation.

10. Omit hesitations, ums and ahs, repetitions, false starts, meanderings, aborted phrases, the ritual lines of greeting, small talk. And try to keep characters from saying the same thing twice or from repeating something the narrator said. And specifically, beginning a line of dialogue with one word or two, then a comma before the content, though it is the way we talk, does not work well in dialogue. (I first heard this advice from George Garrett at a writers' conference, and it's the best single bit of wisdom I know of for improving dialogue.) *Yes, no, okay, I guess, I suppose, not really,* etc. These filler words can almost *always* be eliminated. You want spontaneity without repetition. For example, this exchange:

> *"I'm going to the market. Would you like to join me?"*
>
> *"No, I'll just stay here."*
>
> *"Okay, suit yourself."*

becomes:

> *"I'm going to the market. Would you like to join me?"*
>
> *"I'll stay here."*
>
> *"Suit yourself."*

The *no* is redundant, and so unnecessary. The *okay* is certainly dispensable. The dialogue now is tighter, crisper.

11. Scatological language may show that the author feels contempt for his characters or has sold out to what he perceives are the demands of the marketplace. If you need to use foul language, use it sparingly or it will lose its effect. Don't think you're shocking the reader with strong language. We've heard it all. Our children have heard it all. We're beyond linguistic shock. If Richard Nixon curses, that's one thing; if Mother Teresa does, that's quite another. In the former case, we shake our head at the lack of imagination; in the latter case, we sit up in our chairs.

12. Beginning a story with dialogue does plunge the reader into scene, and it's good to begin with scene (if you haven't started with scene, maybe you haven't started), and it does begin in the middle of things, but it can effect a

gossipy tone and can disconcert with its lack of point of view. Until we know where we are and who is speaking to whom, we can't pay attention to what is said. So don't let your characters go on for long before you ground us in place and character.

13. One of the most common reasons for flat dialogue is formality of language. This is conversation that sounds stilted. Now, in some ways dialogue has to be more formal than our daily speech because dialogue, remember, has to be more focused and compressed than speech. Dialogue is something artificial that sounds real. But sometimes it comes out sounding stiff. When it does, use more contractions. *"I would not do that if I were you,"* she said. *"But you are not me,"* he said. That exchange becomes: *"I wouldn't do that if I were you,"* she said. *"But you aren't me."* And you can use sentence fragments in dialogue. That's how we talk, after all. In fragments. Like this.

14. After you've written your dialogue, be sure to read it out loud. Lock yourself in the bathroom or go out to the yard if you'll be disturbing people or if you're self-conscious about your voice. If the dialogue doesn't sound natural, then it isn't right yet. Play around with it. Try to hear your characters speaking. Write down what they say, not what you want them to say.

15. Don't use dialogue to present exposition. The result is usually disastrous. That's what narrators are for. Don't, in other words, have one character tell another something they both obviously know. Don't have them talk for the benefit of the reader. *Remember last night when I showed you your son's report card and you looked at it and said that his education was no concern of yours?* If that scene is important—write it, don't refer to it. If it's not important, then we don't need it now. If you must, for some reason, use dialogue for exposition, then make the information, important though it is, backgrounded Couch the dialogue in strong feeling so that the emotions get our attention and the dialogue is not there only for informational purposes. Dialogue is not there to furnish the stage, either. *My, that is an exquisite painting of Elvis. It really brings out the turquoise of the polyester drapes.* Dialogue is not a substitute for action, nor is it a vehicle for the author to show off his vocabulary and education. Elizabeth Bowen said, "All good dialogue deals with something unprecedented." Have we learned anything new about the characters as a result of their conversation? Has the plot advanced? Has the theme been expressed? Was there tension in the dialogue? Conflict? Was there a clash of agendas?

16. You can't moan words, smile them, chuckle them, fume them. Try it. You can

only say them, and then chuckle. "You're a fool," he laughed. Wrong. A laugh is a series of spontaneous unarticulated sounds.

17. Don't tag an adverbial clause depicting action to a line of dialogue. *"I'll get the door," she said, as she crushed out her cigarette and stood.* Either the behavior is important or it's not. If it's important, it should not be subordinated to a line of speech. If it's not important, it gets cut. *"I'll get the door," she said. She crushed out her cigarette and stood.* I think that the writer's impulse here is a good one. She knows that people do things when they speak, and so she has them doing things. But I think she's gone too far. She thinks that each character has to earn the write to speak by behaving as well. (See Number 19.)

18. Once a scene is complete, strike out any line that a character says simply to advance the other character's speech. (You probably should never write lines like "Let me see if I've got this straight. You're telling me . . .") A character's responses should show something about himself, about what it's like to be where he is just then. Dialogue is not small talk. It must always depict change, reveal character, advance the plot, and express theme. Everything in a story, and this includes dialogue, must lead inevitably, though unpredictably, to the end. If you do need to break up a character's speech, you can give him a bit of physical description. You can have him do something significant.

19. Don't describe your dialogue, show it. No talking heads. Dialogue is part of a scene. Characters don't just talk, they behave while they're talking. A character stands, looks out a window. But only if you have set the scene, placed the reader in the room, in the car, the shop. No dialogue can take place nowhere. You need to know the setting in great detail so you can know what the potential for movement and behavior is. We always speak with at least two languages, with our verbal utterances and our physical utterances (our body language), and they don't have to be saying the same thing. In fact, it may be more interesting if they are not. Then there is immediate tension in the scene.

20. Characters do not talk alike. And they don't talk like the third-person narrator. (And only one of them talks like you.) Your job is to create a convincing idiolect for each character. Don't go crazy here. Most, if not all, of your characters will be from a similar region, a similar culture, and will talk a lot alike. But each of them will have some unique phrases or figures of speech or another linguistic peculiarity that distinguishes his speech from everyone else's. One character tends to drop the subject from her sentences: *Going out on Friday. Dining and dancing. Having some fun.* Another uses "wicked" as an intensifier: *The final*

exam was wicked difficult. Another speaks by asking and answering his own questions: *Am I hungry? You bet I am. Will I be chowing down? You know it!* Like that.

21. Always think dialogue, not monologue. Give and take. Back and forth. A sparring match, not shadowboxing. Don't let any one character talk too much at one time if you can help it. Dialogue is not a series of speeches. It is interaction. It is dramatic, exciting. Speeches are not inherently exciting or tense, are they? If a character says more than six sentences at a time, it is likely too much. Characters say less than you think they did. Let the other character interrupt if he has to—he wants his time onstage, too. Let the listener step in with questions that the reader is also asking.

22. Dialogue by beginning writers can be too clear, believe it or not. When characters talk too precisely and respond exactly to what has been said, then the words are probably being put in their mouths by the writer. Beginning writers think they know what a character needs to say, and so they don't listen to the characters. They don't want the character screwing up the plot they took so long to devise. And so the character isn't credible. So remember that a character can talk one kind of way and act another; that characters can talk to each other, not listening, but only waiting until the other finishes speaking, and then continue on their own line; that characters can change the subject arbitrarily; that characters can talk at cross-purposes; that characters can understand each other so well that they finish each other's sentences, repeat each other's words. Remember that what's not said is often as important as what is said. Speech moves forward as both concealment and revelation. And remember also that people in intense emotional states—as your characters are likely to be—are often the least articulate. Billy Budd died because he couldn't speak. Characters, in general, might be less articulate than overly articulate. What they want to say might be more important than what they do say.

23. We tend to trust a character who speaks in concrete details and we are skeptical of one who generalizes, is vague. The same can be said, of course, of writers and their narrators. Think of characters who speak in the passive voice all of the time. What do you suppose they are up to? *Mistakes were made.* Well, who made them? *A chemical spill was discovered at the site of the General Electric plant.* (We're not saying who's responsible.) If we told the speaker of this sentence—*Lies were told*—to rewrite, we'd get *I misspoke.*

24. People seldom speak in unison. A child addresses his parents: *"Hi, Mom,*

Dad," I said. "Hi, Mike," they said. That's awkward and would be better reported. Either that or differentiate who said what. *"Hi, Mike," Mom said. Dad nodded.* If you ever write *they said,* or *the crowd responded,* you'd better think some more.

Let's try editing some dialogue with the above list in mind. Read the following passage, a scene involving conversation, determine what's not working, and then edit the piece into shape:

Denis mixes two very dry martinis and carries them to the parlor, where Aurelia is curled on the couch reading *Metropolitan Home.*

"Oh, thanks, hon," she smiles.

They clink their cocktail glasses. As she sips, she watches Denis. He acts nervous.

"Rough day?" she asks thoughtfully.

Silence. He doesn't know where to begin.

She says, "Oh, dear, I just remembered. I forgot to tell you, Denis. I ran into another one of your old students today."

"Who?" Denis asks inquisitively.

"Her name's Lucier now, but it was, let's see," Aurelia thinks, "Duhamel. Bambi Duhamel. Yeah, that's it. Bambi Duhamel."

Denis thinks, yes, pigtails, fringed suede jacket. He sees her now pounding at her locker that won't open. Denis says, "Don't tell me she has five kids or something. I remember her in pigtails," he adds.

"No, not five, Denis. Two," Aurelia tells him. "And a husband with a drug problem. She lives in Scarborough. She says hi."

"Do you like the martini?" Denis asks Aurelia.

"Yes, I do. I like it. It's good," says Aurelia.

"I picked up some Stoli at the package store on the way home," he explains. Then he decides that he doesn't just want to chat. He wants to talk. Wants Aurelia to listen. He wants to convince his wife that they are still young enough to change everything, that in a single stroke they could at last begin to become the people they thought they'd be when they were in college.

"So, Denis, tell me. Do you want to talk about it?" Aurelia asks him point-blank.

"What?" he coughs.

"Whatever it is," she says and knocks gently on his head. "Anyone home?" she jokes.

He tells her he was thinking about his father, how he had that first stroke when he was forty-nine. How it left him limp and aphasic.

"That won't happen to you, Denis," she says. "Is that what you're worried about? Is that it?"

"Suppose it does?" Denis theorizes. Suppose I have four years," he says.

Aurelia fidgets, leans back. She doesn't say anything.

"Maybe if we lived with our death in mind, we wouldn't waste our time," Denis says with a hint of desperation in his voice. Pause. "That's all I'm saying. We'd do what made us happy," he summarizes.

Okay. Well, so much is wrong, where do we begin? Let's look at specific lines:

3. You can't smile words. You say them and then you smile. 5. *Nervous* tells us nothing, shows us nothing. What behavior indicates nervousness? 6. *thoughtfully* is intrusive and unnecessary. 7. No stage directions allowed. "Silence" is unnecessary, since the ensuing sentence implies that anyway. 8. We don't need this attribution. We know who's talking from the conventions of dialogue. 8. Her first two sentences say the same thing. It's wordy; tighten. 10. Need I mention *inquisitively?* 11–12. This is wordy and repetitive. Dialogue should suggest real speech, not represent it. She is speaking, not thinking. 15. *He adds* is unnec-

.

"A conversation is a journey, and what gives it value is fear."

—ANNE CARSON

essary. 16. Again this is wordy, in her speech and in the attribution. 18. Unnecessary attribution. 19. Her speech is repetitive, and the attribution is unnecessary. 20. The comment about Stoli is tangential and perhaps unnecessary, as is the attribution. 26. The attribution is unnecessary and clichéd. 28. You can't cough words. 30. We don't need to be told it's a joke, we hope. 33–34. Her repetition is unnecessary. 35. He *says*, doesn't theorize. That's intrusive and unnecessary. The second attribution is unnecessary. 37. Show us the fidgeting. 38–39. A very intrusive and inappropriate and undramatic adverbial prepositional phrase. We need to show the desperation. 39. No stage directions. 40. *Summarizes* is intrusive.

This is how that passage might read:

Denis mixes two very dry martinis and carries them to the parlor, where Aurelia is curled on the couch reading *Metropolitan Home.*

"Oh, thanks, hon," she says.

They clink their cocktail glasses. As she sips, she watches Denis. He rests his glass on his thigh, looks at it, drums his finger on the rim.

"Rough day?" she says.

He doesn't know where to begin.

She says, "Oh, I forgot. I ran into one of your old students today."

"Who?"

"Her name's Lucier now, but it was, let's see, Duhamel. Bambi Duhamel."

Denis thinks, yes, pigtails, fringed suede jacket. He sees her now pounding at her locker that won't open. "Don't tell me she has five kids or something."

"Two. And an unemployed husband with a drug problem. Lives in Scarborough. She says hi."

But Denis doesn't want to chat. He wants to talk. He wants Aurelia to listen. He wants to convince his wife that they are still young enough to change everything, that in a single stroke they could at last begin to become the people they thought they'd be.

"Do you want to talk about it?" Aurelia says.

"What?"

"Whatever it is," she says and knocks gently on his head. "Anyone home?"

He tells her he was thinking about his father, how he had that first stroke when he was forty-nine. How it left him limp and aphasic.

"That won't happen to you," she says. "Is that what you're worried about?"

"Suppose it does? Suppose I have four years."

Aurelia leans forward and puts her drink on the coffee table. She sits back.

"Maybe if we lived with our death in mind, we wouldn't waste our time. That's all I'm saying."

Now take a look at this conversation between two people. Read the dialogue and you'll know something's missing:

"May I come in?" he said.

"Sure you can. You're a tad young for a priest, ain't you, Father?" Earlene said.

"Well, you see, I'm not actually a priest. And call me Billy Wayne."

"If you ain't no priest, why you wearing that sorry black what's-it then?"

"Cassock," he said. "I'm a novitiate."

"I need to speak with someone."

"That's what I'm here for," Billy Wayne said. "Your name is Earlene?"

"That's right."

"Well, Earlene, I'm listening."

"I need forgiveness."

"Yes."

"You can do it, can't you?"

"You mean Confession?"

"Yes."

"No, I can't do that, Earlene."

"Please."

"I told you I'm not a priest."

"I need to tell somebody. That's what Confession's about, isn't it?

"Just listen to me," Earlene said, "and when I'm finished, tell me it's all right. Tell me that people will want me still, that I'm not just a cracked pitcher like Pawpaw says.

"Did you hear what I said, Billy Wayne?"

"I'll close the door," he told Earlene.

"And shut down the air conditioner at the window," she said. "I want to whisper and I need you to hear."

Earlene began, "Bless me, Billy Wayne, for I have sinned. These are my sins," she said. "I did it to this boy, Marzell Swan, and Marzell Swan did it to me. Then Marzell and me went all the way." Earlene continued. "Every blessed night for three months, no matter where we was, we was on it. Just like frogs in a slough. I didn't love Marzell.

I didn't even want him around. He's just a dumb redneck shitkicker. Excuse my French, Billy Wayne. All's he cared about was driving his truck and working his little wand up inside me somewhere. But every night I ached for him. Billy Wayne?"

"It's all right," he said. "Your sins are forgiven."

The point is that dialogue is not a matter of talking heads. We could never see these people. We could only hear them. When people have a conversation, they don't just talk, as they did in our example. They do things. They do things in a place. They think things in a place. Here the scene is not set. The reader does not know where he and the characters are. It is impossible then to imagine the characters, to collaborate with the author in the creation of the scene.

The dialogue is mine from *Louisiana Power & Light.* And when I was writing that scene, I probably wrote the dialogue pretty much as you just read it. If I'm hearing the characters, I just listen and write down what they say as fast as I can. I know I'll have to go back and put in the room, put in the behavior, revise what I've already written. So I wrote what you have in a few drafts, let's say, but knew I

.

"Language shapes the way we think, and determines what we can think about."

—BENJAMIN LEE WHORF

wasn't finished. So, first, I knew I had to set the scene, had to put the reader in the place with the characters. And then I had to let the reader not just listen, but see. So here's the final version, with the problems solved, I hope:

What happened was this. On one of his regular evening visits to the infirm, Billy Wayne had occasion to comfort and aid one Earlene deBastrop, a poor young thing being treated for female problems. Earlene lived alone with her eighty-year-old grandfather, Papaw, in Bawcomville out by the paper mill.

Billy Wayne tapped on the door, opened it, stuck his head into the room. "May I come in?" he said.

"Sure you can."

Until his eyes adjusted to the crepuscular light, Billy Wayne squinted toward the bed when he spoke.

"You're a tad young for a priest, ain't you, Father?" Earlene said.

"Well, you see, I'm not actually a priest. And call me Billy Wayne."

"If you ain't no priest, why you wearing that sorry black what's-it then?"

"Cassock," he said. "I'm a novitiate."

Earlene smiled, told Billy Wayne to take a load off his mind. Then she said he might could move his chair closer by her bed. She switched off the gooseneck lamp on her bedside table. "I need to speak with someone."

"That's what I'm here for," Billy Wayne said. "Your name is Earlene?"

"That's right."

"Well, Earlene, I'm listening."

"I need forgiveness."

"Yes."

"You can do it, can't you?"

"You mean Confession?"

"Yes."

"No, I can't do that, Earlene."

"Please."

"I told you I'm not a priest."

"I need to tell somebody. That's what Confession's about, isn't it?"

Billy Wayne knew Earlene was right about that, about the desire for human forgiveness. God's, you can always get. The room now seemed close, airless. Billy Wayne's hand shimmered and dissolved. He blinked. Yes, if you stare at something long enough, it disappears.

"Just listen to me," Earlene said, "and when I'm finished, tell me it's all right. Tell me that people will want me still, that I'm not just a cracked pitcher, like Papaw says."

Billy Wayne listened as Earlene poured out her heart like water, like cool water to his thirsty soul. Her voice, like a river, washed over him. He had looked at God for so long that God had vanished suddenly, and all Billy Wayne saw before him now was Earlene, and he looked upon her as upon the face of the water and saw himself reflected there. Saw his yearning. Was that it? An emptiness? He had not sipped, yet could taste the sweet draft of intimacy.

"Did you hear what I said, Billy Wayne?"

Billy Wayne nodded, placed his missal on the nightstand. "I'll close the door," he told Earlene. He stood.

"And shut down the air conditioner at the window," she said. "I want to whisper, and I need you to hear."

Earlene, fragrant with lilac water, began. "Bless me, Billy Wayne, for I have sinned."

Billy Wayne shut his eyes, dropped his forehead onto his folded hands, smelled Earlene's womanly substance on the bedsheets, and listened.

"These are my sins," she said. "I did it to this boy, Marzell Swan, and Marzell Swan did it to me. Then Marzell and me went all the way."

Suddenly it was like Billy Wayne was under water and couldn't breathe and couldn't talk, couldn't fathom this whirlpool in which he was drowning. He could not imagine what "it" could possibly mean that was different from "all the way," and he had only a clinical notion of "all the way," but he understood from the solemn tone of Earlene's voice, from her tears, and from his own lightheadedness that it must be miraculous, all of it.

Earlene continued. "Every blessed night for three months no matter where we was, we was on it. Just like frogs in a slough."

Billy Wayne knew about the frogs, all their furious croaking and the other moist noises. He saw them now, coupled, wet, the jerky little spasms, that frothy business clinging to their slimy thighs.

"I didn't love Marzell. I didn't even want him around. He's just a dumb redneck shitkicker. Excuse my French, Billy Wayne. All's he cared about was driving his truck and working his little wand up inside me somewhere. But every night I ached for him."

Billy Wayne opened his eyes. He heard a call for Dr. King on the hospital intercom. He saw himself as if from the ceiling, a figure in black, sitting on the edge of his chair, bent toward a bed on which a woman in a white slip sat, pillows at her back. Can any man forbid water? he thought. He wanted to say something. He heard the whisper of the vinyl seat cushion as he stood.

Earlene looked up at him. "Billy Wayne?" she said.

"It's all right," he said. He lifted a damp curl from her cheek. "Your sins are forgiven."

What I did was use the scene, the dialogue, as an opportunity to get into Billy Wayne's head. That's where the real drama and conflict in the scene is

going on. The struggle here is between Billy Wayne and himself. And then I added beats, little bits of action interspersed through the scene. Beats allow you to picture the action, allow you to vary the rhythm of the dialogue, and help reveal the characters' personalities. Beats remind the reader of who the people in the story are and what they are doing. As this from *LP&L*:

> "So if I say 'I love you' after you bring it up, the emotion is invalid? Jesus, Earlene. I love you. You're my wife."
>
> "I'm twenty-two years old, and my marriage is in trouble. And I want to know why. So just don't treat me like an idea, Billy Wayne. I'm more important than that."
>
> Billy Wayne thought that he should reach across the table and touch Earlene's elbow or maybe get up and go over to her, hug her, kiss her neck.
>
> "What am I supposed to think? Either you don't love me," Earlene said, "or you take our love for granted because it's not important to you for some reason."
>
> "That's not true."
>
> Earlene thought, "Taking love for granite. Taking it for granite. Love as a rock. Love as a tombstone." She'd have to fool with this later. Earlene said, "Count your mercies, Billy Wayne."

These beats, the impulse to act coupled with the failure to act on Billy Wayne's part, and Earlene's fooling with her words, both help to illustrate the difficulty in their relationship that is the subject of their conversation. (While we're on this subject, Earlene's remarks are also emblematic of the writer's creative process, something also commented on by the writer/narrator of my second novel, *Love Warps the Mind a Little* [this entire spiel a beat, by the way]:

> And it's funny, but as that rather tense exchange was going on, while I was earnestly trying to apologize for my inconsiderateness, trying to say what I thought Judi needed to hear, and while she was cursing me and calling me a delusional parasite, it was like I was watching all this happen from behind a screen or from front row center. This has always been my personality, and I think it must be so with other writers. We are watching ourselves the same way that we watch others. This must be disconcerting to those who notice the detachment.

Sincerity has nothing to do with it, I don't think. But I can't ever be completely involved in the here and now like other people claim to be because, as I've said, the present is the least important time in my life. I wouldn't like to be dealing with someone like me about something crucial in my life. It would be like talking to someone who can't stop making puns. You tell this friend of yours how you're worried that your wife might be fooling around on you and you want to sit her down and question her about it, if just to ease your own mind. And your friend says, The examined wife is not forgiving, or something. He may be listening and may be sympathetic, but you know he has pulled away emotionally in order to stay alert to the process. He may make you laugh, but you can never trust the punner.

Be careful not to get carried away with beats. You don't want to interrupt your dialogue so often that the flow of the scene is damaged. You want to give the reader enough detail to allow him to picture the action and enough leeway for his imagination to work. And then you want him to listen. Say your scene takes place at a meal. A dropped fork, a scraped dish, or the reflection of the candelabra in the crystal glass is enough to rivet the reader to the scene. You do not have to define the four courses, the leg of lamb, "grilled to perfection" (a meaningless remark anyway), and the aroma of mint "permeating the air" (another faulty description—who smells it?). Yet uninterrupted dialogue becomes disembodied and hard to follow. A good way to fine-tune your dialogue, as I have suggested, is to read it aloud. Listen for the pauses as you read, and if you find yourself pausing between two consecutive lines, insert a beat. If you are wondering just what the listener is doing while the speaker talks, insert a beat. Beats can also define a character. What people do defines them for us. In Chekhov's "The Lady with the Pet Dog," Dimitri Gurov peels a melon while Anna cries. The precise gesture nails down a character better than a page of exposition. A long beat can turn up the tension. At a moment which calls for action, the writer can keep us waiting. On the other hand, a beat can provide a respite from an emotionally trying scene. Familiar, everyday actions like

> *"Dialogue has to show not only something about the speaker that is its own revelation, but also maybe something about the speaker that he doesn't know but the other character does know."*
> —EUDORA WELTY

lighting a cigarette, blowing a nose, coughing, don't tell us much about a character, however. Neither do involuntary bodily responses, like sweaty palms, chills up the spine, rapidly beating hearts.

So ask yourself how many beats are in the dialogue. How often do they interrupt? What are the beats describing? Do you repeat your beats: Your characters are always drumming their fingers, looking in the mirror? Do your beats illuminate character? Are they idiosyncratic? Do your beats fit the rhythm of the dialogue? Read it aloud and find out.

> *"Dialogue in fiction should be reserved for the culminating moments and regarded as the spray into which the great wave of narrative breaks in curving toward the watcher on the shore."*
>
> —EDITH WHARTON

Here's a bit of dialogue with beats. Your job here is to edit out the beats that don't work because they don't reveal character, don't advance the plot, interfere with the rhythm of the prose, or are distracting. Something's wrong and they are ineffective:

"Could you tell me the way to Davie?" the man said.

I furrowed my brow. "Davie?" I put my hands in my pockets. The man looked familiar.

The man read from a paper in his hand. "Yes, 1200 Davie Road Extension in Davie." He looked at me.

I snapped my fingers. "Davie Road Extension," I said. "Okay, first you'll want to turn around." I stepped over to his car, put my hand on the roof, pointed up the block. Yes, around the eyes. I know this guy. From where?

He looked where I was pointing.

"Then," I continued, "head north for about . . ." I put my hand on my chin and thought. "For about three miles." I held up the appropriate number of fingers.

The man nodded.

"When you come to Sterling Street, take a left." I coughed and excused myself. "Do I know you?" I said.

"I'm from out of town," he said. He shook his head no. "A left on Sterling?"

I smiled and nodded. "Then continue west." I sliced the air with my hand. "Sterling takes you to Davie."

He thanked me, put his car into gear, checked the rearview mirror, and eased out into traffic. Looked like Mr. Davis from Fidelity Life. But Mr. Davis died in a boating accident, didn't he?

And here's a conversation in need of beats. Add them, but be sure they are vivid and significant:

"Do you really want to do this?" she said. "You'll be giving up seniority and everything. I mean, we'll have to sell the house, move, find Terry a new school. Start over."

"Isn't this what you want?" he said.

"You know how I feel about the company."

"This will be the best for all of us. This may be the last chance I get. We get."

"David?"

"What is it, dear?"

"It's just such a big decision. I'm worried."

"Well, if it makes you feel better, I'm scared to death."

"Tell me we'll be okay, David."

"Of course we'll be okay."

When you've finished with your dialogue and are revising it, you might ask some of the following questions to help you focus. Is every line carrying its weight? Has the character, the narrator, or another character said this before? If so, is the repetition intentional? Is the speech explaining something that should have been demonstrated elsewhere in the story? Does the speech sound like the character? Does it tell the reader something about the character? Does it advance the scene? Does it express theme? Does it say just what you want it to say? Does it say too much? Is it too short to do the job? Or too long for what it does?

.

"'And what is the use of a book,' thought Alice, 'without pictures or conversation?'"

—LEWIS CARROLL

EXERCISES

.

Dialogue Is Not Conversation

And to prove that the way people talk in stories is not the way they talk in real life, try this experiment. Find a place where two or more people are conversing—your parents in the next room, the loud couple in the next apartment, a pair of older gents in the corner booth at the Rascal House. You can do this while you're out eavesdropping. Now take down everything exactly as they say it. If you can get away with it, use a tape recorder, but transcribe the talk later. If you have the time (and you will if you tape-record), you might take notes on their body language, facial expressions, etc. What you'll notice is how much action is a part of the meaning of speech and that without gesture and movement, language can seem hollow.

Now edit the transcribed dialogue. Take out the ums, ahs, the pauses, the repetitions, the small talk—everything that is unnecessary. What you have left is what is important. Less becomes more.

Talking in Bed

Ford Madox Ford writes about an agreement that he and Joseph Conrad had for writing dialogue: "One unalterable rule that we had for the rendering of conversation—for genuine conversations that are an exchange of thought, not interrogatories or statements of fact—was that no speech of one character could ever answer the speech that goes before it. This is almost invariably the case in real life where few people listen, because they are always preparing their own next speeches." And Philip Larkin's poem "Talking in Bed" begins with, "Talking in bed ought to be easiest/ Lying together there goes back so far . . ." His image of love and intimacy is the marriage bed where couples share their bodies and hearts. Where they are alone and can speak honestly. But as the verb in the opening line—*ought to be*— suggests, there is trouble. So let's follow the examples of Ford and Larkin and do this: Put your character in bed or in another intimate place with her spouse or with another significant character, and let them talk for *several*

pages about important matters. Here's the catch. No speech of one character can ever answer the speech of the one that goes before it. The characters speak at cross-purposes or must have their own agendas. Remember that in conversation, characters do things.

Talk Talk Talk

Recall a conversation you have had recently with a friend or colleague—preferably a fellow writer. Write out the conversation. Now ask your friend to write her version of the conversation as she remembers it. What do the differing versions have to tell us about truth, about memory, about the concerns and attentions of the talkers?

Assisted Suicide

I recently had a heated discussion over several drinks with a couple of friends—poets—about the Taliban, international terrorism, the World Trade Center attacks, all that's on all our minds these days as I write. When I suggested that the U.S. should not be surprised that all the world is not sympathetic to our cause, to our outrage, because we have been supporting oppressive right-wing dictatorships all over the world for decades, I thought the poets were going to leap across the table at me. We did not see eye to eye that evening. (We're all still buddies, by the way.) If I were to write a dialogue in a story about characters discussing the Taliban, al-Qaida, and other terrorist organizations, my job would be to take the side of each of the combatants in the discussion in turn. (For one thing, I might learn something in doing so. I always think I'm right when I'm not writing. When I'm writing, I know I'm not right about anything.) My job would be to let each of them make his case as eloquently, passionately, and intelligently as he could and to let the reader judge the merits. My job—no matter what I believe or how passionately I believe it—is not to take a side. As Yeats told us, "It's not a writer's business to hold opinions." Tolstoy put it this way: "I have found that a story leaves a deeper impression when it is impossible to tell which side the author is on." Your job is to be honest with your characters. They are at least as smart as you are, by the way. So let's let some characters talk about assisted suicide. I listened one night in our car to my friend Thomas Lynch, poet, essayist, and undertaker, and my son, Tristan—he was about twelve at the time—discuss just this subject quite eloquently.

Tom has run into Jack Kevorkian in the local morgue on more than one occasion. Does not have pleasant things to say about him. You can do this exercise with any one of dozens of controversial and highly charged issues, like abortion and capital punishment, say. But let's start with assisted suicide. Let two of your characters—they're friends—discuss the issue of doctor-assisted suicide. One argues that terminally ill patients are in intractable pain and suffer a poor quality of life, and they ought to have the dignity of being able to end that life. The state has no right to deny them their wish. The other argues that God gives life and only God ought to be able to end life. Suicide is an insult to God's sovereignty. Human suffering can have a positive value in a person's life. It's an opportunity for learning and purification. Begin there and let them talk. Make sure that each of them gets her say. You might wonder what has brought each to take the position she has. You might find out by letting them think, remember, imagine.

Secrets and Lies

Try to develop the beginnings of conversation based on these scenarios. You don't need to complete the dialogues right now. Just get them talking. Write for a page on each situation. You can get back to them later:

A husband and wife on the brink of divorce clean out the attic of the house they've decided to sell, the house they've lived in for twenty years. They come across albums of photos taken during their early years of marriage. The honeymoon, the trip to the Grand Canyon, and so on. Tracy opens one, flips to the shot of the two of them. She's waving to the photographer, her husband's kissing her cheek. She turns to Mark and speaks.

Nate can't find his wife, Virginia. She hasn't come home from her office Christmas party. He's been driving around all over town looking for her. He stops in on his pal Ray. He could use a coffee, wants to phone home, see if she's gotten back. He tells Ray how worried he is. No, Ray says, he hasn't seen her. Nate asks his friend what he should do. Virginia is in Ray's bedroom.

A florist is engaged in a discussion with a customer about the floral arrangements for her upcoming wedding. The florist's child has recently died. He never mentions this to his customer, but everything he says is colored by that awful truth.

Jack is visiting his mother at the nursing home. She doesn't know who he is.

For their fortieth wedding anniversary, Meg has surprised her husband Bailey with tickets for the two of them on a cruise to nowhere. Bailey has just learned that he has cancer, that the cancer has metastasized, that he has four months to live.

May I Ask Who's Calling, Please?

X

More fiction fails because the author has not
had the discipline and ingenuity to provide and sustain a
means of perception than for any other single reason.

—William Sloane

The author writes the story; the narrator tells it. One of the author's first obligations is to create this storyteller, this persona. *Persona* from the Latin for *mask, role, person.* The author puts on his storytelling mask. (In a nonliterary sense, a *persona* can be one's public image or personality. The public self, in this case, as opposed to the private self. We are always more than one person.) Selecting a narrator to tell your story is a matter of point of view. Think of point of view as the vantage point. Where does the reader stand to watch the events of the story unfold? A reader will be unable to concentrate on the story until she understands who is telling it, and until she understands to whom it is being told. (Most stories are told to a reader, but one may be told to a character or characters and the reader overhears it.) The choice of narrative voice and point of view—who is speaking (and how) and through whose consciousness and emotional focus is the story understood?—will affect every other choice the writer makes in the story. In that sense, point of view is the writer's most important technical choice. It is both the reader's means of perception and the writer's.

Our point-of-view options are usually described by the grammatical person of the narrator: First-person point of view (*I'm standing in line at the*

butcher shop when I recognize Prince Charles over by the deli counter.); second-person (*You can't help staring at him. The pompous little man at the prince's elbow looks at you, whispers into the prince's ear. They titter.*); third-person (*She can't help feeling embarrassed. She wonders what on earth the prince is doing in this little shop in Bayonne, New Jersey. Why hadn't she worn her Milano shirtdress today?*). And, in fact, that's how we'll talk about them shortly. But more important than the identity of a narrator's person, it seems to me, is the question of distance. How close are we to the hearts and minds of the characters in the story? To what depth, if any, do we enter the mind or minds of the characters in the story? Through point of view, the narrator offers us or denies us access to the sensibilities and perceptions of the characters.

As a writer, you're like a photographer who sees the city before her, sees the dizzying combinations of people and buildings and automobiles, of light and shadow, and knows that she has to focus, compose, and frame. She can't get it all in the lens. Nor would she want to. She has to select the combination of images that compels her, needs to decide what she wants that photograph to mean to the viewer. What does she want him to think and feel when he sees her photograph? Like the photographer, you have choices to make. You have to choose the combination of images, characters, diction, tone, events, and so on, that express exactly what you want them to. To do so, you have to know what you want the experience of the story to be for the reader, and then decide which point of view will most effectively and efficiently address your goal and explore the values and motivations of the characters, answer the question *Why?* Some stories arrive with point of view attached. This mostly happens to me with first-person stories. I hear a voice talking. I start writing down what it says. When this happens to you, go with it. The voice and the story are inextricably linked in your mind. This is a gift you cannot refuse. You'll find out soon enough if it's working, if it's capable of getting at the truth.

More often you'll need to consciously decide which is the best point of view for your story. Know that no point of view is inherently better than any other. They're just different, each with its own capabilities and limitations. We all tell stories about ourselves in first person. (Well, most of us do. Politicians sometimes lapse into the royal third, as in, "You won't have Richard Nixon to kick around anymore.") So first person can seem an easy and natural way to write a story. On the other hand, most of the first stories we heard, fairy tales, are told in third person. So third person might seem like

the more authentic storytelling medium. Third person, past tense. Once upon a time . . .

Which character's point of view ought your story be told through? To answer, ask yourself, Which character is in the most trouble? Which character has the most to lose? The character in direst straits ought to be your choice. Which character can be present at the obligatory scenes? Which will change as a result of the story's events? Who are you most interested in? Again, what do you want the reader's emotional and rational experience of the story to be? The answers ought to lead you to your point-of-view character. Know that every story is many possible stories, that different people will perceive events in different ways, and that every one of those people is the hero of his own story.

Let's take a look at the various points of view we can choose from. We'll start with first person. Here a character narrates the story. He uses the pronoun *I*, normally. We hear the sound of his voice as the story opens, and it's the only voice we'll hear for the rest of the story, unless and when he drops us into dialogue. A caveat here, before we go on. Don't necessarily use first person to tell the stories that you cull from your own life. (The narrator is not the author, remember.) You might, in fact, benefit from the distance a third-person narrator would afford you. Write about yourself as if you were someone else, and write about others as if they were you. Voice is or ought to be one of the strengths of first person narration. That means you have to nail the narrator's speech, have to have the cadence of his language and the idioms down pat. The voice of a first-person narrator determines the story's style, its content, and its structure. The narrator's tone of voice sets the tone for the story. So it had better be an engaging voice. And every word that this character/narrator speaks tells us about him. What do we know, for example, about the following narrator after hearing her opening words?:

> *"The use of point of view is to bring the reader into immediate and continuous contact with the heart of the story and sustain him there."*
>
> —TOM JENKS

"I was getting along fine with Mama, Papa-Daddy and Uncle Rondo until my sister Stella-Rondo just separated from her husband and came back home again. Mr. Whitaker! Of course I went with Mr. Whitaker first, when he first appeared here in China Grove, taking 'Pose Yourself' photos, and Stella-

Rondo broke us up. Told him I was one-sided. Bigger on one side than the other, which is a deliberate, calculated falsehood: I'm the same. Stella-Rondo is exactly twelve months to the day younger than I am and for that reason she's spoiled." That from Eudora Welty's "Why I live at the P.O."

We hear the sound of the narrator's voice, and we know what she's like. (We'll learn in a bit that her name's Sister.) She's jealous. She's literal-minded (she takes "one-sided" to refer to her physical appearance), not very bright in that way. She's living in what promises to be a colorful extended family at the outset, and we do wonder what drove her from it. The voice is colloquial. This is the voice of gossip, isn't it? We feel we're on the porch with Sister sipping iced tea, and she's whispering the story to us. We know it's her story, so there's the authority: "I was there; this is what happened." We are close in on the action, and yet we're not sure we're getting the full story. She is directly involved in what went on, and she's bitter about it. Her life has been changed for the worse. Will she be able to put aside her bitterness, her jealousy, and her wounded pride to tell us the truth? Or will she use the story to indulge her bitterness? Why is she telling us the story? (A question we don't ask of a third-person narrator.) All of which brings up the question of reliability, which we might as well talk about now.

The first-person narrator may be trustworthy or may be somehow unreliable through mendacity, naïveté, insanity. Since she is a character in the story, we don't have to believe everything she tells us. Is the narrator being honest? Is the narrator too innocent to understand what is happening to her? Just how unreliable is she? The reader needs to know if the first-person narrator can be trusted, and the author must let the reader know the answer without intruding. (I'm letting this woman tell her story, but I want you know she's not completely trustworthy.) How do you know when someone is lying to you? (In this case, *suspecting* and *knowing* may have the same distancing effect.) (My mother used to tell me to stick out my tongue, and if I was lying my tongue would be black. It was almost always black. For punishment I had to wash my mouth out with Ivory soap while my mother watched. Well, getting close to my little private psychodrama here, so back to *reliability* it is.) Where was I? The liar, perhaps, can't look you in the eye. His story's too pat, too well shaped. He's exaggerating. His different versions don't jibe, or we've heard other versions. That's how the writer clues us in. The narrator says her sister's a shrew, but we meet the sister, listen to her in conversation, and she seems gracious and kind. We do not share the narra-

tor's version of reality. Maybe all first-person narrators are unreliable to some degree.

So, the authority of the first-person narrator is immediate (he was there, after all), but qualified. The first-person narrator can't easily get into the heads of the other characters. He can speculate, but he can't be sure. We would certainly dismiss or at least suspect anything Sister told us about Stella-Rondo's thoughts, feelings, or motivations, wouldn't we? But Nick Carroway, the first-person narrator of *The Great Gatsby*, renders thoughts and behaviors of Jay Gatsby that he could not possibly know, and yet we trust his observation. He's a diligent observer, an honest interpreter of Gatsby's life. He's looking for the truth in Gatsby's world. And we know, too, that he's about the business of imagining a Gatsby who is perhaps larger than the real Gatsby. (Which brings up another issue. First-person narrators ought to be the central characters in their stories, I think. Nick, I would argue, is the central character of *Gatsby*—Gatsby is Nick's subject. It's through Nick's consciousness that we come to understand the significance of Gatsby's life. I think it's a mistake to choose a peripheral character to tell us about someone else's trouble. Don't you want to be close to the action? Don't you want access to the thoughts and feelings of the character who is struggling? All right, you might ask, how do I explain the Sherlock Holmes stories in which Watson, our narrator, is decidedly not the central figure? Well, I might say the real struggle in the stories is Watson's struggle to figure out how Holmes does it. Or I might say that Holmes is a fictional hero that Watson is creating. Watson is writing the stories, remember. [First-person narrators can speak or they can write in diaries or compose letters or scribble in journals.] But I can see you're not buying that.)* You can go where your narrator goes, but nowhere else. You can see what he sees, but nothing more. (Of course, you can and should make him look closely.) If he's in the kitchen when the fight's going on in the parlor, we can't hear the fight. (So get him to the parlor.)

We see the first-person narrator less clearly, perhaps, than those whom he sees. He's looking out at the world and can describe it for us, can describe the people he sees, but he's seldom looking at himself. To describe this char-

* Let me quote Rust Hills on the subject: "Beginning writers often choose to tell their story from the point of view of a character who is not central to the action—a 'bystander,' so to speak, 'friend of the hero,' or someone like that, not directly involved. This is thought to make exposition easier: the reader is able to learn the facts of the situation along with the narrator. But the need for exposition is seldom sufficient to make up for the sense of consequencelessness that often results from uninvolved narration" (from *Writing in General and the Short Story in Particular*).

acter you probably don't want to resort to the cliché of a mirror or a shop window. In fact, he *can* describe himself if he wants to, if he thinks it's necessary. *The ladies say I'm easy on the eyes. I guess they like my hazel eyes and blond hair. Or maybe it's my dimples. . . .* What he says may not be flattering, but it certainly gives us a picture, and it tells us more about him than he may want us to know. The truth is that you can do anything you want in any of the points of view if you're skillful enough. First-person narrators can occa-

.

"It is always dangerous to write from the point of 'I.' The reader is unconsciously taught to feel that the writer is glorifying himself. . . . Or otherwise the 'I' is pretentiously humble, and offends from exactly the other point of view. In telling a tale it is, I think, always well to sink the personal pronoun."

—ANTHONY TROLLOPE

sionally be omniscient, as in *Gatsby*, as in *Heart of Darkness*. My own novel *Louisiana Power & Light* is told by a first-person plural narrator—*we*—who is omniscient. Many stories are a combination of points of view. Hemingway's "A Clean Well-Lighted Place," for example, begins with an omniscient narrator who sets the stage for us, tells us a bit about the old deaf man's habits. The narrator knows what the café is like

at other times, tells us what the waiters know. After the opening paragraph, we get an objective point of view, including both description and dialogue, for most of the story. We seem to be watching a play. When the waiters finally close the café and part, we stay with the older waiter, and we go deeply into his point of view, into his consciousness.

The use of first-person point of view allows you as a writer to know your character fully and intimately. While you're writing the story, you are in his head at every moment. You identify immediately with him, and so will the reader, you hope. (Even if you're writing a third-person story you can use first person to get to know your characters. You do so in your notebook, of course. Ask your husband, for example, why he left his wife, your central character. And let him answer in his own voice. He might say [and you will write it down], "Look, you're only getting her side of the story. But maybe that's all you want. The marriage wasn't all peaches and cream like she says. Did she tell you about her little affair three years ago? You know I did love her once, maybe I still do, but I'm happier alone, not listening to her complain and whine about my incompetence." And so on. You've been in his head, and now you know him, and now you won't manipulate him.) First-person view-

point is easy and natural, as I said. It's direct, immediate, and it can be intense. It's an excellent device for a beginning writer to learn character. You'll know at once who the character is, how he is going to express himself, how he knows what he knows, and how much he knows because, for the purposes of the story, you are that person. You will know what's the matter with him. What he wants. You'll know, that is, if you think hard about it.

And first-person point of view is almost instantly convincing, since it seems to relate the narrator's actual experience. You create a distinctive voice, a character, a personality with the first words of the story. Like these: "If you really want to hear about it, the first thing you'll probably want to know is where I was born and what my lousy childhood was like, and how my parents were occupied and all before they had me, and all that David Copperfield kind of crap, but I don't feel like going into it, if you want to know the truth." That, of course is the opening to J. D. Salinger's *The Catcher in the Rye.* Here's another: "When I finally caught up with Abraham Traherne, he was drinking beer with an alcoholic bulldog named Fireball Roberts in a ramshackle joint just outside of Sonoma, California, drinking the heart right out of a fine spring afternoon." And that's James Crumley's *The Last Good Kiss,* and I know, after hearing that, I'm bellying up to the bar, buying that man a drink, and listening to the rest of his story.

First person is unambiguous, and it's easy to tell if you've violated point of view. Do you, for example, attribute information or ideas or emotions to a character that he can't possibly think or feel or know? He is an eyewitness, and so he can convincingly relate the events without committing himself to scene. He was there, so he ought to know. And that can be a problem. A first-person narrator tends to tell too much and not to show. We already believe that he is credible, you see, and so he does not have to persuade us with scene the way a third-person narrator does. Here you must influence your narrator to show and not merely to tell. We want scene, not exposition. Drama, not explanation. It may seem awkward to do so, but you need to slow the narrator down and be sure that everything important gets dramatized, not summarized. For example, here's what a first-person narrator might say: *I tried to talk with my father about her, but he just kept chewing his food and staring at the newspaper. I told him I thought she didn't love us, and he mumbled some answer, and it went on like that until I could see he was crying, and then I felt like crap.* You might encourage the narrator to fill in the details. As I said, this might seem awkward at first, but you'll see how seamless it all reads. The easiest way to

accomplish scene is to drop right into dialogue. Don't tell us they talk; let us hear the conversation. Like this: *I tried to talk to my father about her, but he just kept chewing his food and staring at the newspaper. I said, "I don't think she loves either of us."*

"She's your mother."

"What?"

"Don't talk about her that way. Of course she loves you."

"You're her husband. Does she love you?"

He set his fork on the rim of his plate. I heard his jaw crack as he chewed, then swallowed. He said, "What do you know about love?"

And so on. Now we're there in the room, watching the painful interchange between these two, and we get to feel what they feel. Fiction works with feelings, and feelings come to life in scenes. Another possible advantage here is that in dialogue we get as close to objectivity as we can in first-person narration. The narrator's hand is off the machine for the time being. His mind is hidden.

There are at least two ways of telling a story in first person. There is the narrator who creates a story as it seems to be happening, either in past or in present tense, although present tense will seem even more immediate; and there is the narrator who is reflective, tells the story at a remove from the events. The former has a single narrator, a single *I* ("I'm sitting at the bar, minding my own business, when this guy walks in with a bulldog and takes the stool beside mine."); the latter has two *I*'s, the person who experienced the event and the older, wiser, we assume, person who tells the story ("It all started one miserably hot spring afternoon in Sonoma thirty years ago. I remember it like it as yesterday. I was sitting alone in this bar when in walked this guy . . ."). In this case, the older *I* can emphasize some events and summarize others, can explain how those past events are responsible for his present condition. This reminiscent narrator shares some of the advantages of the omniscient narrator. He knows how the story ends before he begins. He knows the future, as it were. He's knows what is significant and what is not.

Let's move on to second-person point of view. First of all, apostrophe is not second-person point of view. The omniscient narrator who addresses "You, Dear Reader," is not employing second-person narration. "How do I love thee?" is not second-person narration. Obviously in this case the *I* speaks to the auditor *thee*. First person. Second-person point-of-view narration can work in a couple of ways, but in each the *you* is a character in the story, an

actor in the drama. Like this: "There are moments in your life when you think you can change absolutely everything—your disposition for starters, your past, your values, your weight, your I.Q. score, your obsessions, your friends, your unflattering habits, your future, your heredity—by making that one small, but consequential change in the kitchen. You realize, for example, that this bread machine you're staring at could be the first step on your path to a life worth living" (from my story "You're at Macy's, Killing Time, When It Hits You"). Here the reader is asked to imagine herself a character in the story. This can draw the reader into the story if I do it right, put her off if I don't. She might say, No, I don't shop at Macy's. I'm allergic to wheat. But since this particular story deals in speculation, with what might be, and not what is, and since it's rooted in our basic desire to better ourselves, I hope the reader will enjoy the opportunity to pretend to be the person she might wish to be. I'm not asking her to be someone she is not, someone she might not want to be. This and most second-person stories that I know about are written in the present tense. (But, of course, they don't have to be.) It just seems to fit. Because it's unusual, second-person point of view always catches the reader's attention. As writers, we couldn't ask for more. But we need to remember that our focus still needs to be on character. Without exploration of character, the point-of-view experiment will simply be annoying.

> *"The whole intricate question of method, in the craft of fiction, I take to be the question of point of view—the question of the relation in which the narrator stands to the story."*
>
> —PERCY LUBBOCK

Here's another example of second-person point of view, from my story "Cancer": "So let's say you've got a wife and you love her, have been crazy about her since you first watched her walk into your tenth-grade home room wearing a plaid jumper and a white blouse, hand a note to Sister Dominic Marie, and, without looking at anyone, take a seat behind Maureen Mathurin. And you've got two kids who have your hazel eyes and your wife's high cheekbones. You're looking forward to teaching the boy how to handle a six-ounce fly rod and the girl, well, you're not sure what you can teach a daughter." In this case the *you* is clearly (I hope) a substitute for *I*. This is disguised first-person point of view. The reader doesn't know any Maureen Mathurin, didn't go to a Catholic school, isn't a man. Second person as used here is a not always subtle substitute for first person. The narrator here is dis-

tancing himself, moving his ego offstage, asking us to imagine what it might be like to be in his situation. Perhaps he feels that the emotions are too raw, too painful to admit to first person. And that tells us something about the narrator, doesn't it? (It could be [but isn't in this case] that one part of the narrator is talking to the other—and then we have quite a different story.)

Second person, it seems to me, works best in short pieces. The second-person pronoun can become distracting and intrusive in the long haul. It can seem too contrived—all right, we get the conceit, now let's get on with the story.

Third-person narrators are not characters in the story, not actors in the drama, but they are inventions. The narrator, remember, is not the author. Think of the third-person narrator as the character who tells the story but remains outside the story's action. And you have to know how he talks, and he doesn't talk like any of the characters, probably. Will he stay effaced, off the stage? Will he intrude, editorialize, address the reader directly? Some third-person narrators are more dramatized than others. The third-person narrator tells us about someone else's adventure. He uses the third-person pronoun, of course. Third-person points of view are defined by the privilege of access they afford us to the eyes and minds of the characters. Do we go into a single character's thoughts and feelings (and how deeply)? Into many characters' minds? Into none? Let's start with the last.

Third-person objective point of view is sometimes called the fly-on-the-wall technique, or the camera lens, or dramatic point of view. What you see is what you get. We never enter the consciousness of any of the characters. The narrator is distant, impersonal, a reporter of sorts. We are always outside the characters. This is fiction approaching theater. It's a splendid technique to use if you want to develop suspense because you can withhold information honestly. Stories that begin with dialogue begin objectively. And if the characters continue speaking and behaving, and we are not given access to their thoughts and emotions, then they remain objective. It's not unlike writing a screenplay. You can't film emotion or thought, and so the screenwriter needs to illustrate thought and feeling with behavior, with imagery, with the spoken word. Idea to image. You might ask yourself why you're using a point of view that won't allow you to do what fiction does best—enter the mind of the characters, see through their eyes, detail the rich interior lives of characters. Perhaps, you might think, I should be writing a play. Objective point of view was used brilliantly by Shirley Jackson in her

story "The Lottery." The only reason this story succeeds at all is due to the objective point of view. If at any moment we got into any character's thoughts, the power and the irony of the story would be lost. Read or reread that story to see how this viewpoint can produce devastatingly effective results when well handled.

Hemingway often employed the objective point of view for long stretches in his stories. "Hills Like White Elephants" consists primarily of a tense conversation between a man and a woman at a train station café in Spain:

> "What should we drink?' the girl asked. She had taken off her hat and put it on the table.
>
> "It's pretty hot," the man said."
>
> "Let's drink beer."
>
> "*Dos cervezas*," the man said into the curtain.
>
> "Big ones?" a woman asked from the doorway.
>
> "Yes, two big ones."
>
> The woman brought two glasses of beer and two felt pads. She put the felt pad and the beer on the table and looked at the man and the girl. The girl was looking off at the line of hills. They were white in the sun and the country was brown and dry.

The last sentence approaches the girl's point of view, but doesn't quite enter it. She looks, and the narrator reports what there was for her to see. We don't see the landscape through her eyes. Everything we learn in this story we learn from inference. The trouble is never stated. The true text is the subtext. After an argument which culminates with the girl, Jig, telling her companion that all right she'll have the unmentioned abortion if that's what he wants, we do get her point of view. We're given the landscape again, and then "she saw the river through the trees." Later, we get the man's: "He drank an Anis at the bar and looked at the people. They were all waiting reasonably for the train." The adverb *reasonably* is the man's adverb. That's his take on this unfortunate business with Jig. Why can't she be reasonable? Another appropriate, indeed crucial, interruption of the narrator's objectivity.

Let's go to the other end of the viewpoint spectrum, third-person omniscient point of view. This is the narrator as god. He can be anywhere at any time, can tell us everything about everyone: who they are, who they think they are, what happened to them before they came to be here, what will hap-

pen to them long after the story is finished, what they are thinking, feeling, and so on. The term *omniscience*, of course, is inaccurate. If the narrator did indeed tell us all that he could know, the story wouldn't end, and it would remain shapeless and pointless. The omniscient narrator may tell us a lot, but he necessarily withholds much more. He'll get into the minds of many characters, but present many more characters dramatically.

The omniscient narrator can examine characters' thoughts, can take us from character to character, can interpret events, divine the future. The omniscient narrator may tell us in his own voice what we are supposed to think, may comment on the progress of the story, philosophize about life and death, provide historical background for our tale, and offer insights into the characters' behaviors. His is the voice of the classical epic. Omniscient narration's preeminent virtue is the sense it gives of the panorama and complexity of human life. It can turn one story into several stories. Its biggest problem, as you might expect, is focus. There is always a temptation to tell too much, to digress. Since the omniscient narrator knows everything, he is (like the first-person narrator) tempted to tell the reader what happened rather than depict the actual event. He depends on the summary and often, in juggling groups of characters, leaves one group in the air while turning his attention to another. He has lots of freedom, but that can get in the way of the story itself. Freedom can lead to excess, loss of control. Omniscience, then, can be the most difficult point of view to handle successfully. Here's Leo Tolstoy handling the point of view masterfully in my favorite novel, *Anna Karenina*:

>
>
> *"The artist must be in his work as God's in creation, invisible, yet all powerful; we must sense him everywhere but never see him."*
>
> —GUSTAVE FLAUBERT

Happy families are all alike; every unhappy family is unhappy in its own way.

Everything was in confusion in the Oblonskys' house. The wife had discovered that the husband was carrying on an intrigue with a French girl, who had been a governess in their family, and she had announced to her husband that she could not go on living in the same house with him. This position of affairs had now lasted three days, and not only the husband and wife themselves, but all the members of their family and household, were painfully conscious of

it. Every person in the house felt that there was no sense in their living together, and that the stray people brought together by chance in any inn had more in common with one another than they, the members of the family and household of the Oblonskys. The wife did not leave her own room, the husband had not been at home for three days. The children ran wild all over the house; the English governess quarreled with the housekeeper, and wrote to a friend asking her to look out for a new situation for her; the man-cook had walked off the day before just at dinner-time; the kitchen-maid and the coachman had given warning.

The next point of view is called third-person limited omniscience (an oxymoron) or selective omniscience or third-person attached. This viewpoint can be subdivided according to the narrator's access to the character—is he always inside the character or is he sometimes inside, other times outside the character? And then there's what's called multiple selective omniscience. (Fun, isn't it?) Let's start with the first, the tightly restricted point of view sometimes called central intelligence (Henry James's term) or unified point of view. This point of view has a lot in common with the first person and shares the same limitations. Only what the viewpoint character knows, sees, feels, guesses at, and so on, can be told. This point of view, then, can also be unreliable in that sense—our viewpoint character is misinterpreting his environment, let's say. We enter the thoughts, feelings, and the senses of that one character, and we never surface. The narrator seems to vanish. The important events take place in the mind of the character. The events of the story, the characters in it, all are filtered through the consciousness of a single character. It's not his behavior that's important, but what he thinks and feels as he acts. The reader lives the experience of the story through the viewpoint character.

Eudora Welty's "Death of a Traveling Salesman"[*] employs this point of view, and it begins like this: "R. J. Bowman, who for fourteen years had traveled for a shoe company through Mississippi, drove his Ford along a rutted dirt path. It was a long day! The time did not seem to clear the noon hurdle and settle into soft afternoon. The sun, keeping its strength here even in winter, stayed at the top of the sky, and every time Bowman stuck his head out of

[*] If you were wondering as I was, Arthur Miller's similarly titled play about Willy Loman premiered in 1949. Miss Welty's story appeared in *A Curtain of Green and Other Stories*, 1941.

the dusty car to stare up the road, it seemed to reach a long arm down and push against the top of his head, right through his hat—like the practical joke of an old drummer, long on the road. It made him feel all the more angry and helpless. He was feverish, and he was not quite sure of the way." We get Bowman's thoughts, feelings, his confusion and his emotion. We even get his diction. There are two other characters in the story, both of them seen through the addled and fevered mind of a man who can't quite wrest control of himself.

Third-person limited has another, more familiar narrator who can be both inside the viewpoint character and outside. Like this one from William Faulkner's "Barn Burning":

> The store in which the Justice of the Peace's court was sitting smelled of cheese. The boy, couched on his nail keg at the back of the crowded room, knew he smelled cheese, and more: from where he sat he could see the ranked shelves close-packed with the solid, squat, dynamic shapes of tin cans whose labels his stomach read, not from the lettering which meant nothing to his mind but from the scarlet devils and the silver curve of fish—this, the cheese which he knew he smelled and the hermetic meat which his intestines believed he smelled coming in intermittent gusts momentary and brief between the other constant one, the smell and sense just a little of fear because mostly of despair and grief, the old fierce pull of blood. He could not see the table where the Justice sat and before which his father and his father's enemy (*our enemy* he thought in that despair; *ourn! mine and hisn both! He's my father!*) stood, but he could hear them, the two of them that is, because his father had said no word yet.

Here the narrator deeply penetrates the consciousness of the point-of-view character. He reports everything the boy thinks, everything he observes, what he hears and sees, what he almost tastes. We get the boy's involuntary visceral response to the cans of tuna and deviled ham. We get his diction in the parentheses, but not elsewhere, you noticed. That seems to be a clue to why Faulkner may have chosen this particular viewpoint and not first person and not central intelligence. Why not let the boy tell his own story? Well, what do we know about him? We know he's somewhat fright-

ened and confused. More important we know he's illiterate. He can't read the labels on the cans of food. The limits of your language are the limits of your world. This boy's world is small, too small for the themes that Faulkner needs to explore. Moreover, it would be difficult and distracting to read an entire story in the dialect and the limited vocabulary of the boy. So Faulkner gets the best of both worlds, as it were. The narrator has all the intimacy and authority of first person and retains the ability to see the character from the outside. He can describe the character's looks, for example. And he's not limited to the character's diction or vocabulary. The narrator can also tell us more about a scene than the character might want to tell, than the character might be aware of, and he can, if he wants to, tell it in more lyrical and graceful language.

The third-person point of view can shift from one character to another. Think of this as serial third-person limited, more traditionally called multiple selective omniscience. If you do opt for multiple viewpoints, you need to set them up early in the story and not drag in someone else's point of view toward the end, and you need to use the different viewpoints in different scenes or sections to make clear whose perceptions we are following at any given moment. In this viewpoint, we can, as with limited, be inside a character's consciousness and can pull back out of his consciousness into the mind of a narrator who knows more than the character does, to give us another take on the character's behavior. The viewpoint will also shift from character to character, to give us different views of how the same circumstances affect each of them. As in the opening of Stephen Crane's "The Open Boat":

> None of them knew the color of the sky. Their eyes glanced level, and were fastened upon the waves that swept toward them. These waves were of the hue of slate, save for the tops, which were of foaming white, and all of the men knew the colors of the sea. The horizon narrowed and widened, and dipped and rose, and at all times its edge was jagged with waves that seemed thrust up in points like rocks.

What we have at the start is a collective point of view. We are in the minds of "them." And then in the several following paragraphs:

> The cook squatted in the bottom and looked with both eyes at the six inches of gunwale which separated them from the ocean. . . . Often

he said, "Gawd, that was a narrow clip." As he remarked it he invariably gazed eastward over the broken sea.

Here we focus on the cook, one of the four survivors in the lifeboat, and we see what he sees, but not really through his eyes. And we hear him speak. We seem to be outside observing him. Next:

The oiler, steering with one of the two oars in the boat, sometimes raised himself suddenly to keep clear of the water that swirled over the stern. . . .

Even more distant than the cook. We see him move and that's all. And then:

The correspondent, pulling at the other oar, watched the waves and wondered why he was there.

Clearly here we are in the mind of the correspondent. Watching and wondering. We are in his thoughts. We've shifted from collective to objective to the correspondent. And finally:

The injured captain, lying in the bow, was at this time buried in that profound dejection and indifference which comes, temporarily at least, to even the bravest and most enduring. . . .

We get the captain's feelings through his point of view. But we are not as close to him as we are to the correspondent. We don't know what he thinks. The writer, we might guess, has decided which of the characters will be the central character: the correspondent. It will be through his point of view that we will come to understand the significance of the events, although significantly the story closes with a collective viewpoint much as it opened:

When it came night, the white waves paced to and fro in the moonlight, and the wind brought the sound of the great sea's voice to the men on shore, and they felt that they could then be interpreters."

One of our characters does not survive, and we might guess that it would

be the oiler, the character we have been most distant from. The story, by the way, is based on an incident from Crane's life. He was on his way to Cuba on a merchant ship, the *Commodore,* which was carrying contraband to Cuban rebels, when the ship was wrecked, and sank off St. Augustine, Florida. Later Crane made it to Cuba as a war correspondent.

Just a couple of other matters having to do with technique in point of view: interior monologue and stream of consciousness. Interior monologue is generally used in third-person point-of-view narration (although it can be used in first or second), and it's an effective method for going deep into a character's thoughts and feelings by rendering them as they pour from the mind of the character. Here's a paragraph from my novel *Deep in the Shade of Paradise.* Rance Usrey is defending Alvin Lee Loudermilk at trial. In the middle of direct examination he daydreams:

> Rance wondered why in blazes he took this case anyway? Why was he a lawyer at all? He never wanted to be a lawyer. He'd just have to tell his wife tonight that's all. Emma, he'll say, honey, I have to quit. I'll call Jack on Sunday, meet him out at the club. We'll talk. I'll tell him my heart's not in it anymore. I'll stay on till he finds someone else. And Rance saw Emma right then in front of his eyes. Emma's on the sofa, listening to him, her legs tucked under her. He sees that her eyes are glistening. She's gripping a melon-colored Kleenex in her hand; now she's smoothing it out. It matches her blouse. He touches the tear in the corner of her left eye. She smiles, looks at her hands. God, he loves her so much he can hardly believe it sometimes. He'd like to be with her now instead of in the courtroom. He'd draw the living room curtain, put on Mozart's "Violin Sonata in C, *Andante Sostenuto,*" pour two glasses of Pedro Ximénez sherry, touch her knee. She might ask him, What will you do now, dear? He'll say, Maybe I'll work with the Bastrop Community Theater. I've always wanted to act. I could teach at the community college. I'll write a book—

We go beyond reporting what Rance is thinking, *we experience* what he is thinking. When he says, "I'll tell her my heart's not in it anymore," that is his actual thought. That is *direct* interior monologue. There is no intermediary processing the thoughts for us. We are in his head completely. But notice

later: "He'd draw the living room curtain. . . . She might ask him, What will you do now, dear?" He did not actually think *he* or *him*, did he? He thought *I'll* (note the tense change as well) and *me*. "She might ask me . . ." This is *indirect* interior monologue and it allows the narrator to be both inside and outside the character. We get the thoughts, but we're not as deep as we were with the direct interior monologue.

Thoughts rendered in interior monologue are generally ordered, rational, and sensible. Not all of our actual thinking is so well mannered. That's where stream of consciousness comes into play.

The term *stream of consciousness* was coined by Henry James's brother, the philosopher William James, and is often associated with James Joyce, particularly the Molly Bloom soliloquy in *Ulysses*. Joyce did not agree, however. In response to a remark to that effect, Joyce, not one to mince words, said, "When I heard the word 'stream' uttered with such a revolting primness, what I think of is urine and not the contemporary novel." He went on to say that "Molly Bloom was a down-to-earth lady. She would never have indulged in anything so refined as a stream of consciousness." That being said, we might define the term as a narrative technique that renders the flow (sticking with the metaphor) of the countless, incessant, seemingly random associational impressions that impinge on the consciousness and rational thoughts of a person. It is like direct interior monologue in that it presents a character's thoughts and feelings without narrative intercession. The difference is that stream of consciousness does not try to edit, arrange, or clarify those thoughts. Rather, it tries to capture the dizzying, illogical process of the mind at work, the way seemingly simultaneous impressions and thoughts tumble into one another, and tries to make some sense of this virtual chaos. This is as deep as we can plunge into the psyche of a character. Here's an example, with apologies to Joyce, from *Ulysses*. Not Molly, but Poldy:

> "He walked on. Where is my hat, by the way? Must have put it back on the peg. Or hanging up on the floor. Funny, I don't remember that. Hallstand too full. Four umbrellas, her raincloak. Picking up the letters. Drago's shopbell ringing. Queer I was just thinking that moment. Brown brilliantined hair over his collar. Just had a wash and brushup. Wonder have I time for a bath this morning. Tara street. Chap in the paybox there got away James Stephens they say. O'Brien."

Yes, you can shift points of view, but should you? Have a good reason if you do. I usually advise beginning writers to stick with one point of view per story until they're comfortable with it. And then move on. In short stories, you often need only a single point of view. Novels are more flexible and may benefit by shifts in focus and mind. William Faulkner's *The Sound and the Fury* is the same story told from four different points of view. Three are first person, one is third.

EXERCISES

.

Depending on Your Point of View

I'd like you to look back at the autobiography you did at the start of the book and pick out an event in your childhood, one in which you learned something about the world or yourself and your place in it. At least one other character should be involved. If you write about someone who frightened you, this will work well. Now begin to tell the story of the event in the first person as the child you were then. Use present tense. Use the vocabulary of a child of whatever age you were. You understand only what the child would understand, and so on. Write that now. Be detailed. Get into your childhood mind. One memory leads to the next. When you've finished that, begin to tell the story once again, in the first person as well, but as a reminiscent narrator. You are remembering back to when it happened, and you understand the significance of it all in retrospect. Use the past tense. Begin with "I remember . . ." Write it now. How has the story changed? And now for a third time. Begin to tell it again, this time from the point of view of the other character, the antagonist, if you have one. Let that person tell the story in first person. Use his diction, his patterns of speech, his thoughts, his feelings, and so on. Now do it again, this time in third-person limited, getting into the child's mind (your mind) only. And then tell it one more time from the objective point of view. Don't get into any character's point of view. Write down what they do and what they say. When you've finished, consider the differences in point of view. Consider which point of view works best for you and why. What did it feel like to write from the various viewpoints? Was one more comfortable than another? Did one reveal secrets that another did not?

Starting Over

Take the opening paragraph of several stories or novels that you like and rewrite them from a different point of view. It's somewhat easy to shift from first person to third-person limited, more difficult to shift from first to third-person objective. But try them all.

Here's the opening paragraph of my short story "Electric Limits of Our Widest Senses":

> "I left Dentaland, swung by the house to pick up Spot, and drove on out to Pembroke Lakes Animal Hospital where he wasn't known. My fingers tingled—evidently I still had nitrous oxide in my brain. I stopped for a green light on Federal Highway, heard tires squeal behind me, horns squawk. I had been thinking about the note my girlfriend e-mailed me: *We don't have much time left.* What did she mean by that? We have all our time left."

First-person narration told by the character, Johnny. Here it is shifted to second person:

> "You leave Dentaland, swing by the house to pick up Spot, and drive out to Pembroke Lakes Animal Hospital where he isn't known. Your fingers tingle—evidently you still have nitrous oxide in your brain. You stop for a green light on Federal Highway, hear tires squeal behind you, horns squawk. You've been thinking about the note your girlfriend e-mailed you: *We don't have much time left.* What does she mean by that? You have all your time left."

Third-person objective:

> "He leaves Dentaland, swings by the house to pick up Spot, and drives out to Pembroke Lakes Animal Hospital. He rubs his fingers, shakes his head, takes a deep breath. He stops for green light on Federal Highway. Tires squeal, horns squawk. He looks at the copy of

e-mail his girlfriend sent him. He reads it to Spot. "'We don't have much time left.' What does she mean by that, Spot? We have all our time left."

Play around, see what happens.

You Can't Do Anything If You're Nowhere

ᛞ

Place conspires with the artist. We are surrounded by our own story,
we live and move in it. It is through place that we put out roots.

—*Eudora Welty*

Way back when we started the book, you got to write about your
hometown. (It was fun, wasn't it? And if you no longer live there, it was prob-
ably sad, too.) And so did I. Here's what I wrote (after a revision or two):

> I spent half my childhood in a housing project called the Curtis
> Apartments and the other half across town in a small, asbestos-
> shingled cottage on a grassless, cindered lot that my father bought
> from his father on Grafton Hill in Worcester, Massachusetts. My
> neighborhood was a gritty, blue collar world of three-deckers, facto-
> ries, Catholic churches, mom-and-pop markets, tailor shops, and
> taverns.

Grafton Hill is where I, at eight years old, sat on the hill overlooking St.
Stephen's schoolyard one May lunch hour and talked about art for the very
first time in my life, talked about it with my friend Paul McDonald. What we
talked about was *Them,* a movie starring James Arness and a cast of giant
atomically mutated ants in the New Mexico desert. I don't remember what
was said except that I recall how animated we both were and how filled with
nuclear dread. I do remember thinking that here was someone else who con-

sidered those celluloid images important. Images weren't only to be absorbed, but were to be thought about and discussed. I understood that imagination was crucial in someone else's life, and the knowledge that it was legitimized my own daydreaming.

When you live in a neighborhood for decades, then practically every storefront, every tree, every corner has a memory attached to it. And the memories bind you to the place. If geography is destiny, so is memory. I remember a low stone wall in front of Jimmy Mulrey's house on Cohasset Street where Bobby Farrell and I sat one summer night and talked about Jackie Wilson. I remember the Billings Square Library where I borrowed my first book (*Black Beauty*) and where years later as an adolescent I spent hours sitting at the reading tables gazing across the room at the marvelous girls who went to public schools. And pitching pennies out front of Thompson's Market, rummaging through the debris in the spooky old abandoned house on Trahern Avenue. What else? Walking to church on Saturday morning in a blizzard, basketball days in the schoolyard, corn muffins and Blennds at Tony's Spa, building a gig with Eddie Dunphy and driving it down Dell Avenue. I could go on.

It is this primal landscape of childhood that shapes us as it shapes the characters in our stories. "You write from where you are," William Stafford reminded us. I am who I am because of where I grew up and when I grew up there. Throughout much of the fifties and sixties, I was confined to Worcester, Massachusetts, at the time, and until recently, the second largest city in New England, the Heart of the Commonwealth, the city that gave the world the liquid-fueled rocket, barbed wire, candlepin bowling,* the birth control pill, and (just this week as I'm writing this essay) the first cloned human embryo. (And it's the home of Elizabeth Bishop, Stanley Kunitz, Charles Olson, S. N. Behrman, John Casey, Frank O'Hara [all right, so he was born in Grafton, a suburb], and Robert Benchley.) Grafton Hill was in the fifties and sixties as exclusively Catholic and blue collar as neighborhoods get.

* In 1880, Justin White devised the game of candlepin bowling at his billiard and bowling establishment on Pearl Street. The ball is $4^1/2$ inches round and weighs $2^1/2$ pounds. The pins are $15^3/4$ inches high, about 3 inches wide in the center and tapered at the top and bottom. The pins are spaced 12 inches apart. Pins knocked over are not removed. Candlepins are so difficult that despite the fact that you get three balls per frame, no one has ever bowled a perfect game. The highest-ever score: 240. A 300-triple is considered a good score. The game is played in Massachusetts, New Hampshire, Maine, and the Canadian Maritimes. It's worth the trip just to bowl a string. As long as you're there, head down to southeastern Massachusetts or to Rhode Island and try duck pins.

Jobs ran to the trades, factories, and public service. There were no dancers or brain surgeons, actors or professors on the Hill. There were no writers, so it was impossible to imagine being one. The exotic vocations were never mentioned. We knew that explorers and chefs and scientists existed because we saw them on TV, but those jobs were for people who were not at all like us. We were styled to survive the neighborhood, and we learned not to set our sights too high.

With character (and characters) in mind, consider that for months in New England, the sun barely shines. In winter, darkness arrives at four or four-thirty. It's too cold to go outside. You've got clogged nasal passages, achy neck and shoulder muscles, and bronchitis from November till April. You're just happy you don't have the flu. And then you get the flu. At best, fun is seasonal. But in summer, fun season, it rains most weekends. You can plan an outdoor activity if you're a fool, but it will be canceled. Optimists are severely punished.

As children, we learned to do without short term gratification, a fortunate quality for a writer, it turns out. We learned to act spontaneously, to seize the moment. There's the sun, let's get to the beach before it rains again. We were always prepared for the accident of good fortune, another literary benefit. Massachusetts is not the sunshine state. It is generally bleak except for the first two weeks of October, which are indeed glorious if a storm has not already defoliated the maples before we get the chance to celebrate the death of nature. Here's what the narrator of my story "Hard Time the First Time" has to say about the neighborhood and the people who lived there:

> Until I was in seventh grade, I lived that normal life. My mother shopped, cooked, and made me wear rubbers to school. My father laid cable for the electric light company, and I got As in geography and Cs in arithmetic at St. Stephen's School. On special occasions, like First Communion or a birthday, we went to eat at Messier's Diner. Once in a while we'd vacation at Nantasket Beach. Then my father left us and moved to Tahiti with Donna Mungavon's mother. Never said a word. One night he's lying on the couch watching The Naked City on TV, the next afternoon he's on a plane to paradise. Something must have dawned on him. He left us a note. The part to my mother said how he knew this was the best thing for all of us and how he couldn't deny his real passions and like that. The part to me just said, "Get yourself a trade." We never heard from him again.

Mom took a job waitressing at the new Holiday Inn and on Friday nights she'd bring home a salesman. Whoever he was, he'd wear a beige trench coat and black wing-tipped shoes. And he'd ask me about the Red Sox. Guys that date your mother think all you want to talk about is sports. I got so uncomfortable with the long silences and with Mom's laughter that I started staying over my friend Cooch O'Hara's house, which was also O'Hara's Funeral Home, his dad being the Irish mortician in the neighborhood. One night Cooch brought me to the basement, to his father's studio, he called it, and let me touch Eddie Duffy's corpse. Eddie was our friend who had gotten locked in an old refrigerator at the dump and had died several days before the cops found him. Cooch gave me a long, steel clawlike tool and told me to be careful. I pressed on Eddie's chin. Maggots bubbled from his mouth. You don't forget a thing like that.

That's when I decided if I lived a holy life, maybe my body would stay together like St. Anthony's and not rot. I ran for president of the St. Dominic Savio Club at school. This, of course, is not normal. Normal people vote or don't vote. Show-offs run for office. I told the students on election day that I had dreamed of carrying the Eucharist through an angry mob of nonbelievers. I promised that if I won, I would pray for each of them when I entered the seminary. I lost to Monica Hebert and forgot about the priesthood.

As a child you have certain uninformed expectations. You assume that you will mature into someone special, say, like your father or like James Dean or John Kennedy, someone unlike the fat men in T-shirts yelling at their kids there in your neighborhood. The fact that there is only one James Dean and a thousand fat men does not influence your thinking one bit. Then something happens like you lose a seventh grade election or you don't make the high school team, and you realize that maybe you are not so special as you think, but at least you're alive and don't have maggots, and so you set your sights a little lower and you decide to settle for the small pride of a handsome garden, a tidy house, a sweet wife, and adorable children.

This kind of neighborhood, those kinds of people. Every winter at least one child in our neighborhood would fall through the ice at the brickyard pond or at the lake. Occasionally some kid trying to flatten a penny on the railroad tracks or trying to hop a freight would be killed by a train. One kid

would shoot another in the eye while hunting rats at the dump. Seven boys on my block died when they accelerated into an elm tree on Lincoln Street. I saw a child killed in the street when I was three. She was two and was run over by the ice man's truck. I remember the pool of blood spread out below the girl and her tricycle and the water dripping from the back of the truck. I remember my mother holding the girl's mother. I remember the ice man on the stoop crying. And there was the plague of polio and the marks of its victims, all children: their braces, their crutches, their iron lungs.

As place shapes the writer, it also shapes the writer's characters. Your hero grew up somewhere at some time and does not arrive immaculate and unformed at the moment your story begins. Like you, he has been fashioned by his environment, by the landscape, the community, by the folkways and foodways of his home place, by the local traditions, by the friends he has made, the friendships he has lost, by the schools he has attended, by the light and the weather, by the opportunities afforded him, by the possibilities denied. Place shapes the way we think, and determines what we can and what we will think about. And every story is about that place as much as it's about the characters who live there or those who are passing through.

> *"I don't really understand what a 'Southern' writer is. Writers just tend to write about their environment. If the South tends to be more poverty stricken, or has a less-educated population, or the politicians seem more arrogant, or there's a more intense devotion to religion, that's just the way it is."*
> —TIM GAUTREAUX

Every narrative has to take place somewhere, but that does not make the fiction regional. Fiction should not be qualified by place, as in "Southern Fiction," "Western Fiction," "Canadian Fiction." These regional tags are always pejorative and dismissive. Don't think of place-bound stories but of stories with a strong sense of place. Faulkner was not only talking about truth as it existed in north Mississippi, but a truth more plain and simple. We all sleep with the corpses of our dead lovers. He knew that. Fiction begins with the senses, and the senses go to work in a place. Let Madison Avenue speak for the country, fiction writers speak for Baraboo or Tahlequah or Truth or Consequences. The fiction writer's job is to look at the world one street, one tenement at a time because it is through the particular that we come to know the general, through the concrete that we come to know the

abstract, through the peculiar that we come to know the normal, through the home place that we come to understand the world. Instead of "Once upon a time in Utopia," better to write, "Just this morning in Boothbay Harbor, a woman who loved her husband realized that she would have to turn him in to the police."

What I'm suggesting is that a sense of place and of community is crucial to every writer. By that, however, I don't mean that you can only write about your hometown. There are landscapes of memory and there are landscapes of imagination. I grew up in New England but have lived now in the South (if, for the sake of argument, we still consider Florida the South) for twenty years. I write about both regions, though primarily about Worcester and about northeast Louisiana. Many interviewers I've spoken with have been curious about this notion of a New England native writing about the South. I find this an odd concern. It's as if that old saw about writing what you know must necessarily confine the writer to the region of her birth. What people may misunderstand is that what you can know is not simply what you've lived. Valerie Martin from Louisiana wrote convincingly enough about Scotland in *Mary Reilly*. Melville was not born in Polynesia, after all, and as far as we know Shakespeare never saw Verona or Elsinore. You may remember that in Faulkner's masterpiece *Absolom, Absolom!*, Quentin Compson lives and dies not in Yoknapatawpha County, Mississippi, but in Cambridge, Massachusetts. Andre Dubus grew up in Louisiana but wrote about Massachusetts, where he lived and worked. Our sense of place is rooted in narration. When a place evokes stories in us, then that is home, and we can write those stories.

> "There ain't anything that is so interesting to look at as a place that a book has talked about."
>
> —MARK TWAIN

The setting of a story colors the people and events in the story and shapes what happens. Place connects characters to a collective and a personal past, and so place is the emotional center of story. And by *place*, I don't simply mean *location*. A location is a dot on a map, a set of coordinates. Place is location with narrative, with memory and imagination, with a history. We transform a location to a place by telling its stories. In his essay "A Note on the Origin of Southern Ways," Thomas Landess talks specifically about the Southern sense of place in a discussion of Shirley Jackson's story "The Lottery." Every story, he says, would be another story if it happened some-

where else. He argues that "The Lottery," written by a New Englander, could not have taken place in the South. In the story, you may remember (and if you haven't read it, I'm about to spoil it for you—it's a story you can only read once, a tour de force of point of view, as I pointed out in the previous chapter, with a stunning finish), a nameless village conducts an annual lottery, though no one knows why, to choose the one among them who will be stoned to death by the rest. In the final scene, a woman is chosen and is ritually executed by the cheery townspeople, including her own dispassionate family. Landess writes: "If such a practice were to persist, say, in Yazoo City, any number of old maid aunts would be able to tell you *precisely* why it was done. Their facts might be in error, but they would have an explanation. And in the second place, no one in that part of the country would participate in organized cruelties that cut so easily across family lines. Other kinds of cruelty might be (indeed are) perfectly acceptable in Mississippi, but where the South is still the South, the family remains its most important institution."

>
>
> *"Well, writers don't write about real places. I mean, the London of Charles Dickens is not London, it's a London that is in his mind and his spirit, his way of looking at the world. That's his London. And I suppose the West is my mythologized place. It's where I grew up. I had a sense of myself as belonging here whether I did or not, of being from here, whether I was or not, and so my thoughts have returned here."*
>
> TOBIAS WOLFF

Place is about language as much as it's about anything. Community defines language, and language is culture. The place where I grew up and the South have different relationships to language. Worcester was settled by waves of immigrants who learned their English as a second language. This immigrant English focused on the practical, on the necessary, on the transmission of information. It was a written language, the language of the newspaper and of commerce. If my grandparents wanted to read for pleasure, they read French. When they spoke with friends after church, they spoke

>
>
> *"The local is the ultimate universal, and as near an absolute as exists."*
>
> —JOHN DEWEY

French. Southerners, on the other hand, at least those I know from Louisiana, Arkansas, and Georgia, whose families often went back genera-

tions in a community where English was the only language, relied on the spoken word, a much more intuitive, sympathetic, and capable medium than that available in my hometown. It was layered speech, subtle, playful, and emotional.

The immigrants want sense from their language. Southerners want music. New Englanders want to know "Why?" and want the answer in twenty-five words or less. A Louisianian prefers to tell you "How" in as many words as possible, indulgently, discursively, lyrically, following every tangent, surprising even herself with revelation. The two impulses, one toward efficiency, the other toward seduction, are not mutually exclusive. Asking *why* is the most important question a fiction writer can ask, the question that gets below the surface of plot and addresses values and motivation. And, of course, *how* you tell the truth, how you attend to the gestures and detail, fashions the truth and makes all the difference. When I write about the

.

> *"The writer operates at a peculiar crossroads where time and place and eternity somehow meet. His problem is to find that location."*
>
> —FLANNERY O'CONNOR

North, I'm guided by the former impulse; about the South, by the latter. And I hear, I hope, the appropriate voice.

The word *place* can also mean something other than location—it can mean "position or standing on the social scale," as in, "I hold to being kind to servants—but you must make 'em know their place." (That from Mrs. Stowe's *Uncle Tom's Cabin*.) It's this definition of place as an economic state, one that transcends geography, that may explain why, when I was able to hear a compelling literary voice, it spoke with a Southern accent, specifically William Faulkner's, Flannery O'Connor's, Harper Lee's. Here were people writing about their hometowns in a part of the country that was undergoing enormous changes, that was in danger of becoming something it did not wish to be, but they were clearly speaking for the folks I grew up with.

These writers dealt with depravities and misfortunes of poor people which other writers, in my experience, were not doing. I found the honesty attractive and familiar. I already knew the world was a mess because I looked around me and saw men, young men, grown pale soft and cynical, all up and down Grafton Hill, in the Diamond Café, the Cosmopolitan Club, the American Legion, sitting with other men in the dark watching TV, smoking, drinking, reminiscing, wondering, some of them, where their dreams had

gone. And these were the men who had the jobs, the families, and the homes. I saw friends, teenagers and already alcoholics and junkies, toothless and conniving. So when Harry Crews says of the South, "If we are obsessed with anything it is with loss, the corruption of the dream. And the dream was the dream of the neighborhood," I know he is speaking as well of Grafton Hill.

It just seemed to me that these Southern writers understood obsession and sin and grief and loneliness in a way that no New England writer since Melville and Hawthorne had. They acknowledged the human condition and made no apologies for it. There are some nasty and forlorn people in the world. There are zealous fools, and there are victims of tragic compulsions. The authors witnessed their behavior and did not shift the blame. Something a good Catholic boy could understand—if trouble happens, you must have deserved it. I feel like I had lived in the South long before I moved there.

EXERCISES

.

Our Town

You look at a map, see a dot and a name, and you wonder what the place looks like, and what kind of people live there. That's what we're going to do. We're going to get a story under way, and we're going to do it by thinking about place. *Louisiana Power & Light* began this way. I wanted to write about Monroe. I was new in town, and I paid attention to what was going on more than I might have if I had grown up in some place like it. I loved the cadence of the speech for starters. I liked walking out of the A&P and seeing a cotton field across the street. I liked the way people knew the histories of each other's families. Every neighbor, it seemed to me, was viewed as a potential narrative. I gathered pecans and persimmons in the backyard. For somebody from New England, that was astonishing and wonderful. My friend Dan Whatley and I used to paddle around Black Bayou Lake looking for alligators and admiring the wood ducks and herons. I wanted to write about the place, and I did so for months—in my notebook. Just jotting down sights, sentences about flowers and critters, lines overheard. But, being a fiction writer, I needed characters to live in the town in order to write about it. I found one on the nightly news—a man who had kid-

napped his boy from elementary school. I was off and running. But it started with place.

Imagine a town that you've never been to. It's an American town, and it's in the Southwest or in the Dakotas or in some New England valley or wherever your imagination takes you. This is a town that doesn't exist on the map—you're putting it there. It's unfamiliar to you right now. In fact, you might open your road atlas and find an empty spot in the region you'd like to visit and set the town there. Maybe it's by Stevenson Lake in western Nebraska, thirty-five miles to the nearest town. And it's called, what? Prague. Settled by Czech immigrants. Or it's in the Black Rock Desert of northwest Nevada and it's called Alkali. Make this a place where you'd love to live—you're going to be spending a lot of time there. See your town. Give it a name. Here are some interesting names that I picked at random from my road atlas: Turners Falls, Holliday, Lake Ariel, Start, Broken Arrow, Cut and Shoot, Frostproof, Beowawe. Take your time with the name. It may suggest something about the history of the town, about the landscape. The name will become a magnet, you'll see. Significant details will attach themselves to it. The name of the church in Prague, Nebraska, is St. Vitus after the cathedral in old Prague, in what is now the Czech Republic. The Czech-American Club holds Saturday night polka dances. And at Nita's Dumpling House you can order a three-course meal of *dršt'ková*, *telecí*, and *koláč* for eight bucks. You also want to consider what year it is. Einstein taught us all that there's no such entity as "place," but there is something called "space-time." To know a place we may need a map, but we also need a calendar. Alkali, Nevada, in 2002, population thirty-five, is nothing like the Alkali back in the thirties during the boom days when the gold and opal mines were running full tilt and there were eighteen saloons and fifteen houses of ill repute right there on Washoe Street.

Imagine the main street of your town—not necessarily called Main Street. Now I want you to walk down the main street and describe it in great detail. If you'd rather drive, go ahead, but drive slowly, pull over occasionally and take notes. Name the businesses, the churches, the institutions. Describe the buildings. Look at the people on the street. How are they dressed, and how is that different from how folks dress where you live? What time of day is it? What season? What's the weather like? Describe the flora, the fauna, the cars or other conveyances. Use your five senses. What does it smell like? If there's a paper mill nearby, you'll know about it. What are the

sounds you hear? If you're a decent artist, you might want to paint what you see. If you're like me, you'll have to settle for a rudimentary map. Walk down that street and spend as long as you need to, to capture it all. Look for the vivid and surprising details. When you've done that, we'll go on to the next task.

Now I want you to pick one of those buildings you described and I want you to walk inside. Look around. Sniff the air. Listen. Touch the walls. Describe the interior in as much detail as you can. Once again, take your time. Walk into every corner, every room, every closet. You're looking for the revelations that lurk in details. Every detail tells you something about this town. So do that. Write about this building and the business that goes on inside of it. When you've finished, we'll go on to the next step.

Maybe you thought you were alone, but now you notice that there's a person there besides you. This person is troubled, you think. Why do you think that? Something in the way she stands? The look on her face? Write about her. Or maybe there are several people here. It's a bank or a restaurant or a bar or a hardware store. Choose one of these people, the one who seems troubled, preoccupied, and describe him or her and what he or she is doing. Give the person you're writing about a name and address. The address must be in this town. Imagine what's going through his or her mind. What does the person want? What's stopping him or her from getting it? If you aren't sure, go up and ask. You are an author in search of a character. You want to write this person's story. There has to be trouble in his life. Write about that before you continue. Give the person a voice and let her tell you her story. Buy her a coffee, a drink, sit down where it's quiet, listen to her, and write it all down.

All right, so now you have a town, and a person in that town who's troubled. And if you're lucky, you learned about several other characters involved in your hero's life. She told you how her husband's been cheating on her with their daughter's fifth-grade teacher, let's say. Her daddy, the judge, never trusted Phil anyway. What you want to do now is follow your central character home. You've given him an address, remember. Now describe the house, the trailer, apartment building, whatever it is. Walk around—you're alone. No one's home. Describe the yard and its maintenance. Look closely. Does the home tell you anything about the character? When you get done with the exterior, we'll go inside.

Now we're in the house. Look around in each room. What's there?

What's missing? In the kitchen: any pet-food bowls? Has it been cleaned up or is it messy? Dishes in the sink? Dead coleus on the windowsill? Describe the kitchen. Open the fridge and see what's in there. Who's on a diet or who needs to be? Batteries in the vegetable drawer? What else is unusual in the fridge? Medicines? Might they have something to do with the character's problem? Check the freezer, too. Frozen fast-food burgers still in their waxy paper? What's that about? Open the junk drawer. We all have one. Bottle openers taken from restaurants? String, twistees, measuring tape? Go through the drawer. Being a fiction writer is being an archaeologist. You're looking for clues to these people. (Interesting—*people!* Who lives here besides our hero—if anyone?) Look through the cabinets, under the sink and all. There's a pile of mail on the kitchen counter. Go through it. Let's see who our character owes money to, what magazines she reads, who is corresponding with her. Now go nose around in the bathroom. Check the medicine cabinet first. Prescription drugs? What else? What kind of soap is there? Shampoo? Creams, and so on? Now be just as thorough in the living room, the den—open the desk drawer—the dining room and bedrooms. Let yourself be surprised by what you find here. Not every detail will spark your brain, but some will. Look from floor to ceiling, and look closely. Check in the closets, too. If there's a cellar or an attic or a garage, go there. What have they got stored in these places? What are they saving from their pasts and why?

You've been here awhile, but it's only now, as you're getting ready to leave, that you notice Post-it notes stuck to the walls, to the fridge, the ceiling, mirrors. Stop and read them. What do they say? They seem rather cryptic, don't they? What do they have to do with this character's problems? His or her developing story? Who wrote them and why? Follow the tangent for a few minutes.

Begin to write the story. What does he or she want? Why does she want it? What's stopping her from getting it? How will she struggle? Will she get what she wants?

May-December

Here's a situation from Chekhov's notebook: "N., forty years old married a girl seventeen. The first night, when they returned to his mining village, she went to bed and suddenly burst into tears, because she did not love him.

He is a good soul, is overwhelmed with distress, and goes off to sleep in his lit-
tle workroom."

Okay so let's make that little mining village the town that you've just
imagined into existence. Every town is full of stories. Here are two people—
the husband might even know the people you've already written about in
"Our Town." Ask the questions that are suggested by this sketch: If she
didn't love him, why did she marry him? Where was the marriage ceremony
performed? Why did he marry her? Does he love her? What will happen to
them, to their marriage? etc. Write the story that is suggested by your
answers.

Home Furnishings

If, as is likely, in the course of your story your characters are home,
you'll need to furnish the house. And you will want the home to have an
interesting and revealing decor. And one that reflects, perhaps, the region
where the home stands. You certainly can browse through *Apartment Life* or
Town & Country or *Backwoods Home* or any number of chic and practical
magazines to do the decorating. But why not use your own past as a source
of material, since your memory is a warehouse of furniture that is not only
functional but that has some emotional resonance for you?

Make a list of homes that you recall fondly. This list might include your
own childhood home or several of them. How about your grandparents'
homes, the summer camp on the lake, a friend's house? Think of those places
where you felt comfortable and relaxed.

Now for each of the places on your list do the following: Visualize the
home. Now take a leisurely stroll through the house. Walk through all of
the rooms. Go into all the rooms. Notice the colors, the light, the propor-
tions, the furniture, the decorative pieces. Pay attention to the cozy places.
Sit down where you feel most relaxed, secure. Look around—write down
what you see, hear, taste, smell, touch. When you've finished with your list
of homes, you'll have lots of furniture. Now steal some of it for your stories.

I picked up the following in a brief tour of the several apartments and
houses I've lived in: an oval tin box of Cavalier cigarettes on a coffee table; a
Motorola TV with a round screen; an orange bean bag chair; Venetian blinds;
radiator covers; a sansevieria plant with two leaves in a ceramic St. Francis
planter; a wall calendar from Moore's Pharmacy with the best days for fish-

ing on it; an enamel-top kitchen table; a white plastic filigree crucifix with a gold plastic Jesus; confetti linoleum; Melmac dishes. I already know something about the man who lives alone in a third-floor apartment with the above furnishings. He works the graveyard shift at St. Vincent's Hospital as a security guard.

The Art of Abbreviation

℣

The secret of being tiresome is to tell everything.

—*Voltaire*

The history of fiction has been dominated by the novel and more
recently by the novel and the short story. But now there is this brave new
genre around, and like God it has many names, like Proteus it takes many
forms. I'm talking about very brief fiction, what has been called *sudden,
micro, hyper, mini, short-short, flash, nano, instant, postcard, fast and furious*. I
thought of calling it *breviloquent* ("given to concise speaking, laconic" [so is
the word itself oxymoronic?]) *fiction*, but the name would never catch on.
Abbreviated fiction (Abbfic) carries the unpleasant suggestion of thematic or
structural truncation. I suppose the fact that no one can name the beast,
means that no one knows what it is. (*Swift-fic? Compact fiction?*) It's short, but
even its brevity is in debate. (*Storyella? Storyette?*) It's fifty-five words, or it's
fifteen hundred words, or it's somewhere in between. A sentence long? A
paragraph? (*Quick-fic?*) And really, it's not so new, after all. We've had biblical
parables, of course, Aesop's fables, Kafka's paradoxes, and Borges's *ficciones*,
to name a few precursors. What's new, however, is the attention this succinct
genre is getting. This is fiction approaching haiku, the art of few words and
many suggestions.* Like a haiku, these *Augenblick* fictions, as the Germans

* The Japanese form, haibun, is a combination of prose and poetry. The prose often depicts a journey—it's not
generally fiction—and is interrupted on occasion with lines of meditative haiku. Basho's *The Narrow Road
to the Deep North* is an example.

might call them, start us thinking. (The French might call them *coup de fic-tions*.) The reader goes on after the piece is finished, goes on in the emotional direction suggested by the poem. This is the zen of fiction—it doesn't explain; it only indicates. It has no truck with ideas. Here's one I wrote:

HONEYMOON

The wedding itself is so exciting, so dazzling, that it almost makes Tandra, our bride, forget that she has made a grievous mistake. When they arrive in Gatlinburg the next day, Tandra and Clell, Mr. and Mrs. Hollis, check into the Travelodge and then go out to see the sights. They take the tram to Obergatlinburg. Clell pulls a muscle in his back trying to hit curveballs in the batting cage. He wonders did he somehow do that on purpose. They take the trolley to Dollywood, see a show called *Hillbilly Hoedown*. They nurse drinks and talk as long as they can in the Jacuzzi. Eventually they make love in the Honeymoon Suite (which the man at the desk pronounces *suit*— Honeymoon Suit, he says, otherwise it would be Honeymoon Sweet. And he spells it out.) As Clell grinds into her, Tandra imagines her future. She thinks of this new life as a career—wife, mother, social adjunct, companion. Beats working in an office. She'll get busy with PTA soon enough, and dinner parties, charity events. She'll take up tennis. When Clell is finished with his business, he rolls to his side of the bed. He puts Betty Shackleford, maid of honor, out of his mind. He puts the heating pad on his lower back. He wonders where his love for Tandra has gone, and is it gone for good? Somehow the real-ization that he has deceived his wife makes Clell feel closer to her. Protective. He is willing, he knows, to sacrifice his own happiness for hers. In deceit begins responsibility. Clell is surprised that he feels this benevolent way.

Here I'm trying to tell a larger story in a smaller space by using exposi-tion primarily. I'm expecting you to imagine the missing plot. (*Elliptical fic-tion?*) The struggle is off the page, isn't it? What led Tandra to make this "mistake"? Why did Clell consent to marry Tandra? I'm playing with the irony inherent in the title, of course (and later the difference between the *suit* and *sweet*) and with the whole optimism of the marriage ritual. I think the

story is about secrets as much as it's about anything. It's about dreams and reality. And about emotions we have no control over. It's about what love is, not what we're told it is. I present a moment in this marriage and you construct its history. I tell the story of a honeymoon, you imagine the novel that you call *Marriage* or *Tandra and Clell*. And this points out an important characteristic of this new lean fictive genre. *Snap fiction* (?) carries the collaboration between author and reader to another level. The story is the call that awaits its response. So maybe the important event in a short-short is what happens to the reader, not what happens to the characters.

> *"Not only lotus leaves, but little hollyhock flowers, and indeed all small things, are most adorable."*
>
> —SEI SHONAGON

When I wrote "Honeymoon" I thought maybe I'd written a prose poem and didn't know it. Of course, I didn't know what a prose poem was. If it doesn't have line breaks, it's prose, right? The *Princeton Handbook of Poetic Terms* defines a prose poem as "a composition able to have any and all features of the lyric, except that it's put on the page . . . as prose. [It differs from] short prose in that it has, usually, more pronounced rhythm, sonorous effects, imagery, and density of expression." Of course, as a fiction writer, I like to think that fiction has to do everything that a poem does—the precision, the music, the vivid imagery, etc.,—do all of that plus tell a story. When I think what the differences might be between a prose poem and a short-short story (between prosaic poetry and poetic prose?), I think that the prose poem is a bit self-conscious in that it has chosen to forsake its conventional form. And I think that poets often seem to be talking to

> *"I have made this letter longer than usual, only because I have not had the time to make it shorter."*
>
> —BLAISE PASCAL

themselves (even if it's with a wink, knowing we're nearby eavesdropping). Fiction writers are always talking to someone else. Poets want to have their say; fiction writers want to listen to what their characters say. But I'm probably wrong about all that. I don't think I'm writing poetry, that's my point. I'm telling a story in a new way, new for me. (*Fictionette?*) Here's another one, brief as the lightning in the collied night:

TABLE TALK

At breakfast this morning, my son Bilbo asked me if I knew that Ann Landers or Dear Abby, one of them, says that masturbation does not kill virginity. I said, Do you know those two gals are actual sisters in real life? He said, Lame, Dad. No, I said, it's true, and they don't even speak to each other. He said, You're making that up. Then he asked me if I dreamed about making love to faceless women. I said, Of course not. What kind of question is that? Well then, what do they look like? he said. I told him he was out of order. Ever since his mother left me, Bilbo's been on about sex and more sex, every time he stays over. Of course, he *is* fourteen. I said, Eat your Wheaties. He said he'd been thinking about breasts a lot. I didn't care to know *what* he thought exactly. I said, Why? He said, Debate in civics class today. Resolved: *Breast-Feeding in Public Is an Affront to Our Municipal Morality.* Bilbo was against it—the feeding, not the resolution. I told him he was breast-fed in public and in private until he was three, and he's got the fourth highest grade-point average at Crispus Attucks Middle School and a 1300 on his PSATs. He said, Hey, I worked for those grades. Bilbo's mom left me when I fell in love with a twenty-one-year-old student in my class. Bilbo said he wasn't against all breast-feeding. He thought welfare mothers should *have* to breast-feed, thereby saving the taxpayers millions of dollars in baby formula. He's been talking to his mother's boyfriend, Bob, a prosecuting attorney, a Republican. I tell Bilbo, Why don't you let your hair grow, pierce your tongue or something?

.

"Haikai exists only while it is on the writing desk. Once it is taken off, it should be regarded as a mere scrap of paper."

— BASHO

This is bit more scenic than the earlier piece. We almost join Bilbo and Dad at the breakfast table. Dad tells his own story. Or does he? He describes a politically disturbing conversation with his son, and he takes a somewhat superior tone. His liberalism has made him a bit arrogant, hasn't it? But where has it gotten him in his own life? He's alienated from his wife, from his child. The boy supports a political agenda

that I personally, Mr. Author, might find distasteful, but even I know that Bilbo's the person being honest at this table. And for all I know, he's pulling Dad's chain. Again, the big trouble seems to be implied. Dad's struggle is in the past, though its repercussions are keenly felt today. Dad talks to Bilbo ostensibly about sex, and he is aware of the trouble sex can lead to. Maybe he'd rather forget. Which brings up the Iceberg Theory of Fiction.

Eighty-seven percent of an iceberg's volume lies below the surface. (Put a chunk of ice in the kitchen sink and measure.) Every story is an iceberg, and all we see is what's on the surface, and we call it the plot. The characters behaving. But *what* characters do is not as important as *why* they do it. Values and motivation lie below the surface. What we see in "Table Talk" is a father-son conversation, the exasperated father

> "The notes I handle no better than many pianists. But the pauses between the notes—ah, that's where the art resides."
>
> —ARTHUR SCHNABEL

trying to set his boy on the right path. The other seven-eighths of the story is literally under the table. What isn't said is as important as what is. Here we left out the romance and marriage, the birth of a child, the affair, the betrayal, the breakup, the subsequent agreement as to child care, and so on. And maybe what's even more important, the future is missing. Why is Dad telling us about this conversation he had this morning? Why has he been moved by it? Why does he find it important?

Whatever we decide to call this form (*the shorter story?*), I urge you to try it. Think of yourself as a pioneer. The form is open, unexplored. You are helping to define it. (*Fictionelle?*) Like all fiction,

> "I am always doing what I cannot do yet, in order to learn how to do it."
>
> —VINCENT VAN GOGH

it needs to be compelling, needs to engage us emotionally, needs to take us out of our world and drop us in the world of the story, needs to tell us something we don't know about ourselves. It might be funny or unsettling. It should provoke us, change our lives, break our hearts, or stun us with insight. Your dense little story might be or might contain a snatch of dialogue, a want ad, a voice-mail message, an e-mail exchange, an encyclopedia entry, a bit of theology (fiction with an attitude), an inscription on a headstone, a last will and testament, a TV show, a billboard, a memo. It ought to have people in it—people like you and me, flawed and struggling. Fiction is about people. I was going to say it ought not to be just a character sketch, but

why not, if the character is unlike anyone we've ever seen before, if the sketch offers us a peek into the real trouble in that character's life? You should write a piece of expeditious fiction every day. Call them lunch stories or coffee-break stories or bedtime stories. Take chances, experiment. What's to lose? Write them quickly in your notebook. Revise and type them later. Have fun with diminutive fiction. Size doesn't matter when it comes to wisdom and perception. A short-short story is not a novel, just as a sonnet is not a saga. But each form, the novel and the very short story, is important in its way; each can say what the other form cannot. Each helps us understand who we are. One is a glimpse, the other a stare.

E X E R C I S E S

.

A Man and a Woman

A man and a woman in a room. This is Salina, Kansas. He wears cuff links on his white shirtsleeves, a silk tie. She seems preoccupied. She holds a glass in her hand. Write their story in three hundred words. Use the word *salvation* and the word *light*. Make one of the pair the central character and construct the story from his/her point of view.

Words of Wisdom

Remember the words of wisdom your parents shared with you so often you thought you'd scream if you heard them one more time. "Neither a borrower nor a lender be"; "You judge a man by the company he keeps"; "If all your friends jumped off a bridge, would you?"; "Children should be seen and not heard"; "Wait till your father gets home"; "Keep your eye on the ball"; "Do as I say, not as I do." Do you still live by those rules? What do you think of them now? Do you use them? Spend some time recalling and writing about these aphorisms. Then pick the one that brought back the strongest feelings or the one that seems particularly fertile right now. Make it the title of your new 250-word story. And just to help you along, here are some words you need to use: *fasten, rain, irregular, linoleum, grace, left.* Now only 244 words to go. Give yourself a half hour to write a workable first draft. Put the draft away

for a couple of days. Take it out, read and revise. Let the story tell you where it wants to go. Revise again.

Renga

This is a group exercise. Try it with your writing group or your writing pals. Renga is a form of linked poetry written by two or more people. The first renga poet writes a verse and hands it to the second, who uses the verse as a springboard for hers. We'll do the same with our very short stories. The Japanese used haiku and tanka to construct renga; we'll use length as our limitation. You've got, say, one hundred words, a half page of type, to tell your story. When you've finished, pass it on. The next writer makes the leap inspired by something in your story—an image, a character, a place, something tells him where to go. If you've got a group, take a half hour or twenty minutes or whatever time you need for each person to write his story. And then everyone pass to the left. Continue until you're done. Have a reading before you adjourn. You could write a book this way.

Two Truths and a Lie

Here's another group exercise. We all learned to lie as children. How to explain the broken lamp, the spilled milk. How to avoid the anger and disfavor of our parents. Our first lies were probably denials or statements of ignorance. No, I didn't do that. I don't know how it happened. When that didn't work, we learned to be more detailed and specific, more creative and imaginative. Well, Ma, the lamp was pretty close to the edge of the end table and Spot was walking by and he must have been happy 'cause he was wagging his tail like mad and he knocked the lamp with his tail, and I tried to catch it, and I almost did, but I missed, and it crashed to the floor, and that's how it broke. In this way, we learned that detail convinces. A fine lesson for the budding fiction writer.

Think of fiction as telling lies. Telling lies takes imagination and a bit of courage and convincing details. I first played a game called "Two Truths and a Lie" in a bar in Columbia, Missouri, with my friend Maureen and her fellow dean at Stephens College. A couple of characters in my novel *Deep in the Shade of Paradise* play the game and the result is disconcerting for one of them. The idea is to make three brief statements about yourself. One is a lie. You want to do it so well that the other players can't tell which. What I

noticed in this session is that people tend to put more detail into the lie than the truths, thus giving it away. Remember, details must be vivid and significant. No details for details' sake. Remember that the whole exercise is deceit. In a short paragraph, then, write down two things that happened to you and one that did not. When everyone is finished, read your three events. Let the group guess. Continue until everyone is finished. You'll have plenty to talk about when you're done. You'll be amazed at the revelations that surface.

Taking Direction

Take directions from labels of household products and apply them metaphorically to items that don't require such instructions. The heart, for example: "To retain freshness, keep the heart dry at all times." "Discard after use" could apply to what? About your beloved's protestations of love: "May be harmful if swallowed." The bitter truth: "Keep out of reach of children."

Other Matters

Reading to Write

X

It seems to me that one should only read books which bite
and sting one. If the book we are reading does not wake us up
with a blow to the head, what's the point of reading? . . . A book
ought to be an icepick to break up the frozen sea within us.

—*Franz Kafka*

Writing fiction is a craft which favors the diligent over the inspired.
We are all and always apprentices at this craft. We never accomplish the
story we're trying to write, the Great American Novel, the Great American
Short Story. We always have more to know. We always have additional skills
to acquire. There are two ways to learn how to write fiction: by reading it and
by writing it. Yes, you can learn lots about writing stories in workshops, in
writing classes and writing groups, at writers' conferences. You can learn
technique and process by reading the dozens of books like this one on fiction
writing and by reading articles in writers' magazines. But the best teachers
of fiction are the great works of fiction themselves. You can learn more about
the structure of a short story by reading Chekhov's "Heartache" than you
can in a semester of Creative Writing 101. If you read like a writer, that is,
which means you have to read everything twice, at least. When you read a
story or a novel the first time, just let it happen. Enjoy the journey. When
you've finished, you know where the story took you, and now you can go
back and reread, and this time notice how the writer reached that destina-
tion. Notice the choices he made at each chapter, each sentence, each word.

(Every word is a choice.) You see now how the transitions work, how a character gets across a room. All this time you're learning. You loved the central character in the story, and now you can see how the writer presented the character and rendered her worthy of your love and attention. The first reading is creative—you collaborate with the writer in making the story. The second reading is critical.

I've heard writers say that they can't or don't read fiction when they're writing. They don't want the prose to interfere with their own, I guess. I don't understand that. First of all, when would you read fiction? How can you just stop your writing in order to read? How could you not read fiction? I read constantly because I love it, because I want to be moved by it, because I want to know about me and you, and because I want to learn from it. Don't be afraid to be influenced by any writer whom you admire. We should be flattered if anyone notices a similarity between our little story and, say, a passage from Melville. If you aren't influenced by the masters, then you may only be influenced by yourself. Influence doesn't necessarily mean imitation—although we learn most important behaviors, like speaking, by imitating. And if you read widely, you won't be imitating but rather assimilating. For the passionate writer, everything she does in the service of her fiction. She doesn't socialize without acquiring material from the unsuspecting; she doesn't walk down the block without gathering material for her story; and she doesn't read without paying attention to the craft. And she doesn't read crap. She doesn't want to be influenced by the worthless, and she doesn't have time for it.

>
> *"Read! Read! Read! And then read some more. When you find something that thrills you, take it apart paragraph by paragraph, line by line, word by word, to see what made it so wonderful. Then use those tricks the next time you write."*
> —W. P. KINSELLA

>
> *"Read the best books first, or you might not have a chance to read them at all."*
> —HENRY DAVID THOREAU

So here's a lifetime reading plan for fiction writers. It's actually the poet/novelist Jim Whitehead's plan. He was a teacher of mine who once said, "Dufresne, how can you expect to understand Philip Larkin if you haven't read Schopenhauer?" And then he called a bookstore on Dickson Street in Fayetteville, told them to hold a copy of *The World as Will and Idea,* and sent

me off to buy it. We'll talk when you're finished, he said. (When the student is ready, the teacher will appear.) Whitehead said we need to begin our reading with the Bible (make it the King James) and with the Greek and Roman classics. Most of our Western mythology comes from these two sources. So read the Bible, the Old Testament, at least. Start with the Song of Solomon, the Psalms, and the Book of Job. And read Homer, of course. Maybe you've never read *The Iliad* because you were put off by it at school or were intimidated by its length. Well, trust me on this one, you're going to love it. It's magnificent. And *The Odyssey* is even better. I favor the Richard Lattimore translation of the first, the Robert Fitzgerald translation of the second. And read the great Greek dramatists: Sophocles, Aeschylus, Euripides, Aristophanes. And you'll want to read Plato (*Phaedo*) and Aristotle (*Poetics*). It's about 300 BCE. On to the Romans, to *The Aeniad*. To Ovid. And now you're off and running.

When you finish your classical introduction, Whitehead said you buy yourself *The Norton Anthology of World Masterpieces* (there's a new single-volume, 3,052-page edition) and read it. Just read, don't fret. You're not being critical. You're trying to learn. And don't speed through it. Go slow, move your lips when you read. I don't care what the nuns told you. That's how you read poetry, anyway, and fiction has to be at least as well written as poetry, so do it. Enjoy it all. Read generously, lovingly, attentively, serenely. And when you've finished, read it again. This time take some notes. Highlight the

> *"The habit of reading is the only enjoyment in which there is no alloy; it lasts when all other pleasures fade."*
> —ANTHONY TROLLOPE

passages you want to remember. Jot down what you like, what doesn't interest you, what you don't understand, and so on. (By the way, you do have the rest of your life to do this, and you have no idea what delight is in store for you. Don't hurry, just keep reading. Which brings up distraction once again. Perhaps the best thing we could do to jump-start our writing careers would be to murder our televisions. They suck the life right out of us. Keep us slumped on that couch. At least get rid of the satellite dish or the cable. Of course, not watching TV keeps you out of the popular-culture loop, and that may cost you some hip readers down the road. And what would you talk about at lunch? Maybe you'll have to start a reading group at work. Or recruit a reading pal to enlist in the lifetime reading plan. If you must watch TV, don't watch till your writing and your reading are done. You'll feel better about yourself.) When you find a writer you like, read more of her work. Read her until you're ready to move on.

One of the people you'll like is Shakespeare. Understand that if you don't get Shakespeare, if you don't understand him, this is not a judgment of Shakespeare. Shakespeare is not up for debate. He's our greatest writer. He reinvented our language. You have to read Shakespeare. Or better yet, if you're able, see the plays in performance. You can get *The Riverside Shakespeare* or buy the individual paperbacks. Then you can buy or borrow from the library tapes or CDs of the great performances and listen as you read along. You could take a week's vacation on some secluded mountain lake, sit out on the porch with a drink and the complete works, the complete performances, and get through all of Shakespeare on your holiday. And what a holiday it would be. Treat yourself.

> *"Reading makes immigrants of us all. It takes us away from home, but more important, it finds homes for us everywhere."*
>
> —JEAN RHYS

So you've done the classics, the ancients. You've read Gilgamesh and Dante, Augustine and *The Thousand and One Nights*, Chaucer and Montaigne, Cervantes and Dickinson, Flaubert, Tolstoy, and Proust. You've read Japanese haiku, Icelandic sagas, ancient Egyptian poetry, and Navaho Night Chants. What to do next? Well, you're a fiction writer, so it's time to read all the great novels and stories you can get your hands on. You know the ones. The ones that people have been telling you to read all your life. There's a reason they've been telling you. So read Joyce, Dickens, Trollope, Mann, Proust, Sterne, Stendhal, Céline, Colette, Balzac, Melville, Flaubert, Dostoyevsky, Tolstoy, Twain, Hardy, Conrad, Kafka, Fitzgerald, Hemingway, Dos Passos, Nabokov, and all the ones I forgot to mention. You'll never read everything you want to read or that you ought to read, so relax. This is an impossible but noble task. Besides, they keep printing new books. We can't catch up. Which brings us to contemporary literature. You have to read that as well. What do our best writers have to say about how we live these days? If you want to write

> *"There are worse crimes than burning books. One of them is not reading them."*
>
> —RAY BRADBURY

mysteries, you'll want to concentrate on the best of our mystery writers, people like Peter Høeg and Martin Cruz Smith, perhaps. If you want to write thrillers, read all the best thrillers you can find. Same goes for science fiction, westerns, or any other genre. If you asked me which contemporaries to read,

I'd tell you Alice Munro and William Trevor. After that you're on your own.

Will good literature change your life? You bet it will. Because you'll be living a thousand lives and learning who you are by learning who these made-up people are. Reading honest literature makes you love the world. Knowledge and understanding are love. Reading educates our feelings and enhances our sympathy. When you read for understanding, you are fundamentally changed. You are a different person at the end of the story or the novel than you were when it began.

EXERCISES

.

Television

I spent too much time telling you not to watch the tube, but since we all do, maybe we can use our knowledge of TV characters to build a story. Why do we have televisions anyway? Why do we still turn them on? Not for the news, a distant fifth to newspapers, the Internet, news magazines, public radio. Sports have become an ugly, boorish business. (Okay, I'll admit it, I still watch a game or two.) Talk shows à la Springer are poor substitutes for tabloids. Well, as long as we have them on, let's make use of them. Select a program. It should be a series, and one whose characters you are familiar with.

Characters on television never change—that is the essence of their appeal—and so they are the opposite of characters in fiction, who must always be changed. We want Kramer to be Kramer, to come bursting full-tilt through Jerry's door every time. Take a character from your series—not necessarily the central character—and imagine a changing point in his or her life. One that we'll never see on TV. Write the story of what happens. For example, let's say Bob Hartley's wife Emily dies (*The Bob Newhart Show*; I'm giving my age away). What does Bob, the sweet, neurotic shrink, do now? This isn't funny at all, is it? How would he now react to Howard's non sequiturs? How does he go on with his life? What does he want now that he is alone? How does he deal with his grief, his loss, his anger? You've got a setting, a central character, a supporting cast.

Reincarnation

Authors often take characters from one of their books and use them in
another book. I've certainly done this, and so has John Updike rather more
famously. Mark Twain, James Joyce, the list goes on. Other authors borrow
characters from books that they haven't written. Jean Rhys borrowed
Antoinette Cosway, from Charlotte Brontë's *Jane Eyre*. In Brontë's book,
Antoinette is the madwoman in the attic. Rhys gives Antoinette her own
book, her own story in *Wide Sargasso Sea*. Valerie Martin uses Robert Louis
Stevenson's Dr. Jekyll in her novel *Mary Reilly*, but now he's not the main
character. So feel free to take a character from one of the novels or plays or
narrative poems that you've been reading and write a story or novel about
this character. It's probably most fun to take a minor character and imagine
the rest of his or her life. And it's probably a good idea not to use the work of
a living writer or a work that is still under copyright.

The Evening Muse

When I read something beautiful and stirring, I want to close the book
and go write. When I see a brilliant movie, I want to drive home and get to the
writing desk. Good art makes me want to write something as good as I've
read or seen or listened to. I want to make someone feel as transported as I
just felt. I hope this happens to you. To help the process along, write in your
notebook about what you're reading. This keeps you in the world of the story
even when the covers are closed. As you're reading, highlight the beautiful
sentences. When you stop for the day, write those sentences in your note-
book, so you'll always know where they are when you want them. (Or keep a
separate notebook for such quotes.) Think over what you've read today. Write
down any ideas that have been provoked by the story you're reading. Note
what you admired, or didn't, about what you've read.

The Writer Reads

X

How could you write about anything without wondering
if it were true? I mean you'd be describing a bird in the garden
and suddenly there would be that awful question in your mind,
did they have birds in the fourth century?

—*Gore Vidal* (quoting *Christopher Isherwood*)

A fiction writer has to read everything from Wittgenstein's
Blue and Brown Books to the backs of cereal boxes. (My own cereal box says,
"Tiny dark specks which are natural to corn are occasionally found in this
product. They are not harmful in any way, and will not affect the taste or tex-
ture of this product." I'm given a phone number to call if I'm anxious and
told to "Please retain box when calling.") The writer's problem, and opportu-
nity, is knowing the world. That's why we can never have enough reference
books. Reference books supply the facts we need, and then, as Kenneth Clark
put it, "Facts become art through love, which unifies them and lifts them to
a higher plane of reality." How nice, when writing your story, to reach over
to a volume on the shelf—always keep your books near the writing desk—
and learn that, yes, they did indeed have birds in the fourth century, and the
one I'm thinking of now is this one on page 187, the song sparrow.

When I was writing *Love Warps the Mind a Little*, I came to a scene in
which my hero, having left his wife and taken up with another woman, is at
a party. He drifted outside to the bar in the backyard. I decided we ought to
have a floral arrangement of some kind out there—that was the kind of

party it was. I looked on the shelf where the natural history books and field guides were stacked and took down *Simon and Schuster's Complete Guide to Plants and Flowers*. I let it fall open and received one of those gifts you can only hope for. The flowers of the plant on the opened page were long, crimson pendant racemes. The oval leaves were light green. The plant's name: love-lies-bleeding. Detail and theme all in one. So good, in fact, that I considered whether it might not be too heavy-handed, might seem like I'd worked too hard finding just the plant. But I decided never to look a gift flower in the corolla.[*]

> *"I always come to life after coming to books."*
> —JORGE LUIS BORGES

Reference books are one of the tools of your trade, and you need to have them in your toolbox. The most important book to have, of course, is a good dictionary. You can't be without one. (And you probably should have many.) The best is the *Oxford English Dictionary*, which comes in a compact edition, in typographically condensed form—a couple of twelve-by-nine-by-three-inch volumes and an only slightly smaller supplement, complete with a magnifying glass. The *OED* is also available these days on a CD-ROM at $295, only a bit more expensive than the books. Even better news is that the Quality Paperback Book Club (which, alas! has never chosen one of my books for its members, so I owe them no favors) offers free access to the *OED* on-line to its members. It seems to me that's worth the four bucks to join. (No kidding!) What makes the *OED* so essential, and so enjoyable to read, is the extensive etymologies of English words. The history of any word is a poem. Let's choose one and see. How about *flower*, since we were talking about them?

When someone says "flower," the image I see is the red blossom of a cut flower. It's tuliplike or roselike, which is curious, because my favorite flower is the iris, a lavender and yellow iris, like the ones that grew by the wall in our yard when I was a kid. So why do I, or why does my brain, insist on this generic image? Blame it on St. Valentine's Day? On Holland? The word *flower* comes from the Middle English *flour* from the old French *flour* (*fleur*) back through Spanish, Portuguese, and Italian to the Latin *florem*. We can trace

[*] And today, driving home from picking up my son at school, I read a truck, a semi, a Kenworth T2000, it looked like. We were stopped at a red light on Federal Highway. The white cab was undistinguished except for the following, written on the rear, facing the load—and written in an Old English font: *I'm in Love With Your Beauty*. It so happens that in the novel I'm beginning—I'm early in the note-taking stage—the father of my young hero is a long-haul trucker. And now maybe I know what he has written on his truck. And maybe I have some unexpected insight into what drives the driver. Who knows where this will lead?

the word further back to the Indo-European root *bhlo*, which we'll do shortly. But first, the definitions. A flower is the colorful business on the end of a plant. If it's not colorful, it's not a flower, is it? Well, that's what many of us think. And a flower is, indeed (just listen to the precise use of language here) "a complex organ in phenogamous [*pheno*: displaying; *gamous*: reproductive organs] plants, comprising a group of reproductive organs [watch how this plays out in a moment] and its envelopes [lovely word, isn't it?]. In the popular use of the word, the characteristic feature of a *flower* is the 'coloured' (not green) envelope, and the term is not applied where this is absent. . . . In botanical use, a flower consists normally of one or more stamens [pollen-producing organs] or pistils [the female or ovule-bearing organs] (or both), a corolla [the petals as a group], and a calyx [the sepals of a flower as a group]; but the last two are not universally present." So that's one definition, the one usually conjured by the word

> "Books are the carriers of civilization. Without books, history is silent, literature dumb, science crippled, thought and speculation at a standstill. Without books the development of civilization would have been impossible. They are the engines of change, windows on the world, 'lighthouses' (as a poet said) 'erected in the sea of time.' They are companions, teachers, magicians, bankers of the treasures of the mind. Books are humanity in print."
>
> —BARBARA TUCHMAN

flower. (Words are magic.) The flower Shakespeare had in mind when he wrote, "This bud of love, by summer's ripening breath/ May prove a beauteous flower when next we meet."

This definition is extended to denote the reproductive organs in mosses, colorless, calyx-free, and all, and to the feathery seeds of the thistle or the dandelion. And then this. *Flowers*, plural, denotes the menstrual discharge, the menses, as in *"The same water . . . causeth women to have her flowers, named menstrum."* (Back to the reproductive organs.) The pulverulent (fine powder or dust) form of any substance is called the flower. I would think this is how *flour*, a fine powdery foodstuff, is related, but the dictionary suggests it comes from another meaning—the best of everything, the choicest, the most attractive, as in "the flower of womankind," "the flower of friendship." The flower of the wheat, I suppose.

Flower is also the scum formed on wine (does it contribute to the bou-

quet?) and on vinegar in fermentation; it's an adornment or ornament or embellishment; the condition of being in bloom; a period of vigor or prosperity; and so on. And it also means, or more correctly did mean, since it has gone out of fashion, virginity. "O Pallas, noble queen, help that I lose not my flower." More sex here than we might have expected. But let's look at the Indo-European root again.

Bhlo- or *bhle-* *(identical to bhel-), to blow.* Derivatives from this root include *foliage* (and from that *folio, defoliate, portfolio,* and *trefoil,* among others), *blossom, bloom, flora* (and *floral, floret, florid, florist, flour, flourish, flower,* and, of course, *deflower), bleed, bless,* and *blade.* And that's just for starters. You can never know too much about words and what they mean and how they were born and grew, what need they met, and so on. And besides all of that, while you investigated the word, what other images, ideas, and memories intruded on your work?

When we first mentioned *flour,* I remembered being a boy at my great-grandmother's apartment, where I was allowed to sift the flour while she made cakes, and when she wasn't looking, I buried my hand in the canister of flour. I loved the cool smoothness of the flour on my skin. She never once yelled when I managed to dust the counter and the pantry floor with the flour. I remembered her tiny flat, the TV with the round screen that was never turned on, the doilies on the chairs, the rocker in the kitchen by the stove, the oranges in a bowl on the kitchen table. I remember how she opened a closet door and banged on the water heater to signal my aunt Bea on the second floor. Now I've got a place my characters could live. And I think, virginity, menstruation, roses, valentines, baking, and I wonder how I can let these notions guide my story.

>
> *"I was reading the dictionary. I thought it was a poem about everything."*
> —STEVEN WRIGHT

So here's the thing. You should never again watch TV without a book in your hand, even if you're watching *Nova.* You ought to be reading the dictionary for fun. You ought to be keeping lists of words you love, words which you want to use in your next story. Here are some from my list that I plan on using in my next novel: *abortuary, aestheticienne, burble, grabble, huitlacouche, deliquesce.* In writing *L'Homme Foudroye (The Astonished Man),* Blaise Cendrars, poet and memoirist, made a list of three thousand words, arranged them in advance, and used all of them! Anthony Burgess, who was a com-

poser as well as a novelist, developed a writing process, called aleatory composition, which meant, for him, that he chose ten words at random from the dictionary and let those words guide his novel. (*Aleatory*: from the Latin *aleatorius*, from *aleator*, gambler, from *alea*, game of chance, die.)

If you don't have access to the *OED* (and even if you do), you ought to have *The American Heritage Dictionary of the English Language*. It's the best American dictionary we have, largely because of its word histories and usage discussions. Get the fourth edition if you can. The new one. There's really no limit to the dictionaries you can have at your disposal. People you live with will tell you you don't need any more English-language dictionaries. They are wrong, of course, but you'll need to be careful not to clutter. I know there are dictionaries other than the *OED* available on-line,

> *"Reading furnishes the mind only with materials of knowledge; it is thinking that makes what we read ours."*
>
> —JOHN LOCKE

and that could save space, but I haven't used them yet. Shame on me, I suppose. And we haven't even talked about Spanish/English, French/English dictionaries. You need them. Cover the Romance and Germanic languages for a start. Your character has pulled into a motel in Artesia, New Mexico, and there's a sign over the registration desk that says—reach for the *Harper's Concise Spanish*—it's handwritten, it says, *$10 deposito para el gato!* Maybe our character ought to check out the motel over in Maljamar.

And you need several thesauri. The best one, by far, is *The Synonym Finder*, by J. I. Rodale (Warner Books). It's thick, it's cheap, it's indispensable. When you know you don't have the exact word just yet, open the thesaurus, start reading. If you're like me, you're still happily chasing words down an hour later. And you haven't gotten the exact word yet, but you've got a better one. Rodale's does not have antonyms, so it's a good idea to keep a Roget's around or those from Oxford, Merriam-Webster, American Heritage.

I like to go to used bookstores (I'm allergic to the mold and dust from the old books, but I can't let that stop me) and look for reference books. I try to buy whatever I can. I figure if I use the book only once, it has paid for itself. I might not open the book for years, but then comes the day that I need to know what tool my handyman needs to attach the cabinet doors on the kitchen counter he's building in the fixer-upper he and his bride-to-be will soon be moving into (he thinks). I consult *The Complete Illustrated Guide to Everything Sold in Hardware Stores* (Steve Ettlinger, Macmillan) and find the

router right there by the biscuit joiner. And I'm glad to know there is such a thing as a biscuit joiner and that there are the appropriate joiner biscuits to fit the slots. And now I know what dadoes and rabbets are as well.

You want to have field guides of all kinds. Peterson's or Audubon's or both and any others you can hunt up, because one day your character's going to pull over at a rest stop in Louisiana or Missouri or wherever it is he's from, and you're going to have to know what flowering plants might be growing there by the side of the road, and what shrubs and trees, and what birds might be warbling in those branches, and what butterflies might be alighting on the hood of his pickup, and what bug is crawling across the picnic table. And you'll be able to find out quickly. Field guides to flowers, to seashells, to the stars, to fungi, to mammals, to insects, to reptiles, to shrubs, and, well, you get the picture.

.....

"My library was dukedom large enough."

— WILLIAM SHAKESPEARE

Fiction writers need to know the names of things, and this is where visual dictionaries can be helpful. I've listed some in the toolbox at the end of the chapter, and I won't go into the merits of each (there are no demerits), but having them around is so wonderful. You're probably not going to need to know the structure of a motor neuron for your next story, but if you did, you could find it all wonderfully illustrated and labeled in *The Ultimate Visual Dictionary* (Dorling Kindersley), from nucleolus to axon. You're more likely going to want to know what the little deal is that connects the head and neck of your character's golf club to the shaft. It's a hosel. Found that in *What's What* (Fisher and Bragonier, Hammond).

I used to keep used almanacs around, like *The World Almanac and Book of Facts*, or the *New York Times Almanac*, but I moved so often and then found out I could find a lot of the information on-line. My characters are eighteen and in love. It's 1948, and they're spooning out on the front porch, listening to the radio. What's playing? "Buttons & Bows," probably (unfortunately). So they turn to a country station and hear Hank Williams's "I Saw the Light." Much better. Now, I found that on the Web, but it took me longer than it would have to open a book, and I missed the opportunity to browse and invite the serendipitous discovery. I miss those almanacs.

You should have a road atlas of North America and a world atlas of some kind. Yes, the world's political borders keep changing, and you'll have to keep

up with it, but don't toss out the old atlases. If your characters are living in 1936, say, they will need to know that there is no Pakistan, no Bangladesh, that India stretches from Mandalay near French Indo-China to Gwadar on the Gulf of Oman. That information according to the map in my *Rand McNally Ready-Reference Atlas of the World*, copyright 1936. In 1936, Newfoundland was a country and so was the Irish Free State. My *Harper's School Geography*, published in 1878, and wonderfully illustrated "by eminent American artists," has this to say about Florida: "The population is nearly all in the northeast, and within a hundred miles of the northern boundary. The southern half of the state is a low morass." And that's still true, metaphorically, at least.

"The greatest part of a writer's time is spent in reading in order to write. A man will turn over half a library in order to write."

—SAMUEL JOHNSON

You'll want to have books about history, like J. M. Roberts's *History of the World* (Oxford); like *The Expansion of Everyday Life* by Donald E. Sutherland (Harper & Row), which portrays daily life in this country before, during, and after the Civil War; and like Bernard Grun's *The Timetables of History* (Touchstone). (Where I could have found out quickly that while "Buttons and Bows" was leading the Hit Parade, Olivier was winning the Academy Award for *Hamlet* and Michener the Pulitzer Prize for *Tales of the South Pacific*.) You'll want every book you can find on words, on

"As writers who try to document popular culture, our most valuable resource has always been the Sears Catalogue. Square, common and only timidly trendy (you could buy Scottie-dog ash trays in 1938, Flower Power wallpaper in 1968, open-to-the-navel disco shirts in 1985), this vast syntagma of American stuff is a reflection not of reality, but of the popular vision of what life was supposed to look like, year by year."

—JANE AND MICHAEL STERN

science and philosophy, on religion and mythology, on literature, music, and art. See the toolbox below for some suggestions.

And you'll want cookbooks, right? Your characters ought to eat and they ought to eat well. I have vegetarian friends, vegan friends. I have friends who do not eat cooked food! Or processed food! But my characters will not suffer such ignomiry. They all eat well, if sometimes unusually. I have an entire bookcase of cookbooks and other books on and about food. Don't let your

husband and wife go to a generic restaurant for their anniversary. Make reservations at the nice little Caribbean place downtown. And let them dine imaginatively on mannish water, stamp and go, and an entrée of ackee and saltfish. Maybe fried bananas and rum for dessert. All those delights found in *The Restaurant Lover's Companion* by Steve Ettlinger (Addison-Wesley). (Could it be the same Steve Ettlinger who wrote the hardware book? How many Steve Ettlingers can there be in publishing?) Or maybe these are stay-at-home folks, and they live down South. So when they invite the new neighbors over, they serve swamp cabbage, hoppin' john, smother-fried chicken, and cornbread (from Ernest Matthew Mickler's legendary *White Trash Cooking*, Ten Speed Press).

And one more item (because I was thinking they need to dress, too). Collect catalogues. I have old ones, reproductions like the Sears, Roebuck & Co. catalogue from 1908. (What ever happened to Roebuck?) I have toy catalogues from the 1930s, historical supply catalogues, old medical catalogues, but mostly I save the catalogues that come flying at me through the mails. Catalogues for office supplies and pens, for lingerie and oddities, for household furnishings and flower seeds. Save them and when you need the right piece of furniture, there it is in living color and fully described.

A Writer's Toolbox

· · · · ·

The American Heritage Dictionary of the English Language, Fourth Edition, Houghton Mifflin, 2000. *The best American dictionary. Great on usage and etymology.*

The American Heritage Book of English Usage, Houghton Mifflin, 1996. *A practical guide to understanding and solving problems of English usage.*

The Apocrypha, an American Translation, Edgar Goodspeed, Vintage, 1959. *The rest of the story from the Greek version of the Jewish Bible. In the original King James, but not in the modern versions.*

The Art of Looking Sideways, Alan Fletcher, Phaidon, 2001. *Over a thousand pages of thoughts and images on creativity. Mind-boggling.*

Aw, Shucks, The Dictionary of Country Jawing, Anne Bertram, NTC Publishing Group, 1997. *Colorful expressions used by American folk.*

Brewer's Dictionary of Phrase & Fable, Centenary Edition, Ivor Evans, edi-

tor, Harper & Row, 1981. *Three hundred new entries in this classic. Everything you've always wanted to know. . . .*

Bulfinch's Mythology, Spring Books, London, 1963. *Stories of gods and heroes from the Ages of Fable and Chivalry.*

The Complete Book of Bible Quotations, Mark Levine and Eugene Rachlis, editors, Pocket Books, 1986. *A Bartlett's of the Bible, which uses the King James.*

The Complete Rhyming Dictionary, Clement Wood, Doubleday, 1936. *With sections on verse forms and prosody.*

The Concise Dictionary of Word Origins, Helicon, 1995. *A dictionary of two thousand words with their brief histories and with false etymologies where appropriate.*

The Concise Oxford Dictionary of English Etymology, T. F. Hoad, Oxford University Press, 1986. *An adjunct to the OED. Histories of basic words.*

Death to Dust, Kenneth V. Iserson, M.D., Galen Press, 1994. *What happens to dead bodies? Everything you've ever wanted to know about corpses, and some things you didn't want to know.*

The Describer's Dictionary, David Grambs, W. W. Norton, 1996. *A compendium of descriptive terms and literary quotations.*

The Dictionary of American Food and Drink, John F. Mariani, Hearst Books, 1994. *The history of eating and drinking in America with recipes, anecdotes, and definitions.*

Dictionary of American Regional English, Frederick Cassidy, editor, four volumes. *Expensive and indispensable. Folk expressions of the American people. A look at the language we've made from the bottom up.*

A Dictionary of Philosophical Quotations, A. J. Ayer and Jane O'Grady, editors, Blackwell, 1994. *A survey of 330 philosophers and what they have pithily said.*

A Dictionary of Quotations from Shakespeare, Margaret Miner and Hugh Rawson, Dutton, 1992. *A topical guide to over three thousand great passages from the master.*

The Elements of Style, Stephen Calloway, editor, Simon & Schuster, 1996. *A practical encyclopedia of interior architectural details.*

Essential American Idioms, Richard A. Spears, National Textbook Company, 1994. *The basic and essential expressions of American English.*

A Field Guide to American Houses, Virginia and Lee McAlester, Knopf, 1990. *The best field guide to American residential architecture.*

The Golden Bough, James George Frazer, Simon & Schuster, 1996. *The classic work on myth, religion, magic, ritual, and taboo.*

A Guide to the Gods, Richard Carolyn, Quill, 1981. *A Who's Who of world mythology from the continents and Oceania.*

The HarperCollins Illustrated Medical Dictionary, Ida Cox, B. John Melloni, Gilbert Eisner, HarperCollins, 1993. *Twenty-five hundred clear line drawings, charts, graphs, definitions.*

Holy Bible. Make sure one of your editions is the King James.

The Hour of Our Death, Philippe Ariès, Knopf, 1981. *A classic study of death and dying.*

Lempriere's Classical Dictionary, J. Lemprière, Bracken Books, 1984. *Originally published in 1788, over fourteen hundred entries. Probably the one Keats read.*

The Longman Dictionary of Poetic Terms, Jack Myers, Michael Simms, Longman, 1989. *Defining the techniques devices, histories, theories, and terminologies of poetry.*

Love, Stendhal, Penguin Classics, 1975. *The great novelist's meditation on the history and philosophy of love.*

The Macmillan Visual Dictionary, Macmillan, 1992. *A graphic, full-color visual dictionary identifying twenty-five thousand terms.*

The Merriam-Webster New Book of Word Histories, Merriam-Webster, 1991. *Fifteen hundred thorough etymologies.*

Mythology, Edith Hamilton, Mentor, 1940. *A popular retelling of ancient myths.*

The New Food Lover's Companion, Sharon Tyler Herbst, Barron's, 1995. *Definitions of over four thousand food, wine, and culinary terms. Finally, you'll know what flummery is.*

The New York Public Library Desk Reference, Webster's New World, 1989. *An almanac of knowledge. Fun to browse.*

NTC's Dictionary of Changes in Meanings, Adrian Room, NTC Publishing Group, 1996. *What the words mean now and what they did and when the meanings entered the language.*

On Food and Cooking, Harold McGee, Collier Books, 1984. *The science and lore of the kitchen. Culinary lore and the scientific aspects of food and cooking.*

The Oxford Book of Aphorisms, John Gross, Oxford University Press, 1987. *A splendid collection of quotes arranged by topic.*

The Oxford Book of Marriage, Helge Rubinstein, Oxford University Press,

1990. *Every pithy statement you've ever wanted on the institution of matrimony.*

The Oxford Book of Quotations, Oxford University Press, 1979. *Organized by author. The extensive index makes it easy to use.*

The Oxford Companion to the Mind, Richard L. Gregory, editor, Oxford University Press, 1987. *A lively guide to the philosophy, psychology, and physiology of the brain.*

The Oxford Companion to Philosophy, Ted Honderich, editor, Oxford University Press, 1995. *A comprehensive single volume covering the history of philosophy worldwide.*

The Oxford-Duden Pictorial English Dictionary, Oxford University Press, 1995. *A visual dictionary of twenty-eight thousand objects done in black and white drawings and especially focusing on workplaces.*

The Princeton Handbook of Poetic Terms, Alex Preminger, editor, Princeton University Press, 1986. *A selection of entries from the larger* Princeton Encyclopedia of Poetry and Poetics.

The Rolling Stone Illustrated History of Rock & Roll, Anthony Decurtis et al., Random House, 1992. *Everything you've ever wanted to know about the sound track to your life.*

The Roots of English, Robert Claiborne, Times Books, 1989. *Indo-European roots of English words.*

Slang American Style, Richard A. Spears, NTC Publishing Group, 1996. *Ten thousand colloquial expressions in American English.*

Southern Food, John Egerton, University of North Carolina Press, 1987. *My personal favorite. I hope Egerton is working on the revised edition. Southern food at home and on the road. Anyone who loves food will love this book.*

The Synonym Finder, J. I. Rodale, Warner Books, 1978. *By far the best thesaurus available.*

Ultimate Visual Dictionary, Dorling Kindersley, 1994. *Five thousand color photos and thirty thousand terms.*

What's What, David Fischer and Reginald Bragioner, Hammond, 1990. *"A Visual Glossary of the Physical World." A visual dictionary of the details all around us. Black and white photos and drawings.*

Who's Who in the Ancient World, Betty Radice, Penguin, 1973. *A dictionary of Greek and Roman mythology.*

Word Menu, Stephen Glazier, Random House, 1992. *Organizes language by subject matter. Kind of a dictionary/thesaurus/almanac. For example, under*

bottle *you would find* flask, flagon, cruet, *etc.*, with *definitions for each of those words.*

The National Audubon Society has field guides to birds, butterflies, fish and whales, insects and spiders, mammals, fossils, the night sky, reptiles and amphibians, rocks and minerals, seashells, seashore creatures, trees, weather, wildflowers, dinosaurs, for starters.

Peterson Field Guides offers most of the above, plus some others: medicinal plants and herbs, geology, animal tracks, ferns, mushrooms, the atmosphere, and more.

EXERCISES

.

The Naturalist

So today take that field guide to trees off the bookshelf, slip on your walking shoes, maybe take along a camera, some water, your notebook, of course, and walk around your neighborhood. Identify all of the trees you see. Sounds easy, but it can be frustrating until you get the hang of it, until you know what it is you're looking for. The tree you can't find in your field guide might not be native, might be an ornamental planted years ago by a neighbor who's no longer around to name it for you. You may need another field guide. Take your time and have fun. Tomorrow take the field guide to birds and sit in your backyard or in a park. Take binoculars for this excursion. For the insects, you may need a magnifying glass. This will get to be fun, you'll find out.

Found Stories

In a sense all stories are found. They are out there in the world. They are there in your reference books. Everyone has a story, and the writer can find them if she looks. As Picasso put it, "I don't seek, I find." The writer with her antennae up, her senses alert, finds stories everywhere. The term "found poetry" is used to describe a text lifted out of some original context and arranged to give the appearance, form, or sound we associate with poetry. It must be found somewhere among the vast sub- or nonliterature which sur-

rounds us. It must be taken from an innocent or naive context, from advertising, say, newspaper reports, police logs, menus, billboards, memos, and so on.

The rules are a bit different for the found story, since we probably won't lift the text itself, or at least not all of it. What we're looking for is character, perhaps, situation, the kernel of a narrative that we can spin. It's important that the found story isn't art. That's our job, to make it so. It could be a human figure we see in a medical text with his musculature identified by arrows and terms. Donald Barthelme was perhaps so inspired to write his wonderfully comic story "The Illustrated Man." Lewis Nordan writes about his character's mother telling him stories about the people in the Sears, Roebuck catalogue. The woman there by the Cold Spot refrigerator on page 311 is worried because her husband's late. He's the dark-haired guy in the mohair suit on page 223. He's in sales. Covers the whole eastern part of the state. He's stopped at the Dew Drop Inn after a lousy day. He knows he should call Helen. He looks at his watch. He'll just have the one more beer and then head home. So let's stay with him a minute. He orders the beer. He can't get the Neely account off his mind. If he loses this one, Larry Shank will have a conniption fit. While our salesman's been lost in thought, a young woman has taken the seat beside him. She sniffles. She looks like she's been crying. Let the scene continue. What does our salesman do? (What does he say? Think of saying? For that matter, what does he sell? What's his name? How long has he been married?)

Tomorrow you might try opening a catalogue of your own and finding a couple of characters. You already know what they look like when you find them. Here's a guy in the Orvis Holiday 2000 catalogue. He's lounging on a patio chaise reading the *New York Times*. He's wearing his polo shirt, pressed khaki slacks, sand-colored socks, and shiny penny loafers. His hair is perfect, his belt is braided. His name is Todd. Actually, Todd's not reading the paper; he's thinking about the pretty young gal over on page 86. She's in a red cotton pullover, a plaid pull-on skirt, black riding-style boots. Her hair is thick, long, and curled. She's Linda from the club. Steven's wife. How did she end up with Steve Yablonski? Todd's wife's the woman to the right, on page 87, the woman with the short blond hair, wearing the black-trimmed boiled wool jacket, the white wool turtleneck. Denise. She likes the needlepoint flats on page 81. Todd finds them impractical. So what's the trouble in the marriage? Why is Todd so taken with Linda?

Or try something like this. Find a room in a catalogue and note the

details. What do the details of the place tell us about the people who live there? Like this kitchen featured in the Christmas 1998 Pottery Barn catalogue. Stainless steel gas stove with a vent and pot rack above it. White counters and cabinets. A large window and French doors curtained in white lace. In the center of the room a metal-topped breakfast bar surrounded by chrome-plated steel barstools covered in black vinyl. A rattan area rug on the hardwood floor. There's an easel with a reproduction advertising print for Cinzano, featuring an equestrian on a spirited red horse. Whose idea was that? If they had kids, that would be impossible, wouldn't it? It would be getting knocked over every day. So maybe they're an older couple—second marriage for both. She used to paint. Gave it up when Husband #1 needed her help with his real estate business. She's always thought that this would be her dream kitchen—light, spacious, airy. But now she's thinking she'd like something more serviceable, something like her grandmother's kitchen. A bit cluttered, cramped, cozy. Enamel-topped table, white Tappan range, floral bread box, and matching canisters. But how to tell Russ? What does this mean, her dissatisfaction with the modern, stylish kitchen, her desire for another?

Aleatory Composition

This is a technique, as I mentioned, employed by, if not developed by, Anthony Burgess. *Aleatory* means *depending on chance or luck or uncertainty; characterized by gambling,* from the Latin *aleator—gambler,* from *alea: dice.* It comes to literature by way of the musical term *aleatorism*—the incorporation of an element of chance in the performance of music, placing an object on the piano wires, say. It is the imposition of what is arbitrary. Not unlike the conventions of the Shakespearean sonnet which says there will be fourteen lines of iambic pentameter rhyming *abab cdcd efef gg.* Why fourteen lines? Just because. Burgess began his writing of each novel by selecting ten words (nouns or verbs) at random from reference books and letting the words direct the writing. If you're stuck, you might consider opening the dictionary and choosing the third word in the fourth column whatever it is and using that word in your next sentence or paragraph. Or letting the first blue object that you see when you look up be the subject of your character's next utterance. Like that. You are shaking up the very logical and rational way you think and allowing opportunity for discovery. Your brain will make connections.

Arts & Science

Read a book on popular science, on archaeology, ecology, physics, or some science that you know very little about. The book should be written for the layperson. Now let one of your characters consider his circumstances in light of the science you've just read. Let him think metaphorically about himself and his condition. For example, your character had a great loss in his life several years ago. Let's say his spouse died. Well, you've read a book on paleontology and now your character thinks about himself as a fossil, as a shell of his old self, trapped in the matrix of the past. And like most fossils, he's incomplete. If someone were to discover what remains of him now, maybe they could imagine what he was like back then, back before the catastrophe buried him. Like that.

Small Craft Warnings

X

English usage is sometimes more than mere taste, judgment and
education—sometimes it's sheer luck, like getting across a street.

—E. B. White

Some random thoughts here on punctuation, grammar, usage, and
mechanics. They are all mistakes I've made, mistakes I see frequently. No
doubt you've gotten some of this advice before, but it doesn't hurt to hear it
again.

Avoid the use of hackneyed phrases—those you've come to depend on in
your speech ("You know what I'm talking about?") as well as your writing.
Don't try for the easy way out of the difficult thought. Stay away from
phrases like the following: "As everyone knows . . ." (This would include the
reader.); "It came as no surprise . . ." (Then what's it doing in a story?);
"Needless to say . . ." (Then don't say it.); "An emotional roller coaster."

Beginning writers all too often use this formulaic sentence: "_____
filled the air." The blank can be fear, panic, the scent of cheese, the blare of a
marching band. It's part of a larger tendency of description without detail.
It's telling and not showing. Like this one: "The coffeemaker was steadily
perking and gradually the aroma of coffee filled the air." Nothing fills air.
Cacophony is a favorite word for this writer. It indicates unpleasant noise
without describing it. Grackles in trees, autos at an intersection, a family jab-

bering at dinner—all produce cacophony. But cacophony is in the ear of the beholder. Do not, under any circumstances, use the "_____ filled the air" sentence structure.

If you use the verbs *lie* and *lay*, you will get them wrong. I wish I were overstating the matter. The meanings and principal parts of the two verbs are similar and therein *lies* the problem. Well, let's clear this confusion up once and for all. *Lie* means "to recline." It is an intransitive verb, does not take an object. *Lay* is a transitive verb—it takes an object. "I was laying out in the sun" is incorrect. The principal parts: *Lay:* **lay** *laid laid laying. Lie: lie* **lay** *lain lying.* You see the problem. The past tense of *lie* is the present tense of *lay.* As a student once somewhat crudely explained, "It takes one to lie, two to lay."*

Beware of the overuse of the pronoun *it.* "It was back in '78 when I bought it, and my son was so delighted, and it really surprised my wife." *It* can only have one meaning per sentence. And the meaning needs to be unambiguous. As for the third *it,* does it refer to the purchase or the delight?

While we're on the subject, beware of any pronouns with ambiguous antecedents. "Marlon told Carl he should arrive at around nine o'clock." Who should arrive? You could revise or recast in several ways. Here's one: Marlon told Carl, "You should arrive at about nine o'clock."

Be careful of the dangling construction. Next to comma splices, this may be the most common error in prose. "At the age of forty-five, the lightly gray hair crowning his small head came to look distinguished." The gray hair is obviously not forty-five. The person is. Or this: "But outside of performing, her history was hazy." Her history was not performing.

Typography is important and ought to be conventional. You ought to double-space, indent your paragraphs, use a readable and unembellished font, justify the left margin only, use white space to indicate an abrupt shift in

* Here's our president, George W. Bush, for example: "I think we're making progress. We understand where the power of the country lay. It lays in the hearts and souls of Americans. It must lay in our pocketbooks. It lays in the willingness for people to work hard. But as importantly, it lays in the fact that we've got citizens from all walks of life, all political parties, that are willing to say, I want to love my neighbor. I want to make somebody's life just a little bit better." April 11, 2001. The leader of the Free World.

time or space. Don't use all caps to indicate importance or volume: "NO YOU MAY NOT!" he shouted.

Don't overuse the verb "to be." It's handy and it's necessary (twice in that sentence alone, but it ought not be universal). We write with nouns and verbs which need to be vivid and propulsive. "To be" is neither. Read through your story and look for each "to be." Take out every one you can.

All right, already. There are *all ready* and *already*; and *all together* and *altogether*, but there is only *all right*—two words. While we're thinking about it, *alot* is not a word. *A lot* is two words. *Allot* is one word. I'm baffled by *alot*, though it seems universal and evidently our public-school teachers have given up the fight.

In a related matter. There is *awhile*, an adverb, and *a while*, an article and a noun. The two-word version is never wrong, according to *Word Court*. In most cases, both forms are acceptable. At least the *American Heritage Book of English Usage* thinks so. But you should use the two-word form following a preposition, shouldn't you? Prepositions take noun objects, not adverbs. So, *I studied for quite a while*. Webster's Third, however, says "for awhile" is fine. My copy editor* says he'll only allow *awhile* if *for a while* can be substituted in its place and make sense.

Similarly, *anymore* is an adverb meaning *no longer. We don't eat meat anymore*. But in parts of the South, the word has come to mean *nowadays* as well. As in, *Folks are all talking on their cell phones anymore*.

Periods and commas go *inside* quotation marks. Always. Even when only the last word in the sentence is enclosed. *His favorite song of all time is "In-A-Gadda-Da-Vida."* (This is an American printing convention. You'll see British

* The making of a book (like this one) is not the product of a single person. One of the most important people involved in the process is the copy editor. I have one; you'll have one. Mine happens to be brilliant. His name's Dave Cole, and his careful reading and insight have saved me far more humiliation and embarrassment than I care to divulge. His questions have made me think harder than I had. I'm in his debt. Know that your work will be copyedited by someone like Dave (you hope) who has *The Chicago Manual of Style* and *Words Into Type* within easy reach. (You might want to keep them around, too.) Dave recommends that you also get yourself a copy of Theodore M. Bernstein's commonsensical *The Careful Writer*. I'm on my way to the bookstore now!

and Commonwealth publications that seem to violate the "rule.") Now you don't have to think about it again. Colons and semicolons go *outside* quotation marks. *He never read "A & P"; he didn't like Updike.* Question marks and exclamation points (and dashes) can go in either position depending on the sentence. (It's not arbitrary.) Like these: *Does he know all the words to "In-A-Gadda-Da-Vida"?* Here the entire sentence is the question. *All he could say to that was "Damn!"* Here the exclamation is in the quoted word. (You might think a period would follow the closing quotes for what is, after all, a declarative sentence. But when two different marks are called for at the same location—the end of a sentence—only the stronger mark is retained: question mark or explanation point, not period.) In American English single quotation marks are used inside double quotation marks (the way brackets [like this] are used inside parentheses). *"I sang 'In-A-Gadda-Da-Vida' at the prom," Mike said.*

No more sighing by characters. And they probably shouldn't chortle, either. And don't use the following words: *unicorn, lifestyle, soulmate, holistic, quickly, slowly, dysfunctional, bonding, dialogue* (as a verb), or the phrases *quality time, win-win situation, outside the box, push the envelope, net result, on the same page.*

Let the character cry. There is, for some reason, a reticence to use the simple expression. Instead we're pummeled with dubious and unnecessary euphemisms: *Hot tears leaked from her eyes. Hot tears sprang to her eyes, trickled down her cheeks. Quick tears sprang to her eyes. A single tear ran down her cheek. Big tears, heavy as hail, poured down my cheek.* Better: *She cried.* And there's no need to say *She began to cry.* You don't ever have to write the phrase *She began* anything. She either cried or she didn't.

Redundancies: *He thought to himself.* (How else?) (See *began* above.) *Sit down on the chair.* Isn't *sit* enough? *Stand up!* How about, *Stand!*

A third-person narrator ought not to make grammatical errors except when she's in the mind, the speech of the character—interior monologue, stream of consciousness, etc.

Nothing is cooked to perfection. Not even Mom's chicken soup.

No stage directions. Don't write *Pause*. Or *Silence*. Or *A beat*. Save it for your screenplay. Show the pause, indicate the silence. Do so with a bit of vivid and significant behavior.

Why spelling counts; why spell-check doesn't. You might end up with something like this: "Wesley wrapped the towel around his waste and opened the bathroom door."

Or this: "She was wearing a black, leather donna matrix outfit on this particular day."

Or this: "The bomb squat and firefighters are getting ready to leave the cite."

Or this: "Borrowing owls were on the endangered spices list."

Or this: "Brandon came into the meeting in a fowl mood."

Or this: "Many say they wish you were air to the throne."

Spelling mistakes, typos, mistakes in idiom, and so on, characterize you as a writer controlled by language, not in control of it.

Till and *until* are pretty much interchangeable, meaning "before" or "up to the time of" or "up to that time" or "to the point or extent." *Until* is preferred when beginning a sentence. (Though *till* can also mean "to cultivate," "a drawer," and "glacial drift.") But *'till* is not a word. *Till* is older than *until* and so was not formed from it, so no need for the apostrophe to indicate the missing *un*. What about *'til*? Well, like *'till* it is etymologically incorrect. So don't use it even though you'll see it all over the place.

Why proofreading is important. You might end up with this: "The instructing sergeant again ordered all the soldiers to drink the entire canteen before existing." We've got an awfully big canteen evidently. And why all take turns drinking it and not the water in it? And then there's the small matter of existence, of being and nothingness.

Never use "try and" (everyone does, of course) instead of "try to." (A character may say it, but not the narrator.) You may think that "try and" implies a real hard try, and therefore success, but you're wrong—if it's a successful attempt, why use "try" in the first place? "I'm going to try and build a house" means the same thing as "I'm going to build a house." It's not about the attempt but about the execution. If you change it to the past tense, you

can see the difference: "I tried and built a house" is not the same as "I tried to build a house." What goes for *try and* goes for *be sure and*.

Don't capitalize terms of endearment. "I'll get that for you, honey." Not "Honey."

Don't exaggerate. You lose your credibility as soon as you say, "Mavis washed the floor for the hundredth time." We might believe eighty-one, but when we hear the swollen round number, we know the narrator is being lazy, and so loses his authority.

I'm not sure when this became a spelling problem, but I notice it frequently. *Breath* is a noun and rhymes with *death*. *Breathe* is a verb and rhymes with *seethe*. Folks have taken to spelling both without the *e*. Don't. Another baffling but frequent misspelling is *quite* for *quiet*.

Edgar Allan Poe said there is obscurity of expression and expression of obscurity. Don't mistake them.

Know what each and every word you use means. Look them up in dictionaries—not a dictionary you can tuck into your back pocket. Love words. Read about them. Read books on usage, on etymology, on the history of our language.

Spell out all numbers from one to one hundred and any number that can be expressed in one or two words, including references to decades and centuries (the fourth century, the thirties). Use numerals for dates, for street numbers, for page and line numbers, and in referring to parts of books or times (January 24, 2002 [but spell out dates that don't include year: March first]). In fiction, time is spelled to half hour or quarter hour: five-fifteen P.M., but 5:16 P.M. In fiction, numbers are almost always spelled out: two to one, seventeen percent, twenty-five rpm. Never begin a sentence with a numeral. Not "1,223,452 U.S. citizens neglected to file taxes this year." And you certainly don't want your sentence beginning with "One million two hundred twenty-three thousand, four hundred and fifty-two . . ." So you recast the sentence. It begins, "This year . . ."

Compound words and hyphens. A compound word is made up of two or

more words that express a single idea. Some of those are hyphenated (*brother-in-law*), some are not (*basketball*). Compound modifiers are generally hyphenated: *green-eyed cat*, but *a cat with green eyes*. Compound adjectives with *high-* or *low-* are hyphenated: *low-budget movie*. Compound numbers from *twenty-one* to *ninety-nine* are hyphenated. A compound adjective formed with a noun, adjective, or adverb and a present participle is hyphenated when it precedes the noun it modifies: *a mind-boggling puzzle*.

Collective nouns are singular in form, refer to a group of people or things, and may be singular or plural in use. When a noun refers to the collection as a whole, the noun is singular: *The team was united in its resolve.* When the noun refers to the individual members of the group, the noun is singular: *The committee were fighting among themselves.*

It's and its. Every time I write either of these words I have to stop and read the sentence again. *Its* is a possessive pronoun even though it does not have an apostrophe. In fact, none of the possessive pronouns employ an apostrophe: *yours, hers, his, their, whose. It's* means "it is."

If the sentence expresses a wish or a contrary-to-fact condition, use the subjunctive mood of the verb. *If I were a bigger man, I'd forgive you.* (But I'm not.) *I wish I were on some secluded island right now.*

I'd could be a contraction for *I would* or for *I had.* Be sure your reader knows which one you mean.

Use the past perfect tense to indicate a time before a time in the past. *I had finished the test before I left the classroom.* Past perfect uses the auxiliary *had* with the past tense form of the verb. We seldom use the past perfect in speech and it can sound awkward. If you're writing a story in past tense and include a flashback, you will have to use the past tense to signal the shift, but then you can revert to the simple past if you also signal us that we have left the flashback when it's over.

Farther indicates physical distance. *The mountains are farther away than they look. Further* indicates nonphysical advancement. *I'll have to think further about the proposal.*

To form the plurals of numbers, letters, and abbreviations, you should use *s* alone if you can do so without confusion. *The 1950s, IOUs.* But, *Mind your p's and q's.* Not *ps* and *qs.* If an abbreviation ends in a period, use the apostrophe. *Ph.D.'s.* When pluralizing proper names use an *s* only. *The O'Malleys.*

When I was in grammar school (which grades K–8 are no longer called, evidently), the nuns taught us (when we weren't diagramming sentences) about the auxiliary verbs *shall* and *will.* When we were trying to express action in the future we were to use *shall* with the first person ("I shall never lie again, Sister") and *will* with the second and third persons ("You will be sorry one day"). But you could use *shall* with second and third person to indicate emphasis or command ("You shall do what I say") and *will* in the first person for the same reason. This distinction seems to have vanished. The only time *shall* is regularly used these days is with an invitation: *Shall we go? Will we go?* has a whole other meaning.

Go Forth and Write

X

What thou hast seen, write in a book. . . . Write
the things which thou hast seen, and the things which are,
and the things which shall be hereafter.

—*Revelation 1–11 & 19*

Here we are at the end of the trail, and I have a confession to make.
The longer I write, and the longer I teach writing, and the more often I talk
about writing, the more I realize I know nothing about it. I passionately
believe in what I'm saying, but I'm wrong about it all. We all have our aes-
thetic principles, though we aren't always aware of them because we aren't
often asked to articulate them. We like one story and dislike another. Why is
that? What compelled us in Story 1 and repelled us or bored us in Story 2? You
ought to know what you think a good story is so that you can try to write one.
(Even if what you think a good story is changes next week.) If you aren't writ-
ing to please yourself, you may be writing to please the workshop or an agent
or an imagined audience. So it's a good idea to try to articulate your beliefs.
And feel free to disagree with me. Send me a letter and straighten me out.

I do know—

I do *believe*—that's closer to the truth—that telling stories is what builds
a culture and a community, any community. Our community or cultural
story may have to do with exiles in a brave new world, or with a divine sav-
ior, or with death-defying acts of bravery and courage, or with all of the
above. I believe that if you're a writer you will write. And you need to believe

that, too. And you don't need to tell anyone just now that you're a writer if you don't want to. You just need to bring pen to paper.

In other words, don't worry about being a writer, just write. Writing provokes more writing. Be inspired by literature. Love words, read about them. Make every sentence you write an event. Believe in the power of limits and in the potential of mistakes. The only success is failure. So think about what isn't here. Find a way to say the things that cannot be said. Write now, plan later. Make the remark today. Tomorrow you'll see if it's true or not.

Until we meet again . . .